D1389989

QMW Library

23 1101478 X

WITHDRAWN
FROM STOCK
LIBRARY

0162771
21 2·90

ART IN THE MAKING
REMBRANDT

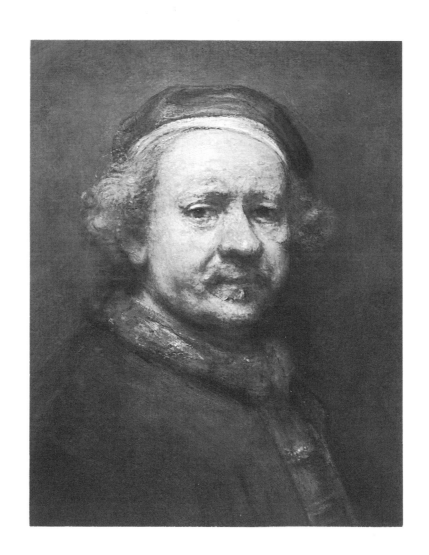

ART IN THE MAKING
REMBRANDT

David Bomford Christopher Brown Ashok Roy

With contributions from
Jo Kirby and Raymond White

National Gallery London
12 October 1988 – 17 January 1989

Sponsored by Esso in
its Centenary Year

National Gallery Publications
Published by order of the Trustees

© The National Gallery 1988

All rights reserved. No part of this publication
may be transmitted in any form or by any means,
electronic or mechanical, including photocopy,
recording, or any information storage and
retrieval system, without the prior permission in
writing from the publisher.

British Library Cataloguing in Publication
Data

Bomford, David
 Art in the making: Rembrandt.
 1. Dutch paintings. Rembrandt – Critical
 studies
 I. Title II. Brown, Christopher III. Roy,
 Ashok IV. National Gallery, *London*,
 England
 759.9492

 ISBN 0-947645-49-7

Printed and bound in Great Britain by
W. S. Cowell Ltd

The cover shows a montage of
Rembrandt's *Woman bathing in a Stream*
and an X-ray of the painting

Frontispiece: *Self Portrait at the Age of 63*
(detail)

Exhibition design by Herb Gillman

Catalogue designed by Chris Millett
Catalogue edited by Ralph Hancock and
Diana Davies

Acknowledgements

Many people have helped with this
catalogue, but in particular the authors
would like to acknowledge the help of
Aviva Burnstock, Sue Curnow,
Sara Hattrick, Jo Kent, Jacqui McComish
and J. J. Seegers

Contents

Foreword

This is the first in a series of exhibitions about new ways of looking at paintings. Over the last fifty years the techniques of X-ray and infra-red photography have, in their application to paintings, advanced rapidly, as have new methods of distinguishing paint-layers and analysing pigments. It is now possible for us to know an exhilarating, indeed at times disconcerting, amount about how old master paintings were made.

Many of these developments were pioneered in the National Gallery's Scientific and Conservation Departments, whose systematic researches have been published year by year in the Gallery's *Technical Bulletin*. It is the intention of this new series, *Art in the Making*, to bring these findings before a wider public and to present the information alongside the paintings themselves. Beginning this year with the Gallery's outstanding holding of Rembrandt, we shall focus in 1989 on fourteenth-century Italian painting and in 1990 on the Impressionists.

The results of scientific examination cannot always make for easy reading; but we believe that as understanding of the techniques of paintings deepens, so delight in their appearance grows. To follow, layer by layer, Rembrandt's application of paint is to be more than ever in awe of his skill. The skewed canvas in *Belshazzar's Feast*, or the comings and goings of Philips Lucasz.'s hand, make us look at familiar paintings with a new eye. In the case of a picture like *The Woman taken in Adultery*, we can now see much more clearly what was in Rembrandt's mind as he made his final decisions about the composition. We have a rare opportunity to look over his shoulder, as it were, while he worked at the interpretation of a biblical theme which was to have very particular relevance to his own life.

It would not have been possible to mount this exhibition, or to produce the accompanying catalogue, without the generous assistance of Esso UK plc. From the beginning, they have supported the venture with enthusiasm and understanding. The National Gallery would like to express formally its thanks to them; and we look forward to working together over many years.

No less essential to the exhibition has been the generosity of lenders: two private collectors in this country and our colleagues at the Print Room of the British Museum and the Rijksprentenkabinet at the Rijksmuseum in Amsterdam have enabled us to present a virtually complete survey of Rembrandt's career. We are most grateful to them for entrusting their possessions to us.

The preparation of such an exhibition has placed great burdens on the Conservation, Design, Photographic and Scientific Departments. To them, and in particular to the compilers of the catalogue, David Bomford, Christopher Brown and Ashok Roy, I should like, on behalf of all at the National Gallery, to say thank you.

Neil MacGregor
Director

Sponsor's Preface

Science and Art are conventionally spoken of as separate or even antagonistic cultures. In that view Esso would definitely be located on the Science side, but we hope that our support for this series of exhibitions at the National Gallery on '*Art in the Making*' will provide a bridge for people on both sides of the divide.

Great painting depends on a mastery of a complex technology, and our understanding of the creative process behind a masterwork is enriched by an understanding of how it was produced. In industry we use a whole battery of scientific techniques to measure, monitor and test without damaging the material we are using. The experts at the National Gallery have used similar methods to deduce, without harming the paintings, exactly how great painters achieve the effects which move us as they moved those for whom they were first created. We cannot reduce great art to the techniques which constitute it, but that knowledge can only enhance our respect for the masters represented in these exhibitions.

This is the Centenary year of Esso in Britain, and we have tried to reflect, in the various programmes we have organised, as many as possible of the various aspects which constitute a corporate citizen in these times. As a science-based organisation with a growing commitment to the social role now expected of major companies, we were delighted to find at the National Gallery a project which so appropriately symbolised the cross-fertilisation between technology and the wider society we serve.

This first exhibition, on the work of Rembrandt, begins our association with the National Gallery, and we look forward to a long and happy collaboration. In the year when we are reaffirming our commitment to Britain, it is a great honour to work with such an important national institution.

Sir Archibald Forster
Chairman & Chief Executive
Esso UK plc

Introduction

This is the first of a series of exhibitions with the title *Art in the Making* which aim to present to a non-specialist public the results of technical research undertaken by the National Gallery's Conservation and Scientific Departments. The exhibition, devoted to the Gallery's large group of paintings by Rembrandt, has been organised by a committee of three: a restorer, David Bomford; a curator, Christopher Brown; and a scientist, Ashok Roy. All the Gallery's 19 paintings by Rembrandt are included in the exhibition with one loan, the *Judas and the Thirty Pieces of Silver* of 1629 (Cat. No. 1), from a private collection in this country.

The National Gallery's Rembrandts have a remarkable chronological spread: from the *Ecce Homo* of 1634 (Cat. No. 2), painted when the artist was 28, to the *Self Portrait at the Age of 63* painted in 1669 (Cat. No. 20), the year of his death, most of his major concerns and preoccupations as a mature painter are represented. There are a modello for an etching and a large-scale history painting from the mid-1630s, small-scale history paintings from the 1640s, half- and bust-length figures from the 1650s, and portraits from his earliest years in Amsterdam and from the last decade of his life. There are two self portraits. There are no genre scenes, no still lifes and no landscapes, but these are minor themes in his painted oeuvre as a whole. A more important lacuna, in any exhibition of this work that aims to be at all representative, is the absence – since the recent removal from Rembrandt's oeuvre of *A Man in a Room* (Fig. 1) – of any painting from his years in Leiden. He worked there from 1625, shortly after completing his apprenticeship with Pieter Lastman in Amsterdam, until 1631, when he moved in search of a larger and richer market to Amsterdam. It is for this reason that we have borrowed the *Judas*, one of the most famous (among Rembrandt's contemporaries) and complex of his works created during the Leiden years.

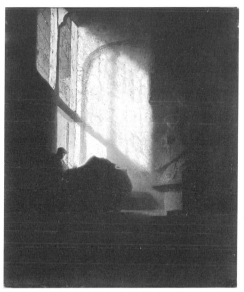

1. Imitator of Rembrandt: *A Man in a Room.* London, National Gallery

Rembrandt's paintings have been the subject of much, often heated, discussion in recent years. This has largely centred on the establishment of an authentic oeuvre. Rembrandt had many pupils who painted, at least in their earlier years, in his style; and, as an immensely successful artist, he was also much copied and imitated. There can be no doubt that a number of works by his pupils as well as copies and imitations have been accepted in the past as authentic works by Rembrandt. Hofstede de Groot's catalogue of Rembrandt's paintings, published in 1913, had 988 numbers (which included inventory mentions); Bredius's catalogue of 1935 had 630 numbers; Bauch's catalogue of 1966 rejected about 70 of the items accepted by Bredius; Gerson's revised edition of Bredius's catalogue, published in 1969, places 56 of Bredius's accepted works in an index of rejected paintings and raises doubts about many more; Gerson's own *Rembrandt Paintings*, published in 1968, has only 420 numbers; and the current work of the Rembrandt Research Project, of which only the first two volumes have appeared, seems set to reduce the artist's total oeuvre even further, to fewer than 300 authentic paintings.

This continuing reductionistic tendency in the assessment of Rembrandt's surviving work has also affected the National Gallery's representation of the artist. In his 1960 catalogue of the Dutch School, Neil MacLaren included 18 paintings by Rembrandt as well as a painting, *Anna and the Blind Tobit*, which he believed to be a collaboration between Rembrandt and Gerrit Dou and another, *A Seated Man with a Stick: 'A Jew Merchant'*, which he described as 'ascribed to Rembrandt'. By this he meant that it 'may be at least in part, possibly wholly, the work of a pupil in Rembrandt's studio'. Since the completion of that catalogue, the National Gallery has bought three paintings by Rembrandt, the *Portrait of Frederik Rihel on Horseback* (in 1959; Cat. No. 19), *Belshazzar's Feast* (in 1964; Cat. No. 7) and the *Portrait of Hendrickje Stoffels* (in 1976; Cat. No. 13). The present exhibition includes 19 paintings. Two of the paintings catalogued by MacLaren as authentic have been omitted: the *Man in a Room*, which he considered to be a painting of the Leiden period, is the work of a later imitator, as is the *Old Man in an Armchair* (Fig. 2), which bears a signature and the date 1652. *Anna and the Blind Tobit* (Fig. 3) is solely by Dou, although the composition certainly reflects Rembrandt's influence on the young Leiden painter, and the *Seated Man with a Stick* (Fig. 4) is by a follower. They have not been included in the exhibition. Of the 19 which are discussed in this Catalogue, two are particularly problematic: *A Franciscan Friar* (Cat. No. 12) is a painting in very poor condition and it is difficult to be sure of its status; while the *Portrait of Margaretha de Geer, Bust Length* (Cat. No. 18) displays unusual technical characteristics which raise the possibility of its being a later imitation. On the other hand, our technical investigations lead us to believe that the *Portrait of Philips Lucasz.* and the *Portrait of Frederik Rihel on Horseback* (Cat.

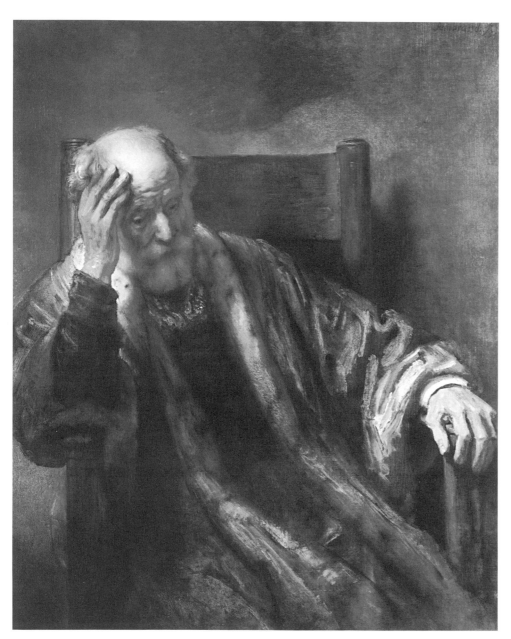

2. Follower of Rembrandt: *An Old Man in an Armchair*. London, National Gallery

authenticity of individual paintings by Rembrandt inevitably provides the background to the present exhibition, it is not its subject. Because of the wide chronological spread of the National Gallery Rembrandts and their representation of his major concerns as a painter, we felt that they provided a valid sample of his painted work on the basis of which we could make useful generalisations about his technical procedures. We wished to establish patterns of procedure: how Rembrandt prepared his canvases and panels (if indeed he did it himself), how he first laid in the composition, how he applied glazes, to what extent he made alterations on the canvas, and so on. It is this information, based on evidence obtained from X-rays, infra-red photographs and the analysis of paint samples by a wide range of modern scientific methods, that is presented in this exhibition. Such technical investigation can assist in matters of attribution, but only to a limited extent and should not be regarded as a panacea. Scientific examination will, broadly, establish the outer limits within which the art historian must work. It can identify later copies and recent fakes, and it can establish conventional patterns of procedure. However, the very nature of the apprenticeship system in the Netherlands in the seventeenth century meant that the pupil would adopt his master's method of working, and so it is rare that technical analysis can help us distinguish between the two.

In preparing the exhibition we are very conscious of a debt to the work of the Rembrandt Research Project, which has been assembling in the twenty years since its inception a huge archive of technical information about Rembrandt's paintings. Both Josua Bruyn and Ernst van de Wetering, who joined us in London for a stimulating symposium in January this year, have been immensely helpful. We have benefited not just from access to their archive, but from the Project's first two volumes and from being permitted to see the manuscript entries

Nos. 4 and 19) are executed by Rembrandt himself and do not contain, as has been suggested, substantial areas of studio participation. We have also been especially impressed by the results of our analysis of the *Portrait of Hendrickje Stoffels*, a painting which, perhaps because of its being un-

finished, has a slightly disturbing surface appearance. Having carefully examined all 19 paintings, we feel that the technique of 17 of them is not inconsistent with Rembrandt's technical procedures as far as these can be established.

While the continuing debate about the

for National Gallery paintings in the third volume. However, despite the debts we have incurred to the members of the Project and other Rembrandt scholars, we believe that our enterprise is pioneering. With the exception of the neutron activation autoradiography project recently undertaken at the Metropolitan Museum in New York, detailed physical descriptions of the type that we have undertaken here have not previously been published. We consider that if such descriptions were to be undertaken by the other institutions with major holdings of paintings by Rembrandt, the resulting synthesis would immensely enhance our understanding of the artist's technical procedures.

The Catalogue is prefaced by a chronology of the principal events of Rembrandt's life and his most important works, and an essay which outlines our historical knowledge of training and studio practice in the Netherlands in the seventeenth century, and Rembrandt's painting materials and techniques. A survey of Rembrandt's paint medium,

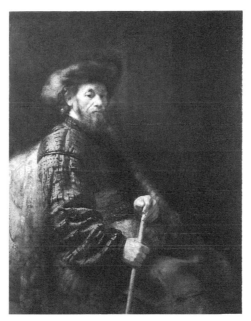

4. Follower of Rembrandt: *A Seated Man.* London, National Gallery

carried out by Raymond White, is also included. The main body of the Catalogue consists of the entries for the individual paintings. These begin with a short art-historical description of the subject and the dating of the painting. This has been kept brief intentionally: the arguments about subject, date, function and related works which are outlined there will all be made at greater length in the new National Gallery Dutch School catalogue to be published early next year. The core of the present Catalogue entries is the technical descriptions, which cover the material bases of Rembrandt's paintings. At the back of the book are a glossary of technical terms including short descriptions of the methods of physical examination we have employed, which we hope will be of use to the non-specialist reader; and an extensive, annotated bibliography of technical sources, which has been prepared by Jo Kirby of the Gallery's Scientific Department.

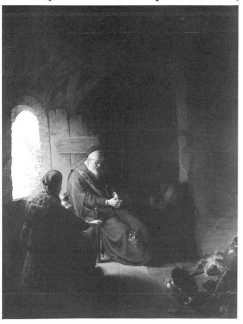

3. Gerrit Dou (1613-1675): *Anna and the Blind Tobit.* London, National Gallery

Abbreviations used in the Catalogue

B.	(J.A.B. von Bartsch, *Le peintre graveur*, 21 vols., Vienna, 1803-21) Ed. W. Strauss, *The Illustrated Bartsch*, New York 1978-
Bauch	K. Bauch, *Rembrandt Gemälde*, Berlin 1966
Benesch	O. Benesch, *The Drawings of Rembrandt*, 6 vols, second edition, London 1973
Bredius	A. Bredius, *Rembrandt Gemälde*, Vienna 1935
Bredius/Gerson	A. Bredius, *Rembrandt. The Complete Edition of the Paintings*, revised by H. Gerson, London 1969
HdG	C. Hofstede de Groot, *Catalogue raisonné of the Works of the most eminent Dutch Painters of the Seventeenth Century*, 10 vols (vols 9 and 10 are in German), London/Stuttgart/Paris 1907-28
Rembrandt *Corpus*	J. Bruyn, B. Haak, S. H. Levie et al., *A Corpus of Rembrandt Paintings*, The Hague/Boston/London 1982-
Strauss Doc.	W. L. Strauss and M. van der Meulen, *The Rembrandt Documents*, New York 1979

Chronology

1606 Rembrandt van Rijn was born in Leiden, the son of Harmen van Rijn, a prosperous miller, and Neeltge van Suydtbrouck. He was the ninth of ten children, of whom seven survived into adulthood. Rembrandt's father was a member of the Reformed Church and the marriage of his parents had taken place in the Calvinist Pieterskerk in Leiden, despite the fact that the bride's parents were from an Old Catholic family in the town. Rembrandt remained a Calvinist, if an unconventional one, throughout his life.

1620 At the age of 14 Rembrandt was registered as a student at the University of Leiden, having spent the previous six years at the Latin School in Leiden. Later that year, despite his registration at the University, Rembrandt entered the studio of the local painter Jacob Isaacsz. van Swanenburgh, who specialised in architectural views and scenes of Hell. Van Swanenburgh, like many Dutch artists of his generation, had spent several years in Italy. Rembrandt stayed with him for three years, learning the craft of painting. Rembrandt's earliest works show, however, no similarities, in subject-matter or style, to the work of van Swanenburgh.

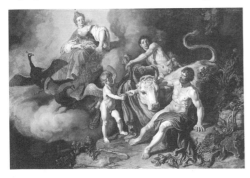

5. Pieter Lastman (1583-1633): *Juno discovering Jupiter with Io.* 1618. London, National Gallery

1623-4 Rembrandt spent six months in the Amsterdam studio of Pieter Lastman, the leading history painter in the city. Lastman had had an extended stay in Italy and two of the principal influences on his style were Caravaggio (for his dramatic chiaroscuro) and Adam Elsheimer (for the small scale of

his work, the elaboration of detail and bright palette). These were very important months for Rembrandt, who was profoundly influenced by Lastman (Fig. 5) and continued to admire him throughout his career.

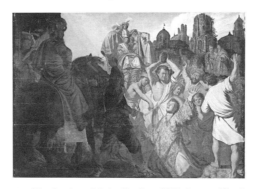

6. *The Stoning of Saint Stephen.* 1625. Lyons, Musée des Beaux-Arts

1624-5 Back in Leiden, Rembrandt set up as an independent painter with his own studio. His earliest dated work, *The Stoning of Saint Stephen* of 1625 (Fig. 6), displays the powerful influences of Lastman and Elsheimer. During these early years in Leiden he worked closely with another young Leiden painter who had been a pupil of Lastman, Jan Lievens (1607-74). There was a lively exchange of ideas between the two artists, who may even have shared a studio.

1628 The 15-year-old Gerrit Dou joined Rembrandt as a pupil, and was to stay with him for about three years. Isaac Jouderville was also apprenticed to Rembrandt at about this time (1629-31).

1629 *Judas and the Thirty Pieces of Silver* (Cat. No. 1). This painting was singled out for praise in an account of Rembrandt and Lievens written by the Secretary of the Prince of Orange, Constantijn Huygens. Huygens was particularly struck by Rembrandt's skill in depicting highly charged Biblical subjects on a small scale. He expressed the view that both artists, whose strengths and weaknesses he analysed at

some length, were destined for very successful careers.

1631 Rembrandt invested 1000 guilders in the Amsterdam art-dealing business of Hendrick Uylenburch, and it was probably later in the year that he moved to Amsterdam and lived in Uylenburch's house in the Sintanthonisbreestraat. Uylenburch appears to have provided studios and perhaps also materials to young artists in exchange for marketing their work. Having attracted Huygens's attention as a history painter, Rembrandt was in great demand in Amsterdam as a portrait painter. His portrait of the Amsterdam merchant Nicolaes Ruts (Fig. 7) is an outstanding example of the portrait style which proved so successful that, according to Houbraken, sitters had to beg Rembrandt to paint their portrait 'and then add money'.

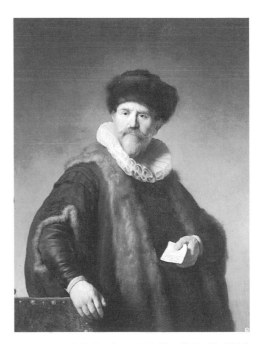

7. *Portrait of Nicolaes Ruts.* 1631. New York, The Frick Collection

1632 *Portrait of Marten Looten* (Los Angeles, County Museum of Art). *Portrait of Amalia van Solms, Wife of Prince Frederik Hendrick of Orange* (Paris, Musée Jacquemart-André). *The Anatomy Lesson of Dr Tulp* (Fig. 8).

13

1634 Rembrandt married Saskia van Uylenburch (the name is also spelt Ulenburch, Ulenborch, Uylenburgh and in other ways), the cousin of Hendrick Uylenburch. At the time of the marriage Saskia, the

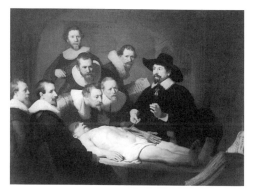

8. *The Anatomy Lesson of Dr Tulp.* 1632. The Hague, Mauritshuis

daughter of a former burgomaster of Leeuwarden, was 20. *Ecce Homo* (Cat. No. 2). *Portrait of an 83-year-old Woman* (Cat. No. 3). *Saskia as Flora* (Leningrad, Hermitage).

1635 *Portrait of Philips Lucasz.* (Cat. No. 4). *Saskia van Uylenburch in Arcadian Costume* (Cat. No. 5). First state of the etching *Ecce Homo* (B.77). Gerbrandt van den Eeckhout (1621-74) entered Rembrandt's studio and was to stay for about five years, during which time he became a favourite pupil and close friend of Rembrandt. Govert Flinck (1615-60) and Jacob Backer (1608-51) were also in Rembrandt's studio in the first half of the 1630s. Both had previously trained with Lambert Jacobsz. in Leeuwarden.

1636 Rembrandt wrote the first of seven letters to Constantijn Huygens concerning a commission for a series of paintings of Christ's Passion for the Prince of Orange. The series was eventually to consist of seven paintings, six of which are today in the Alte Pinakothek, Munich (Fig. 9). *The Blinding of Samson* (Fig. 10). This violent, life-sized canvas was probably painted for Huygens to thank him for his part in securing the

commission for the Passion series. It is one of a group of large-scale baroque history paintings, displaying strong Caravaggesque and Rubensian influence and painted in the second half of the 1630s. Another is *Belshazzar's Feast* (Cat. No. 7). *The Ascension of Christ* from the Passion series. Second state of the etching *Ecce Home* (B.77). Ferdinand Bol (1616-80) entered Rembrandt's studio in 1636 and Jan Victors (1620-c.1676), Gerrit Willemsz. Horst (1612-1652) and Reynier Gherwen (d.1662) also joined Rembrandt at about this time.

1639 Rembrandt purchased a house on the Sintanthonisbreestraat. In the event, he never completed the payments on it. All the other five letters to Constantijn Huygens were written in this year, recording Rembrandt's progress on the Passion series. Rembrandt attended the sale of the collection of Lucas van Uffelen and sketched Raphael's *Portrait of Baldassare Castiglione*. *Portrait of Alotte Adriaensdr.* (Rotterdam, Museum Boymans-van Beuningen). *Portrait of Maria Trip* (Amsterdam, Rijksmuseum). *Self Portrait leaning on a Stone Sill* (Etching: B.21).

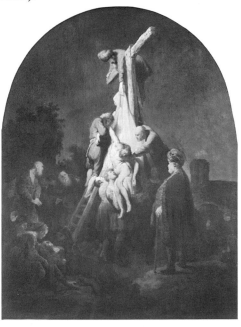

9. *The Descent from the Cross.* Munich, Alte Pinakothek

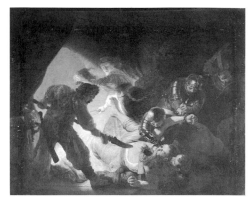

10. *The Blinding of Samson.* 1636. Frankfurt, Städelsches Kunstinstitut

1640 *Self Portrait at the Age of 34* (Cat. No. 8). In the early 1640s, Abraham Furnerius (c.1628-54), Samuel van Hoogstraten (1627-78) and Carel Fabritius (1622-54) were in Rembrandt's studio.

1641 Birth of Titus, Rembrandt's fourth child and the only one from his marriage to Saskia to reach adulthood. *Portrait of the Mennonite Minister, Cornelis Claesz. Anslo and his Wife* (Fig. 11).

1642 Death of Saskia. *The Night Watch* (Amsterdam, Rijksmuseum). *The Descent from the Cross* (Etching: B.82).

1643 *The Three Trees* (Etching: B.212).

1644 *The Woman taken in Adultery* (Cat. No. 9).

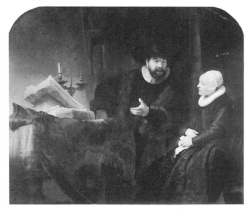

11. *The Mennonite Minister Cornelis Claesz. Anslo and his Wife.* 1641. Berlin-Dahlem, Gemäldegalerie

1645 *'Six's Bridge'* (Etching: B.208).

1646 *The Adoration of the Shepherds* (Munich, Alte Pinakothek), one of the Passion series. *The Adoration of the Shepherds* (Cat. No. 10). *Winter Landscape* (Cassel, Gemäldegalerie). Karel van der Pluym (1625-72), Rembrandt's cousin, and Johann Ulrich Mayr (*c*.1630-1704) from Augsburg were in the artist's studio at about this time.

1647 *Jan Six standing at a Window* (Etching: B.285).

1648 *The Wedding of Jason and Creusa* (Etching: B.112). Rembrandt etched this plate as an illustration for the printed edition of a play, *Medea*, by his friend Jan Six.

1649 Hendrickje Stoffels is first mentioned as a member of Rembrandt's household. In a document of 1 October she is said to be 23.

1651 *Portrait of Clement de Jonghe* (Etching: B.272). Constantijn van Renesse (1626-80) and Willem Drost (*c*.1630-87) were probably in Rembrandt's studio at this time.

1652 *Portrait of Nicolaes Bruyningh* (Fig. 12).

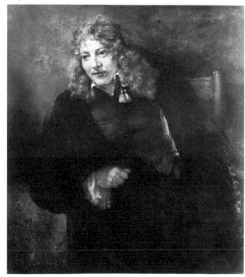

12. *Portrait of Nicolaes Bruyningh.* 1652. Cassel, Gemäldegalerie

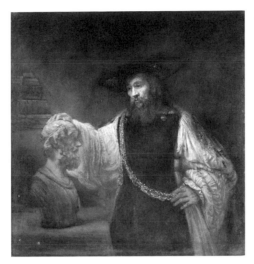

13. *Aristotle contemplating a Bust of Homer.* 1653. New York, Metropolitan Museum of Art

1653 *Aristotle contemplating a Bust of Homer* (Fig. 13). It was painted for Don Antonio Ruffo of Messina in Sicily, who subsequently commissioned Guercino and Mattia Preti to paint pendants to it. *The Three Crosses* (Etching: B.78).

1654 *A Woman bathing in a Stream* (Cat. No. 11). Hendrickje Stoffels, who was probably the model for this painting, was summoned before the church council in Amsterdam for 'living like a whore' with Rembrandt and banned from celebration of the Lord's Supper. Birth of Hendrickje and Rembrandt's only child, a daughter, Cornelia. *Portrait of Jan Six* (Amsterdam, Six Foundation).

1655 *Titus at his Desk* (Fig. 14). *Joseph accused by Potiphar's Wife* (Berlin-Dahlem, Gemäldegalerie, and Washington, National Gallery of Art): both versions of this composition date from the same year. *A Franciscan Friar* (Cat. No. 12) was probably painted at about this time. Four etchings illustrating Menasseh ben Israel's *Piedra Gloriosa* (Etchings: B.36).

1656 Rembrandt, having attempted to stave off bankruptcy for a number of years, applied for a *cessio bonorum*, a form of voluntary bankruptcy which saved debtors from harassment by their creditors and from possible imprisonment. Under the terms of the *cessio bonorum*, an inventory of Rembrandt's possessions was drawn up for the purposes of sale. It provides us with an enormously valuable record of his art collection (which probably included the *Ecce Homo*, Cat. No. 2). *Jacob blessing the Sons of Joseph* (Fig. 15). *The Anatomy Lesson of Dr Jan Deyman* (Amsterdam, Rijksmuseum): the painting is a fragment. The *Portrait of Hendrickje Stoffels* (Cat. No. 13) was probably painted at about this time.

1657 *Portrait of Caterina Hooghsaet* (Great Britain, Private Collection). *A Bearded Man in a Cap* (Cat. No. 14).

1658 Rembrandt's house in the Sintanthonisbreestraat was sold and he, Hendrickje and Titus moved to a house on the Rozengracht, where the artist was to live until his death. There were further sales of Rembrandt's possessions, among them his collection of prints and drawings.

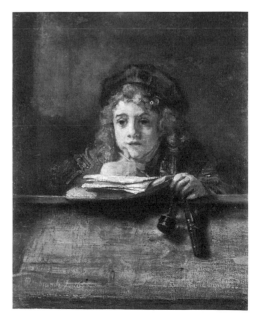

14. *Titus at his Desk.* 1655. Rotterdam, Museum Boymans-van Beuningen

15. *Jacob blessing the Sons of Joseph*. 1656. Cassel, Gemäldegalerie

1659 *An Elderly Man as Saint Paul* (Cat. No. 15).

1660 A document was drawn up making all Rembrandt's production the property of Hendrickje and Titus. This was a legal device to prevent Rembrandt's creditors from seizing his work. *Titus in a Franciscan Habit* (Amsterdam, Rijksmuseum). *Self Portrait* (New York, Metropolitan Museum of Art). There is a portrait of Hendrickje Stoffels in the same collection which appears to be a pendant to this self portrait. Ruffo orders a pendant to the *Aristotle* from Guercino (see under 1653).

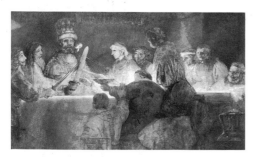

16. *The Conspiracy of Julius Civilis*. 1661. Fragment. Stockholm, Nationalmuseum

1661 *The Conspiracy of Julius Civilis* (Fig. 16). This large history painting was intended for the Town Hall in Amsterdam. The preparatory drawing was certainly made in this year and the painting was described in place in 1662. Shortly afterwards it was removed and the canvas cut down. The surviving central fragment is in the Nationalmuseum, Stockholm. *Portrait of Jacob Trip*

and the two of *Margaretha de Geer* (Cat. Nos. 16, 17 and 18). Aert de Gelder (1645-1727) probably entered Rembrandt's studio in this year. He remained faithful to Rembrandt's late style, until well into the eighteenth century.

1662 *The Sampling Officials of the Drapers' Guild ('The Staalmeesters')* (Fig. 17).

1663 Death of Hendrickje Stoffels. *Homer dictating to a Scribe* (The Hague, Mauritshuis). Painted for Ruffo, the picture is now a fragment. *Portrait of Frederik Rihel on Horseback* (Cat. No. 19).

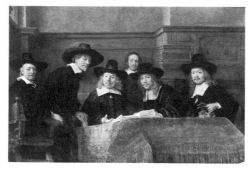

17. *The Sampling Officials of the Drapers' Guild ('The Staalmeesters'.)* 1662. Amsterdam, Rijksmuseum

1665 *Portrait of Gerard de Lairesse* (New York, Metropolitan Museum of Art).

1666 *Lucretia* (Fig. 18). *Portrait of the Poet Jeremias de Decker* (Leningrad, Hermitage). *The Jewish Bride* (Amsterdam, Rijksmuseum).

1668 Marriage and death of Titus van Rijn.

1669 *Self Portrait wearing a Turban* (The Hague, Mauritshuis). *Self Portrait at the Age of 63* (Cat. No. 20). *Simeon with the Infant Christ in the Temple* (Fig. 19). Death of Rembrandt. He was buried in the Westerkerk on 8 October.

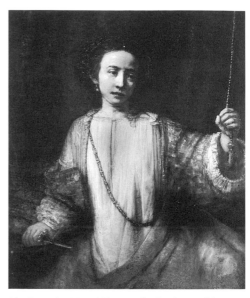

18. *Lucretia*. 1666. Minneapolis, Institute of Arts

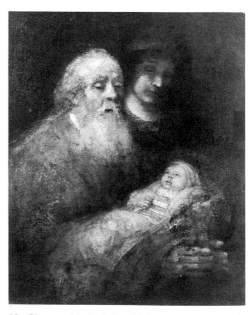

19. *Simeon with the Infant Christ in the Temple*. 1669. Stockholm, Nationalmuseum

The painter's studio

The appearance and routine of the painter's studio in seventeenth-century Holland are well documented in treatises, archives and inventories of, for example, artists' possessions at their death. Such documents make references to plaster casts; lay figures; studio props of every kind; panels and canvases, both unpainted and in various stages of completion; stones and mechanical mills for grinding pigments; easels; painting cabinets; and so on.

There are also a number of genre and allegorical paintings showing artists at work. Rembrandt himself made drawings and paintings of the painter at work, and showed himself holding palette, brushes and mahlstick in a couple of the self portraits (Fig. 20). Specific comments about his studio and working methods may be found in the writings of a number of authors who were trained by him or knew him – Hoogstraten and Sandrart in particular.

In a well-known passage, Sandrart – writing a decade after Rembrandt's death – recorded how Rembrandt had 'countless distinguished children for instruction and learning, of whom every single one paid him 100 guilders annually'. The training of pupils in a painter's studio was usually very strictly controlled by the Guild of Saint Luke, the craft guild of which painters formed an élite group. While it is true that the Amsterdam Guild was less effective in enforcing its regulations than the guilds in other cities, it does seem that Rembrandt had many more pupils than the four to six usually allowed; and yet Rembrandt could clearly not be operating outside the guild because it was essential for him to have been a member.

It is now clear that the situation in Rembrandt's studio was far from the traditional arrangement of the master instructing a limited number of pupils. Some members of the studio were long-term apprentices of the traditional kind: Samuel van Hoogstraten, for example, was with him for about seven years from the age of thirteen. Others, however, were probably

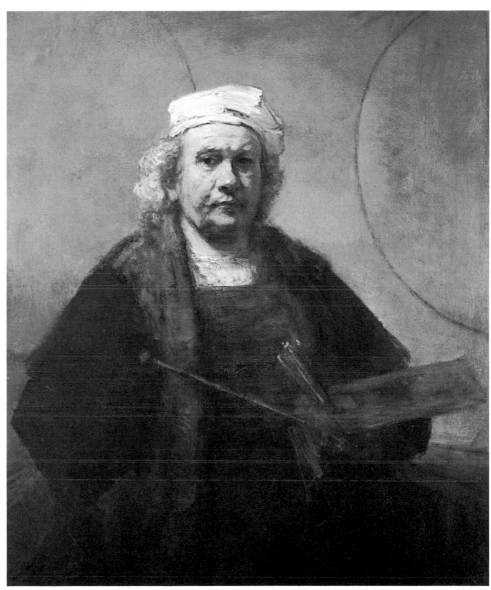

20. *Portrait of the Artist.* London, Kenwood, The Iveagh Bequest

amateurs receiving instruction in what was essentially an *academy*; based on Italian prototypes, the academy system of training was fairly novel in Amsterdam in the 1630s and offered a freer, less rigidly administered regime of tuition than guild-regulated apprenticeships. The most famous image of an academy at work is that of Michiel Sweerts who in 1656 set up an academy for life drawing in Brussels. His painting (Fig. 21) shows young pupils sketching a male model standing on a raised platform while

the teacher in his white cap shows a visitor around.

The method of instruction in Rembrandt's studio may at times have resembled the informal cluster of chairs and students shown in Sweerts's painting. But Houbraken records that in a warehouse that Rembrandt rented on the Bloemgracht in Amsterdam, his pupils 'in order to be able to paint from life without disturbing each other, made small cubicles, each one for himself, by setting up partitions of

paper or oilcloth'.

Rembrandt's studio was an unashamedly commercial operation. As well as apprentices and paying pupils, a steady stream of young qualified painters passed through and painted under his guidance, sometimes in a style closely resembling the master's and sometimes with more individuality. It is clear that Rembrandt signed other painters' works as his own and it is this fact, together with the inevitable similarity in materials and technique, that makes attribution of some works associated with him problematic. The names of perhaps twenty of his pupils and associate painters are recorded in Sandrart, Hoogstraten, Houbraken and other sources, but the full list can never be known with certainty because the records of the Amsterdam Guild of Saint Luke have been almost wholly lost.

But what of the physical surroundings of the studio? Sandrart was very precise in his description of an ideal studio and the limitations of those used by painters in the past:

Many of our forefathers...have erred in that too small chambers, everywhere filled with light and sunshine, served them for their work: whereby lacking the space and the necessary distance to walk far enough back and forth from their model or panel, to inspect their work from a distance...as well as the strength of the light so that all colours become diminished and confused to them. They would, if they had been in a proper studio, have given their excellent works far more life, force and veracity.

Sandrart then gave exact specifications for a 'proper room, especially for painting pictures life–size, also for history painting and the like'. The size of the room should be about 30 feet square; the window, in the highest part of the room, should be about 5 or 6 feet in width, and should have an upper and a lower part both of which could be covered independently. Although this was not mentioned by Sandrart, many studios had two windows, one to illuminate the

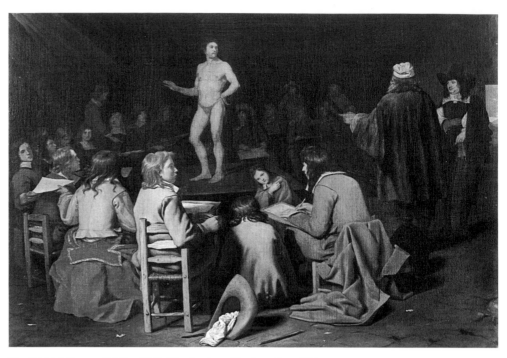

21. Michiel Sweerts (1624–c.1664): *The Academy*. Haarlem, Frans Halsmuseum

painting, the other for the subject – and both would have systems of blinds or shutters to control the light.

The windows should be north-facing 'because from there the sun's brilliance shines at its least'. The light should give to everything 'richness, shadow and reflection'. However, Sandrart acknowledged that lighting conditions would not always conform to this ideal:

...if one must take the light from midday, from a lack of better accommodation, one can provide the window with blinds made of oiled paper: thus the sun causes no false variability in the light. In general, the height of the light should be such that every illuminated body gives a shadow of as great a length on the ground as its own size. When one wishes to represent a History by night, one makes a large fire blazing with light, the brilliance of which shines far from it...one sees from the inconstant appearance of the objects how, from the colour of the fire they naturally appear now nearer, now redder...

In their quest for north light, painters apparently preferred to live on east-west streets, so that rooms at either the front or back faced north. The Sintanthonisbreestraat in Amsterdam, on which Rembrandt's house stands, runs at an angle to the east-west direction; partial north light would have been available therefore, but it

can only be speculated how concerned Rembrandt was with the constancy of a cool light source.

If the painter was right-handed, he would normally work with the window at his left, so that his arm did not cast a shadow as he worked. It is noticeable in Rembrandt's paintings how often the light in portraits and other pictures falls from the left in accordance with this natural arrangement. It would seem to confirm that Rembrandt was indeed right-handed. Certainly he shows himself in the Kenwood *Self Portrait* (Fig. 20) holding palette, spare brushes and mahlstick in his left hand – although indications on the picture surface show that he originally painted a direct mirror image with palette and brushes in the other hand, subsequently altering the composition to the present right-handed configuration.

His small picture of the *Painter in his Studio* in Boston (Fig. 22) shows a young painter (perhaps even himself at work in Leiden) stepping back to consider his work. Unusually, the light source is somewhere high up and to our left (behind the painter and slightly to his right), although he is clearly right-handed. He is shown pausing in the act of painting standing up: this may well have been Rembrandt's normal practice, but many other painters of the period – Gerard Dou, for example – showed themselves seated at the easel. The

easel shown is of a standard type, a simple hinged trestle with movable pegs to support the work at the right height. The panel on the easel is a large one and is strengthened at the top and bottom edges by grooved wooden battens.

Oak panels for painting were, by this time, bought ready made from specialist craftsmen who were members of the joiners' and cabinetmakers' guild and protected their monopoly in panel-making by a restrictive charter. Panels were made in a range of standard sizes, often denoted by cost ('guilder-size' and so on). Rembrandt appears to have been content to restrict himself to standard panel sizes – probably of necessity, since frames were produced to the same dimensions. Close similarities between some of Rembrandt's panels revealed by dendrochronological examination also suggest that he purchased them in batches from particular panel-makers. Larger panels were made by butt-jointing two or three planks together. The back

edges were often bevelled in order to fit the finished painting into its frame, and this can be a useful indication of the original size and shape of a panel if it has later been cut down (see, for example, Cat. No. 4, the *Portrait of Philips Lucasz.*).

The ground or preparation layers (discussed below) might be applied by the panel-maker, or in the painter's studio. It is possible that the panel-maker was responsible for the first layer of preparation and subsequent layers were the painter's responsibility, but there is no firm evidence yet available which clarifies this point. It is certainly the case, however, that Rembrandt could be dissatisfied with the way a panel was prepared: for *The Woman taken in Adultery* (Cat. No. 9) he clearly scraped down the ground in the centre of the panel before painting, presumably because it was too rough.

Canvases too could be bought ready prepared, but were also routinely stretched and prepared in the studio. There were

specialists in making and applying grounds: de Mayerne mentions the formula of a Walloon *imprimeur* in the 1620s and 1630s. There is evidence, however, that at least some canvas grounds were applied in Rembrandt's studio – for the *Portrait of Jacob Trip* (Cat. No. 16), for example.

Linen canvases were made on looms with a range of sizes which were usually multiples of an 'ell', a standard fabric width which in the Netherlands was equal to about 69 cm. Allowing for tacking margins and seam overlaps, many of the canvas pieces which make up Rembrandt's paintings, singly or sewn together, correspond to these measurements.

For the application of ground layers the canvas would be stretched in a temporary frame, probably with cords. This would produce cusping, that is, scalloping of the regular weave pattern along each stretched edge, the point of each cusp corresponding to the point of tension. When the ground was applied and allowed to dry, these cusps would become locked into the fabric: they can usually be seen now in X-rays (see glossary) and can, like the bevelling on wood panels, be a valuable indicator of whether a painting has been altered or cut down. Of course, Rembrandt did on occasion cut up stretched, primed canvases and reuse them (for example on *The Lamentation* [Cat. No. 6]): in these cases incomplete cusping is an original feature and must be recognised as such. Also, canvas was sometimes stretched in lengths between long battens for the application of the ground and then cut into smaller sections for individual painting canvases. In this situation, one might only see cusping on two sides of the canvas: an example of this seems to be the *Bearded Man in a Cap* (Cat. No. 14).

Canvas pictures were also often painted in a temporary stretching frame. Many contemporary paintings of artists' studios show painters at work on canvases laced inside a larger wooden framework. A particularly interesting example is Aert de Gelder's *The Artist Himself painting an Old Lady* (Fig. 23) which shows the laughing

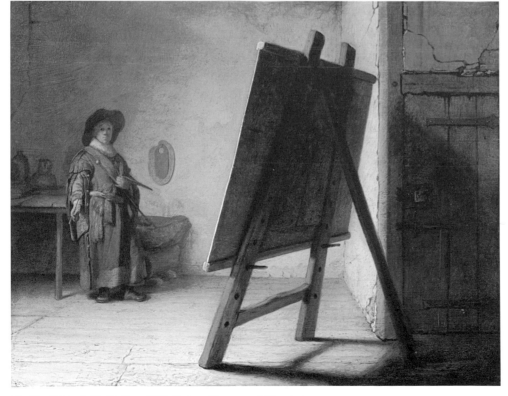

22. *The Painter in his Studio. c.*1629. Boston, Museum of Fine Art

painter, in the guise of Zeuxis – the fifth-century B.C. Greek painter who was said to have died laughing at his comical portrait of an old woman – surrounded by the paraphernalia of a seventeenth-century studio. The Rembrandt connection is very significant here, because not only was de Gelder one of his most notable later pupils, but this composition was probably based on an original by Rembrandt of which only part – the fragmentary *Laughing Self Portrait* in Cologne – survives.

In de Gelder's picture the canvas is indeed shown stretched with cords inside its temporary frame. Behind the easel is another canvas, perhaps finished, which is on a strainer, tacked conventionally around the edges. Presumably, when complete, a painting would be cut from its stretching frame and mounted on a strainer in the modern fashion; but other painters also depicted themselves actually at work on canvases tacked to strainers in this way. Both methods of painting on canvas were practised, it would seem. The modern expanding stretcher with wedges or keys was not yet in use.

The light in the picture comes from the painter's left in the accustomed way. Knotted cords just visible behind the easel may well be connected to blinds or shutters controlling the light.

On the table there are several clues to the painter's working methods. From a nail hang dividers with which proportions were checked on both subject and picture. At the near side is a lump of chalk for sketching a rough design on to the prepared canvas. There is no evidence that Rembrandt himself used chalk for the initial sketch – rather, he seems usually to have roughed in his design with a brush and brown paint – but certainly it was common practice for many painters of the period, especially when working on dark grounds.

Paints, oils and other materials are shown in various earthenware pots on the table, together with discarded brushes of miniver, badger or hog hairs tied inside quill ferrules. In his left hand the painter

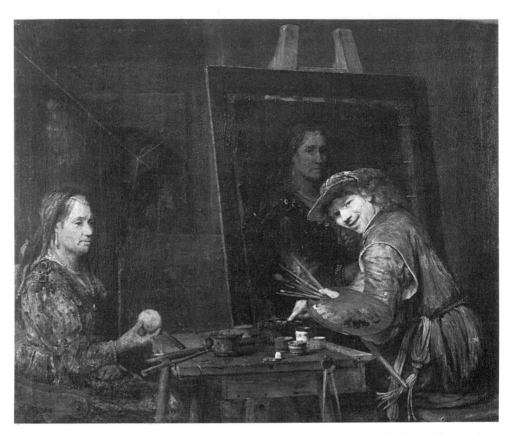

23. Aert de Gelder (1645-1727): *The Artist Himself painting an Old Lady.* Frankfurt, Städelsches Kunstinstitut

holds a curved wooden palette, brushes and a mahlstick which would be braced against the edge of the picture or frame to support the painting hand and prevent it from touching the wet paint. The palette is loaded with oil colours, ranging from white at the top to black at the bottom. Painters usually had a standard working order for colours and any assistants or apprentices in the studio would be trained to load the master's palette in the preferred way. Between white and black on Aert de Gelder's palette is a range of yellow, red and brown earth colours but, significantly, no blue.

Paints were still prepared by assistants in some artists' studios: in some seventeenth-century paintings we see colours being ground on stone slabs. This was a long, tedious process to ensure that pigment and oil were properly mixed to a smooth, stable paint: a task traditionally given to apprentices and assistants to keep them occupied for hours on end. But mechanical colour mills were already in existence – Gillis van Coninxloo, for example, is recorded as having had one in about 1600. And, of course, commercial suppliers of artists' materials were beginning to appear: the first recorded general supplier of such materials in Holland was the pain-

ter and dealer Volmarijn who, in 1643, established a shop in Leiden for 'prepared and unprepared colours, panels, canvas, brushes and painting utensils of every kind'.

Bibliography: Sandrart, *L'academia todesca...*; Bredius, *Künstler-Inventäre...*; E. van de Wetering, 'Painting materials and working methods', in Rembrandt *Corpus*, vol. I; E. van de Wetering, 'The canvas support', in Rembrandt *Corpus*, vol. II; A. Blankert, 'Rembrandt, Zeuxis and Ideal Beauty', in *Album Amicorum, J. G. van Gelder*, ed. J. Bruyn and others, M. Nijhoff, The Hague 1973; J. Bruyn, 'Een onderzoek naar 17de-eeuwse schilderijformaten voornamelijk in Noord-Nederland', *Oud Holland*, 93, 1979, pp. 96-115; Martin, '"Een kunsthandel"...'; E. Haverkamp-Begemann, 'Rembrandt as teacher', in *Rembrandt after Three Hundred Years: an exhibition of Rembrandt and his followers* (catalogue), Art Institute of Chicago, Chicago 1969, pp. 21-30; E. van de Wetering, 'Problems of apprenticeship and studio collaboration', in Rembrandt *Corpus*, vol. II; H. Miedema, 'Kunstschilders, gilde en academie. Over het probleem van de emancipatie van de Kunstschilders in de noordelijke Nederlanden van de 16de en 17de eeuw', *Oud Holland*, 101, 1987, pp. 1-34.

Rembrandt's painting materials and methods

Rembrandt's palette

The technical examination of the National Gallery Rembrandts has provided us with a mass of information about the detail of the painting methods used throughout Rembrandt's career. Part of this investigation has consisted of recording the painting materials and their manner of use to create specific effects of colour and form, light and shadow. The range of pigments Rembrandt employs involves no arcane knowledge, no secret formulae, but falls firmly within the mainstream of painting practice in Holland in the seventeenth century. The palette is entirely made up of pigments which were commercially widely available,[1] and by that time well understood in their qualities and drawbacks. Seventeenth-century Holland was something of a centre for the manufacture of artists' pigments on an industrial scale, and the technologies required had been evolved to the extent of removing the uncertainties in the preparation of standard products. Fairly large-scale chemical processes for the production of high-quality lead white, artificial vermilion, smalt and lead-tin yellow, all of which are found frequently in Rembrandt's paintings, had reached an advanced degree of empirical refinement and these artificial pigments were available in both home and foreign markets. Imported pigments from Italy and elsewhere made up local deficiencies in both naturally occurring mineral and earth pigments, and in some of the raw materials for the preparation of certain artificial colours.[2]

Some commentators have been inclined to stress the restricted nature of Rembrandt's palette, implying its basis in a theory of painting practice. It is true that the total number of pigments regularly employed is not large, especially if the natural earth colours which contribute substantially to the palette are treated as a single group; but it is the method of their use in the complexities of pigment mixture and elaborate paint layer structure that gave Rembrandt access to such an impressive range of effects in colour, translucency and texture.[3] Rembrandt's method of painting is highly sophisticated in material terms, not only in its visual suc-

cesses but also in the soundly based painting procedures he adopts. The good condition of many of the pictures shown here is a result of his choice of mainly stable materials used in compatible combinations, and to a good understanding of the ways in which those chosen materials behave singly and in combination. There are examples to be found of unusual and innovative techniques in paint structure, used alongside ways of painting which are fundamentally based in a long tradition of technique. There is no single pattern to be drawn out; there are ways of painting which recur, although rarely in any rigidly controlled framework of technique.

It is true that Rembrandt's panel and canvas paintings are dominated by the most limited selection of pigments: the artificial colours lead white and bone black, as well as a generous selection of natural earth pigments, such as the ochres, siennas and umbers. Other pigments are regularly used, but these are the staples. Yet this description of Rembrandt's palette, however accurate, obscures the point of the painting method, in which colour and transparency are adjusted as continuously varied combinations of relatively few pigments, and further modified and adjusted as one layer of paint is laid over another until the desired effect has been reached. In terms of painting technique, opacity and built-up texture are usually interrelated, with much of the thickest impasto formed from the most solid and opaque of pigments, frequently lead white and sometimes lead-tin yellow. But there are also passages to be found of very thickly laid translucent dark-coloured paint, and for these Rembrandt uses novel methods involving unusual combinations of pigments chosen for their bulk and transparency as well as for their colour.

Lead white and chalk

Among manufactured pigments, lead white is of the greatest importance. Used on its own, it forms the thick white paint of collars and cuffs and other highlighted details of costume. In mixture with other tinting pigments, it is the essential component of the

lighter flesh paints. The presence of lead white in large quantities in the opaque parts of Rembrandt's paintings ensures that radiography can successfully reveal something of the structure of the pictures, since the pigment absorbs X-rays strongly. It is capable of being used in high impasto untroubled by excessive cracking as the paint film dries since, in common with all lead-containing pigments, lead white enhances the drying of oil paint, forming a particularly tough and flexible film.

Lead white has a long history as an artificially prepared artists' pigment, stretching back to classical times. In seventeenth-century Holland it was being made by a method which came to be known as the 'Dutch process', based on the historical means of manufacture. This involved exposing strips or buckles of metallic lead to the chemical action of vinegar vapours in closed but not sealed containers, in an atmosphere rich in carbon dioxide generated by decomposing manure or tanbark. The pigment forms as a pure white corrosion crust on the lead, and is collected by scraping the metal.[4] Chemically the product that forms is a basic lead carbonate, $2PbCO_3.Pb(OH)_2$, which often contains a proportion of neutral lead carbonate, $PbCO_3$. In samples of lead white from paintings by Rembrandt, varying quantities of the neutral carbonate have been detected by analysis, from very little to up to roughly one-third of the total weight. Dutch lead white[5] in seventeenth-century pictures is often seen under the microscope to contain large aggregate particles of very pure, rather pearlescent white pigment in association with more fine-grained material; the samples from the Rembrandts here are no exception. A number of cross-sections illustrated in the Catalogue show these coarse particles of lead white, particularly in the upper ground layers of the paintings which bear double grounds.

The neutral lead carbonate content forms during the manufacturing process, but samples of white also frequently contain deliberately added chalk, $CaCO_3$. Evidence from analysis and from the contemporary

literature suggests that at least two grades of lead white were offered as artists' pigments. Pure basic lead carbonate, known as *schulpwit* (flake white) and by other names, was the finest-quality pigment, while a cheaper mixture of lead white extended with chalk, known as *lootwit*,[6] served for the less demanding applications, for example in grounds, and was also used for underpaint layers. The addition of chalk to lead white reduces the opacity of the pigment when used in oil.

Each of the pictures illustrated in the Catalogue makes use of lead white in some section at least, but it can be seen to best advantage as a pure white pigment of great opacity, used in high impasto, in the painting of the woman's shift in *A Woman bathing in a Stream* (Cat. No. 11), the lace collar in the *Portrait of Philips Lucasz.* (Cat. No. 4), and the turban in *Belshazzar's Feast* (Cat. No. 7). The white ruffs in the portraits of women, including the two of *Margaretha de Geer* (Cat. Nos. 17 and 18), are painted principally in pure lead white.

Rembrandt used chalk in its own right as a pigment and extender, where bulk without density is required in the paint. When mixed in oil medium, chalk is virtually transparent, making it suitable as a modifying agent for glazing paints that also contain translucent coloured pigments. The effect is to add body and translucency to glaze-like paints without inducing a great change in colour. The dark-coloured glazes to the background of *Saskia van Uylenburch in Arcadian Costume* (Cat. No. 5) contain chalk mixed with yellow lake and earth pigments to achieve a rich translucent effect.

Lead-tin yellow

The second traditional manufactured lead pigment of prominence in Rembrandt's work is a binary oxide of lead and tin, called lead-tin yellow. The early history of the pigment is obscure, but it begins to appear in European painting around 1300, disappearing entirely from the artists' palette around the beginning of the eighteenth century. It was made in two distinct varieties at various

times and in several centres, both types being used for oil painting in Venice during the sixteenth century. In Northern Europe only one variety, which has the chemical composition Pb_2SnO_4, appears to have been made regularly. All the examples in Rembrandt that have been identified correspond to this particular constitution. Lead-tin yellows of both types probably owe their origins to the combined use of lead and tin for ceramic glazes and as opacifiers for glass; perhaps this accounts for the production of both forms of the pigment in sixteenth-century Venice. The type of lead-tin yellow used by Rembrandt would have been made by roasting to a high temperature a starting material such as lead white, red lead (lead tetroxide, known as minium) or even metallic lead with tin dioxide.[7] The conditions of preparation, particularly the temperature of the furnace, determine the precise shade of yellow in the final product, which ranges in colour from a light primrose to a deep golden yellow. Descriptions in the contemporary literature, which term this artificial yellow *massicot* or *masticot*, imply that several kinds of the pigment were available, although these are always found to be chemically identical. That the painting treatises refer to artists' pigments described as *massicots*[8] suggests varying shades of the same material. Curiously, the modern name 'massicot' is reserved for a yellow or orange-yellow simple monoxide of lead and not a compound of lead and tin, although early recipes for the preparation of the opaque yellow artists' pigment confirm the equivalence of the name *massicot* with the modern designation, lead-tin yellow.

Like lead white, lead-tin yellow is dense and opaque, and dries well in the oil medium. Also, since it is a lead-based pigment, it registers strongly in X-ray images. Good examples of its use in Rembrandt can be seen in *Belshazzar's Feast* in the lightest opaque yellow paint of the embroidery on Belshazzar's cape as well as the lettering on the wall; also in the embroidered waistband in *Saskia van Uylenburch in Arcadian Costume*. Lead-tin yellow forms the impasto lights and

darker yellow touches to the gold chain in the *Portrait of Philips Lucasz*. On a more modest scale it is used for the background highlights in *The Woman taken in Adultery* (Cat. No. 9), and for the Child's swaddling blanket in *The Adoration of the Shepherds* (Cat. No. 10). Occasionally Rembrandt incorporates lead-tin yellow to modify flesh tones, and makes opaque greens based on a mixture with blue mineral azurite. *Saskia* reveals examples of both practices.

Vermilion

Seventeenth-century Holland was famous for the manufacture of vermilion,[9] another key artists' pigment. In the form of ground natural cinnabar, it had been used for painting since the earliest times. Chemically it is a sulphide of mercury (HgS). Its synthetic equivalent, produced by direct combination of mercury and sulphur in heated retorts followed by sublimation, was an ancient technology introduced into medieval Europe via the Islamic world from China. Vermilion, either natural or artificial, is generally bright scarlet and very opaque. More orange or crimson varieties are possible. Since it was a moderately expensive manufactured pigment, specimens adulterated with red lead (minium) were sold in the seventeenth century, which may account for contradictory assessments in the painting treatises regarding the stability of the pigment. Dutch dry-process vermilion was a major export, a great deal finding its way to England.[10]

Vermilion is not a pigment Rembrandt employs with great regularity, finding others sufficient for his purposes. The paintings shown here are not notable in their need for large areas of intense bright scarlet. Where a strong opaque red was required, vermilion was usually not the chosen pigment; in its place bright red ochre, heightened by the admixture of red lake, is used. A few particles of vermilion are sometimes added to enhance a flesh tone, but the only striking case of its use is for the opaque red and orange-red highlights of the woman's dress in *Belshazzar's Feast*. Mary's bodice in *The Adoration of*

the Shepherds also contains a little vermilion, but here used only to strengthen red ochre mixed with white. Rather more of the pigment was added to both colour and solidify the hot brown background depths in *The Woman taken in Adultery*.

Earth pigments

Rembrandt's palette is rich in the earth pigments. As a group they provide the greatest range of the more muted warm colours of red, orange, yellow and brown. All the earth colours used by Rembrandt would have been from naturally occurring sources, which are abundant in many parts of Europe,[11] particularly in Italy, France and England, and were an established part of the pigment trade. Sources farther afield in Cyprus and Turkey supplied specialised grades and colours, particularly of the umbers.

The great advantages of earth colours to the painter are that they are entirely stable in all painting media and do not interact with more chemically sensitive pigments, making them suitable for any kind of pigment mixture, and that they dry perfectly well in oil. Some, like the umbers, are particularly effective driers. Their disadvantage, perhaps, is lack of intensity of colour, but what they offer in range of colour and choice of translucency must have suited Rembrandt well. Certainly earth pigments are used in great profusion and for many purposes in Rembrandt's painting.

Natural earth pigments are loosely classified as ochres, siennas and umbers, but all contain natural ferric oxide (Fe_2O_3) as the essential colouring matter. The dividing lines are not clearly drawn, but in general ochres are earthy deposits of fairly pure hydrated or anhydrous ferric oxide, and may be yellow, orange, brown or red. Red ochre in its best form is almost entirely anhydrous ferric oxide, while the yellows and browns contain varying proportions of several hydrated iron oxides. Ochres are the most opaque of the earth colours.

Siennas are essentially ochreous pigments which contain greater proportions of mineral impurities in addition to the iron oxide, particularly alumina and silica, rendering them more transparent. Siennas were used as pigments in the raw state, or gently roasted (burnt sienna) to produce a warmer shade. Analytically, aluminium and silicon as well as iron are always detected in this group of pigments, arising from the colourless mineral matter which is part of the deposit. Calcium, magnesium and titanium are often also detectable.

Just as there is a large variety of earth colours and of their sources, the pigments go under a great number of names which often describe their colour and supposed origin. The treatises refer to materials such as Venetian red, Roman ochre, Prussian ochre, Indian red, English red and Spanish brown.

The umbers are rather more distinct, containing, in addition to ferric oxide, a variable proportion of black manganese dioxide. In their natural condition they fall in the colour range from dark brown to almost black, with differing transparencies. The manganese dioxide component gives these pigments a dark tone, and also has a drying effect on the oil medium. For this reason umbers are useful not only for their colours, but also as additions to ground layers to assist their drying. The thin brown *imprimatura* found over the chalk grounds of Rembrandt's panel paintings is revealed by analysis to contain a little umber; so do some of the upper grounds of the canvas paintings. As with the siennas, warmer-toned burnt umbers were made by gentle heating.

Another variety of transparent brown found in Rembrandt, sometimes treated as an earth colour since it is dug up from deposits in the ground, is known variously as Cassel or Cologne earth[12] and later as Vandyke brown. Strictly, it is an organic pigment of peaty or lignitic origin, but often also contains some inorganic mineral matter. Rembrandt uses it for deep brown background glazes, mixed with a variety of other pigments, particularly earths and lakes, and also in the shadows of flesh in some of his portraits. The pigment is a poor drier in oil but, since it is combined with other mate-rials, this potential defect is not apparent in Rembrandt's work.

The occurrence of earth pigments in Rembrandt's paintings is exceptionally widespread. Mainly they are used in mixture with others for every kind of application: for the opaque tints for flesh and details of costume or jewellery; and everywhere as modifying components for the translucent background paints of red, brown and black. Occasionally, pure touches of opaque red, orange or yellow ochre are used to highlight a detail, as in the cloak on the riverbank in *A Woman bathing in a Stream*, or the yellow reflection on the arm of the chair in the *Portrait of Hendrickje Stoffels* (Cat. No. 13); here the colours are at their strongest and brightest. More often the colour of red and yellow ochres is intensified by mixing in a strongly coloured pigment such as red lake to achieve a much more vibrant effect. Examples of this are the red highlight defining the edge of the tablecloth in *Hendrickje Stoffels*, and the almost scarlet stirrup strap in the *Portrait of Frederik Rihel on Horseback* (Cat. No. 19), where in each case red ochre has been enhanced by the admixture of a deep red lake pigment. The technique is also used in *Belshazzar's Feast*.

Lakes

Much use, too, is made of lake pigments. These are a specific category of artificially prepared glazing pigments, for which the source of colour is a natural dyestuff of plant or animal origin. Commonly the dye material would have been co-precipitated on to a substrate of alumina by the addition of an alkali to solutions in water of the dyestuff and alum. The lake pigment forms as a precipitate in which the dye attaches itself to the substrate. The product thus formed can be collected, washed and dried as a solid coloured pigment. Because the substrate itself is transparent when mixed with the painting medium, lakes are used for richly coloured transparent glazes. Lake preparation has always had a close association with textile dyeing, and some recipes for artists' pigments call for the re-extraction of a dye

from clippings or waste dyed cloth as the starting point.[13]

In traditional painting methods, red lake pigments in particular were extensively used over opaque underlayers to add richness and depth to the painting of draperies,[14] the Venetian school providing some of the most impressive examples. Rembrandt uses lakes rather rarely to glaze in this way. Instead, red lakes are commonly added to warm, dark glaze-like mixtures of bone black with earth pigments for translucent background shadows, and to reinforce the colour of otherwise duller ochres in more opaquely painted passages. Sometimes particles of red lake appear in the flesh tints, but still not as glazing pigments.

In Rembrandt's time, red lake pigments were prepared from the red dyestuffs extracted from the madder plant (principally alizarin), and from a variety of scale insects which secrete red dyes, particularly the lac insect (laccaic acid), kermes (kermesic acid) and cochineal (carminic acid).[15] The products varied in colour from brownish reds to deep crimsons. Other imported red plant dyestuffs may also have been used, but exact identification of the sources of the colouring matter in lake pigment paint samples is still quite difficult. A red lake based on madder has been identified in *Belshazzar's Feast* for the deep red glaze of the dress worn by the woman to the right of the composition, and crimson-coloured cochineal lakes in *Hendrickje Stoffels* and the *Self Portrait at the Age of 63* (Cat. No. 20). In the last two cases the red lake was found to have been mixed with an unidentified yellow lake pigment,[16] a technique which seems to be common in Rembrandt's work.

The dyestuffs for yellow lakes are unfortunately even more difficult to identify than the reds; yet yellow lakes are important as artists' pigments in Dutch seventeenth-century painting, particularly as glazes in flower painting and mixed with blue for landscape and foliage greens. Their preparation is similar to the red lake pigments, although all the yellow dyestuffs which are used are derived solely from plant sources.[17]

Painting treatises refer to *schietgeelen* (yellow lakes), an abbreviation for *verschietgeelen*[18] – literally 'disappearing yellows' – referring to the fading of these glazing pigments on exposure to light. Both yellow and red lakes are vulnerable to fading by photo-oxidation, the yellows particularly so. However, when used as tinting pigments, as Rembrandt does, rather than as surface glazes, lake pigments prove much more stable since they are protected from damage from light by the surrounding matrix of pigment with which they are mixed. Frederik Rihel's coat contains a yellow lake pigment mixed with white, the colour surviving very well.

Certain translucent yellows based on plant dyestuffs were true lakes prepared on hydrated alumina by precipitation methods similar to those employed for the red lakes, while others were simply a yellow or yellowish brown dye absorbed on to a chalk base. The seventeenth-century name for these pigments was *pink* or *pinke* – used as a noun, not descriptively: the adjective applied to a tint of red took its meaning more recently. Varieties such as Dutch pink and brown pink were probably prepared from dyestuffs extracted from the unripe berries of buckthorn (*Rhamnus*), struck on to chalk.[19] They offered yellowish green and yellowish brown pigments of good translucency for glazing and mixing. Although buckthorn is the most frequently mentioned source of yellow colouring matter, other plants such as weld and dyers' broom were also used to make lakes.

For Rembrandt's glazes, yellow and red lake pigments are often combined, occasionally with each other alone, but more often together in elaborate mixtures with earth pigments, bone black and even smalt, to create a great range of colour and texture. The consistency with which Rembrandt uses such translucent pigment mixtures can be judged from subjects as different as the small-scale *Woman bathing in a Stream* of 1654 on panel, and the large pair of canvas portraits, *Jacob Trip* and *Margaretha de Geer*, painted seven years later.

Bone black and charcoal

Darks were of the greatest importance to Rembrandt. Although the dark-coloured umbers might have been almost enough for background shadows, the black clothes worn by his sitters called for an intense black pigment. This was almost always provided by bone or ivory black, prepared, as the name suggests, from animal bones or waste ivory by charring in a closed crucible. The product is a warm, deep black composed of carbon and calcium phosphate, $Ca_3(PO_4)_2$, the residue of the structural material of which bone is built. In samples of paint which contain bone black, the phosphorus is readily detectable by analysis, which confirms the use of the pigment in many of Rembrandt's darks.

In the paintings bone black is found everywhere. Frequently it is a component with other pigments of dark-coloured glazes for backgrounds and costumes; often the mixture includes lake pigments, smalt and earth colours in ever changing proportions. It forms the main pigment of sketchy underlayers used to define principal parts of a composition, and it is occasionally used to shadow flesh. Studies of several paintings by Rembrandt using the technique of neutron activation autoradiography[20] have shown the widespread use of the pigment in the initial wash-like sketch over the ground layer. Unusually, bone black pigment unmixed was used to paint the darkest parts of the clothing in the *Portrait of an 83-year-old Woman* (Cat. No. 3) and *Philips Lucasz*.

Wood charcoal, the other common black pigment Rembrandt might have employed, was found not to have been widely used, except as a tinting pigment for the grey upper ground layers in canvas grounds. The *Elderly Man as Saint Paul* (Cat. No. 15) is a good example of this. The slightly bluish-black cast of charcoal when mixed with white enhances the cool half-tones of the flesh painting in *A Woman bathing in a Stream*, as well as in the bluish-grey streaks on the white fur stole and cuff in the *Portrait of Hendrickje Stoffels*. A rather unusual technique for the

deepest green foliage of the bouquet in *Saskia* involves a charcoal-containing scumble drawn over a deep blue-green layer of azurite, while *Judas and the Thirty Pieces of Silver* (Cat. No. 1) makes use of wood charcoal in the dark background.

Blue pigments

The National Gallery Rembrandts are not remarkable for their use of blue pigments, although in the painter's early career blues and greens played a more important role in the biblical and historical works. The only picture shown here with an overall cool tonality is the *Saskia van Uylenburch in Arcadian Costume*, for which Rembrandt widely employed azurite in pigment mixtures of all kinds, imparting a greenish tinge to much of the composition.

Azurite is a natural blue mineral pigment, chemically a basic carbonate of copper, $2CuCO_3.Cu(OH)_2$. It occurs in nature with a closely similar green copper carbonate mineral, malachite, also used as a pigment; but this was not found in any of the samples examined in this study. Azurite is recognisable under the microscope, generally as quite large fractured mineral particles of deep blue or greenish blue. Much of the natural pigment used in European painting was from Hungary[21] or Germany, although sources in the New World are also mentioned in the seventeenth century. In addition to the mineral form, a synthetic azurite called verditer was available to the seventeenth-century painter, and was used similarly. It is chemically identical to mineral azurite, but differs in the form of its particles, which are more rounded crystalline grains of pale blue or greenish blue.

The most striking instances of the uses to which Rembrandt puts azurite are to be found in *Saskia*. Mineral azurite forms the deep bluish-green streaks of Saskia's embroidered waistband; it is the main colouring component in the veil and sleeve; and it is used as the basis of the foliage greens and of the blue flowers in the bouquet. In a rather unusual technique, Rembrandt mixes azurite into the cool brownish-green shadows of

Saskia's hand. Small quantities are also used in the flesh painting of *Philips Lucasz*. and *A Woman bathing in a Stream. Belshazzar's Feast*, too, contains azurite: for the greenish embroidery on Belshazzar's under-robe, and for the intensely blue-green jewels sewn on to the cape. A little is used with lead-tin yellow and other pigments for Mary's skirt in *The Adoration of the Shepherds*. The later pictures contain no azurite as a colouring matter; if a blue pigment occurs, it is always smalt.

Since it is a copper-containing pigment, azurite will improve the drying of oil paint by chemical reaction with the medium. It is likely that Rembrandt used the pigment as a drier as well as a colouring agent, mixing small quantities of natural or synthetic azurite with dark glaze-like paints made up of pigments which otherwise do not dry particularly well in oil. The drying of paint films containing lake pigments and bone black is assisted in this way. For the purpose the proportion of pigment is usually quite low, sufficient to influence the rate of drying but not to impart colour. Examples of the procedure are found in the background glazes of *The Adoration of the Shepherds*, *An Elderly Man as Saint Paul*, *A Franciscan Friar* (Cat. No. 12) and the *Self Portrait at the Age of 63*, among others. A little blue verditer is used for the shadow glazes in *A Bearded Man in a Cap* (Cat. No. 14). Similarly, azurite mixed with yellow lake pigment forms the initial background glazes for *Saskia*; but here intentional use was probably made of the colour of the pigment as well as of its drying quality.

Rembrandt seems nowhere to have used natural ultramarine, the most valued of the traditional blue pigments. Like azurite it is a mineral blue, extracted by a laborious process from the semi-precious stone, lapis lazuli, which was imported into Europe via Venice from Afghanistan. No sample analysed was found to contain natural ultramarine, and no example of its use by Rembrandt has been published. Although scarce and costly, the pigment was certainly available in seventeenth-century Holland, since it is known to have been extensively used by

Vermeer.[22]

The second blue pigment which does occur in Rembrandt's painting is a manufactured one. It is a potash glass called smalt, coloured blue by the addition of cobalt oxide. Smalt has no fixed composition, but cobalt, potassium and silicon are its essential constituents; in addition, arsenic is generally detected as an impurity. The glass was coarsely ground for use as an artists' pigment. The history of smalt in European painting is not known with certainty.[23] It first occurred occasionally in the fifteenth century, although the making of glass coloured blue with cobalt was rather earlier. The seventeenth-century source of cobalt was silver mines in Saxony, but the manufacture of smalt became a Dutch and Flemish speciality. At its best, smalt is a pure, deep translucent blue with a slightly violet undertone. Different grades were made however, the colours of which were influenced by impurities present in the glass melt. Painting treatises of the period refer to 'smalts',[24] suggesting a variety of qualities or colours. Since it is a glass, it covers poorly. In certain cases smalt suffers a defect in that it discolours or blanches in oil medium, particularly if used as a glaze. The cobalt content is sufficiently available from the glassy particles for smalt to exert a strong siccative effect on oil paint, and it was recommended for this purpose.

Rembrandt employs smalt in several ways: as a blue pigment on its own and in combination with others; as a bulking agent for texture in thickly laid glazes; and as a drier. The last two functions are interrelated, since most glazing pigments dry imperfectly in oil when heavily applied.

The patch of greyish-blue sky in the *Portrait of Frederik Rihel on Horseback* uses smalt for its colour, as a glaze, now rather discoloured, over a solid layer of lead white mixed with further smalt. The picture also contains the pigment in the dark brownish-green glazes used in the background foliage and landscape, where it is mixed with yellow lake. Smalt forms part of the palette for *Belshazzar's Feast*: in the background greys,

and with lake pigments for the deep shadows of the woman's red sleeve, where some blanching of the paint seems to have occurred. The small pale blue impasto touches to the feathers of the head-dress worn by the woman to the left are in smalt mixed with chalk and lead white. *An Elderly Man as Saint Paul, Jacob Trip* (Cat. No. 16) and *Margaretha de Geer* all provide good examples of smalt used to constitute texture in dark-coloured translucent paints also containing lake pigments.

References:
1. Bredius, *Künstler-Inventäre*... vol. 1, pp. 112-19; vol. 7, pp. 77-86.
2. Sandrart, *L'academia todesca*..., vol. 1, part I, book III, ch. 14, p. 86.
3. Hoogstraten, *Inleyding*..., p. 291.
4. Harley, *Artists' Pigments*..., pp. 166-72.
5. Graaf, *Het de Mayerne Manuscript*..., p. 34.
6. Graaf, 'Betekens en toepassing van "lootwit" en "schelpwit"...'.
7. An example of a process for lead-tin yellow is given in Vandamme, 'Een 16e-eeuws zuidnederlands receptenboek', recipe 8, p. 116.
8. Hoogstraten, op. cit., p. 220; Sandrart, op. cit.
9. van Schendel, 'Manufacture of vermilion...'.
10. Harley, op. cit., p. 127.
11. Hoogstraten, op. cit., p. 220; Sandrart, op. cit.
12. Biens, *De Teecken-Const*... (reprint by E.A. de Klerk in *Oud Holland*), p. 56.
13. There is a recipe in Batin, *Secreetboek*..., 1650, p. 265, derived from Alessio.
14. Biens, op. cit.
15. J. Kirby, 'A spectrophotometric method for the identification of lake pigment dyestuffs', *National Gallery Technical Bulletin*, 1, 1977, pp. 35-44.
16. Ibid.
17. The 'Pekstok papers', Municipal Archives, Amsterdam, No. N-09-23, give a detailed method for a large-scale preparation of yellow lake from buckthorn.
18. Graaf, op. cit., pp. 48-9.
19. Harley, op. cit., pp. 107-14.
20. Ainsworth and others, *Art and Autoradiography*...
21. Andriessen, *Een schoon Tractaet*...,1581, ch.4.
22. H. Kühn, 'A study of the pigments and grounds used by Jan Vermeer', *Report and Studies in the History of Art*, National Gallery of Art, Washington 1968, p. 168.
23. B. Mühlethaler and J. Thissen, 'Smalt', *Studies in Conservation*, 14, 1969, pp. 47-9.
24. Hoogstraten, op. cit., p. 221.

Rembrandt's paint medium

It is very unusual to find catalogues of easel paintings which pay more than cursory attention to a master's paint medium. Generally it is dismissed in a single word, such as 'oil' or 'tempera'. In an attempt to reach as complete an understanding of a master's technique as is possible, using modern analytical techniques, the Scientific Department of the National Gallery has been carrying out a programme of investigation into the materials used and confection of paint media. Readers of the annual *National Gallery Technical Bulletin* will already be aware of the regular inclusion of summaries of media results, with full technical details. Nevertheless, in view of the comprehensive nature of this special exhibition catalogue, devoted entirely to a particular master, it seemed not unreasonable to collect together our present knowledge of Rembrandt's use of available paint media. The results are displayed in Table 1 (pages 28 and 29).

The primary purpose of the paint medium is to bind together individual pigment particles to permit application of pigment to a surface and provide long-term retention on that surface. Prior to the nineteenth and twentieth centuries, the artist was restricted to materials from nature. Examples include oils from seeds and fruits, resins from trees, waxes, glues from animal and fish sources and gums from plants. Only with advances in chemistry during the last hundred years have synthetic materials become available as paint binders.

In broad outline we may say that the earlier masters chiefly employed glue distemper and egg tempera as binding materials. However, in their endeavour to extend the range of their accomplishments in ever more faithfully representing the optical phenomena they perceived, they experimented with other media. Gradually there was a move towards the use of drying oil. In the fresh state, such oils are free liquids well able to wet and imbibe the powdered pigment. The mixture solidifies not by simple evaporation to any great degree but, rather, by the molecular units of the oil being linked together by a process of polymerisation. The result is that the pigment becomes firmly embedded in a solid organic matrix, whose optical properties are superior to those of tempera for many purposes. Such binders offer the combined advantages of good handling properties for the paint during application, together with the eventual production of a tough, durable film after drying.

Three main drying oil types have found application in easel paintings. The strongest drier, that is, the oil that dries best with a range of different pigments and most rapidly, is extracted from linseed. Walnut oil, much favoured by the Italian masters at one time, is somewhat slower in drying and is more sensitive, in the short term, to the inhibiting effects of some pigments. Much the same may be said of poppyseed oil, but this, and to a slightly lesser extent walnut oil, is considered to yellow less during ageing. As a result they have often been recommended for the lighter colours. It was soon appreciated that pigments such as lead white, red lead and vermilion were good driers, whereas the black pigments and the lake pigments were poor driers, that is they tended to inhibit the drying process in the oil binder.

It is clear, for this sample of Rembrandt's works at least, that there is a preponderance of linseed oil as binder for his paints. One may say that in general a sound medium – linseed oil – has been employed in an uncomplicated way, that is, without detectable additions of other materials. Use of linseed oil is very much in the tradition of North European technique of the period. Interspersed are instances where the binder seems to be walnut oil. This oil shows no signs of being methodically restricted to the lighter colours of the palette.

Only a single instance of the admixture of pine resin and linseed oil was found, that of a sample of black paint from Cat. No.18, *Portrait of Margaretha de Geer, Bust Length*. In one sample from Cat. No. 17, *Portrait of Margaretha de Geer*, taken from the background, some egg tempera was possibly present. However it was not entirely clear that the area sampled was completely free of retouching.

The ground layer: function and type

Some comment should also be made on the results from Cat. No.6, *The Lamentation over the Dead Christ*. Alkyd medium (oil-modified alkyd), established in sample 1, is a synthetic medium and its use here corresponds with an area of paint from an added section to the painting. Sample 2 was taken from the interfacial region between the two. Poppyseed oil, so far, has not figured in the media used by Rembrandt and this instance certainly represents retouching at the divide between the two areas. R.W.

An essential stage in the construction of any easel painting, on both panel and canvas, is the application of a ground to the support before the painting itself is started. It is quite possible that Rembrandt's grounds were in certain instances applied in the studio, while in others they were already in place on the supports when the wood panels or canvases were supplied. There is, however, some evidence from the constitution of the ground layers for two canvas paintings, the portrait pair of *Jacob Trip* and *Margaretha de Geer* (Cat. Nos. 16 and 17), that the grounds for these two at least were applied in Rembrandt's studio. Other canvases were probably acquired ready-grounded.

It is also difficult to be certain how far the grounds on paintings by Rembrandt are a characteristic of his technique, or whether they are frequently to be found on other pictures from the Low Countries in the seventeenth century. Clearly, if canvases and panels were invariably supplied with a commercially prepared priming, the ground type must occur again and again – not just in Rembrandt, but in any representative group of pictures of the period. Unfortunately, the techniques of few seventeenth-century Dutch artists have been comprehensively studied, and the situation is complicated further because ground types which are both similar and markedly different in constitution to Rembrandt's have been found for the work of a few other artists painting on canvas.

The vital function of the ground layer is to provide a suitable surface on to which the layers of paint can be laid. For an underlayer to be properly called a ground it must cover the entire area of the support, whether or not it plays a visual part in the final composition. Ideally the ground layer or layers are finished to be rather smooth, possibly by scraping or rubbing, but in one particular type we have found on the canvas paintings by Rembrandt, the texture is far from smooth, and would have had a noticeable 'tooth' (Fig. 25). The advantage of this kind of surface may lie in the ease with which thickly laid impasto can be pulled up from a coarse painting

surface. Generally, however, the ground layers for the canvas pictures fully fill the canvas weave, and present a flat surface of appropriate absorbency for the application of the layers of oil paint that make up the picture. Rather few clear results of medium analysis of the ground layers have been reported, but the indications are that for grounds on canvas the binder is a drying oil.

The form of the ground for Rembrandt's paintings on oak panel is quite distinct from the range used on the canvas paintings, and presents a pattern thoroughly consistent in all cases we have examined, and with the results of analysis reported elsewhere. Each of the panel paintings bears a fairly thin layer of chalk (calcium carbonate) bound in animal-skin glue, which tends just to fill the grain of the wood. The mixture is usually creamy white. Minute fossil coccoliths have been detected using the scanning electron microscope in the lower ground layer of the *Portrait of an 83-year-old Woman* (Cat. No. 3) and in the *Portrait of Philips Lucasz.* (Cat. No. 4)(Fig. 24), indicating that the chalk is of natural origin.

24. Dispersed fragment of chalk ground from the *Portrait of Philips Lucasz.* Showing fossil coccoliths. SEM micrograph, 14,700x.

There is a long tradition in the use of chalk grounds for panel paintings in Northern Europe, reaching back to the Van Eycks and before. Unlike that of most panels of the fifteenth and sixteenth centuries, the chalk ground of Rembrandt's panel paintings is covered with a very thin *imprimatura*, generally of a warm yellowish brown, made up of a

Table 1

A survey of Rembrandt's paint medium

Picture	Date	Sample	Medium
Judas and the Thirty Pieces of Silver	1629	1. Ground, upper layer 2. Ground, lower layer 3. Black of floor 4. Grey-green background	Linseed oil Linseed oil (?) Linseed oil Walnut oil
Portrait of an 83-year-old Woman	1634	1. Light fawn background to left of sitter 2. Black paint of dress	Linseed oil Linseed oil
Saskia van Uylenburch in Arcadian Costume	1635	1. Grey-white of bottom of dress 2. Dark black/brown of foliage, top	Walnut oil Linseed oil
The Lamentation over the Dead Christ	c.1635	1. Warm white impasto, RH edge 2. White cloud, by cross, upper LH edge 3. Mustard colour, by white shroud 4. Dark brown/black background, RH edge	Alkyd Poppyseed oil Linseed oil Linseed oil
Belshazzar's Feast	1636-8	1. White impasto of robe 2. Yellow impasto of robe trimmings 3. LH woman's head-dress, shadow 4. Red dress of RH woman	Linseed oil Linseed oil Linseed oil Linseed oil
Self Portrait at the Age of 34	1640	1. Light brown parapet, RH side	Walnut oil
The Woman taken in Adultery	1644	1. Dark impasto, top of centre column 2. Pale orange-brown of RH column 3. Ground 4. Red background, top RH edge	Linseed oil Linseed oil Linseed oil Linseed oil

Picture	Date	Sample	Medium
The Adoration of the Shepherds	1646	1. Black background 2. Ground 3. Mustard highlight of roof beam, LH edge	Linseed oil Linseed oil Linseed oil
A Franciscan Friar	c.1655	1. Brown habit 2. Pale buff paint, top edge 3. Grey-blue background	Linseed oil Walnut oil Linseed oil
Portrait of Hendrickje Stoffels	c.1656	1. White highlight of robe 2. Red background	Walnut oil Walnut oil
A Bearded Man in a Cap	1657	1. Black coat 2. Ground	Walnut oil Walnut oil
An Elderly Man as Saint Paul	1659	1. Black sleeve of robe 2. Reddish brown, upper RH corner	Linseed oil Linseed oil
Portrait of Jacob Trip	1661	1. White scarf, right shoulder 2. Reddish brown, side of chair 3. Black, bottom of cane	Walnut oil Linseed oil Linseed oil
Portrait of Margaretha de Geer	1661	1. White ruff 2. Brown background 3. Ground	Linseed oil Oil + egg(?) Linseed oil
Portrait of Margaretha de Geer, Bust Length	1661	1. White impasto 2. Black background	Linseed oil Linseed oil + resin
Portrait of Frederik Rihel on Horseback	1663	1. White impasto, jacket trimmings 2. Red impasto, cuff trimmings	Linseed oil Linseed oil
Self Portrait at the Age of 63	1669	1. Dark brown, right sleeve 2. Olive-brown background at top edge 3. Ground	Linseed oil Linseed oil Linseed oil

mixture of lead white, chalk and a little umber, probably bound in oil. This *imprimatura* coats the entire chalk underlayer and is sufficiently X-ray absorbent for it to show the grain of the wood panel beneath, which is usually only partially filled by the lower layer of chalk. Manganese has been detected by analysis in several examples of this brownish *imprimatura*, indicating that the tinting earth pigment is a true umber, rather than merely a brown-coloured ochre. Apart from imparting colour the umber content would have assisted rapid drying of the *imprimatura*, by catalysing the process.

Rembrandt's canvas paintings are more variable in their ground structure, although two basic types are commonly employed. One main category consists of so-called double grounds, in which the first layer applied directly to the canvas is ochreous, usually of red or reddish-orange earth pigment. There follows an overlayer of grey, light brown or dull greyish yellow, containing lead white as a main component and coloured pigments often with black, to tint this second priming. Examples of this type of double-layered ground are to be found in *Saskia van Uylenburch in Arcadian Costume*, *Belshazzar's Feast* and the *Self Portrait at the Age of 34* (Cat. Nos. 5, 7 and 8). There are variations in the essential form. For example the *Elderly Man as Saint Paul* (Cat. No. 15) has a brown umber-containing lower ground layer, with on top a second greyish-brown priming of coarse lead white, splintery particles of charcoal black and some umber. The constitution of the lower orange-coloured grounds on the canvas paintings varies too, particularly in the purity of the earth pigment used (see Table 2).

It is likely that quantities of fairly cheap earth pigments were used to provide the first layer of priming on canvas, to fill the interstices of the weave, with the second ground layer containing lead white laid over as the chosen surface both in colour and texture for the painting to be executed on top. As with the grounds on panel, it is the upper layer of ground on the canvas paintings containing X-ray-absorbing lead white

that is mainly responsible for the canvas weave registering on the radiograph. Double grounds of this character are by no means unique to Rembrandt. An earlier Dutch painting in the National Gallery Collection with a comparable ground structure is ter Brugghen's *Jacob and Laban*, dated 1627; while elsewhere double grounds were regularly being employed by Rubens and Van Dyck for their works on canvas.

The second category of canvas priming for Rembrandt's paintings is quite different in composition. It is of a single layer of coarsely sieved quartz (silica sand), tinted with a little brown ochre and containing a low proportion of lead white, the mixture bound together in a drying oil. The principal component is the quartz, and its coarse texture is evident at the painting surface (Fig.

25. The top surface of a fragment of 'quartz' ground from *The Adoration of the Shepherds* showing its coarse texture. SEM micrograph, 777x.

25). The motivation for the use of this slightly improbable combination for canvas grounds may again lie in the cheapness and wide availability of the materials. The lead white content in these dark-coloured grounds, although quite low, is still sufficient to show the canvas weave to some degree on radiographs of the paintings that bear them. Examples of the type include *The Adoration of the Shepherds*, the *Portrait of Hendrickje Stoffels*, the *Portrait of Frederik Rihel on Horseback* and the *Self Portrait at the Age of 63* (Cat. Nos. 10, 13, 19 and 20). As with the double grounds it cannot be determined

whether the 'quartz' type would have been applied in the studio or was one of a range of standard commercial products, perhaps the least expensive.

Two of the paintings on canvas, *A Franciscan Friar* and *Margaretha de Geer, Bust Length* (Cat. Nos. 12 and 18), carry grounds which fit neither main category (see Table 2), but are modifications of the more consistently found priming practices. It must be pointed out that the range of seventeenth-century techniques for canvas grounds shows considerable variation, and that alternative methods might well be expected to be reflected in Rembrandt's painting on canvas.

Bibliography: Graaf, *Het de Mayerne Manuscript...*; H. Miedema and B. Meijer, 'The introduction of coloured ground in painting and its influence on stylistic development, with particular respect to sixteenth-century Netherlandish art', *Storia dell'Arte*, 35, 1979, pp. 79-98.

Table 2 The Structure of the Ground in Paintings by Rembrandt

Title	Date	Support	Ground Type	Lower Layer[1]	Elemental Composition[2]	Upper Layer[1]	Elemental Composition[2]	Comments
Judas and the Thirty Pieces of Silver	1629	Oak panel	Single	Chalk	Ca	*Imprimatura:* Lead white, yellow-brown earth	Pb, Fe (Ca, Si)	
Ecce Homo	1634	Paper	Single	Lead white	Pb	–	–	
Portrait of an 83-year-old Woman	1634	Oak panel	Single	Chalk	Ca (Al, Si)	*Imprimatura:* Lead white, umber	Pb, Fe (Mn)	
Portrait of Philips Lucasz.	1635	Oak panel	Single	Chalk	Ca (Si)	*Imprimatura:* Lead white, chalk, umber	Pb, Ca, Fe, Mn (Si, Al)	
Saskia van Uylenburch in Arcadian Costume	1635	Canvas	Double	Orange-red earth	Fe, Si, Al (Pb, Ti)	Light grey: Lead white, charcoal (ochre)	Pb (Ca, Fe, Si)	The painting has been transferred, and the lower layer of ground thinned as part of the process.
The Lamentation over the Dead Christ	c.1635	Paper	No ground	–	–	–	–	Paper mounted on to sections of canvas which bear conventional double grounds (see text).
Belshazzar's Feast	1636/8	Canvas	Double	Orange-red earth	Fe, Si, Al (Pb, Ca)	Light fawnish grey: Lead white, umber, carbon black	Pb, Ca, Fe, Mn, Al (Si)	
Self Portrait at the Age of 34	1640	Canvas	Double	Red earth	Fe, Si, Al (Pb, Ca, Ti, Mn)	Fawnish grey: Lead white, brown ochre (charcoal)	Pb, Fe (Si)	The painting has been transferred, and a layer of dark-coloured adhesive is detectable beneath the original ground.
The Woman taken in Adultery	1644	Oak panel	Single	Chalk	Ca	*Imprimatura:* Lead white, yellow-brown earth	Pb, Fe, Ca (Si, Al, Mn)	Ground scraped down in places.
The Adoration of the Shepherds	1646	Canvas	Single	Quartz, brown ochre	Si, Fe, Al	–	–	
A Woman bathing in a Stream	1654	Oak panel	Single	Chalk	–	*Imprimatura:* Lead white, yellow-brown earth, umber	Pb, Fe, Ca, Mn, Al (Si)	
A Franciscan Friar	c.1655	Canvas	Double	Orange-red earth	–	Lead white (colourless smalt/glass)	Pb, Si	The painting has been transferred and marouflaged. The lower layer of original ground has mainly been removed.
Portrait of Hendrickje Stoffels	c.1656	Canvas	Single	Quartz, brown ochre (lead white)	Si, Fe, Al (Pb)	–	–	
A Bearded Man in a Cap	1657	Canvas	Double	Orange-red earth	–	Brownish yellow: Lead white, brown ochre, umber	Pb, Fe, Al, Si (Mn)	
An Elderly Man as Saint Paul	1659	Canvas	Double	Lead white, umber, black	Pb, Fe Mn, Al, Si (Ca)	Greyish brown: Lead white, charcoal (umber)	Pb (Fe, Mn, Al, Si)	
Portrait of Jacob Trip	1661	Canvas	Double	Orange-red earth	Fe, Si (Ca, Al, Mn, Pb)	Khaki: Lead white, chalk, yellow ochre, umber, charcoal	Pb, Ca, Fe, Si, Mn, Al	Some red lake pigment is present in the lower ground layer (see text).
Portrait of Margaretha de Geer	1661	Canvas	Double	Orange-red earth	Fe, Si (Ca, Al, Mn)	Khaki: Lead white, chalk, yellow ochre, umber, charcoal	Pb, Ca, Fe, Si, Al (Mn)	
Portrait of Margaretha de Geer, Bust Length	1661	Canvas	Double	Chalk	Ca (Al)	Light yellowish brown: Lead white, chalk, yellow and red earth, charcoal	Pb, Ca, Fe	Unusual ground structure (see text).
Portrait of Frederik Rihel on Horseback	1663	Canvas	Single	Quartz, brown ochre	Si, Fe (Al, Ca)	–	–	
Self Portrait at the Age of 63	1669	Canvas	Single	Quartz, brown ochre	Si, Fe (Al, Ca, Ti)	–	–	

Notes to the table:
1. Minor constituents are noted in brackets.
2. Analysis by energy dispersive X-ray microanalysis (EDX) or laser microspectral analysis (LMA) (see glossary).
Minor components noted in brackets. Certain analyses confirmed by X-ray diffraction analysis (XRD) (see glossary).

The paint layers

Writing in 1693 in his *Art of Painting, according to the theory and practice of the best Italian, French and German masters*, Marshall Smith observed, 'Rembrant had a Bold Free way, colours layd with a great Body, and many times in old Men's Heads extraordinary deep Shaddows, very difficult to Copy, the *colours* being layd on Rough and in full touches, though sometimes neatly Finished.' This succinct description certainly captures the characteristic surface appearance of Rembrandt's paintings – the use of texture and expressive brushwork, the juxtaposition of impasto and smooth paint, the precise calculation of colour – but does not attempt to describe the way in which the paint layers were built up or what the preliminary stages were.

Gerard de Lairesse, who knew Rembrandt and had his portrait painted by him, is more analytical in his *Het groot Schilderboek* of 1707. He identifies three main stages in the painting process: the *dead-colouring*, the *second-colouring* and the *retouching* or *finishing*. Since he was reflecting on the practices of the second half of the seventeenth century, it is worth bearing these three stages in mind when examining the methodical build-up of Rembrandt's paintings.

In arriving at a final effect Rembrandt had certain variables to exploit. The first and most profound was the ground colour. As we have seen, this could vary from white or beige on the panels to shades of grey, grey-brown and dark brown on the canvases. When painting on a pale ground, Rembrandt seldom uses its tone directly as a passage of colour, but simply to provide a general luminosity, shining through the superimposed paint layers and appearing between brushstrokes or where adjacent blocks of paint do not quite meet. However, he did use the underlying ground tone directly for the background architecture in *The Woman taken in Adultery* (Cat. No. 9).

By contrast, coloured ground layers on canvas were frequently left exposed and used directly for design elements such as background colours and areas of shadow in faces and hands: a particular place to check is around the eyes in many of the later portrait heads, where projecting highlights are painted but receding shadows are often exposed ground colour. Rembrandt did not always adopt this method: in the meticulously finished *Self Portrait at the Age of 34* (Cat. No. 8), for example, the ground is entirely covered and all shadows in the face are constructed in the upper paint layers only.

Rembrandt's working method on panel and canvas seems usually to have begun with a lay-in of brown paint, defining main forms, principal shadows and so on. This could vary in detail and complexity, sometimes having distinct drawing lines within it, but often consisting simply of broad washes of brown tone. There may have been some rudimentary drawing preceding this to fix the position of the design – perhaps in chalk on dark-ground canvases although this has never been observed – but the lay-in was usually the first painting stage and formed the basis for the colour that was to follow.

The first paint layer identified by Lairesse, the *dead-colouring*, has been variously interpreted. It is a term often referred to in documents and treatises – indeed, as Miedema has pointed out, it was even prescribed by guild regulations in the previous century as an essential test of quality – but it remains a slightly elusive concept. Its relevance to the study of Rembrandt's methods would seem largely academic were it not for the fact that occasional layers of underpaint in his pictures seem to correspond neither to the preliminary lay-in nor to the fully realised colour layers.

The layer beneath the shift in *Woman bathing in a Stream* (Cat. No. 11) could be reasonably described as either lay-in or dead colour, and perhaps a distinction is superfluous; but the dark underpaints in *Belshazzar's Feast* (Cat. No. 7) certainly represent something more substantial than an initial sketch and could well correspond to a complete dead-coloured stage.

Even more significant is the apparently unfinished *Turk* in the National Gallery of Washington (Rembrandt *Corpus* B.8), in which the costume is painted rather loosely in curiously drab, flat tones. Here, almost certainly, is a painting left at the dead-coloured stage, lacking its final colour layers. The head and elaborate turban, unlike the costume, are fully finished, but quite possibly not by Rembrandt himself.

It is now clear that 'dead colour' is a somewhat flexible term and has been applied by some writers to an entirely monochrome stage beneath the colour layers, but by others to dull preliminary colouring that was to be heightened and made more colourful in the next stage of painting. Sandrart seems to imply the latter, because he is specific in describing distinct stages: first (he says) the artist should lay on the sketch, including 'all its appurtenances', then 'examine it well and with dead colours (which one calls underpainting) correct the errors still to be found and finally, when it is thoroughly dry, with diligence paint over and complete it'. In the case of Rembrandt it is certainly worth bearing in mind the possibility of such a layer, as we have seen, but it is a mistake to assume that his paintings must conform to a standard or theoretical pattern of construction. Rembrandt was, above all, a spontaneous and innovative painter and was certainly not constrained by a set academic method: his paintings must be approached empirically and described in a terminology that seems appropriate in each case.

When he came to the principal layers, Rembrandt's approach was direct and straightforward, and can usually be interpreted quite simply from observation of the picture surface and the radiograph. By varying thickness, texture, transparency and colour juxtaposition, a whole range of effects could be achieved.

One particular effect that all painters have to master if they are to suggest form convincingly is the cool half-tone between light and shadow: form will appear solid and deceptive only if this is observed correctly. Essentially, the depiction in paint of three-dimensional objects, faces, hands and so on, requires alternating use of warm and cool colours: shadows are warm, half-tones cool, lights warm and highest lights cool again. If

this sequence is not observed, the illusion of depth and roundness will not be successful. It is instructive to note how Rembrandt almost always adhered to this convention and, where he failed to, the result is flat and unconvincing: *Belshazzar's Feast* is a good example, and there is every reason to believe that a deliberately theatrical effect was being sought here.

The actual painting of the cool half-tone could be done in two basic ways. Either it could be painted directly between light and shadow as a band of colour containing cool, blue-toned pigments; or it could be achieved – and Rubens's later paintings are perhaps the most outstanding example of the method – by exploiting the *turbid medium* effect. A light colour painted thinly over a warm dark tone will appear cooler than if painted over a lighter tone. Thus, by underpainting the shadows and half-tone areas with a dark colour and then overlapping it with the warm translucent colour of the general lights, the cool half-tones are produced automatically. Both techniques may be observed in the paintings described here: the use of turbid medium effects can be seen, for example, in *Woman bathing in a Stream* and the use of direct surface colour in the *Self Portrait at the Age of 34*.

Rembrandt's use of texture and impasto is highly characteristic. He used paint to suggest substance and form in an extraordinarily direct way: the shift in *Woman bathing in a Stream*, the flesh paints of the *Portrait of an 83-year-old Woman* (Cat. No. 3), the waistband of *Saskia van Uylenburch in Arcadian Costume* (Cat. No. 5) and the glittering coat of the *Portrait of Frederik Rihel on Horseback* (Cat. No. 19) are all notable examples. Some texture tricks could become slightly mechanical, such as the use of the brush-handle to scratch out hairs and shadows in wet paint, and were much imitated by *pasticheurs* of Rembrandt's style. But Rembrandt himself, perhaps more than any other painter, challenged that ambiguity of paint as image and image as paint that underlies the whole technique of painting. He instilled in his pupils too a proper sense of the material possibilities of paint: Samuel van Hoogstraten might have been reporting directly his master's teaching when he wrote:

> ...it is above all desirable that you should accustom yourself to a lively mode of handling so as to smartly express different planes or surfaces; giving the drawing due emphasis and the colouring, when it admits of it, a playful freedom, without ever proceeding to polishing or blending ...it is better to aim at softness with a well-nourished brush...for, paint as thickly as you please, smoothness will, by subsequent operations, creep in of itself.

Bibliography: Marshall Smith, *The Art of Painting, according to the best Italian, French and German masters*, London 1693; Lairesse, *Het groot Schilderboek*; Sandrart, *L'academia todesca...*; Hoogstraten, *Inleyding...*; H. Miedema, 'Over kwaliteitsvoorschriften in het St Lucasgilde; over "doodverf"', *Oud Holland*, 101, 1987, pp. 141-7.

Catalogue

*The dimensions of the paintings are in
centimetres followed by inches.*

1.
Judas and the Thirty Pieces of Silver

Oak, 79 × 102.3 (31⅛ × 40¼)
Signed, bottom right: RL (in monogram:
Rembrandt Leidenensis) 1629

Great Britain, Private Collection

The story of the repentant Judas' return to the Temple is told in the Gospel of Saint Matthew, chapter 27. He hurled the thirty pieces of silver, the payment for his betrayal of Christ, on the floor in front of the High Priest, who, in Rembrandt's painting, turns away. Judas then hanged himself.

This is the best documented of all Rembrandt's early paintings as it was seen, admired and described at length by Constantijn Huygens, the artistic adviser and influential secretary of the Prince of Orange. Huygens wrote about his visit to two young artists in Leiden, Jan Lievens and Rembrandt, and their relative strengths and weaknesses, in his manuscript autobiography, which must have been composed between May 1629 and April 1631. His account of the *Judas*, written in Latin, deserves to be quoted in full:

The picture of the penitent Judas, and the pieces of silver, the price of the betrayal of our innocent Lord to the high priest, I would have stand as the example *par excellence* of all his works. Summon all Italy, summon whatever remains from remotest antiquity that is beautiful or wonderful, the portrayal of the despairing Judas alone, leaving aside so many other stupendous figures in this one single work, the figure of Judas only, I repeat, a Judas demented, wailing, beseeching forgiveness but not hoping to receive it or displaying any hope in his features, the awful face, the torn hair, the clothes rent to shreds, the twisted limbs, the hands clenched so hard that they bleed, the knee outstretched in an impulsive surge forward, the entire body contorted in pitiable anguish, I set against all the elegance of the ages, and I am eager that even those most unenlightened should know it, those men who (and I have attacked them for it elsewhere) reckon that nothing can be either done or said today which antiquity has not already said or done before. For I maintain that nobody, not Protogenes nor

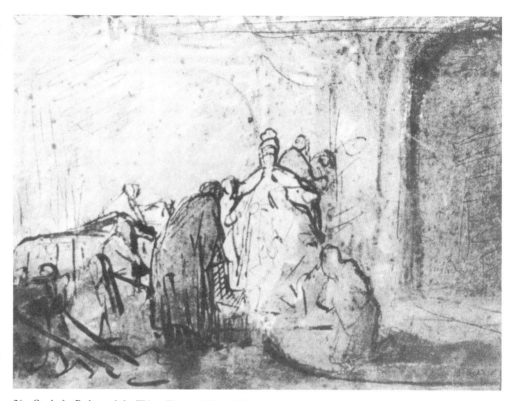

26. *Study for Judas and the Thirty Pieces of Silver.* Private Collection

Apelles nor Parrhasius, ever conceived, or if they returned to life ever could conceive, the things which (I am struck dumb as I tell of them) a mere youth, a Batavian, a miller, a beardless boy has brought together one by one in a single human being and given expression to as a universal unity. In truth, friend Rembrandt, honour is yours: the bringing of Troy, of all Asia Minor to Italy had not such importance as the fact that the highest honour which belonged to Greece and Italy has now been carried off for the Dutch by a Dutchman who has still hardly ever left the confines of his native town.

There are three preparatory drawings for this painting. One (Benesch No. 8; Fig. 26), in pen and wash, is a compositional drawing which shows Rembrandt working out the disposition of the figures and their relationship to the architectural setting. The

other two (Benesch Nos. 6 verso and 9 recto; Figs. 29 and 27), respectively in black chalk and in pen and wash, show in slightly different positions the group of figures in the centre.

Rembrandt made many changes in composition and in detail during the course of the painting's execution. Fig. 30 presents the most significant of these changes in diagrammatic form. There are two principal areas of change: the architectural background and the figure group, particularly the figures in the left-hand half of the composition. A careful study of the painting, on the surface of which many *pentimenti* are visible, the X-ray (Fig. 28), paint samples and the three preparatory drawings makes it possible to identify the ten principal stages in the creation of this complex, intriguing and powerful work:

(1) Rembrandt, or one of his studio

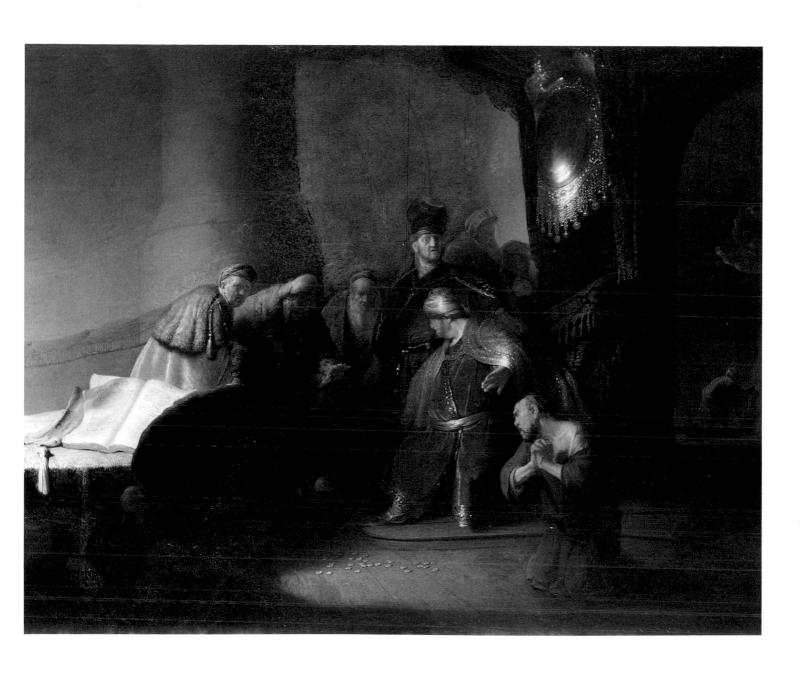

assistants, prepared the panel, creating a smooth surface by applying a chalk ground.

(2) Rembrandt then applied a thin *imprimatura*, the toning layer, using lead white and brown earth pigments in an oil medium.

(3) He then laid in the preliminary architectural elements. The arch that can now be seen apparently springing from the head of the central standing priest in a tall turban and curving to the left was put in at this stage. The column towards the right, of which the High Priest's throne is a part, was probably also roughly sketched in at this stage, as was the original, lower profile of the arch on the right.

(4) After this initial laying-in, Rembrandt made the compositional drawing (Fig. 26), in which he worked out the disposition of the figures within this architectural setting.

(5) Rembrandt then transferred these ideas from paper on to the panel. He changed the architectural background in order to stress the centrality of the standing, turbaned priest. The first arch springing from his head was suppressed and two arches springing from points on either side of his head created. The figures of the standing priest, Judas, a standing priest on the left (who was subsequently painted out but can be clearly seen in the drawing and in the X-ray) and a chair to his right (also painted out later but visible in the X-ray) were painted in at this time. The seated High Priest may have been painted at this stage or added slightly later over the already completed figure of the standing priest. An important compositional element on the left-hand side of the painting was also painted in at this time: it was a tasselled curtain, painted in dark grey-blues (of smalt and charcoal), which begins about a quarter of the way along the top edge of the panel, curves inwards and then billows out again over the area which now contains the table and the open book (see Fig. 28).

Rembrandt's original idea was to make the left-hand side of the painting very dark, so increasing the drama of the fall of light on the figure of Judas: this, as we shall see, was later abandoned. At the foot of this tasselled curtain Rembrandt painted a stool, which can be clearly seen in the bottom left-hand corner of the X-ray. It also seems that it was at this stage in the evolution of the painting that the arch on the right was raised.

(6) Rembrandt was troubled by the left-hand side of the painting and in particu-

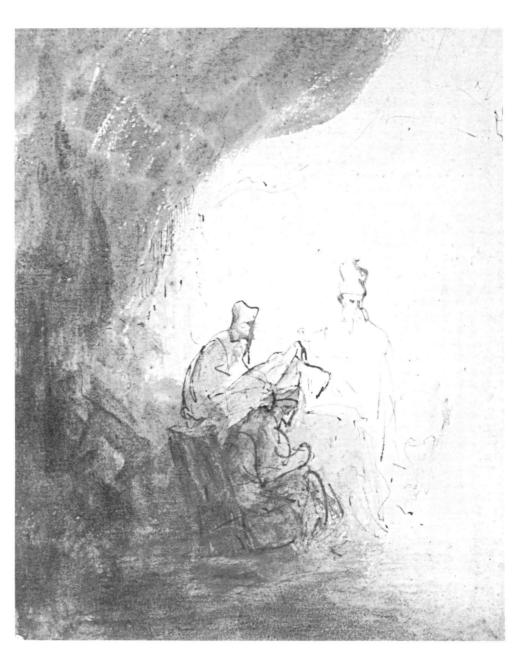

27. *Study for group of figures in Judas and the Thirty Pieces of Silver.* Amsterdam, Rijksprentenkabinet

lar by the figure group of the priests, and he experimented with this group on paper in the two other extant drawings (Figs. 27 and 29). Both show him working out the interrelationship of these figures. In the pen and wash drawing (Fig. 27) – which shows quite clearly the tasselled curtain on the left – the seated figure is seen in a lost profile and the dominating figure of the tall standing priest is moved into the centre of the composition. It is fascinating to note that this figure, having been drawn in pen by Rembrandt, was then removed by him from the composition: he went over the outlines of the figure in chalk, whiting it out. It is only with the wearing away of the chalk that the pen figure has re-emerged. In the second, black chalk

drawing (Fig. 29) the seated figure is seen in strict profile with a second seated figure seen from the back. It is tempting to think that at this relatively early stage in the composition Rembrandt intended to use these figures to close off the figure group on the left-hand side, an idea he later abandoned.

(7) As a result of these experiments on paper, Rembrandt now decided to dispense with the standing priest with his back to the spectator left of centre. He scraped this figure out and also removed the chair on the immediate right of the priest, parts of the curtain at the left and the stool in the bottom left-hand corner.

(8) Rembrandt next painted in the seated priest seen from the back left of centre and

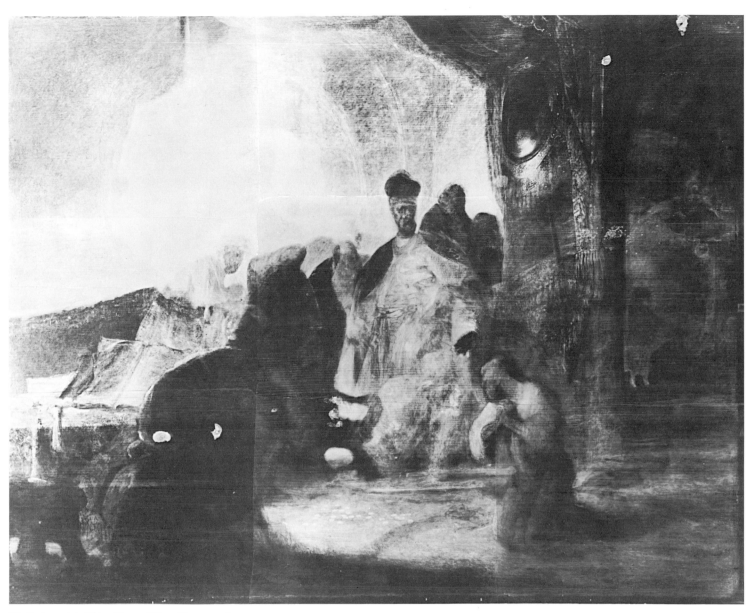

28. *Judas and the Thirty Pieces of Silver.* X-ray mosaic.

suppressed the entire curtain, replacing it with the column on the back wall, the grey-green fringed hanging (painted in poor-coloured azurite mixed with lead white) attached to the back wall which, as can be seen clearly in the X-ray, originally went around the curve of the column, the table and the open book which stands on it. These were radical changes and none more so than the new lightness of tone on the left-hand side of the painting. Replacing a sombre curtain with a brightly lit table and book had the effect of completely altering the tonal balance of the picture, creating a light area to balance that which highlights the central drama. The pigments used for the higher-key passages are lead-tin yellow, vermilion and lead white with touches of azurite.

(9) Rembrandt then painted the figures of the three standing priests above the seated one. They all lean forward to observe Judas. The one furthest to the left is painted over the fringed hanging.

(10) Finally, he corrected the outline of this fringe in the area immediately to the left of the standing priest, who is the furthest of the three to the left. This caused Rembrandt considerable difficulty in the perspective. Formerly, encircling the column, the hanging was painted as if viewed by the spectator from a high viewpoint, but now, by painting it to disappear halfway up the back of the priest, he made the spectator's viewpoint very low down: it is a distinct lapse in the picture's perspective scheme.

The figure group which forms a semi-circle in front of the despairing Judas was admired by Huygens and there can be no doubt that the suppression of the central figure of a standing priest seen from the back (at Stage 6) and the consequent opening up of the composition, which gave greater prominence to the High Priest who turns away from Judas, were great improvements. More important, the thirty pieces of silver themselves assume their crucial importance in the drama. In earlier versions, they would have been far less visible just to the right of the standing priest.

A number of other minor alterations visible in the X-ray were made to increase the dramatic impact of the scene; for example, Judas' money-bag originally was beside his knees but this would have distracted from the silver thrown on to the floor and so was painted out and the bag was shown discarded on the stairs in the shadows behind Judas. The painting's architectural background

29. *Study for group of figures in Judas and the Thirty Pieces of Silver.* Rotterdam, Museum Boymans-van Beuningen

which, as has been seen, caused the artist so much trouble, is the least satisfactory aspect of the composition. The unfortunate craquelure on the picture surface on the right side of the column was caused by the heavy overpainting brought about by the numerous changes in the shape of the arches on top of which the column was painted. The space within the Temple ('And he cast down the pieces of silver in the temple...' Matthew 27:5) is unsatisfactorily defined, the pillar which forms the High Priest's throne is unrelated to the rest of the architecture, and the single column at the back with its massive base and indeterminate moulding belongs to no recognisable architectural order. Rembrandt wanted to convey the immense

cavernous space within the Temple but instead created considerable spatial confusion. In *The Woman taken in Adultery* (Cat. No.9), painted fifteen years later, Rembrandt convincingly conveyed the awesome grandeur of the interior of the Temple.

The extensive changes in *Judas and the Thirty Pieces of Silver* are a fascinating testimony of the young Rembrandt's tentative method of creating a complex multi-figured composition. He made radical changes both in the background and in the central figure group while at work on the painting in order to give the scene the greatest possible dramatic effect. Some of these changes he tried out on paper during – rather than before – his work on the panel. He may

30. *Judas and the Thirty Pieces of Silver:* Appearance of the picture at the first completed stage

well have been aware of the importance of the painting: he could have known of Huygens's visit some time in advance and lavished particular care on the *Judas* in order to impress the influential Secretary of the Prince of Orange. As we have noted, he was immensely impressed by the painting, but ironically it was the figure of Judas, one of the few which had remained unchanged during the evolution of the painting, that elicited the highest praise: 'The portrayal of the despairing Judas alone...I set against all the elegance of the ages...' The painting so admired by Huygens was much copied and imitated by Rembrandt's contemporaries, among them Salomon Koninck, Jacob de Wet the Elder (in 1636), Abraham van der Hecken (in 1654) and, in a drawing, Claes Cornelisz. Moeyaert.

Bibliography: C.H. Collins Baker, 'Rembrandt's thirty pieces of silver', *Burlington Magazine*, 75, 1939, pp. 179-80; Bauch 47; Bredius/Gerson No. 539A; B. Haak, 'Nieuw licht op Judas en de zilverlingen van Rembrandt', *Album Amicorum J.G. van Gelder*, The Hague 1973, pp. 155-8; H. Guratzsch, 'Die Untersicht als ein Gestaltungsmittel in Rembrandts Frühwerk', *Oud Holland*, 89, 1975, pp. 250-1; Rembrandt Corpus, I, A15.

2.
Ecce Homo

Paper, stuck on canvas, 54.5 × 44.5
(21⁷/₁₆ × 17½)

Signed, beneath the clock in the right
background: Rembrandt. f./1634

The subject is known as 'Ecce Homo' from
Pilate's words in John 19:5. The events
shown are described later in the chapter
(verses 13-16): Pilate shows Christ to the
people, who, urged on by their priests,
demand his condemnation.

This is a preparatory study for an etching
by Rembrandt, the first (unfinished) state of
which (Fig. 31) is dated 1635, and the second
state (Fig. 32) 1636. The print, which is
reversed, is of the same size and varies
slightly from this grisaille: the principal
differences are that the crowd on the right
here and the figures above on Christ's left
have been elaborated in the etching, as have
many of the accesssories, and the clock has
been omitted. This is the only known case in

31. *Ecce Homo*. Etching, 1st state. 1635. London,
British Museum

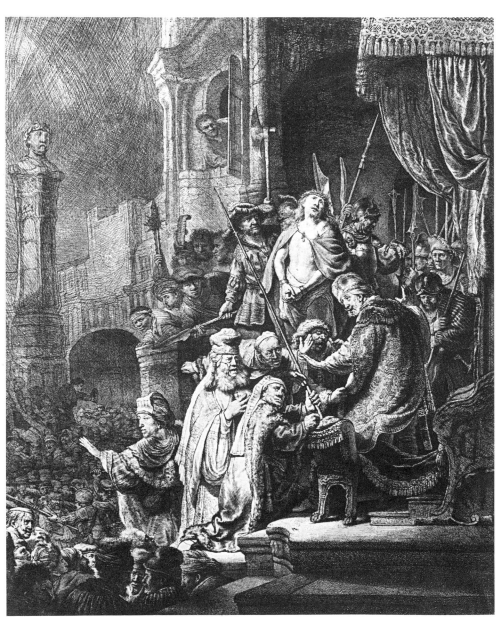

32. *Ecce Homo*. Etching, 2nd state. 1636. London, British Museum

which Rembrandt produced such an elabo-
rate full-scale study for an etching. It can be
seen that it was used for this purpose when
the painting is studied in a raking light, as
many of its outlines have been indented with
a stylus to transfer the design to the etching
plate. It has been argued, most recently by
Royalton-Kisch, that the etching is a col-

laboration between Rembrandt and another
artist, Jan van Vliet, who etched eleven plates
after designs by Rembrandt in the 1630s.
This might well explain the need for such a
detailed grisaille: it would have been given by
Rembrandt to van Vliet as a guide for his
reproductive print. This seems to have been
an experiment on Rembrandt's behalf in the

procedure of print-making. The print of *The
Descent from the Cross* (Fig. 33), which is
dated 1633 and for which the etcher would
have had the original painting (now in the
Alte Pinakothek, Munich: Bredius No. 550)
to follow, is of the same period and the same
size as the *Ecce Homo*. It too contains
substantial passages by another hand,

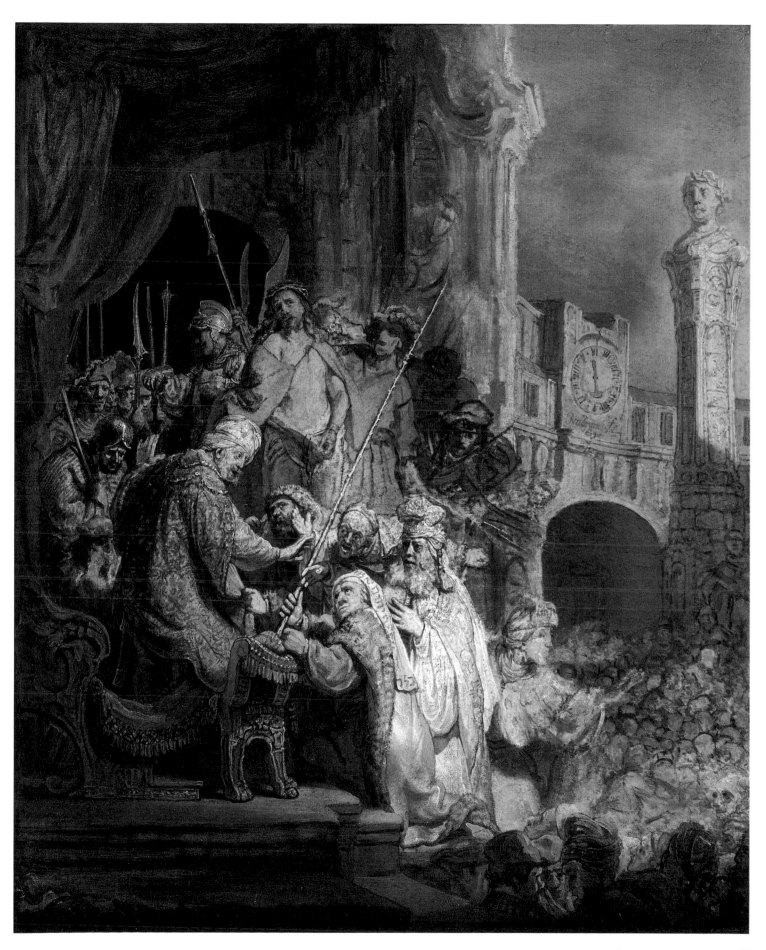

43

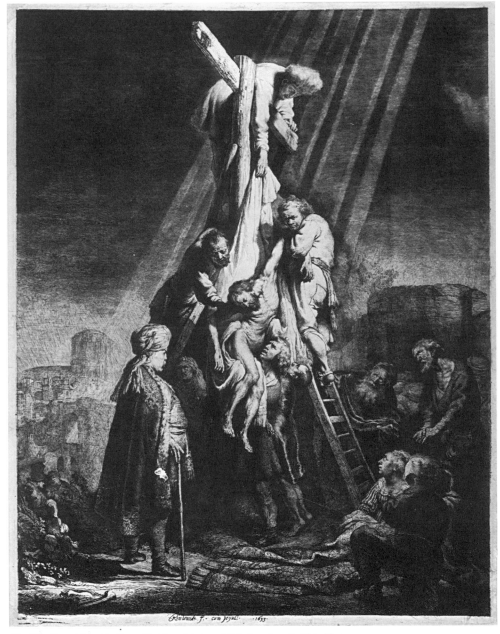

33. *The Descent from the Cross*. Etching, 1st state. 1633. London, British Museum

some preparation present. The X-ray image (Fig. 34) shows both the structure of the paper and, to a lesser degree, that of the canvas. It is possible that the adhesive between the two is faintly radioabsorbent and hence makes visible the pattern of both; however, samples taken from the right side of the picture show that there is certainly a thin cream-coloured coating of white lead on the front of the paper beneath the blue-grey sky (see Plate 1), beneath the yellowish architecture and beneath the brown glaze of shadow of the foreground crowd.

The first stage of working appears to have been a drawing, probably in ink, of the principal elements of the composition. This was followed by a much broader lay-in with a brush using dark earth colours with a little black: there were probably rather dull colours also sketched in at this point and it could perhaps correspond to a 'dead-colour' stage. Some parts of the picture were not, in fact, developed further than this stage, and it can be seen clearly in the figures to the right of Christ, in the curtains and architecture at the upper left and in the steps at the lower left. What is not immediately clear is whether Rembrandt ever intended to finish these

Plate 1 Blue-grey of sky comprising lead white and charcoal, over a thin cream-coloured ground. The paper fibres below are clearly visible. Cross-section, 250x.

parts or whether they were always only intended as a rough guide for the etching (but see below): they are worked up in much greater detail in the etching, but correspond almost exactly in position. It is interesting to note in the X-ray a reserve left in the paint of the archway for the head of the outermost figure in the group to the right of Christ (the negro boy in the etching): this head is virtually unpainted and the prepared paper is almost bare, but Rembrandt was clearly so conscious of its importance as the pivot of the group that he carefully painted the background around it.

The main figure group and the

perhaps that of Jan van Vliet.

The production of these two prints, among the largest and most ambitious ever undertaken by Rembrandt, was a deliberate emulation of the reproductive engravings made of Rubens's work by engravers who were closely supervised by the painter. Although the two prints were eagerly collected during Rembrandt's lifetime and later – significantly they were considered to be a pair by the mid-eighteenth century – Rembrandt apparently abandoned this procedure, presumably unhappy with the quality of van Vliet's work. This would explain why the *Ecce Homo* is the only grisaille which is an elaborate full-scale study for a print.

In the inventory of Rembrandt's goods made in 1656 (Strauss Doc. 1656/12), there is an item (No. 121): *Een excehomo in 't graeuw, van Rembrant* (An Ecce Homo in grisaille, by Rembrandt) which could be this painting.

Technical description

The painting is on paper which has subsequently been laid down on to stretched canvas. There is some wrinkling and a little tearing of the paper, which presumably occurred during this process. There is also extensive foxing of the paper – black spots of mould growth originating from the adhesive used for mounting it - but these have been reduced by retouching so that they no longer disturb the image.

There seems to be a very thin layer of

44

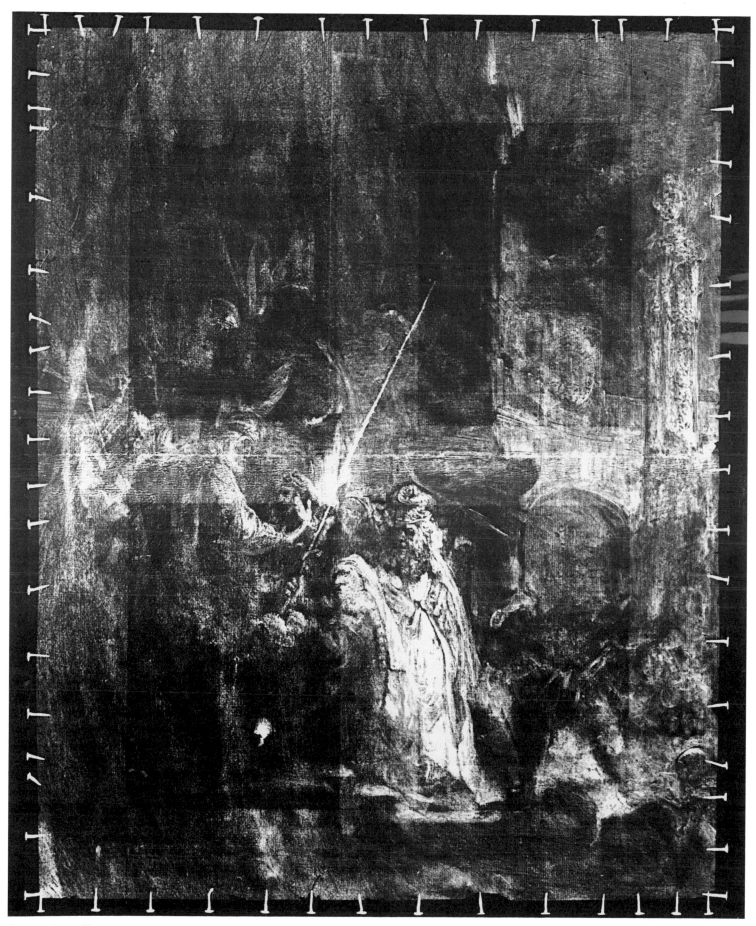

34. *Ecce Homo.* X-ray mosaic

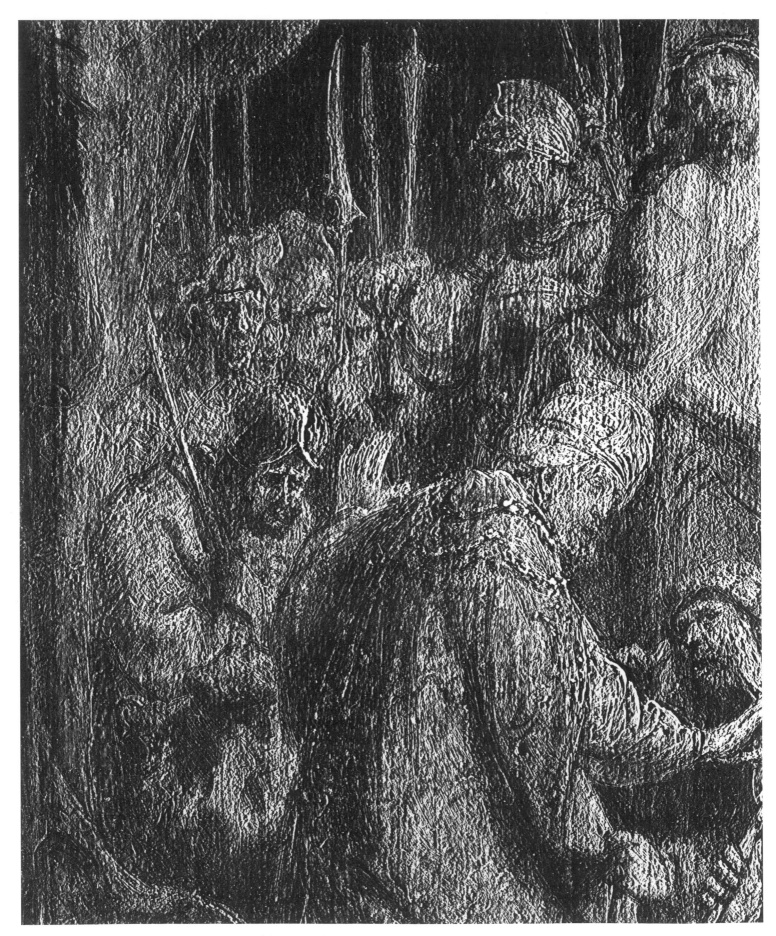

35. *Ecce Homo*. Detail of the picture surface in raking light

Plate 2 *Ecce Homo*. Macro detail of Christ's hair in raking light (approx 10x magnification)

individual locks of hair, fingers and folds of drapery – but in the sketched areas only broad outlines are incised. This is an important indication of Rembrandt's intentions with regard to the etching. The main figure group was worked out in every detail prior to the etching stage; but clearly Rembrandt always intended to develop the secondary figures only when the etching process was under way.

Bibliography: HdG No. 128; Bredius/Gerson No. 546; M. Royalton-Kisch, 'Over Rembrandt en van Vliet', *De Kroniek van het Renbrandthuis*, 1984, vol. 1/2, pp. 3-23; Rembrandt *Corpus*, vol. 2, No. A89.

architecture at the right are worked up in tones of grey and brown, lead white and lead-tin yellow, into a highly finished state over the lay-in. The contrast between the group of priests and Pilate in front of Christ and the unfinished figures to the right of Christ could not be more striking. The meticulous detailing of the finished figures is characteristic of Rembrandt's precision and tight control in the early 1630s: the sketched figures show how his brilliant improvisation was always, literally, just below the surface.

The palette here is necessarily extremely limited. The greyish-blue sky contains no blue pigment but exploits the bluish tinge of charcoal black when mixed with white (Plate 1). The sketchy brown shadows in the less finished parts contain translucent brown pigment, a little black, red earth, yellow-brown lake pigment and even a trace of lead-tin yellow.

It has always been clear that this painting on paper is directly linked to the reversed etching. The identical size, the positioning of the figures and so on place the connection beyond doubt. However, only relatively recently, since cleaning, has it become clear how the painting was used in preparation for the etching. Royalton-Kisch pointed out the existence of incised lines in the paint which follow the main design elements. Some had always been obvious – notably those in the clocktower and archway, delineating the lines of the architecture: it had been assumed that they were simply guidelines or scratched emphases solely connected with the painting

process. However, cleaning revealed incised lines everywhere on the picture surface, following figure outlines, architecture, draperies and minute details such as Christ's hair and hands and hatched shadows on his body (Fig. 35 and Plate 2). It is now clear that the painting was traced or incised directly for transfer of the design to the etching plate.

There are several possible methods of doing this. A tracing might have been made with slightly translucent paper, and this used to transfer the design; or a sheet of paper with a blackened (perhaps with charcoal) reverse side might have been placed below the painting and the design pressed through to the plate with a stylus. A third possibility was that the back of *this* piece of paper was blackened and it was placed directly on the plate: only removal from its present lining canvas would confirm or disprove this.

Any one of these methods would result in the incised lines as we now see them. It is clear that the paint was still relatively soft when the process was carried out. In one or two places in the architecture the scoring has broken through the paint layers to the prepared paper, perhaps indicating the use of a stylus directly on the paint surface: but in most places the paint is simply dented, which could be caused either by direct contact or by indirect tracing.

It is interesting to note that there is a much greater concentration of incising in the more finished areas of the painting than in the sketchy unfinished parts. In the detailed areas almost every feature is incised -

Portrait of an 83-year-old Woman

Oak, oval, 68.7 × 53.8 (27¹⁄₁₆ × 21³⁄₁₆)

Signed, right, centre: Rembrandt . f / 1634
Inscribed, on the left, centre: AE.SVE.83

The sitter was once thought on the basis of a drawing by Jan Stolker (1724-85) in the British Museum to be Françoise van Wassenhove, the widow of a Remonstrant preacher, Eduard Poppius. Stolker omitted this almost certainly incorrect identification from the mezzotint he made from the drawing. He gave the mezzotint the title *Avia*, literally 'grandmother' but here presumably intended to signify merely 'an old woman'. It was, however, on the basis of this title that Gustav Waagen erroneously identified the sitter as the painter's grandmother.

Rembrandt's first oval portraits date from his earliest years in Amsterdam: the shape was fashionable in the city at that time. The *Portrait of an 83-year-old Woman* is fluently and freely painted: the loose modelling and broad application of paint represent a significant change in style from the tightly painted portraits of only a year or two earlier such as the *Portrait of Maerten Looten* (Fig. 36) of 1632.

Technical description

The panel consists of a single piece of oak, its grain vertical. It has been enlarged by later additions forming a hollow oval about 2 cm wide all round, attached by glueing edge-to-edge and reinforced by wooden blocks at the top and bottom (which can be seen as light rectangles in the X-ray [Fig. 37]). The original part of the panel is probably much the same size and shape as when it was painted, unlike the *Portrait of Philips Lucasz.* (Cat. No. 4; see p. 52), but it is possible that it was trimmed and bevelled slightly when the additions were fitted; since the edges are hidden by the added pieces, it is difficult to be sure.

The grain of the original panel is made visible in the X-ray because the ground which covers and fills it is slightly opaque to X-rays. The grain is barely visible on the additions because the preparation here is almost transparent to X-rays. Within the limits of the original panel, the X-ray image

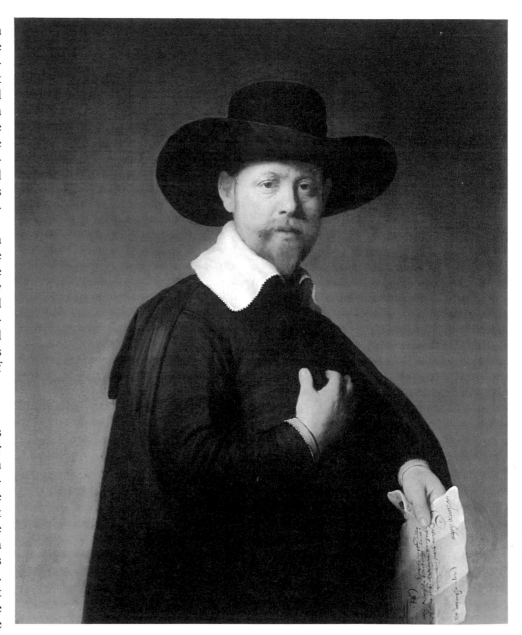

36. *Portrait of Maerten Looten.* 1632. Los Angeles, County Museum of Art

of the grain seems to disappear in an irregular way as it approaches the edge. This is because the ground was abraded around the original edges when the additions were being prepared and smoothed down.

The original ground is of the standard type for a panel painting of this period, consisting of a layer of natural chalk bound in animal glue and finished with a lightly applied *imprimatura* containing a little lead white, yellowish-orange and brown earth pigments, and a trace of black (see Plate 5). The ground and *imprimatura* are very thin and the colour, a warm beige, is clearly

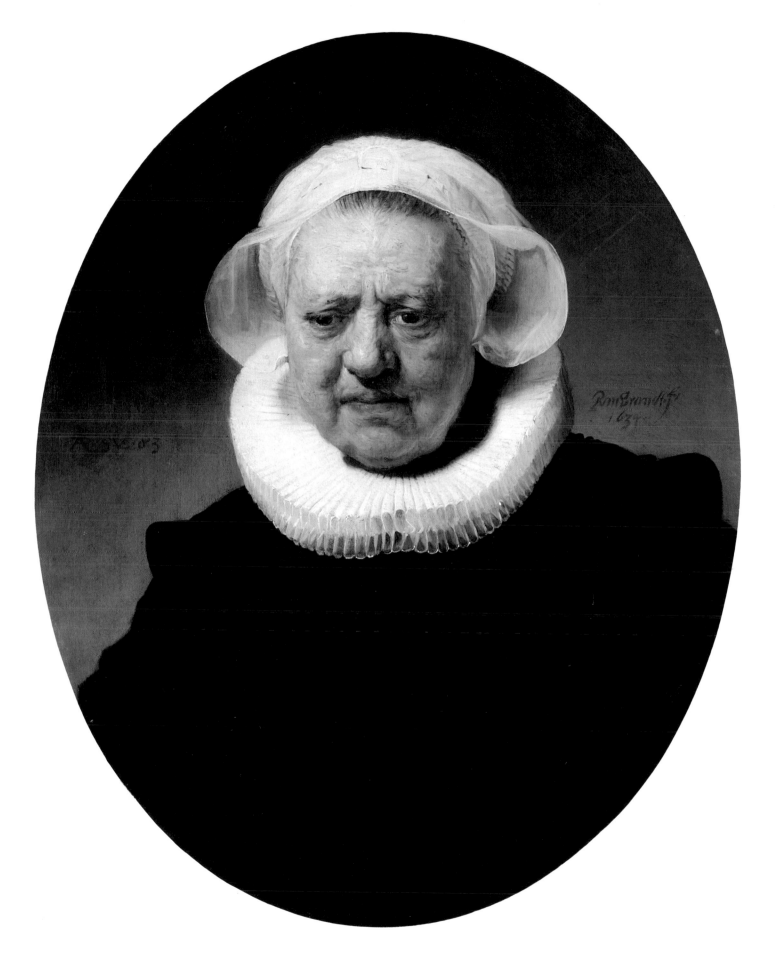

49

influenced by the colour and grain of the wood beneath. This uncovered preparation is visible in a small rectangle between the ruff and the woman's right cheek (viewer's left) and at the junction of ruff, head-dress and background at the right: it also shines through in thinly painted areas, and the underlying wood grain can be seen, as in the shadowed side of the face (Plate 4).

The paint is applied in a manner which is at the same time fluid and yet beautifully controlled. There is a highly conscious use of raised brushstrokes and impasto in the lights and highlights which give liveliness and sparkle, while the half-tones and shadows are painted thinly and smoothly and seem to recede. The very darkest shadows at the nose, mouth and under the chin are, by contrast, applied in thick dark paint, almost carelessly: these are characteristic Rembrandt finishing flourishes seen in many of his portraits.

The brushstrokes of the face are in a variety of colours, short, curved, running mainly along the line of the form; they cross, blend and mix and were clearly done rapidly, wet-into-wet. In the face the thickly applied lead white has been tinted with vermilion and red iron oxide, and then modified with thin scumbles of yellow earth drawn across the surface for the yellowest tones, and a mixture of vermilion, red ochre and a little black for the ruddier passages (see Plate 3). The X-ray image shows the structure of the brushstrokes distinctly, and how they are combined into almost sculptural masses forming the forehead, cheeks, eyes, nose and mouth. The X-ray also makes clear the broad sweeping lay-in for the ruff, painted in lead white of great purity, and for the cap. The shadow on the ruff is left as a reserve and glazed with a dark tone directly on the ground. The lower part of the ruff overlaps the already painted black dress to give the effect of this showing through the translu-

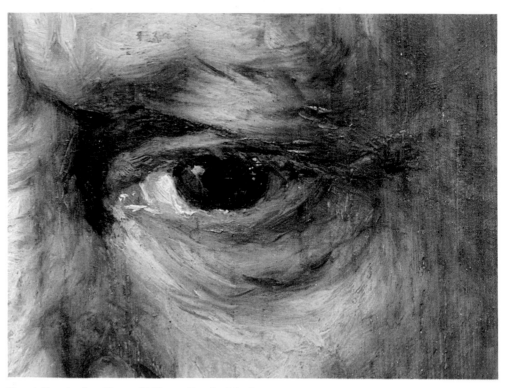

Plate 4 *Portrait of an 83-year-old Woman*. Detail of the face

cent white fabric. The highlights on the ruff and cap were added across the underlying paint when it was already fairly hard, since they have not disturbed the brushstrokes beneath.

The dress is painted directly over the ground as a solid layer of virtually pure black pigment incorporating just a little white for

Plate 5 Dark grey of the sleeve, mainly bone black with a little lead white. The chalk ground and yellow-brown *imprimatura* are also clearly visible. Cross-section, 430x.

the deep neutral grey of the sleeves and ribbons (Plate 5). The structure is closely similar to that of the tunic in the *Portrait of Philips Lucasz*. No other pigments are used in the woman's black dress, although in the darks of many of the pictures small quantities of coloured pigment, often blue or red, are added.

The background is painted around the figure and does not appear to pass under the

cap or ruff: they are painted directly on the ground. The paint of the background has been brushed broadly around and away from the figure, towards the edges of the panel. Initially the background was thinly brushed in with a translucent dark brown containing yellow earth and brownish black, with the admixture of a significant amount of cherry-coloured lake pigment to add depth and warmth to the underlying stone colour of the wood panel and ground. Over this layer the more opaque greyish khaki to the left and right has been directly applied, with white and black pigment adjusted with yellow ochre, and blended into the warmer paint beneath.

Bibliography: HdG No. 856; Bauch No. 476; Bredius/Gerson No. 343; Rembrandt *Corpus*, vol. 2, No. A104.

Plate 3 Reddish paint of the woman's forehead. Top surface of an unmounted fragment, 160x.

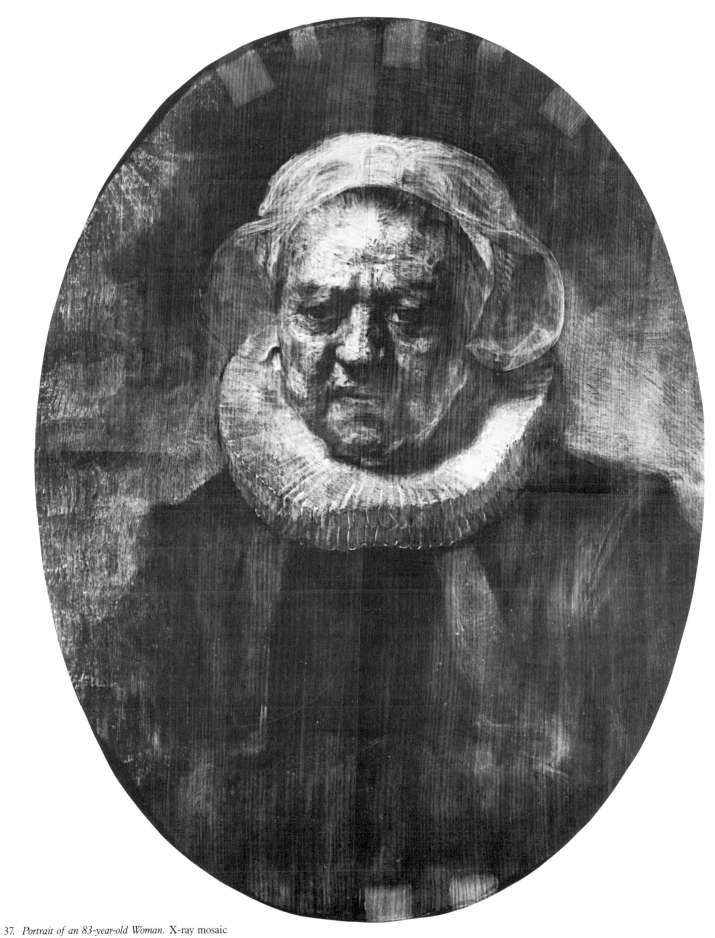

37. *Portrait of an 83-year-old Woman.* X-ray mosaic

4.
Portrait of
Philips Lucasz.

Oak, oval, 79.5 × 58.9 (31⁵/₁₆ × 23³/₁₆)

Signed, on the right, towards the bottom:
Rembrandt/1635

Philips Lucasz., whose family came from Middelburg, was in the service of the Dutch East India Company. From 1625 until 1631 he was on the island of Amboina, for the last three years as Governor. In 1631 he was appointed Councillor General of the Dutch East Indies. Two years later, in December 1633, he commanded a trading fleet which returned to the Netherlands. Shortly after arriving in Amsterdam he married Petronella Buys, whose family was from The Hague, on 4 August 1634. They returned to the East Indies, leaving the Netherlands on 2 May 1635 and arriving in Batavia by 20 September. In September 1640 Lucasz. was given command of an expedition to Ceylon; he died at sea on 5 March 1641. His wife returned to the Netherlands in that year and settled on the Keizersgracht in Amsterdam; she remarried in Vlissingen in 1646 and died in that town in 1670.

A pair of portraits of Philips Lucasz. and his wife by Rembrandt is recorded in the collection of Jacques Specx, the husband of

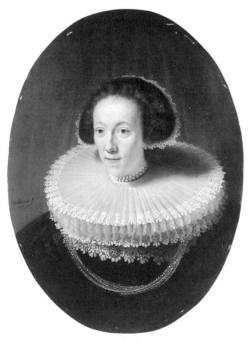

38. *Portrait of Petronella Buys.* 1635. With Wildenstein, New York, 1985

Maria Odilia Buys, Petronella's sister, in 1655. They were painted early in 1635, shortly before Lucasz. and his wife left for the East Indies. On the back of an oval portrait of a young woman (with Wildenstein, New York, 1985) which has the same shape, size and support as the National Gallery painting is an old inscription which identifies her as Petronella Buys and implies that there was a companion portrait of her first husband (Fig. 38). The pictures also correspond in composition and style, and the identification of the National Gallery painting as the companion – first made by Hofstede de Groot in 1913 – has never been questioned. The heavy gold chain is further evidence for the identification of the sitter as Philips Lucasz.: gold chains, not a common item of dress, were often given as a reward for service by the Directors of the East India Company to commanders who had successfully brought home their merchant fleets, as Lucasz. had done in 1634. The archives of the company reveal that on 31 January 1635 Lucasz. received 1,000 *ricxdaelders* for his services.

Jacques Specx, in whose inventory the portraits are recorded in 1655, had himself been in the service of the East India Company. He had established the Company's trade with Japan in 1609 and had served as Governor of Batavia. He had taken his wife and her sister, Petronella, to Batavia in 1629 and it was there that Lucasz. had met her. Specx appears to have been an important early patron of Rembrandt as no fewer than five paintings by the artist, all probably painted between 1631 and 1635, appear in his inventory. In addition to the portraits of Lucasz. and his wife Specx owned the *Saint Peter in Prison* of 1631 (Fig. 39); the *Abduction of Europa* of 1632 (private collection, New York; on loan to the Metropolitan Museum of Art); and a 'Saint Peter's Boat' which may be the *Christ on the Sea of Galilee* of 1633 (Boston, Isabella Stewart Gardner Museum). It seems likely, therefore, that it

was Specx who commissioned the portraits of Lucasz. and his wife.

It has recently been suggested that a substantial part of the portrait of Lucasz. – the lace collar and the bust – and the whole of the portrait of his wife are not by Rembrandt himself, but by an assistant or close imitator in the employ of Hendrick Uylenburch. The arguments concerning the treatment of Lucasz.'s lace collar are discussed below in detail, but here it can be stated that in our view there are no significant differences in style, technical procedures or paint handling to support this idea. We consider both paintings to be in their entirety from the hand of Rembrandt himself. Any weaknesses in the paintings can be paralleled in other portraits from these hectic years of portrait painting in Amsterdam and explained by the speed at which these and other portraits were painted.

Technical description

Examination of the *Portrait of Philips Lucasz.* reveals that it was once substantially different in appearance, although when the

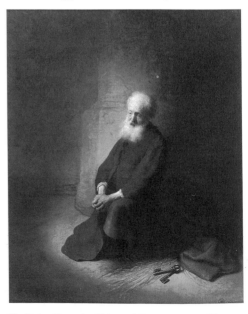

39. *Saint Peter in Prison.* 1631. London, Thomas Agnew & Sons

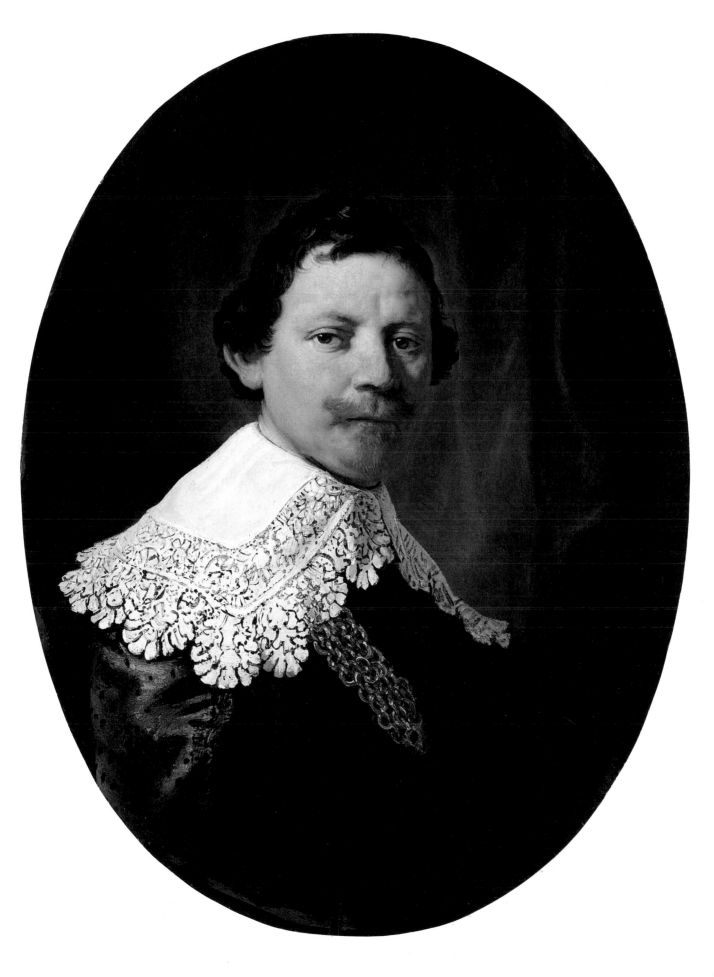

changes to its present state were made is difficult to establish.

At first sight it appears to be one of Rembrandt's standard oval portraits of the early Amsterdam period, similar to the *Portrait of an 83-year-old Woman* (Cat. No. 3). But the oak panel has straight bevelling on the back, widest at the bottom, narrow at the sides and none at all at the top. This indicates that it has been cut down from a rectangle and has lost most at the top, some at the sides and least at the bottom – assuming equal bevelling on all four sides. There are other indications that the portrait has been cut down. For example, the brushstrokes of the background and coat continue fully up to the edge, whereas normally they would diminish and tail off as they approached the true edge of a panel. Also there are signs that the paint at the very limits of the panel has flaked and crumbled a little, as if dislodged by the act of cutting.

Thus we must propose an alteration at some stage from rectangle to oval. But when? Scraps of paper stuck to the back of the panel and dating from the later seventeenth century follow the oval shape: they could indicate a fairly early date for the cutting-down, but the evidence is not conclusive.

The X-ray image (Fig. 41) raises new questions which may also have a bearing on the change in format of the panel. The most obvious feature of the radiograph that does not show in the present portrait is the sitter's left hand, apparently touching the gold chain across his chest. The position of the hand does not fit well with the oval format and the present edge cuts through the light-coloured cuff at the wrist: it is not unreasonable to assume, therefore, that the hand was in place when the portrait was rectangular. It is likely that it was planned at an early stage in the composition since a cross-section shows a thin sketching layer in bone black beneath

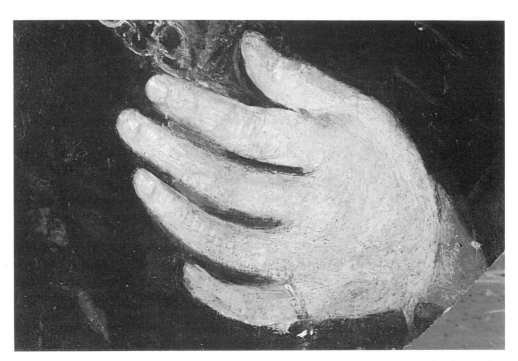

40. *Portrait of Philips Lucasz.* Detail of the hand, revealed during cleaning and subsequently painted out again

the brownish-yellow paint of the flesh (see Plate 6). When the portrait was cleaned in 1941 and again in 1977, it was noted that the paint covering the hand was not original, and it was totally removed in 1977 to reveal the hand (Fig. 40). However, this does not exclude the possibility that the hand might originally have been painted out by Rembrandt himself, since any original black paint covering it could have been scraped away by a curious or ruthless restorer at any time in the last two or three hundred years.

The hand that emerged in 1977 was clumsy and shapeless and much yellower in tone than the paint of the face. The curious shade of the concealed flesh paint, however, is found elsewhere in Rembrandt, for example in the hands and some of the mid-tone features of the faces and necks of the figures in *Belshazzar's Feast* (Cat. No. 7).

Various possibilities had to be considered. Is it unfinished, or damaged, or possibly not by Rembrandt? It was clearly worked up to some degree, since the ring on the finger was painted, and there is a distinct layer structure to the flesh paint. In the shadows, which are fairly dark in the X-ray image, a translucent undermodelling in a mixture mainly of chalk and yellow-brown earth pigment with only a little lead white is completed in a thin mid-yellow layer made up of rather more lead white and yellow ochre. The final shadows are put on as thicker strokes of yellow ochre mixed with umber and black (see Plate 7). A sample from a

concealed highlight shows a much more solid lead-white-containing paint, which therefore registers as a light area on the radiograph (see Plate 6). Analysis has shown that all the pigment materials used in the painted-out hand were in common use in the seventeenth century.

The highlights on the fingernails are present and would have been among the last touches to have been painted. Nevertheless, the formlessness does suggest a lack of final modelling – or, alternatively, the loss of upper layers by scraping (the outlines are undoubtedly damaged) – or both.

It is not possible to establish beyond doubt the authorship of the hand, given its present condition. We must certainly not allow ourselves to think that, simply because its shape is unsuccessful, Rembrandt could not have painted it. Rembrandt's difficulty in portraying hands is evident in a number of undisputed paintings from the 1630s.

Plate 6 Concealed highlight on the painted-out hand, with a thin layer of bone black directly over the *imprimatura*. Chalk ground missing from sample. Cross-section, 320x.

Plate 7 Concealed relative shadow of the painted-out hand in two layers. Cross-section, 300x.

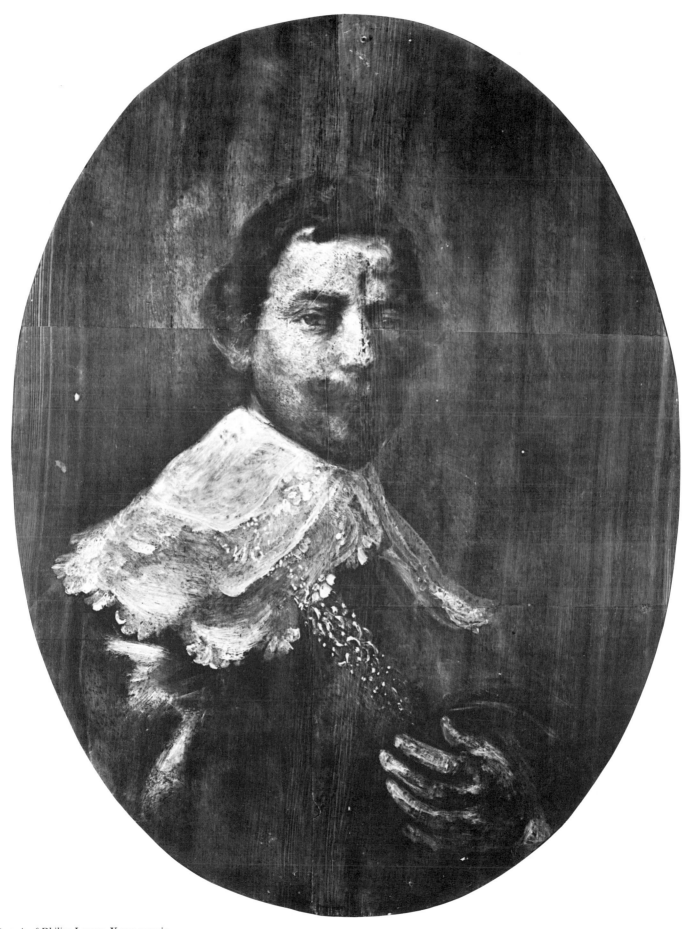

41. *Portrait of Philips Lucasz.* X-ray mosaic

Whatever its status, it seems highly probable that the painting-out of the hand coincided with the reduction of the panel to an oval. The awkwardness of the hand and wrist, now disembodied by the new edge of the panel, would have been only too apparent. As for *when* the alteration occurred, it seems clear that the paint was quite hard and brittle when the panel was cut and so a date later than the 1630s is indicated; at any rate, it now seems unlikely that Rembrandt altered it himself.

The hand is now covered up again: after the 1977 cleaning, it was considered so unsatisfactory in appearance that, once it had been photographed, it was painted out. If the picture is viewed against the light, the outlines can be seen clearly under the present paint surface.

Another area of the portrait that has been questioned is the lace collar. It has often been pointed out that the collar is not so detailed or successful as those in other portraits of the period. The technique is clearly seen by studying the picture and X-ray together. Rather than by painting the individual lobes of lace over the black of the coat, the collar is laid in with broad sweeps of white and grey paint and the black detailing painted on top; pastose highlights and the edges of the lace are applied last in pure lead white (Plates 8 and 9), together with the thick yellow paint representing the links of the underlying gold chain.

While it is generally agreed that Rembrandt painted finer, more controlled lace in other portraits, we should again not leap to the conclusion that this collar must be by another hand. The key to interpreting the whole picture is that it was painted in a great hurry. It had to be done before Philips Lucasz. went abroad in May 1635. If the portrait was to be painted rapidly, two courses of action were open to Rembrandt: either he could paint it himself very quickly, or he could employ an assistant to paint parts of it for him.

The assistant theory is an attractive one, because it explains away the weaker passages that we are reluctant to attribute to Rembrandt. It also explains the discontinuity where the flesh of Lucasz.'s neck meets the collar: they were clearly painted in separate operations and superficially joined by a highlight and shadow afterwards. But this in itself does not exclude Rembrandt's authorship of both parts, especially if painted under great pressure. It is our view that the

Plate 8 *Portrait of Philips Lucasz.* Detail of the lace collar

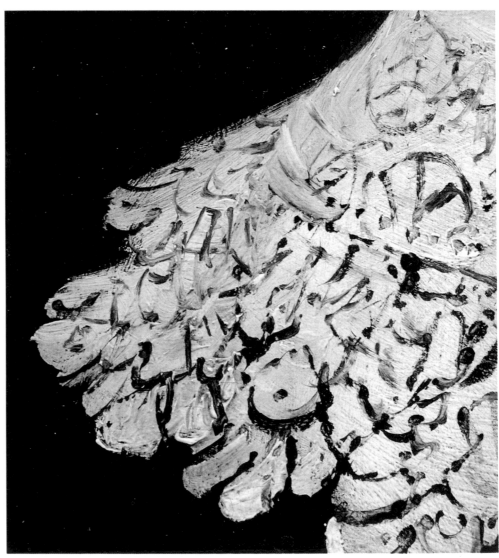

Plate 9 *Portrait of Philips Lucasz.* Detail of the lace collar

56

whole collar is by his hand and that it should be viewed as if painted in a kind of brilliant shorthand. It is difficult to imagine a worthy but pedestrian assistant supplying these flourishes to the lace: it is more plausible to say that here is a great painter working at speed, perhaps not trying very hard.

The gold links of the chain are also painted in a shorthand manner, the shadows and half-tones worked wet-into-wet over the black tunic beneath. The deepest tones contain bone black, while the dark yellow body colour, mainly of yellow ochre, is close in composition to the paint of the concealed hand. The reflective highlights are put on as impasto touches of pure lead-tin yellow, and in consequence register clearly on the radiograph.

The X-ray shows that the initial lay-in for the collar was once larger on the shadowed side: the lower part was subsequently covered by the black coat. The X-ray also shows the difference in technique between the broadly underpainted lace and the small, fluidly worked brushstrokes following the form of the face. The painting of the flesh is markedly similar to that of the *Portrait of an 83-year-old Woman* of the previous year. Over an undermodelling in warm brown, a variety of colours is blended wet-into-wet to form the main paint of the flesh. The pigment combinations chosen for the flesh tones are subtle and complicated: in the cool mid-tone shadow at the temple, the main pigment of lead white is mixed with small quantities of red earth pigment, vermilion, charcoal, yellow lake and a few particles of blue mineral azurite; while for the pinker cheek, the colour is imparted mainly by red ochre and vermilion with a trace of bone black.

Here, as in the other portrait, there is a conscious use of raised and lively brushwork for the lighter areas while the shadows are smoother and seem to recede. The final

Plate 10 Warm grey paint of the background, left, in two layers showing incorporated red lake pigment. Cross-section, 320x.

Plate 11 Grey of sleeve, left, comprising bone black and a little lead white. The chalk ground and *imprimatura* are visible. Cross-section, 330x.

touches are the very hard, thickly painted shadows at the nose, mouth and neck.

The ground is the usual one for Rembrandt's panels, consisting of a chalk underlayer with on top a thin warm brown priming containing umber (see Plates 6, 7 and 11). It may be seen uncovered at a few points in the hair and around the eyes. However, as an optical device, its luminosity is hardly exploited at all. The whole portrait is painted opaquely; the background is unusually dense and does not rely on thin glazes with the ground colour showing through as is so often the case in Rembrandt's work. Instead the curtain which forms a backdrop for the sitter is painted in two fairly solid layers of grey, warmer beneath and cooler above, but in both cases containing substantial amounts of opaque lead white tinted with bone black and adjusted with a little red lake pigment (see Plate 10). To the extreme right and left edges the dark paint is warmer, suggesting the addition of rather more of the red lake to the background shadows.

The black tunic and grey spotted sleeve are painted entirely without addition of a warm-coloured pigment, much in the way of the dress of the *Portrait of an 83-year-old Woman*, the darkest areas being in pure bone black, with only lead white combined to make the grey (Plate 11).

The sequence of painting is complex. A reserve has been left in the background paint for the hair: the ends of some parts of the hair then pass over the background, but in other places are clearly covered by it. At the right side of the face (Lucasz.'s left cheek) the background is painted over the outline of the flesh, but the back of the neck and the collar clearly pass over the background. For a rapidly painted work such as this, the overlapping of adjacent areas of paint in an unsystematic way, and the constant adjustment of outlines, are not unusual.

Bibliography: HdG No. 660; Bauch No. 376; Bredius/Gerson No. 202.

5.
Saskia van Uylenburch in Arcadian Costume

Canvas, 123.5 × 97.5 (48⅝ × 38⅜)

Below, on the left, between Saskia's skirt and her staff, are the worn remains of a false signature and date: Rem[..]a[.] / 1635

Saskia van Uylenburch was the daughter of a burgomaster of Leeuwarden in Friesland and was born there on 2 August 1612. Rembrandt had contacts with Saskia's cousin, Hendrick van Uylenburch, an Amsterdam art dealer, even before he left Leiden. Rembrandt lent van Uylenburch a thousand guilders in 1631 and lodged in his house in Amsterdam from 1632 until, probably, his marriage in 1634. Saskia went to stay with a married sister in Amsterdam and was betrothed to Rembrandt in June 1633. The identity of the model in this and other portraits of Saskia is established by Rembrandt's drawing of her, now in the Berlin Print Room, made three days after their betrothal (Fig. 42). Below her portrait Rembrandt wrote: 'This is my wife made when she was 21 years old three days after our

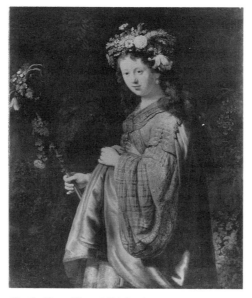

43. *Saskia as Flora*. 1634. Leningrad, Hermitage

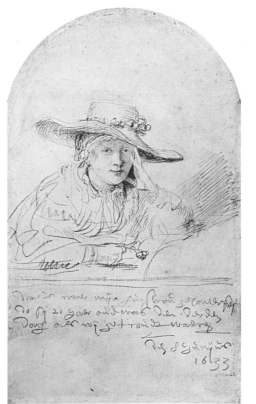

42. *Saskia in a Straw Hat, 8 June 1633*. Drawing. Berlin-Dahlem, Kupferstichkabinett

betrothal on 8 June 1633.' They were married in Sint-Annaparochie, not far from Leeuwarden, on 22 June 1634. Saskia brought Rembrandt a large dowry: after her death her estate was valued at more than forty thousand guilders. Of their four children only Titus, born in September 1641, was alive at the time of her death in Amsterdam on 14 June 1642.

The date on this picture has often been read as 1633; it is certainly 1635. Like the signature, it is obviously false but it may well have been copied from a genuine inscription since it is not incompatible with the style of the painting, although it could conceivably be a year or two later.

In 1634 Rembrandt had already painted Saskia in a similar guise in a picture now in the Hermitage, Leningrad (Fig. 43). There has been a great deal of discussion about whether she is shown in these two portraits as Flora, the Roman goddess of Spring, or as a shepherdess in the current Arcadian fashion. The identifications are not mutually exclusive and it is possible that Rembrandt had both traditions in mind. The low neckline of

her dress adds an element of eroticism appropriate both to Flora and to shepherdesses. Following the example of pastoral plays such as Hooft's immensely successful *Granida en Daifilo* of 1605, Arcadian subjects began to appear in the early 1620s in pictures by Utrecht artists: particularly popular were half-length figures of shepherds and shepherdesses, and portraits of sitters in idealised pastoral dress. By the 1630s or perhaps earlier, the fashion had spread to Amsterdam: Dirck Santvoort's *Shepherd* and *Shepherdess* of 1632 (Rotterdam, Boymans-van Beuningen Museum) are typical examples. This kind of picture certainly appears in the Rembrandt circle at that time, and a *Saskia as Shepherdess* of 1636 by Govert Flinck in Brunswick (Fig. 44) has a companion *Shepherd*, in the Rijksmuseum (Fig. 45), with the features of Rembrandt himself.

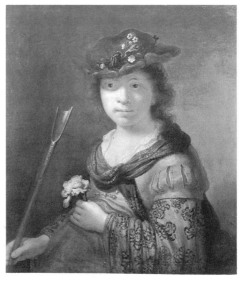

44. Govert Flinck (1615-1660): *Saskia as Shepherdess*. 1636. Brunswick, Herzog Anton Ulrich-Museum

Technical description

It is possible that the painting has been reduced in size: the evidence, which is confused and to some extent contradictory, suggests that the reduction was slight. The most important evidence is provided by a

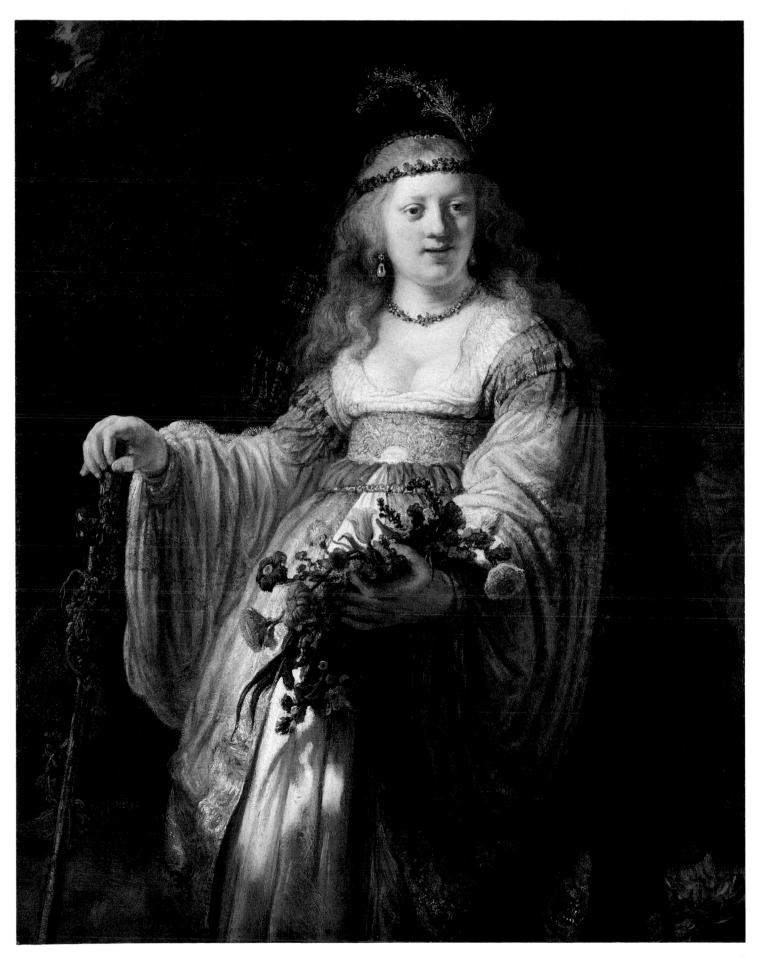

45. Govert Flinck (1615-1660): *Rembrandt as Shepherd.* Amsterdam, Rembrandthuis

drawing in the British Museum which has been convincingly attributed to Ferdinand Bol. It shows the composition extended a little at the top and to the right and fractionally on the left. This drawing is presumably an accurate copy of the painting made shortly after it was painted. Several old painted copies, none apparently older than the eighteenth century, and an engraving of 1763 have different proportions. In two of the copies (those formerly in the collections of Baron Bonde in Ericsberg, Sweden, and of Dan Cevaat) the field of the composition is extended a little to the right but otherwise corresponds with the National Gallery picture. William Pether's mezzotint of 1763, however, shows the composition extended substantially on all sides and the figure continued to about half-way between knee and foot. The print is rather carelessly executed and this difference may have been Pether's invention. Finally, in the copy formerly in the Lechmere collection and now in that of Dr Heinz Kisters, there is about twice as much space between the figure and the edges on both sides and at the top, and the figure is continued to the ground. While it is true that almost all the known full-length life-size portraits by Rembrandt were painted around this time, the additional part in this copy is empty and the lower part of the figure has been partially hidden by plants in a clumsy way that suggests it was not taken from an original by Rembrandt but is the invention of a copyist. It seems most likely, therefore, that the British Museum drawing is an accurate copy of the painting's original appearance and that the present canvas edge has been cut down along the top and right edges and minimally along the left edge. It is worth noting that the National Gallery picture is approximately the same size as the Hermitage painting of *Saskia as Flora* made the year before. Unfortunately there is no clear technical evidence that confirms whether or by how much the composition has been reduced, but a repair to the canvas may have been carried out using a piece trimmed from the edge (see below).

Detailed examination of the X-ray (Figs 46 and 47) shows that the canvas has too fine and regular a weave to be considered Rembrandt's own. Van de Wetering has suggested convincingly that the painting has been transferred to a new canvas. However,

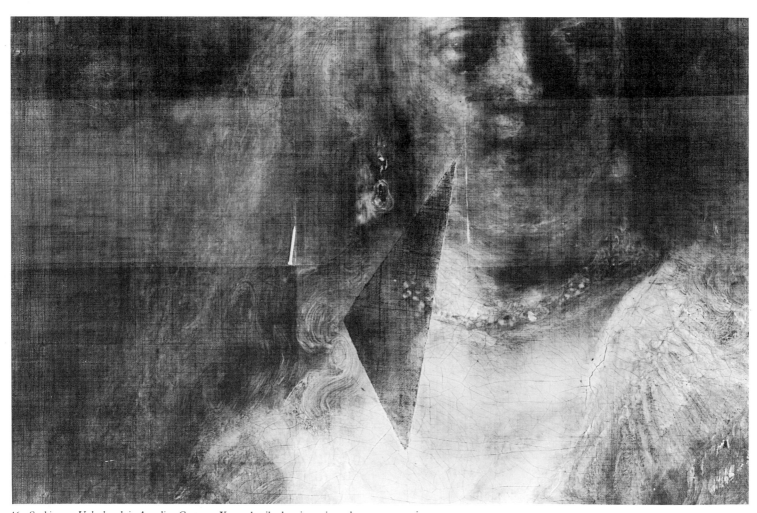

46. *Saskia van Uylenburch in Arcadian Costume.* X-ray detail, showing triangular canvas repair

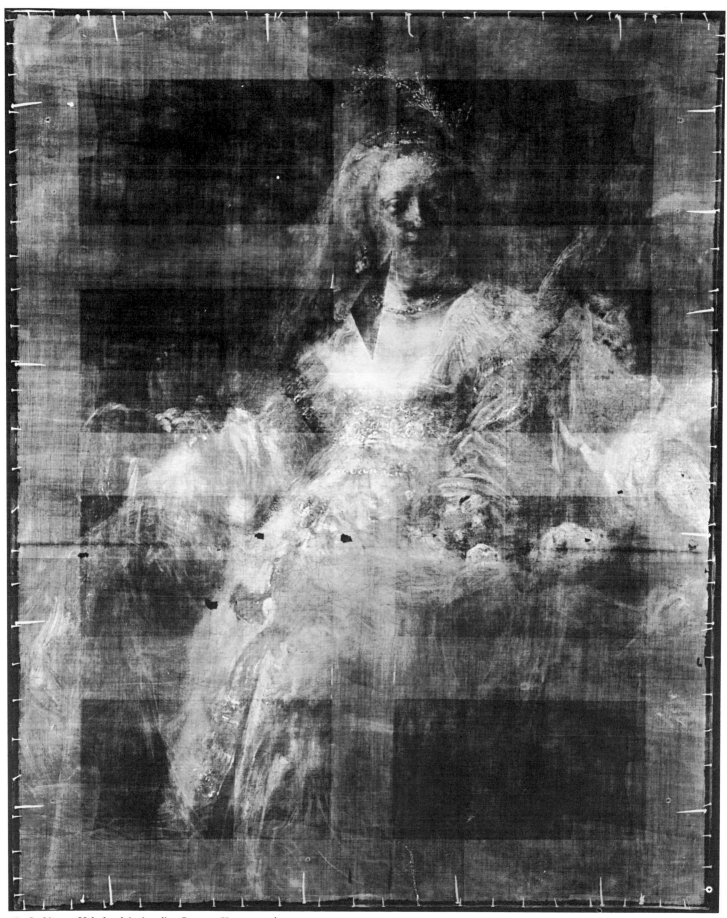

47. *Saskia van Uylenburch in Arcadian Costume.* X-ray mosaic

61

unlike the *Self Portrait at the Age of 34* (Cat. No. 8) which may also be transferred, the imprint of the original canvas in the back of the ground layers (and therefore its image in the X-ray) has been almost entirely lost here. Presumably the back of the ground was sanded or scraped down during the transfer. The new canvas was then applied with an X-ray opaque ground or adhesive, and it is consequently the image of the replacement canvas that we see. It is just possible to see faint remains of the original canvas weave image superimposed on the new weave in a few areas where it was not entirely scraped away.

A particularly interesting area in which to study the canvas weave in the X-ray is the triangular repair at the left of Saskia's neck. Presumably there was a bad tear here which was at some stage cut out and replaced by an insert. On this new piece of canvas a false curl was painted which can be seen in many early photographs of the painting (including the one in the first edition of Bredius's Rembrandt catalogue). The false curl was removed when the painting was cleaned in 1938 and the missing area was then restored

Plate 12 Brown glaze of background, right, concealing paint of the lips of the hidden figure. A single particle of vermilion is visible in the underlayer to the right. Incomplete layer structure. Cross-section, 135x.

the same as that found elsewhere on this painting. In this small area, therefore, we are probably seeing the only well-preserved image of the original weave. The repair must be an early one, since it clearly pre-dates the transfer; the canvas was probably removed from the back of the insert as well during the transfer process, but the back of the ground layers was not scraped down so drastically in this fragile area.

The canvas is prepared with a double ground rather similar to that of *Belshazzar's Feast* (Cat. No. 7), with some charcoal black

incorporated into the upper layer, and a little earth pigment. The lower ground is of a coarse, impure orange-red earth, while the second layer is a rather cool grey (see, for example, Plate 14).

The most important feature of the paint layers, which profoundly affects the painting as we see it now, is that Rembrandt at first had an entirely different subject in mind. The radiographs reveal extensive changes: on the right-hand side a second figure, wearing a flat hat and with eyes cast down, can clearly be seen. A cross-section shows the paint of the lips of the concealed figure (Plate 12). Saskia's right hand was originally lower and did not hold a staff. There are further changes in the confused area of her left arm and hand, which make it likely that she was not originally holding flowers. There are other, smaller, changes in her bodice and skirt. Christopher Brown has argued that Rembrandt originally intended to portray a different subject, Judith with the head of Holofernes, freely based on Rubens's interpretation of the subject now in Brunswick (Fig. 48). (Rüdiger Klessmann, Director of the Herzog Anton Ulrich-Museum, Brunswick, has kindly informed us of his recent discovery that Rubens's painting was in

48. Peter Paul Rubens (1577-1640): *Judith with the Head of Holofernes*. Brunswick, Herzog Anton Ulrich-Museum

to agree with the corresponding area in the old copies. Close inspection (Fig. 46) shows that the regular weave of the transfer canvas underlies the more irregular weave of the inserted piece, which is inclined at a slight angle to it. The intriguing possibility arises that the insert may have been cut from a trimmed-off piece of the original canvas (see above). A cross-section from this area confirms that this is indeed highly likely: below layers of later paint is one layer of old paint on top of a double ground apparently

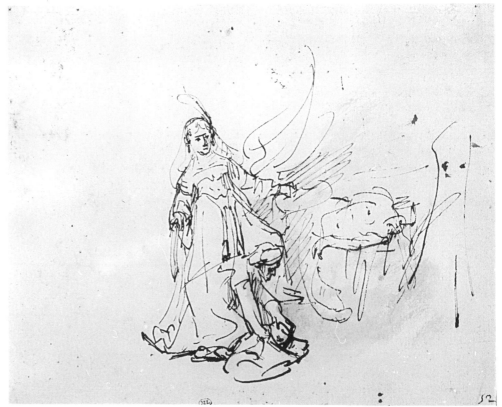

49. *Judith and Holofernes*. Drawing. Paris, Louvre, Cabinet des Dessins

Leiden in the 1620s and so easily accessible to Rembrandt.) The figure standing on the right would be Judith's servant, and Judith's hand would originally have carried a curved sword (indicated by long curving strokes at the lower left). The unresolved area on the right between Saskia's left hand and her servant's hand, which includes several downward strokes, may have indicated the bag in which Holofernes' head was contained or the head itself. It is related to a drawing of the subject by Rembrandt in the Louvre (Fig. 49). If this hypothesis is correct, Rembrandt became dissatisfied with the Judith, based on Rubens's composition, at a quite advanced stage and in her place painted Saskia in Arcadian costume.

There is nothing inherently unlikely in Rembrandt depicting his wife in the guise of the great Jewish heroine. However, it might seem that this transformation from Judith to shepherdess was too radical and that it is more likely that the original composition was another Arcadian subject such as Vertumnus and Pomona, for example. But Vertumnus and Pomona do not seem to fit the original composition, as the woman on the right does not appear to be old and the two women are usually given equal weight in the composition, as, for example, in the painting of the subject by Hendrick Goltzius in the Rijksmuseum. No other pastoral subject fits the key features of the composition. Brown's hypothesis, however startling at first, seems to accord with the composition as we can see it on the radiograph.

The composition underneath the present paint surface has obviously resulted in a much more complex paint structure in some parts. Generally the dark backgrounds, particularly in Rembrandt's earlier pictures, are fairly straightforward in structure, with

Plate 14 Shadowed area of white skirt, bottom edge, showing the complexity of the layer structure due to the reworking of the design of the picture. The double ground is visible as the lower two layers. Cross-section, 175x.

more or less translucent darks barely concealing the colour of the surface layer of ground below. The redesign of the composition in *Saskia* has involved the background as much as any part, and what might be interpreted as light fawn or grey ground, glimpsed through the translucent blackish-brown paint of the swirls of formless foliage to the right edge, is in fact an intermediate opaque layer of lead white that totally covers an earlier glaze of a dark khaki-green (Plate 13), and must arise from Rembrandt's reworking of the composition in the area. By contrast, to the upper left, a light greyish brown underlayer can be seen through a thin dark glaze of bone black; but at this point beneath the opaque paint there is no intermediate glaze, and the underpaint lies directly on the upper grey ground.

Broad brushstrokes which bear no relation to the finished picture show through the

paint in many areas. For example, in the lower part of the dress and in Saskia's right sleeve, great sweeps of paint cross and re-cross the form and are only thinly covered by the uppermost paint layers. Some indication of the complexity in layer structure can be seen in Plate 14 from the lower part of the underskirt, which shows thickly modelled lower layers of rich brown and yellowish brown under the final applications of paint. If the surface is viewed against the light, the vague outline of the second figure near the right edge can be seen, and the positions of the painted-out face and hands are made visible by the slightly altered paint texture on top.

The texture of the whole painting has undoubtedly been flattened considerably by transfer and lining, but enough is still present to indicate how Rembrandt controlled the handling of the paint with great skill to suggest different features. The hair is the most fluid part, with the familiar trick of scoring the wet paint with a coarse brush and stylus (or brush-end) for the flowing form (Plate 15). The waistband consists of almost abstract formations of piled impasto which recall similar passages in *Belshazzar's Feast*; although for *Saskia*, in addition to the highlight ridges of lead-tin yellow, yellow ochre and lead white, there are blue and blue-green strokes incorporating azurite, which create a distinctive range of colour contrasts (Plates 16 and 18). The earring is another pastose touch, the reflection and highlight seemingly casual, but perfectly

Plate 13 Concealed intermediate khaki-coloured glaze, upper right corner, with lead white layer over, and a final dark brown glaze on top. The painted-out glaze layer contains yellow lake, earth pigments, chalk and finely ground azurite. Thin cross-section by transmitted light, 165x.

Plate 15 *Saskia van Uylenburch in Arcadian Costume.* Detail of the hair

placed, and the flowering spray in her head-dress was also clearly intended to be raised up in relief. The paint of the dress and sleeves is different again. Here the texture is dragged with a drier brush and is almost granular in parts. The flesh is thickly painted, making very little use of ground or undermodelling colours, but with yet another kind of surface, essentially smooth

Plate 18 *Saskia van Uylenburch in Arcadian Costume.* Detail of the waistband

Plate 16 Yellow impasto touch on Saskia's waistband. Lead-tin yellow at the surface, with azurite in the underlayers. Incomplete layer structure. Cross-section, 175x.

but reworked into a rounded low relief in the lightest parts.

Colour in *Saskia* is unusual among the National Gallery Rembrandts in two respects. Firstly, the whole painting has a cool greenish light not seen elsewhere, and which cannot be attributed to the distorting effect of discoloured varnish, as the painting was cleaned fifty years ago. Secondly, the construction of colour, allowing for the reworking of the composition, often follows a more

then simply glazed with a thick layer of translucent pure red lake pigment. Similarly, the bluish-green overskirt relies on scumbles of blue mineral azurite drawn over a pale body colour, then glazed with yellow. The deepest blue of the flowers is done in the same way, but without the final modifying glaze. In addition to these quite traditional ways of painting, there are also quite unconventional techniques employed. The deepest greens of the foliage in the bouquet involve no green pigment at all, but are produced by a thin surface film of intense black pulled over a deep blue underlayer of

azurite (Plate 17), prefiguring the method for the dark green gems on the cloak in *Belshazzar's Feast.* The lighter, yellower greens in the bouquet are different again, with combinations of azurite and lead-tin yellow as well as yellow lakes.

The overall greenish cast in *Saskia* has much to do with the use of blue mineral azurite in many parts of the picture. It is present in quantity in the now scarcely visible, very dark brownish-green veil that hangs to the right of Saskia's head, and in some of the background glazing layers as well. Finely ground azurite was combined

Plate 17 Deepest green foliage of the bouquet. Scumble of black pigment over a layer of natural azurite. Top surface of an unmounted fragment, 200x.

traditional method than we generally see. Here Rembrandt makes uncharacteristically frequent use of opaque light-coloured underpaints with final surface glazes to achieve richness and depth. A good example is in the muted dark red of the rose in Saskia's bouquet, which is underpainted in vermilion

Plate 19 *Saskia van Uylenburch in Arcadian Costume.* Saskia's left hand and the bouquet

with yellow lake pigment and earth colours to produce a dark greenish khaki for the initial glaze of the background to the right (Plate 13). The presence of azurite in the flowers and foliage of the bouquet and in the waistband and overskirt have already been mentioned, and its use can be inferred from the colour of the paint in the embroidery of the sleeves, and Saskia's circlet and plume of foliage. The pigment even appears as a significant component in the cool shadows of the left hand (Plate 20).

Smalt, the other blue pigment sometimes to be found in Rembrandt's work, also occurs in the picture, but only in underlayers which form part of the earlier composition. The smalt content seems to have no relation to the final surface colours we now see.

The colouring of Saskia's face and neck is of a delicacy and sensitivity quite unlike the broad yellow expanses of faces in *Belshazzar's Feast*. Here the cool half-tones are subtle and understated but work perfectly in achieving sculptural form. The effect is practically all on the surface: the X-ray does not reveal the massive underlying structure of lead white that Rembrandt was to evolve later. Rather, the form is quietly built up with a variety of pigments which, overall, give a relatively flat X-ray image. Only at the end are the heavy lead white highlights applied selectively to the forehead, nose and right eye. The open mouth is delineated with a characteristic pastose dark line.

The shadow of the hand bearing the bouquet (Plate 19) is painted in an unusually complex mixture of pigment made up of azurite, yellow lake, a little vermilion, a crystalline red earth, white and a trace of black, lending a greenish tinge of reflected light from the foliage on to the flesh (Plate 20). The painting of Saskia's hands is less successful than that of her face. Tonally they are quite different, and no real structure shows in the X-ray. They bear eloquent witness to the struggle that even a great painter like Rembrandt could have in capturing the human hand convincingly.

Bibliography: HdG No. 205; Bauch No. 261; Bredius/Gerson No. 103; C. Brown, 'Rembrandt's *Saskia as Flora* X-rayed', in *Essays in Northern European Art Presented to Egbert Haverkamp-Begemann*, Doornspijk 1983, pp. 49-51: A. M. Kettering, *The Dutch Arcadia: Pastoral Art and its Audience in the Golden Age*, Montclair, N.J., 1983, esp. pp. 61-2 (with previous literature).

Plate 20 Greenish shadow of Saskia's left hand. The pigment mixture incorporates azurite with yellow lake, vermilion, earth colours, black and white. Top surface of an unmounted fragment, 125x.

6.
The Lamentation over the Dead Christ

Paper and canvas, mounted on an oak panel measuring 31.9 × 26.7 (12⁹⁄₁₆ × 10½); the top corners are rounded

The Lamentation over the body of the dead Christ at the foot of the Cross is not described in the Gospels. There was, however, a well-established iconography of the subject long before Rembrandt represented it in this small painting. In accordance with that traditional iconography Rembrandt shows Christ's head cradled by the Virgin in her lap and his feet embraced by the Magdalen. In the centre is the Good Thief on his cross and on the left is the Bad Thief. In the distance is a fanciful view of Jerusalem. This subject caused Rembrandt considerable difficulty. He made many changes in the course of creating this painting. These changes are discussed below and a detailed chronology of its genesis is proposed. Here it is sufficient to note that there were three distinct stages (see Diagram, Fig. 50): Rembrandt painted a

vertical. It was presumably during this third and final stage, which was not carried out by Rembrandt himself, that the painting was laid down on to an oak panel.

There is a drawing in the British Museum (Fig. 51), undoubtedly by Rembrandt himself, which seems to be not a preparatory drawing in the usual sense but a drawing which Rembrandt worked on at the same time as he was reworking the grisaille. It is a study for the lower part of the composition, in a horizontal format, in brown, grey and white oil colours and pale brown ink over red chalk. Rembrandt made many drastic alterations to this drawing, which at some stage he cut into two irregular parts and mounted, with several additions, on a large sheet. The group around the dead Christ and the figures at the foot of the Cross are more or less as in

the painting, while the figures behind and the background are different. In an inscription on the back of the British Museum drawing (which was copied by Sir Joshua Reynolds and pasted on to the back of the National Gallery painting, which he briefly owned) Jonathan Richardson the Younger noted: 'Rembrant has labour'd this study for the lower part of his famous descent from the Cross graved by Picart & had so often changed his mind in the disposition of the clair obscur, which was his Point here, that my Father & I counted I think seventeen pieces of paper.' This is an exaggeration, but it gives some idea of the complexity of the sheet. The engraving to which Richardson refers was made by Bernard Picart in 1730 (Fig. 52) when the painting was in a collection in Amsterdam.

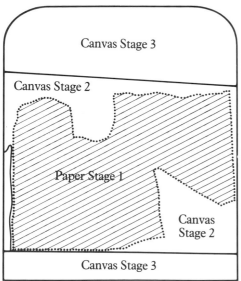

50. *The Lamentation over the Dead Christ.* Diagram showing the original paper and the canvas pieces mounted on the oak panel

grisaille on paper; that grisaille, with sections cut out by the artist, was laid on to a canvas, slightly larger than the original paper, and the composition reworked; finally, further canvas additions at the top and bottom were made which had the effect of transforming the format of the painting from horizontal to

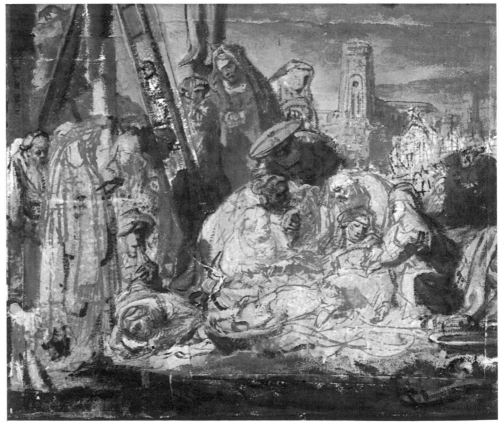

51. *The Lamentation.* Drawing. London, British Museum

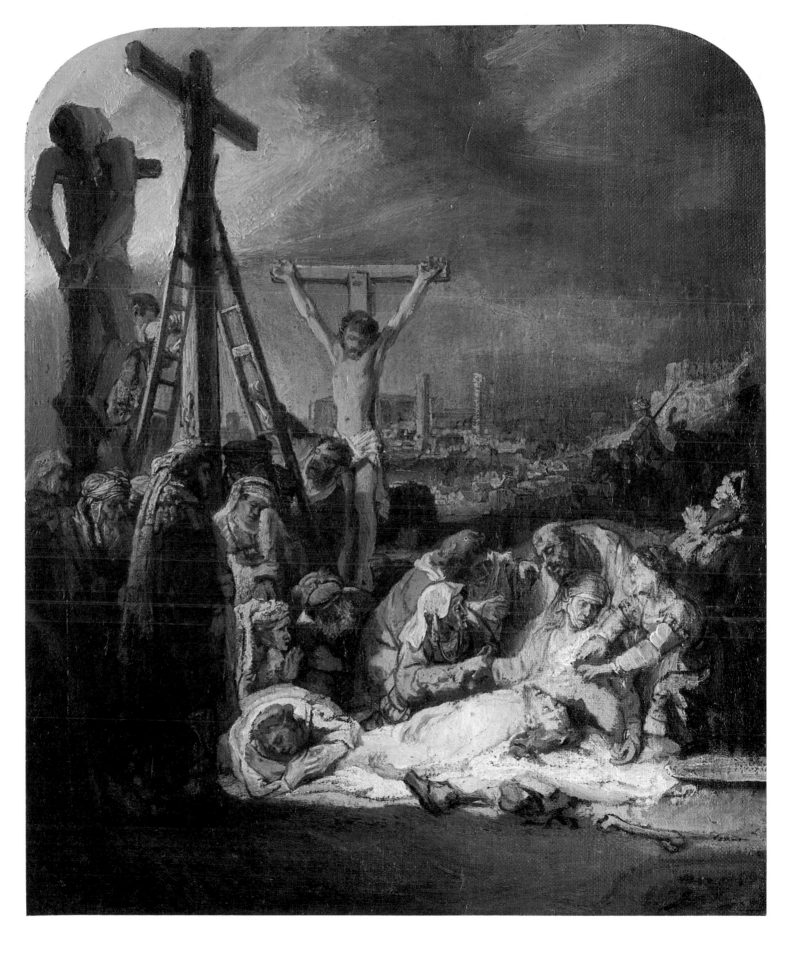

The British Museum drawing seems to be the starting-point for the second stage of the painting. The sequence was that Rembrandt began by painting the grisaille, then worked out the composition further in the various stages of the drawing, then cut the grisaille, placed it on canvas and transferred the composition worked out in the drawing to the grisaille. After this he made further changes to the grisaille, because, as is noted below, elements in the drawing included in the second stage of the painting were subsequently suppressed. There is a second drawing (Fig. 53), in a private collection in West Germany, which records the composition at the end of the second stage and before the third.

In the third stage the format was changed by the addition of two sections of canvas: a thin strip at the bottom and a larger piece at the top which contains the upper part of the empty Cross and the whole figure of the Bad Thief, the lower part of which is painted over the man climbing the ladder. This Thief and the top of the Cross are very coarsely painted and there is a clumsy attempt to match the half-tones in the rest of the painting. It has been suggested that one of Rembrandt's pupils, Ferdinand Bol, was responsible for this section, which alters the format of the composition, but it may be that this addition dates from significantly later, even from the end of the seventeenth or early eighteenth century. It is shown in Picart's print of 1730. The drawing in Germany mentioned above has been convincingly attributed by

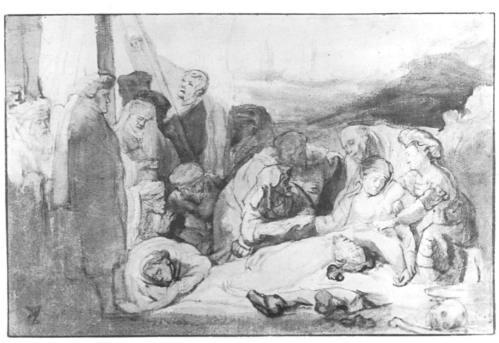

53. Ferdinand Bol (1616-1680) (?): *The Lamentation* (Copy after Rembrandt). Private Collection

Sumowski to Bol and dated around 1643-5 (Sumowski, *Drawings*, vol. 1, Bol No. 146x). It therefore records the composition presumably after its completion, inasmuch as it was completed, by Rembrandt. There is no reason why the changes made by Rembrandt in the painting and the British Museum drawing need have been made over a number of years, as has been suggested. They are

stylistically homogeneous and probably were the result of a single campaign of work.

The painting seems to have been intended as a modello for an etching which was never made. A telling detail pointed out by van de Wetering is that the Thief on the left is presumably the Bad Thief, as the other Thief hangs in the light and his body is not twisted. For the Bad Thief to hang on Christ's right

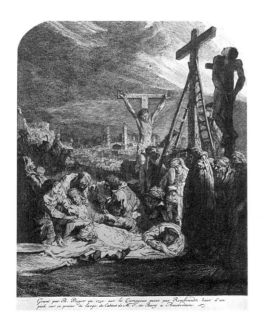

52. B. Picart: Engraving after *The Lamentation*. 1730. London, British Museum

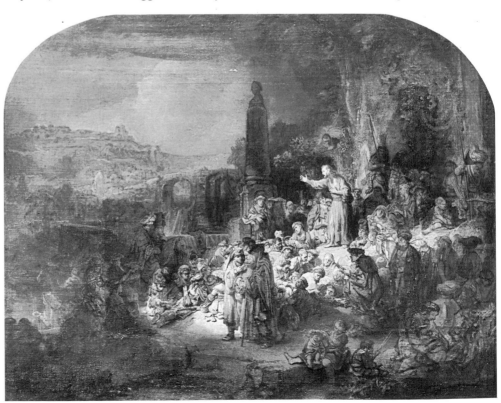

54. *Saint John the Baptist Preaching.* Berlin-Dahlem, Gemäldegalerie

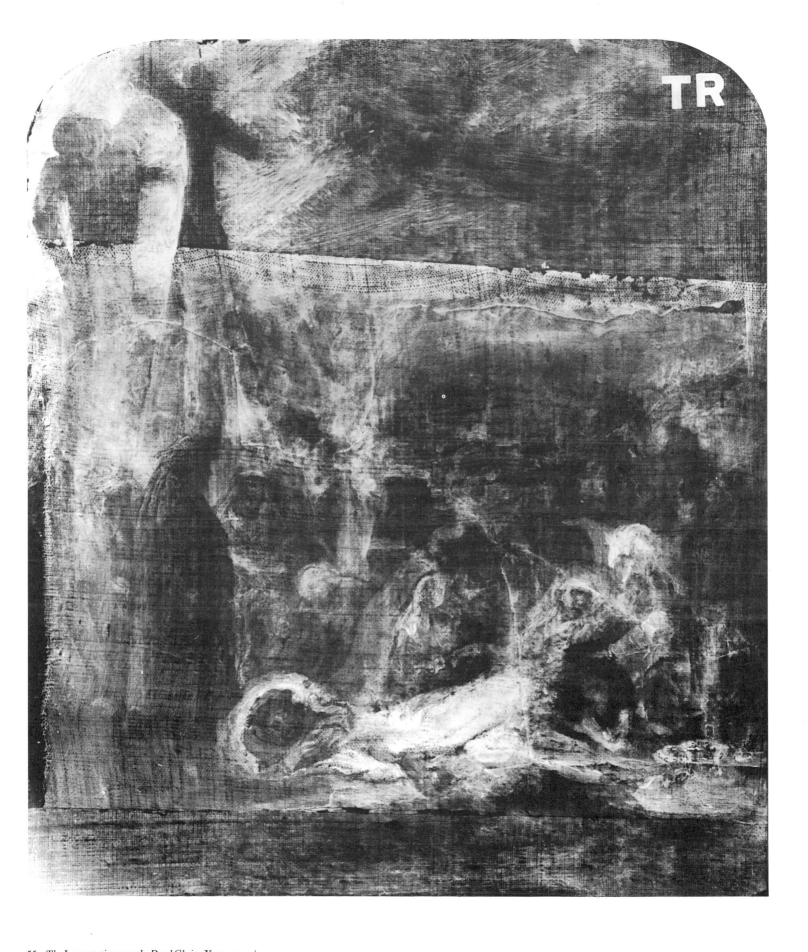

55. *The Lamentation over the Dead Christ.* X-ray mosaic

would be iconographically incorrect, but this would have been corrected when the composition was reversed in a print. The only grisaille modello which was completed and used for this purpose is the *Ecce Homo* of 1634 (Cat. No. 2). There are, however, other grisaille paintings which Rembrandt may have intended to use thus, for example, *Joseph telling his Dreams* (Amsterdam, Rijksmuseum; Bredius/Gerson No. 504) and *Saint John the Baptist Preaching* (Berlin-Dahlem, Gemäldegalerie; Fig. 54). These grisailles all date from the mid-1630s. It is possible that Rembrandt was planning an ambitious series of engravings, which was never carried out. The *Lamentation* belongs with this group; it should – in the second stage, the horizontal form recorded in the drawing attributed to Bol – be dated around 1635. In the sequence of Rembrandt's work, it should be placed shortly after *Saint John the Baptist Preaching*, which can be dated approximately 1634/5.

It may reasonably be asked why this composition caused Rembrandt so much difficulty. It has usually been thought that the problem was technical, that is to say that Rembrandt was concerned about the compositional balance of the figures and was trying to avoid placing figures too close together within a small space. This may be the case, but van de Wetering has recently suggested a new and most interesting possibility. It will be published in detail in the third volume of the Rembrandt *Corpus*, which is due to appear in 1989. He believes that Rembrandt's problems were iconographic rather than compositional. There is, as has been noted, no Biblical text describing the Lamentation and Rembrandt conflates a number of separate scenes from the Passion in this small image in what is, iconographically, a highly original manner. It has a strong narrative element. The men descending from the ladders refer to the Deposition; the central group shows the Lamentation; and in the background the figures on the right are on horseback and one, an older man with a feathered head-dress, may refer to the encounter between Pilate and Joseph of Arimathea in which Joseph requested permission to bury the body of Christ. (This figure is certainly not, as has been suggested, Longinus, as he is not dressed in Roman armour, nor does he carry a lance: the lance is carried by the accompanying figure on foot.) Their presence leads on to the next event in the Passion, the

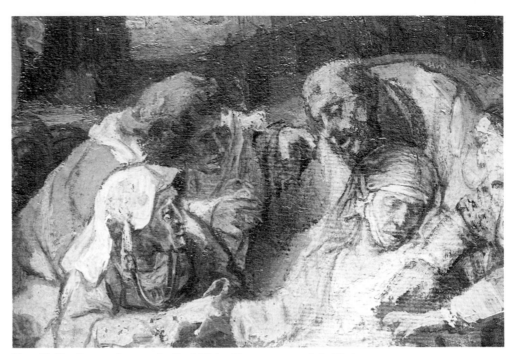

Plate 21 *The Lamentation over the Dead Christ.* The group around the Virgin

Entombment. In this way the painting refers to three distinct events in the Passion and it is this iconographic complexity – with a richness of detail which would have been entirely appropriate in a print – that caused Rembrandt to rework the composition. The question then arises of why, if it was intended to be used for a print and incised on to the plate like the *Ecce Homo*, he attached the original paper to canvas. Canvas could not, of course, be laid on to a plate and the design incised through it, as it is far too thick for this purpose. Rembrandt must have felt that paper which had been cut and rejoined was too fragile to lay on a plate and so have decided to consolidate the paper by attaching it to an odd piece of canvas which had been cut from another painting (which has been identified; see below) and was lying in a corner of the studio. He must have intended to make another grisaille on paper for transfer, but the project was presumably abandoned, as an etching of this composition was never made. However, while the composition was never etched, it is worth noting that there are reminiscences of individual figures and figure groups in the *Descent from the Cross* etching of 1642 (B. 81) and the oval plate of *Christ Crucified between the Two Thieves* (B. 79) of about the same time (around 1641).

Technical description

The *Lamentation* is the smallest picture by Rembrandt in the National Gallery collec-

tion and, structurally, by far the most complex. Of the composition as it now stands, only the central part is by Rembrandt: the top and bottom parts were painted by a later hand. The complex evolution of the picture is made clear by a study of the paint surface, the X-ray (Fig. 55) and cross-sections taken from key points. Instead of the usual description of technique by systematic consideration of layer structure, it is more instructive here to consider chronologically the evolution of the work carried out by Rembrandt himself, in his studio and, then, somewhat later by the further hand.

The first stage of the development of the *Lamentation* was a lay-in done directly on the paper in tones of brown. This thin wash of colour contains black, transparent brown, traces of red and yellow earth and a trace of white. There appears to be no other sort of preparation on the paper. The brown tone is still visible in several areas, and was used directly for shadow and half-tone in the first painting stage. It can be seen in the shadowed side of the man's head immediately above the Virgin (Plate 21) and in the middle-ground landscape above that (Plate 22); the dark standing figures in the left foreground are also composed largely of this brown lay-in with a few lighter scumbles on top.

The first true painting stage of the grisaille used this brown tone directly. Over it, grey and white lights and highlights were applied, leaving blocks or lines of brown

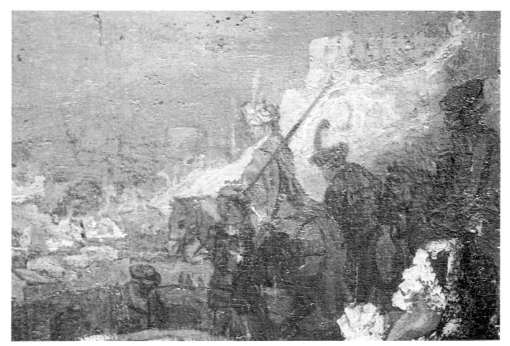

Plate 22 *The Lamentation over the Dead Christ.* Detail of the background

now to overlap both paper and canvas to complete the parts that had been cut away. Whereas the brown tone of the lay-in was allowed to show for shadows and half-tones in the initial grisaille, he now had to paint over the grey-brown ground on the canvas, the edges of the paper and the paint that was already present in order to continue. The

56. *Cupid blowing Bubbles.* 1634. Paris, Collection of Baron Bentinck

wash in between; this was a highly economical way of working. Deepest shadows and linear details were then added in darker browns and black.

We do not know precisely how large the piece of paper was on which this first stage was painted, because Rembrandt decided he was only interested in using part of it for the next stage. Presumably it was a rectangle not a great deal larger than it is now, but Rembrandt then cut and tore away the parts with which he was dissatisfied to leave a quite irregular shape, now clearly visible in the X-ray. The right and left edges run fairly straight, more or less parallel to the edges of the present composition. The top edge is curved at the left side; next to this it is cut away in an approximate rectangle (containing the ladder, the head and torso of the right-hand thief and the head of the man moving the ladder); then it continues irregu-

larly at a higher level to the right side. The bottom edge is lowest at the left side, rises slightly under Christ's body and then is cut away in a large triangle to exclude most of Christ's head and Mary's body and face.

The trimmed and torn paper was now mounted on a slightly larger piece of canvas. This, too, is easily visible in the X-ray. Its upper edge slopes down towards the right and passes just above the Good Thief's hands; its lower edge is approximately horizontal and runs just below the main figure group. The canvas can be seen to have cusping at the top and left, indicating that it was cut from a large stretched piece. A cross-section shows that it is prepared with a typical double ground, on which the paper is directly mounted (Plate 23). The upper layer contains lead white, a little umber and a fine-grained black (not wood charcoal); the lower layer is the usual reddish-orange earth. The canvas was undoubtedly part of a batch present in Rembrandt's studio. Van de Wetering has pointed out that its thread-count and weave characteristics match those seen in other canvas paintings of 1634/5; specifically, he proposes that the piece of canvas on this *Lamentation* was trimmed from the bottom of the *Cupid blowing Bubbles* (Rembrandt *Corpus* A91; Fig. 56) before it was painted.

Once the paper was mounted on canvas, the painting could be developed further. This second stage of painting is done more opaquely than the first, since Rembrandt had

paint of this second stage is therefore more densely worked, and shadows and half-tones are painted opaquely on the surface. This may be seen most clearly in those parts painted directly on the underlying canvas – the head and torso of the right-hand thief, Christ's head and Mary's face and upper body – but many parts of the initial grisaille were now also developed further and it is not easy to distinguish the two stages in some areas.

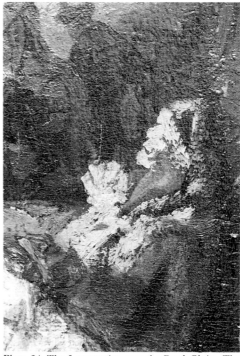

Plate 24 *The Lamentation over the Dead Christ.* The figure at the right edge

Plate 23 Dark grey paint, right edge, over double ground of the central canvas on which paper fragment is mounted. The sample is from an area where no paper is present. Cross-section, 195x.

Although they differ somewhat in density and handling, the finish and detail of these two stages are broadly similar. However, there appears to be a third, quite distinct, stage in which Rembrandt added a few final flourishes: this is typified by the extraordinarily free figure at the right, in which he has suggested a head, arms and praying hands with just a few dragged, almost random brushstrokes of pure white (Plate 24).

It must be remembered that, so far, the painting was only on the paper stuck to one piece of canvas. In the next stage of the evolution of the picture, the canvas was stuck to a larger oak panel which had rounded top corners, together with two other pieces of canvas, one above and one below. This arrangement can be seen clearly in the X-ray. It is probable that the canvases were overlapped at the joins and then cut through along a straight-edge: this would explain both the precise joins and the slight crumbling of the paint layers at the upper and lower limits of the central piece, visible in the X-ray.

The question that must be addressed is when this mounting of the canvas pieces on panel took place and when the upper and lower parts were painted. The mounting on panel certainly appears to have been done in Rembrandt's studio, since the upper and lower pieces also have standard double grounds, identical to each other, although slightly different from that on the central piece: they have the same orange-red earth pigment below, but the upper layer is yellowish brown, containing a more granular lead white, splintery wood charcoal particles, some yellow earth and possibly also some yellow lake pigment (Plate 25).

The painting of the upper and lower parts, however, seems to have been done later, although how much later is difficult to determine. The evidence for this is partly

Plate 25 Detail of double ground on added bottom strip of canvas. The upper layer contains typical aggregate particles of lead white, with earth pigments and charcoal. Cross-section, 400x.

stylistic – the handling of paint bears no resemblance at all to that on the central part – but also technical. Cross-sections from the upper part show a distinct discontinuity – probably a thin, discoloured varnish layer – between the upper ground layer and the paint (Plate 26). Moreover, one cross-section shows a crack in the ground layers which does not continue into the paint (Plate 27). Both these observations suggest that some time had elapsed before the painting was completed. We can therefore propose an intermediate state in which the central part was finished, but the upper and lower parts were simply unpainted grey-brown ground: the entire structure was varnished in this state, and only somewhat later was the rest of the painting carried out over the varnish layer.

It is very difficult to be sure when this later painting was done, but it is most certainly not by Rembrandt himself and quite possibly not even of his studio. The later paint overlaps

Plate 26 Detail of the interface between the sky paint on the upper added canvas strip and the upper ground layer, showing a thin film of intermediate varnish. Cross-section, 350x.

the original sky appreciably at the upper join, and the horizontal bar of the Good Thief's cross is also partly of this stage. The left edge of the original part is overpainted: the two figures at the extreme left are not original and are partly painted on the bare wood of the panel beyond the limit of the canvas. The figure of the Bad Thief is also entirely composed of later paint, the legs covering a substantial amount of Rembrandt's original. The reddish tone seen between the Bad Thief's legs is repeated on the underside of Christ's Cross and, in places, on the lower addition. The later painter has also added small touches to Rembrandt's own figures: for example, the creamy highlight on the upper arm of the richly dressed woman at the right is identical in composition to the cream sky paint at the top left, and its fluid handling is also precisely the same. A cross-section of

Plate 27 Warm grey sky paint, upper right corner, over the double ground of the added canvas strip. Note the drying crack which penetrates both layers of the ground, but not the overlying paint of the sky. Cross-section, 175x.

the highlight on the sleeve shows the original warm greyish underlayers with white, Cologne earth and umber, and then a pronounced discontinuity containing varnish before the later cream-coloured paint applied on top (Plate 28). Medium analysis has also shown that the original paint is linseed oil, while the added sky is in poppyseed oil.

There are some *pentimenti* in the original part of the painting which have a direct connection with the complex British Museum drawing (Fig. 51). For example, a large tower in the centre right background, which is dimly visible both on the picture surface and in the X-ray, occurs in the drawing. In the painting it was clearly tried out and then painted over. Similarly, there is a woman in a large flat hat standing behind the main group of figures in the drawing: she is faintly visible in the X-ray of the painting, standing in a similar position.

It does appear that the painted grisaille and the drawing were developed simultaneously – that the drawing was made, altered, cut and added to while the various stages of the grisaille were proceeding. Certain features from one were incorporated in the other and vice-versa as Rembrandt worked out his trial composition. The drawing was adapted as he went along, in order to visualise how the next stage of the painting might look.

It is significant, for example, that, on the drawing, two parts have been cut, moved apart and remounted in order to make room for the diagonal of the ladder: and on the painting the original paper has been torn and cut away in this very area and the ladder painted in directly on the canvas of the second stage. It appears that experimentation with one version led directly to alteration in the other.

Certain features of the drawing were not

pursued in the painting. The middle-ground figures (of which, as we have seen, the woman shows dimly in the X-ray) were not developed: neither was the cityscape with the large tower. Exclusion of these elements in the painting allowed Rembrandt to move the Good Thief on his cross down into the central part of the composition: and, significantly, this, too, occurs where the paper of the first stage has been torn away.

That the different stages of the painted grisaille and the drawing echo each other is confirmed on the drawing itself. The parts that we have proposed for the first stage of painting – those using the brown lay-in for shadows and half-tones – are done only in pen and ink on the drawing. In the second stage of painting – after the mounting on to canvas –

pursue further the middle-ground figures or the larger cityscape which he had tried out in the drawing.

Bibliography: HdG No. 136; Bauch No. 69; Bredius/Gerson No. 565; A. Harris, 'Rembrandt's Study for *The Lamentation for* [sic] *Christ*', *Master Drawings*. vol. 7, 1969, pp. 158-64; J. G. van Gelder, 'Frühe Rembrandt-Sammlungen' in O. von Simson and J. Kelch, eds., *Neue Beiträge zur Rembrandt-Forschung*, Berlin 1973, pp. 193-4; Rembrandt *Corpus*, vol. 3 (forthcoming).

Plate 28 Detail of later cream-coloured highlight on the sleeve of the woman to the right, over original greyish brown paint. Note the discontinuity between the original and later paint. Cross-section 425x.

the corresponding areas of the drawing are carried out in much coarser chalk and oil paint. The pen and ink lines on the drawing occur only before it was expanded to incorporate the ladder: all drawing lines thereafter are done in chalk and paint.

These observations could suggest the following overall sequence. The painted grisaille on paper was started first, but Rembrandt became dissatisfied with it. He made a copy of the existing composition on joined pieces of paper in pen and ink. He then experimented by cutting the drawing diagonally and remounting it; this allowed room for the ladder which he then included, along with other alterations carried out in chalk and paint. He then cut and tore the original grisaille to eliminate whatever was in this area, mounted it on canvas, and painted the second stage including the ladder which he had developed in the drawing. However, he now developed the grisaille further by painting the Good Thief in a lower position: as we have seen, he chose to do this rather than

7.
Belshazzar's Feast

Canvas, 167.6 × 209.2 (66 × 82⅜)

Signed and dated above the shoulder of the falling woman on the right: Rembrand. / F 163[?]; the signature and date can be best seen in ultra-violet light; there is a damage after the 'd'; much of the penultimate digit of the date is damaged so that only the top of the '3' remains; the last digit is lost

Inscribed, top right-hand corner, in Hebrew, to be read vertically from right to left: Mene mene tekel upharsin

The subject is taken from Daniel, chapter 5. During the feast the golden and silver vessels looted from the temple in Jerusalem by Belshazzar's father, Nebuchadnezzar, were used. Rembrandt shows the moment when the 'fingers of a man's hand' came forth and wrote upon the palace wall. Only Daniel was able to interpret the inscription, which foretold the King's death that night and the division of his kingdom. It has been shown that Menasseh ben Israel, the Jewish scholar who lived close to Rembrandt's house in the Sintanthonisbreestraat and whose portrait Rembrandt etched in about 1636 (Fig. 57), used the same Hebrew formula for the inscription in his *De termino vitae* of 1639 (Fig. 58). The date of the publication of ben Israel's book cannot, however, be regarded as a *terminus post quem* for the execution of the painting. Rembrandt could have obtained the formula from ben Israel before the publication of his book; indeed, the two *pentimenti* in the inscription may well suggest that Rembrandt did not have the formula in

58. Menasseh ben Israel, *De termino vitae*. Amsterdam, 1639, p.160

its published form in front of him when he began work. The lettering of the painted and printed inscriptions do not exactly correspond.

In scale and in violence of expression and gesture as well as in the dramatic effects of light, the painting recalls *The Blinding of Samson* of 1636 in Frankfurt (Fig. 10). There are analogies of individual poses with *The Angel taking Leave of Tobias* of 1637 in the Louvre (Fig. 59) and *The Wedding Feast of Samson* of 1638 in Dresden (Fig. 60). A date of around 1636-8, therefore, seems most likely for this painting.

Technical description

The support of *Belshazzar's Feast* consists of two equal widths of canvas, joined by a central vertical seam. Presumably the warp threads are vertical, and so the width for each piece is about 104.6 cm: however, allowing for the seam overlap, tacking edges and canvas lost by trimming (see below) the original loom width must have been somewhat more, perhaps corresponding to the standard '1½ ell' width of about 107cm.

Several important observations have been made about this canvas by E. van de Wetering. Firstly, there is the same distinct vertical weave fault about 20 cm in from each vertical edge, made visible by the X-ray (Fig. 62). This tells us that the two pieces were cut from the length, placed one on top of the other in the same orientation, seamed along one edge and then opened out flat. But it tells us more besides. The same weave fault, thread count and general weave characteristics are found in other paintings – for example *Abraham's Sacrifice* (Fig. 61) in Munich; in this picture two widths are similarly joined with a vertical seam, but along the opposite edges so that the faults are

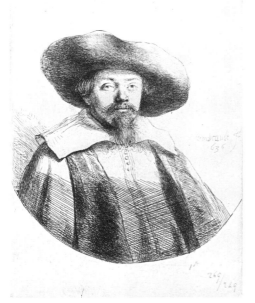

57. *Samuel Menasseh ben Israel*. 1636. Etching, first state. London, British Museum

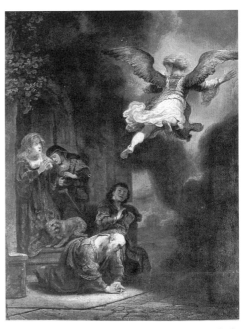

59. *The Angel taking Leave of Tobias*. 1637. Paris, Louvre

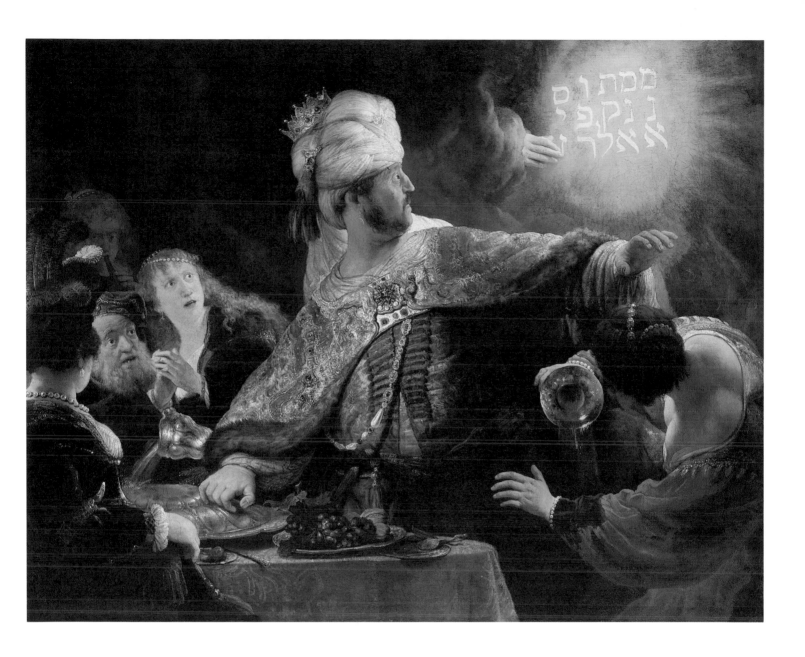

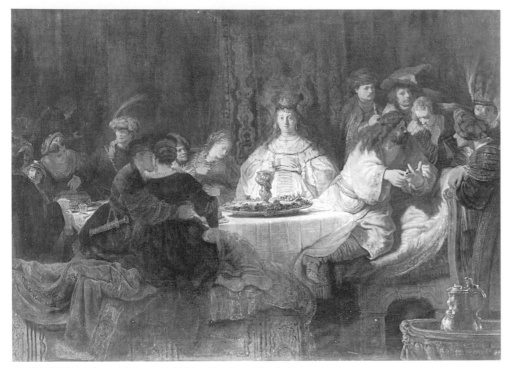

60. *The Wedding Feast of Samson.* 1638. Dresden, Gemäldegalerie

20 cm from the centre line. Without doubt, the canvases for these two paintings came from the same bolt of cloth and were probably seamed and prepared at the same time.

The second important point about the canvas of *Belshazzar's Feast* is that at some stage, narrow wedge-shaped pieces have been cut from all four sides, perhaps during

61. Studio of Rembrandt: *Abraham's Sacrifice.* 1635. Munich, Alte Pinakothek

lining. This was detected by study of the cusping, which becomes progressively shallower along each side, and by measuring the widths of each canvas piece, which differ at top and bottom. The result of this is that the whole picture is now twisted slightly anticlockwise. The seam slopes to the left, the table runs uphill and the wine spilt by the woman at the right falls towards the right instead of vertically. If the missing pieces were replaced (but, it must be said, there are no plans to do so) these small misalignments would be corrected.

The canvas is prepared with a double ground similar to that in *Saskia van Ulyenburch in Arcadian Costume* (Cat. No. 5) and the *Self Portrait at the Age of 34* (Cat. No. 8). The lower layer infilling the canvas weave is of a fairly pure orange-red earth with on top a light fawnish grey consisting of granular lead white combined with some umber and black pigment (Plates 29, 30, 37), although not wood charcoal as in the upper ground of *Saskia*. The umber content has been confirmed by analysis.

The paint layers, although superficially colourful and bright in many areas, have a strikingly dense and dark tonality about them. The reason for this is seen by studying the craquelure on much of the picture surface: showing through almost everywhere is a dark underlayer. It is a particularly prominent feature of the slightly greenish-

grey background glare that surrounds the writing on the wall (Plate 29), even occurring beneath the heavy impasto of the lettering itself and the thickest parts of the brocade cloak (Plate 35). Dark translucent paint underlies the flesh painting as well, lending a morbid tonality to the surface colour; in the paint of Belshazzar's outstretched hand for example (Plate 32), it is present as a most substantial layer (see Plate 37). Dark underpaints occur in the shadows of the woman's red dress and sleeve, where they form a complicated part of the construction of light and shadow (Plates 30 and 31), and surprisingly the deep translucent black dress of the woman to the far left has a thin rich brown underlayer for the bone black glaze that completes the paint structure. These dark preliminary paint layers, which in all cases lie directly on the upper greyish ground, are so general in the picture that there must be a fairly complete composition laid out in sombre tones beneath the more colourful opaque paint of the flesh and drapery at the surface. In this case we can conceive of the underpainting as evidence of a fully realised 'dead-colouring' stage, created before the composition was worked up into its finished form, and involving what seems to be a painted sketch executed mainly in translucent browns. These are composed of bone black, extended with chalk, and adjusted with small quantities of coloured pigment, usually red lake, and the darker earth pigments. Several of these dull underlayers contain the blue cobalt-glass pigment smalt; but whether for its colour, or as a bulking agent or perhaps as a drier, is not certain. It is only the glazed-in deep black background to the upper left, and the greyish tablecloth in the foreground, that have remained uncovered from this first stage of painting.

Plate 29 Thick dark underlayer of the greenish-grey background wall, right, over the double ground. The surface paint contains smalt. Cross-section, 190x.

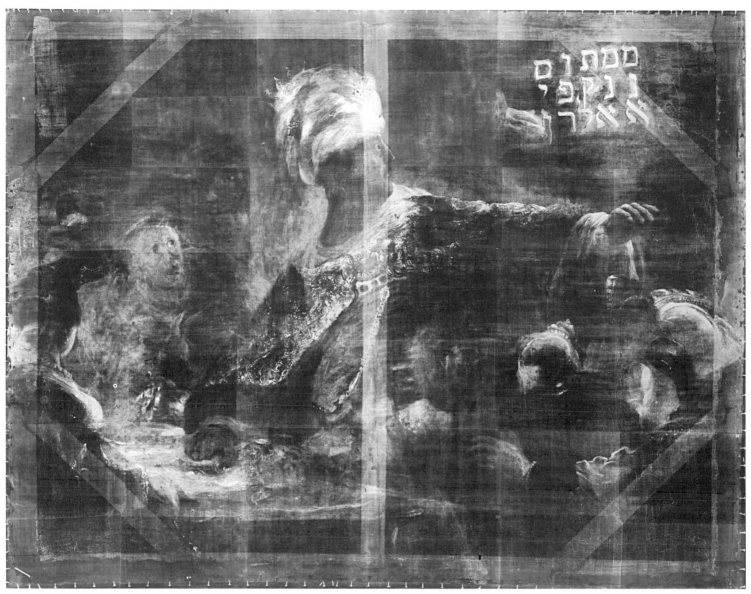

62. *Belshazzar's Feast.* X-ray mosaic

As a result of the very dark underpaint, the colours are painted thickly and opaquely, relying on their own brilliance rather than on any reflected light from underneath except where the underpaint is intended to reinforce shadow as in the red sleeve of the woman to the right. The texture of the paint varies enormously from huge encrustations of impasto in Belshazzar's cloak (Plate 34) and clasp and the writing on the wall to the relatively smooth, but still substantial, flesh and background passages, and the delicate use of the brush-end to scratch out the curls of Belshazzar's beard (Plate 33).

Colour in *Belshazzar's Feast* has no counterpart among the National Gallery Rembrandts other than in *Saskia van Uylenburch in Arcadian Costume* and, on a much smaller scale, in *The Woman taken in Adultery* (Cat. No. 9). Not only is the range of pigments much greater than we find for most of the other pictures, they are used in daring techniques to produce quite specific effects of colour. In some ways the paint layer structures are easier to interpret than for *Saskia*, since there is no major change in the composition to contend with, as there is in

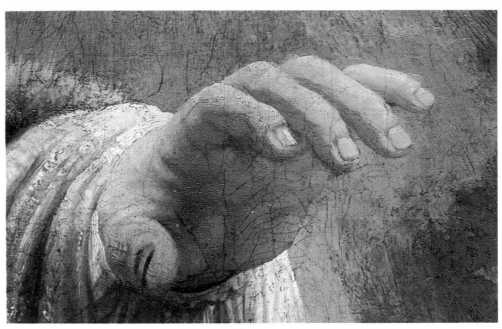

Plate 32 *Belshazzar's Feast.* Belshazzar's left hand

that picture. Perhaps the piece of painting most striking for its unconventional technique is of the red dress of the woman spilling wine. In the deepest shadows it makes use of a powerful purplish-red lake glaze over a compact layer of bone black. Final scumbles of scarlet and orange-coloured vermilion are dragged over for the highlights (Plate 30). The more orange-toned opaque lights incorporate lead-tin yellow with the vermilion, but over a rich translucent orange-brown of red and yellow lakes containing suspended particles of vermilion (Plate 31). Elsewhere, the technique is modified yet again, with

yellow ochre, vermilion and white drawn across a dark brownish purple glaze-like paint of red and yellow lakes containing quantities of smalt. This underlayer of a highly unusual combination of pigments is also to be found in the late portrait on canvas of *Margaretha de Geer* (Cat. No. 17).

Belshazzar's brocaded cloak (Plate 34) and under-robe are painted in an equally rich palette. The fundamentally opaque technique of the impasto of the cloak recalls the embroidered band at Saskia's waist and, less elaborately worked, the painting of the gold chain in the *Portrait of Philips Lucasz.* (Cat.

Plate 30 Dark red shadow of the sleeve of the woman's dress, right. There is a black underlayer glazed with deep red lake over the double ground. A final scumble of vermilion is drawn across the surface. Cross-section, 180x.

Plate 31 Opaque orange highlight on sleeve of woman's dress, right. Vermilion combined with lead-tin yellow forms the surface paint, over a semi-glaze of red and yellow lakes mixed with vermilion. Note the dark undermodelling layer over the fragment of double ground. Cross-section, 180x.

Plate 33 *Belshazzar's Feast.* Detail of Belshazzar's beard

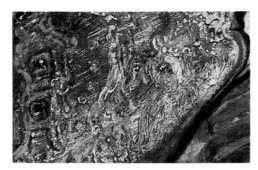

Plate 34 *Belshazzar's Feast.* Detail of Belshazzar's cloak

No. 4). The thickest highlights of the embroidery of the cloak and jewelled clasp are of pure lead-tin yellow (Plate 35), exactly like the raised bright yellow paint of the lettering on the wall. The highlights have been worked wet-into-wet over applications of pure yellow ochre and over brown, somewhat translucent mixtures of dark-coloured earth pigments, chalk and lead white. Overall the choice of pigments is wide-ranging, with a variety of yellow and orange-coloured ochres as well as yellow lake used at the surface for the mid-tones, and both underpainting and glazing layers containing bone black combined with chalk.

For the dark claret shadow of the under-robe to the right, the technique is quite distinct from the construction of the equivalent colours of the woman's red sleeve: there is an orange-red lower layer comprising earth pigments, red lake, vermilion and white, glazed over with one of Rembrandt's usual dark glazing mixtures of bone black and red lake containing just a little yellow ochre and lead white. A similar translucent mixture is present beneath the horizontal bands of greenish-grey embroidery on the under-robe (Plate 36). Blue and green pigments used for their colour alone are not a common feature of Rembrandt's painting after his Leiden

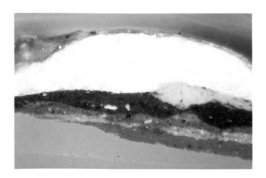

Plate 35 Pale yellow impasto of Belshazzar's cloak. The thick upper layer is lead-tin yellow, and the underlayers make use of a variety of earth colours, bone black, chalk and yellow lake. The double ground is visible beneath. Cross-section, 190x.

years, but in the striking touches of these colours, both *Belshazzar's Feast* and *Saskia in Arcadian Costume* are exceptional. There is no pure green pigment at all in either painting, but the colour is achieved with mixtures of blue mineral azurite with yellow earths or yellow lake, and combination with black. The deep green jewels sewn into the cape and the intense blue-green beads make use of these pigments, while the greenish embroidery on the under-robe has lead white mixed with the azurite (Plate 36).

There is also a second blue pigment, used as a dramatic contrast with the surrounding darks, for the feathers of the head-dress of the woman to the left. Here the pure mid-blue touches are of fine-quality smalt mixed with chalk and lead white.

The flesh paints in *Belshazzar's Feast* contrast strikingly with those in the *Saskia* of

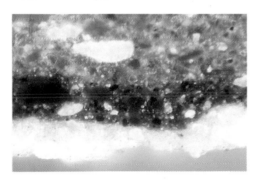

Plate 36 Greenish embroidery on Belshazzar's under-robe, comprising a mixture of natural azurite with a little yellow ochre and white. The lower layer combines red lake pigment, bone black and a trace of white. Lower ground layer missing from the sample. Cross-section, 350x.

only a year or two before. In *Saskia* Rembrandt has observed scrupulously the painter's convention of the cool half-tones, and the sensitivity of the three-dimensional modelling in her face is remarkable. In *Belshazzar's Feast*, the warm-cool-warm sequence moving from light to shadow in the flesh areas is hardly observed at all. Almost everywhere warm shadows are placed directly beside warm lights; the result is strangely flat, unmodelled and linear. It must be deliberate, consciously sought, aiming perhaps for a two-dimensional, almost theatrical tableau. Clearly the painting, with its broad handling, was not meant for close inspection but for a distant, grand effect; and that, presumably, is the key difference, both in intention and technique, between it and the more intimate portrait of Saskia.

For the flesh paint in general, opaque yellow and yellow-brown layers overlie

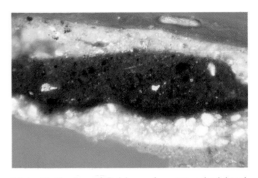

Plate 37 Shadow of Belshazzar's outstretched hand. The flesh paint of yellow earth, yellow lake, white and vermilion is underpainted with a thick layer of translucent dark brown, laid over the double ground. Cross-section, 180x.

darker underpaints, which we interpret as representing initial 'dead colouring'. These early parts of the painting of the flesh tones vary in composition, with greyish browns containing smalt beneath yellowish surface layers for the shadows of the necks of the two women to the left, and a rich brown under the reddish shadow of the palm of Belshazzar's outstretched hand (Plate 37). The mid-brown of Belshazzar's neck involves a similar method of painting. The yellow and yellow-brown, relatively unmodelled surface paint for flesh makes use of various combinations of earth pigment, lead white, and yellow lake to which a little vermilion has sometimes been added (see, for example, Plate 37).

The X-ray shows some changes made during the painting process. Belshazzar's turban was at first higher at the back, before the crown was added. To his right (our left) is the shadowy face of a man, subsequently painted out. Belshazzar's right hand was apparently open, the fingers straighter and not clenched; and the dish beside it was taller. There is some highlighted drapery at his waist which has been subsequently glazed over. The writing has been slightly modified; but only the size of the letters, not their forms.

The X-ray also shows us the reserve left for the back of Belshazzar's neck. This was presumably originally intended to be light-coloured background, but was then transformed into the flowing turban. The shadowy musician at the back does not register at all in the X-ray and must be painted in earth colours alone.

Bibliography: HdG No. 52; Bauch No. 21; R. Hausherr, 'Zur Menetekel-Inschrift auf Rembrandts Belsazarbild', *Oud Holland*, 78, 1963, pp. 142-9; Bredius/Gerson No. 497.

8.
Self Portrait at the Age of 34

Canvas, now with arched top, 102 × 80 (40⅛ × 31½)

Signed, on the sill, bottom right: Rembrandt. f 1640 and inscribed below this: Conterfeycel

The signature and date have almost certainly been repainted and the flourish between the 't' and 'f' of the signature is a later addition; the word 'Conterfeycel', which until the 1690s was the usual Dutch term for portrait, seems to be by a different hand.

In this self portrait, Rembrandt shows himself at the height of his fame as one of the most successful portrait and history painters in Amsterdam. His wealth is proclaimed by his elegant clothes: he is dressed in velvets and furs, a gold chain lies across his chest and jewels sparkle in his cap. The painting closely follows a design for a self-portrait etching made by Rembrandt in the previous year, 1639. In both the print and the painting there are reminiscences of two great Italian Renaissance portraits, Raphael's *Baldassare Castiglione* (Fig. 63) and Titian's *Portrait of a Man* (Fig. 64), in which the sitter was in the seventeenth century thought to be the great Italian poet Ludovico Ariosto. Rembrandt certainly knew the *Castiglione*, as he made a sketch of it (Fig. 66) at or shortly after the sale of Lucas van Uffelen's pictures in Amsterdam in April 1639, when it was bought by

64. Titian (active before 1511-1576): *Portrait of a Man.* London, National Gallery

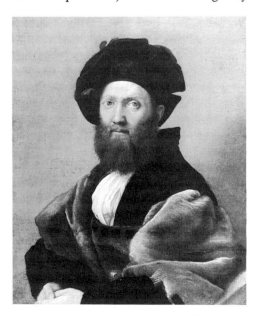

63. Raphael (1483-1520): *Baldassare Castiglione.* Paris, Louvre

Alfonso Lopez. (Rembrandt noted on his drawing that the painting had fetched 3,500 guilders.) He could have also seen the 'Ariosto' in Amsterdam since it (or a copy of it) was in Lopez's collection there at some time between 1637 and November 1641.

Of the two the Titian is the more important model. In both the 'Ariosto' and the *Self Portrait at the Age of 34* the body is

facing to the right; the angle of the head and body is similar; and both pictures are concerned to stress the richness of the material of the sleeve. De Jongh has argued that Rembrandt is here self-consciously emulating Titian's portrait and that by showing himself in the guise of the Italian poet he is contrasting his own art of painting with Ariosto's art of poetry, and so taking part

in the contemporary debate – the so-called *paragone* – in which the relative status of the two arts was endlessly discussed. This may seem a sterile debate to us; but it was significant in the seventeenth century in the Netherlands because it touched on the social status of the painter, who was often still regarded as a craftsman rather than an artist as was the case in Italy – and indeed in nearby Flanders.

The half-length composition and the pose of the sitter were extremely influential, being adopted by a number of Rembrandt's pupils, among them Govert Flinck (in a *Portrait of a Man* of 1643; Fig. 65), Ferdinand Bol (in a *Self Portrait* of 1646; Fig. 67), Gerbrandt van den Eeckhout and Aert de Gelder.

Technical description

The shape of the canvas support has been altered more than once since it was painted. It was probably originally rectangular and then, somewhat later, cut down to an arched format. The remains of the curved tacking edge can be seen clearly in the X-ray near the top corners (Fig. 68): the fact that this tacking edge bears original paint and ground continuous with that on the main part of the canvas is a sure sign that the picture has been cut down, and makes it unlikely that this was the original shape of the portrait. Later still, extra pieces were added to the bottom and at the top corners, to make a larger rectangle. The true lower edge of the picture is visible in the X-ray as a white line just above the

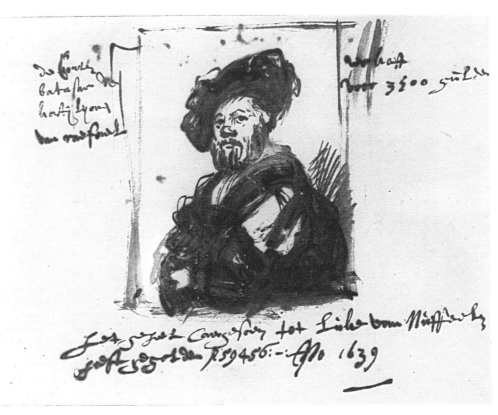

66. *Portrait of Castiglione* (after Raphael). 1639. Drawing. Vienna, Albertina

stretcher bar. The canvas was removed from this stretcher in the 1970s and is now marouflaged on to a synthetic panel.

The condition of the canvas support is problematic. While the X-ray shows the image of a weave that is undoubtedly original, it is clear that the original canvas is no longer present: all that we are seeing in the X-ray is the memory of the canvas weave imprinted in the dense ground layers. Two

observations suggest that this is the case. Firstly, the paint surface has a slightly sunken, wrinkled texture that is often associated with a transferred picture subsequently relined. Secondly, cross-sections show a highly unusual layer of black paint or adhesive between the lower layer of a conventional double ground and the present canvas (Plate 38). In one section it was possible to see the curved imprint of a coarse canvas thread on the bottom surface of the original ground filled by the black paint which, in turn, bears the multiple imprint of a finer canvas weave. In another place there is an equally unusual grey filler below the original ground, which can only be explained

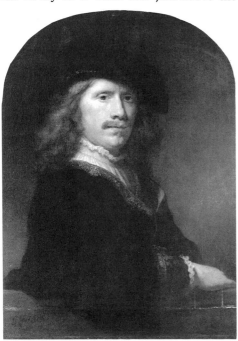

65. Govert Flinck (1615-1660): *Portrait of a Man*. 1643. Sotheby's, London, 11 December 1985 (lot 62)

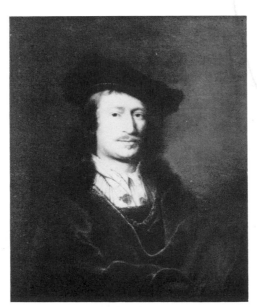

67. Ferdinand Bol (1616-1680): *Self Portrait*. 1646. Dordrecht, Dordrechts Museum

Plate 38 Lower part of the parapet in shadow, right. The double ground and a thin layer of black transfer-adhesive beneath the orange lower ground are visible. Cross-section, 170x.

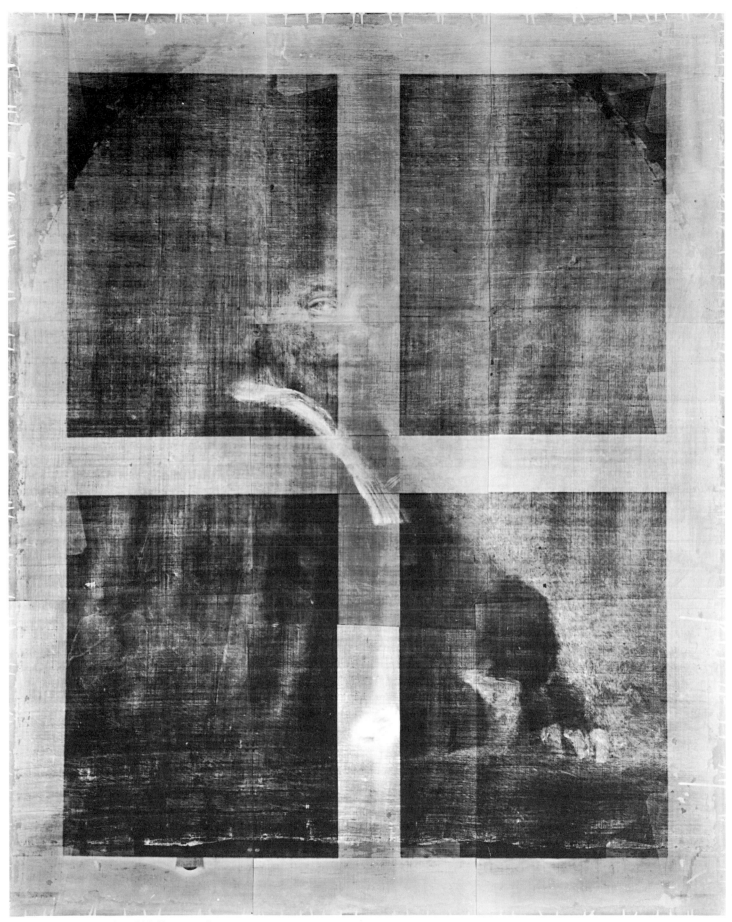

68. *Self Portrait at the Age of 34*. X-ray mosaic

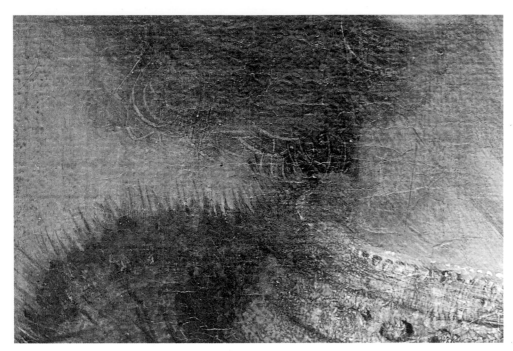

Plate 39 *Self Portrait at the Age of 34*. Detail of the hair

if thin or missing areas of the original ground were filled from the back during the transfer process.

It may be asked: why is it not obvious when the original canvas is missing – can its absence not be detected by simple examination? The answer is that an old transfer from canvas to canvas results in a structure almost indistinguishable from the original; and subsequent relinings which conceal the back of the canvas make it impossible to compare its weave with that seen in the X-ray. Unless the layers of canvas are removed from the back of the painting it is very difficult to be sure, except where unusual evidence such as that found here comes to light. The transfer probably took place before the reduction to the arched format, since it is unlikely that the fragments of tacking edge would have survived the process.

The transfer certainly took place long after Rembrandt painted this *Self Portrait*, and therefore has no direct bearing on his technique. However, our interpretation of the technical evidence depends on a realisation that such changes may have occurred.

The original canvas had a double ground of a heterogeneous lower layer of coarse red earth, with on top a thinner fawnish-grey priming of lead white, brown earth and a little charcoal (see Plate 40); these layers have survived the transfer. The ground colour plays almost no direct part in the finished painting. The whole picture is painted in a smooth, meticulous technique, covering the ground completely. This is Rembrandt at his most precise and controlled; there is virtually no impasto, no contrast of thick or thin paint, no use of open brushwork to suggest form, texture and the play of light. Everything is achieved with blended colour quite unlike the fluid portraits of the mid-1630s or the

massed lead-white underpaints of later years. Perhaps the only texture trick in the picture is the by now familiar one of suggesting the hairs at the back of the neck by scratching with a stylus or brush-end in the wet paint (Plate 39); in the adjacent fur collar, Rembrandt resists the temptation to repeat the trick and paints the fur normally in light scumbles of brown and black over the dark cloak.

The X-ray shows two notable *pentimenti*. Firstly, the artist's left hand was originally included, the fingers resting on the parapet next to the other hand. The composition is clearly a more powerful one without it and the painting-out is undoubtedly original.

A cross-section through the right side of the cloak just above the parapet shows a thin layer of black paint of the sitter's garment concealing the painted-out hand (Plate 40). The flesh paint itself is executed as two substantial layers of lead white, yellow and red ochres, with a little vermilion and a translucent brown pigment, probably Cologne earth, laid over a thin sketching layer of mid-brown paint, which may well represent the initial design for the hand. The high lead-white content of the paint ensures that this hidden feature is readily revealed in the radiograph. By contrast, the dark glaze on top is the thinnest covering of bone black, charcoal and red lake pigment, of much the same composition as the surface paint at the shoulders, where no redesign of the figure has been carried out.

Secondly, the coloured collar was once a more rounded shape and extended farther to the right, and the shirt front was longer. These alterations can be seen if the picture surface is examined closely. The X-ray also shows that the reserve left in the background for the left arm was smaller than the present silhouette, which thus extends over the background paint. Interestingly, there does not seem to be a correspondingly clear reserve left for the artist's hat: this must therefore be painted over the paint of the background, or be in paint of almost identical density.

It is probable that the face is modelled in a conventional sequence: the brown lay-in of the shadows, followed by mid-flesh tones, highlights and final details of shadow, beard, eyes and so on. However, it is constructed so smoothly and opaquely of blended tones that the underlayers seem to play no part in the final appearance. The half-tones, for example, are cool surface layers, rather than the

Plate 40 The painted-out hand beneath the cloak to the right. Cross-section, 400x.

Plate 41 Greenish-grey background, just above parapet, right. Cross-section, 445x.

warm undertones showing through semi-transparent flesh paint that we see in other portraits.

The background colours and parapet are painted rather solidly, in a less glaze-like technique than comparable parts of the panel paintings. A single fairly thick layer of yellow and red earth pigment, black and translucent brown combined with white is used (Plate 41). The lower part of the parapet makes use of two layers; an undermodelling of warm brown consisting of ochre, red lake, bone black, chalk and lead white, with a thinner, lighter yellow-brown on top (Plate 38). The yellow ochre of the upper layer here seems much extended with chalk for additional translucency.

Bibliography: HdG No. 550; Bauch No. 316; Bredius/Gerson No. 34; E. de Jongh, 'The Spur of Wit: Rembrandt's Response to an Italian Challenge', *Delta*, Summer 1969, pp. 49-67; C. Brown, *Second Sight: Titian and Rembrandt*, catalogue of an exhibition held at the National Gallery, 1980 (with further references).

9.
The Woman taken in Adultery

Oak, top corners rounded, 83.8 × 65.4
(33 × 25¾)

Signed, bottom right: Rembrandt. f. 1644

The story of Christ's forgiveness of the adulteress is told in the Gospel of Saint John, chapter 8. Rembrandt shows the moment when the Scribes and Pharisees, hoping to trap Jesus, bring the adulteress before him and ask whether the sentence of the Mosaic law, which condemned adulteresses to be stoned, should be carried out. One of them points to the kneeling woman. Christ replies, 'He that is without sin among you, let him first cast a stone at her.'

This depiction of the scene is an outstanding example of Rembrandt's small-scale religious works of the 1640s. It reveals his great gifts as a colourist, an aspect of his art which is sometimes forgotten. The figures are dwarfed by the cavernous temple, their drama heightened by a fall of light on the ornate gilded altar and the rich robes of the priest. The form of the altar may have been suggested by the type of ornamentation found in the work of Dutch silversmiths of the seventeenth century, such as that designed by Jan Lutma, whose portrait Rembrandt etched in 1656. In the elaborately detailed, decorative treatment of much of the background the picture recalls Rembrandt's style of the early 1630s – for example, the *Simeon and the Infant Christ in the Temple* of 1631 (The Hague, Mauritshuis) – in a way that is otherwise unparalleled in the 1640s. The freely drawn foreground figures are entirely consistent, however, with his style in the mid-1640s. Rembrandt's ability in this painting to work simultaneously in two different styles is a valuable corrective to attempts to define his stylistic development too rigidly.

Benesch identified six preparatory drawings for *The Woman taken in Adultery* (Nos. 531-535 and A.42) but, with the exception of a study for the Adulteress (No. 535), they seem not to be by Rembrandt himself and should be placed among the large group of drawn and painted derivations and copies of this influential composition.

Rembrandt returned to the subject of Christ and the Adulteress years later in two bold drawings (Benesch Nos. 1046 and 1047) which show him abandoning the spaciousness of the composition of the National Gallery painting, and concentrating on the figure group and reworking it. The second of these drawings can be at least approximately dated, as it is drawn on the reverse of a death announcement of 14 May 1659. It also carries a quotation from the Biblical text in Rembrandt's own hand. It seems likely, therefore, that around 1659/60 Rembrandt was working on a new version of the composition, but if these drawings were intended to be preparatory to a painting or an etching, it was never carried out.

There are a number of *pentimenti*: one, perhaps two, figures on the extreme right, beside the man with the crutch, have been painted out. Other changes are in the face of the man in red in the right foreground, in the top of Christ's head and in the head-dress of the man in yellow above the Adulteress.

Technical description
The oak panel is very thick and heavy, and in fine condition except for a repaired split running down from the top edge. It was probably originally rectangular and the top corners rounded off later. The evidence for this is twofold: the brushstrokes at the rounded edges are interrupted and fractured

Plate 42 Warm brown glaze, upper right corner. The *imprimatura* contains large aggregate particles of lead white. The glaze incorporates vermilion with earth pigments, lakes and bone black. Cross-section, 215x.

as if they have been cut and also the bevelling on the back is right-angled, not curved. In addition, a black border, which may not be original, runs more or less continuously around the painted surface, but is absent at the rounded corners. The distinctive grain of the oak is made visible in the X-ray by the slightly X-ray absorbent ground layers (Fig. 69). As with Rembrandt's earlier panel paintings, the ground consists of a layer of chalk finished with a warm light brown *imprimatura* of lead white combined with a little yellowish-brown earth pigment. Some of the lead white in this upper ground layer is present as large aggregate nodules of very pure pigment (Plate 42), and is mainly responsible for the visibility of the ground in the radiograph.

There is a prominent knot in the upper left centre which has been filled (probably during a subsequent restoration) with a dense filler. To the right of the knot is a large area which appears dark in the X-ray, the image of the wood grain apparently absent; there is a similar smaller area to the left of the knot. This gives a fascinating insight into the preparation of the panel before painting, because clearly the ground layers have been scraped away in these areas. Presumably the combination of prominent wood-grain and rough ground gave an unacceptable surface around the knot and it was necessary to scrape it and smooth it down. Whether Rembrandt himself or the *imprimeur* carried this out can of course only be guessed at, but the painter clearly needed the smoothest possible surface for a painting of such high finish. The absence of a complete ground in these areas has been confirmed by a cross-section from the thin paint of the central pillar which showed only a lightly applied brown glaze of non-X-ray-absorbent pigments, principally bone black and red lake, over a trace of the chalk lower ground layer. The final *imprimatura* containing lead white is not present here.

The painting of much of *The Woman*

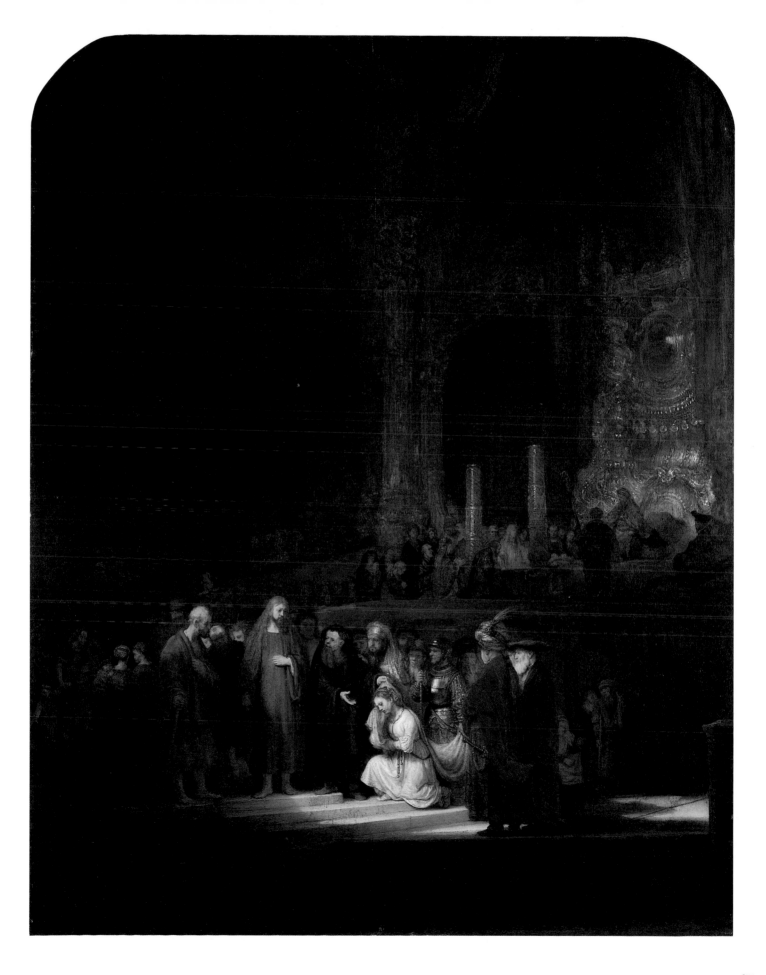

taken in Adultery is of a detailed, meticulous style and rich colour that echo Rembrandt's paintings of a decade before. He seems to have consciously painted the principal figure group in the highly finished manner of the early 1630s and, although the background and secondary figures are handled more sketchily, there is still a marked contrast with the rather slack handling of *The Adoration of the Shepherds* (Cat. No. 10) painted just two years later.

The rather mannerist range of colour is created in a number of ways. In some cases rather pure pigment is used, for example tiny impasto dabs of unmixed lead-tin yellow (Plate 43) and pure lead white for the

Plate 43 Impasto highlight of pure lead-tin yellow on the throne. Top surface of an unmounted fragment, 200x.

reflections on the elaborate throne to the right. Small areas of blue and green complement the warmer tones, but these rely on mixtures of pigment dominated by blue or greenish-blue mineral azurite. The deep crimson cloak of the turbaned standing figure employs a similar technique to the red dress of the woman to the right in *Belshazzar's Feast* (Cat.No.7), although on a smaller scale. The rich effect is achieved in a most unusual way, with red lake glazes over a black underlayer in the shadows. The colour of the priming is used directly for the highlights of the architecture in the centre background (Plate 44) and shows through the paint in the background figures and elsewhere. The main figures are painted thickly and opaquely with only minor adjustments of outline. The reserve left for the red-cloaked figure is the most striking feature of the X-ray: his outline was determined first and the illuminated forms behind painted up to it. There is a *pentimento* in this man's face (it was once larger) and in the face of the black-hatted man immediately to his left: the X-ray shows much more prominent features than those of the slightly shadowy head that we see on the surface. Further to

Plate 44 *The Woman taken in Adultery.* Detail of the background

the left, the turban of the man above the kneeling woman was initially taller.

At the right, next to the man with the crutch, there was at first another figure which may be seen in the infra-red photograph (Fig. 70) and, vaguely, on the picture itself,

but not on the X-ray except for the reserve in the floor left for his foot. The scale of this figure is too large for its position in the middle ground, and it was clearly abandoned at an early stage after the initial lay-in.

The infra-red photograph also makes

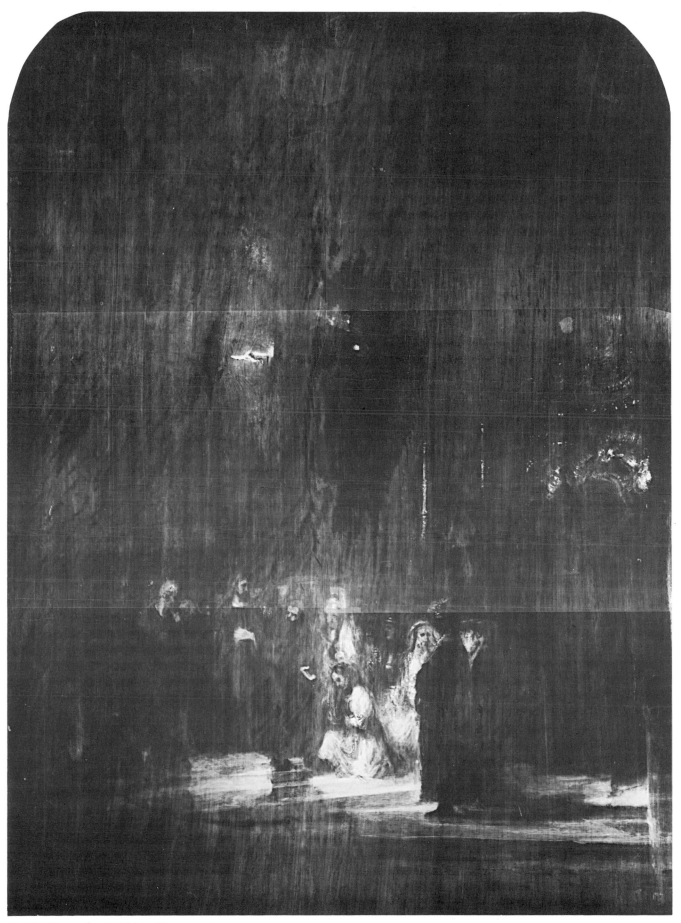

69. *The Woman taken in Adultery.* X-ray mosaic

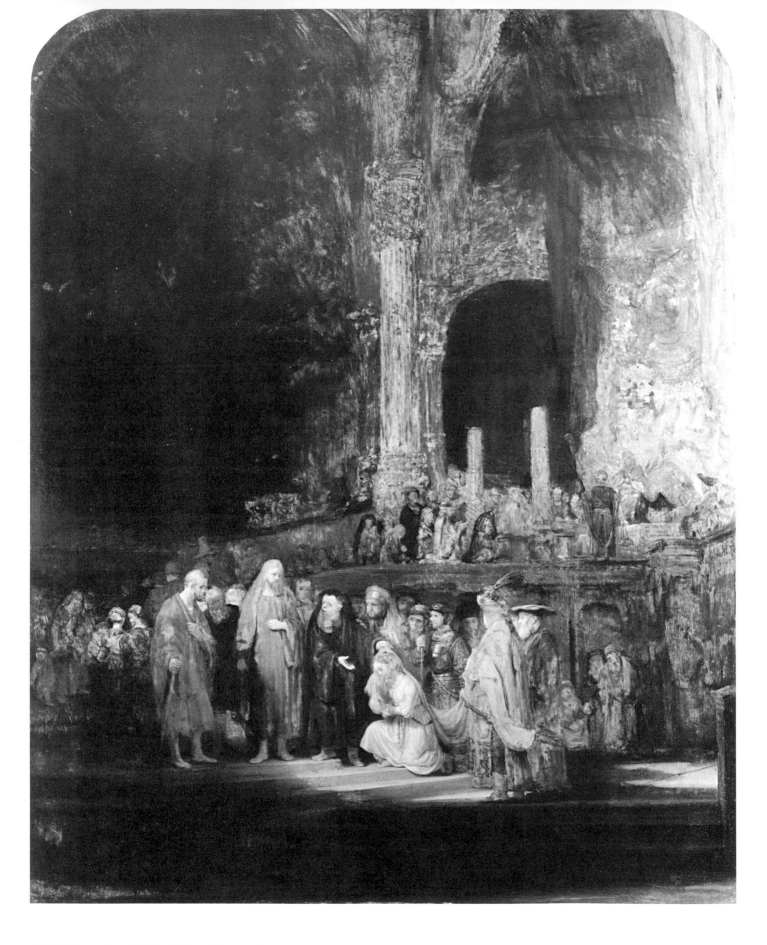

70. *The Woman taken in Adultery.* Infra-red photograph

clearer the very free vigorous brushwork with which the background is constructed. Penetration of the infra-red rays to the reflective ground enhances the glaze-like quality of the background paint. The composition of the dark-coloured glazes in the foreground and background depths is remarkably sophisticated, with a number of transparent and semi-transparent pigments mixed in continuous variation to achieve subtle gradations of colour even in the darkest tones. The glazes applied in single layers over the ground vary in composition and thickness, but all are based on some combination of bone black, red and yellow lake, and small quantities of earth pigment and vermilion. Where a deep translucent black is required the paint is mainly bone black with some added red lake pigment, and where a warmer, more opaque result is desired, the proportion of vermilion in the

brandt perhaps intended the stream of figures behind the main group to curve round in front of them at the left side. This would clearly have diminished the dramatic impact of the scene on the steps and was not pursued.

Bibliography: HdG No. 104; Bauch No. 72; Bredius/Gerson No. 566.

Plate 45 Warm brown glaze as Plate 42 above, seen by transmitted light. The transparent red and yellow lake pigments are evident, whereas the vermilion particles are so opaque that they appear black in transmitted light. Thin cross-section, 160x.

mixture is increased (Plate 45). In passages of intermediate warmth and translucency, yellow, orange and red earth pigments become significant components of the paint. Translucency within the background colours is partly provided by admixture of chalk with the tinting pigments.

The main puzzle of the X-ray is the dark form which seems to lie across the steps in front of Christ and the kneeling woman. The position of the light source suggests that it cannot be a shadow and it is clearly connected to some further silhouettes in the X-ray to the left of it. It seems that these are reserves left for figures in the immediate foreground which were never developed. Cross-sections show two layers of off-white lead-containing paint in an area of shadow on the X-ray, while three are present in the adjacent more opaque sections; but it is difficult to assess how the composition might have differed here. Rem-

10.
The Adoration of the Shepherds

Canvas, 65.5 × 55 (25¾ × 21⅝)

Signed, bottom left-hand corner: Rembrandt. f.
1646

The composition is connected – although
there are many significant differences be-
tween the various figures and their poses –
with a larger painting in the Alte Pinakothek
in Munich (Fig. 71). The composition of the
Munich painting is also in the opposite
direction, so that the group of the Holy
Family are on the right and the standing
shepherds on the left. It has been suggested
that the London painting is a loose copy of
that in Munich, but the differences are too
great for this to be an accurate description.
Rather, it is a variation on the composition
used by Rembrandt in the Munich canvas,
which is almost certainly the earlier of the
two. The National Gallery painting has
numerous *pentimenti*, some of which show
considerable changes of the design: they are
discussed in detail below. The Munich
painting is also dated 1646 and was one of the
last two of a series of scenes from the life of
Christ painted for the Stadholder, Prince
Frederik Hendrik of Orange: the other was a
Circumcision, the original of which is now
lost.

Technical description
The canvas is of medium weight, with fairly
regularly spaced thicker threads (showing in
the X-ray [Fig. 72] as dark lines). There is

Plate 46 Dark background, upper left, showing the
coarse-textured brown 'quartz' ground beneath. Cross-
section, 240x.

moderate cusping on three edges but not at
the right: the canvas may have been trimmed
a little on the right, therefore, but the

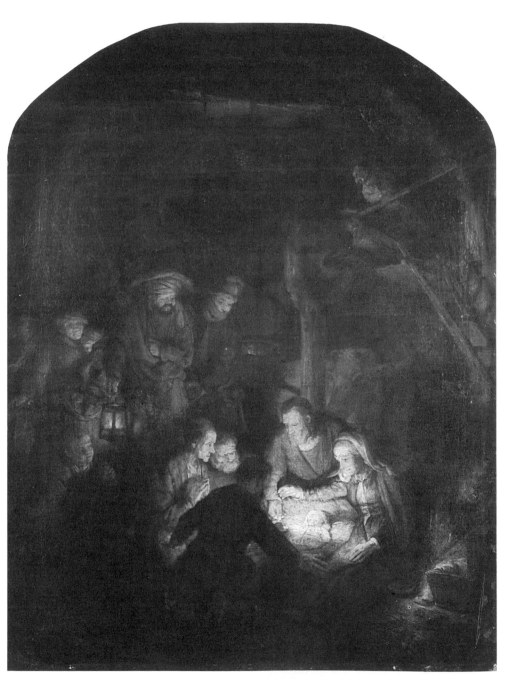

71. *The Adoration of the Shepherds.* 1646. Munich, Alte Pinakothek

composition itself clearly has not been cut.
Possibly some trimming took place between
the application of ground and the painting
stage.

The ground has been identified as a
rough-textured single layer of quartz (silica)
combined with a quantity of brown ochre
(Plate 46) bound in linseed oil. The composi-

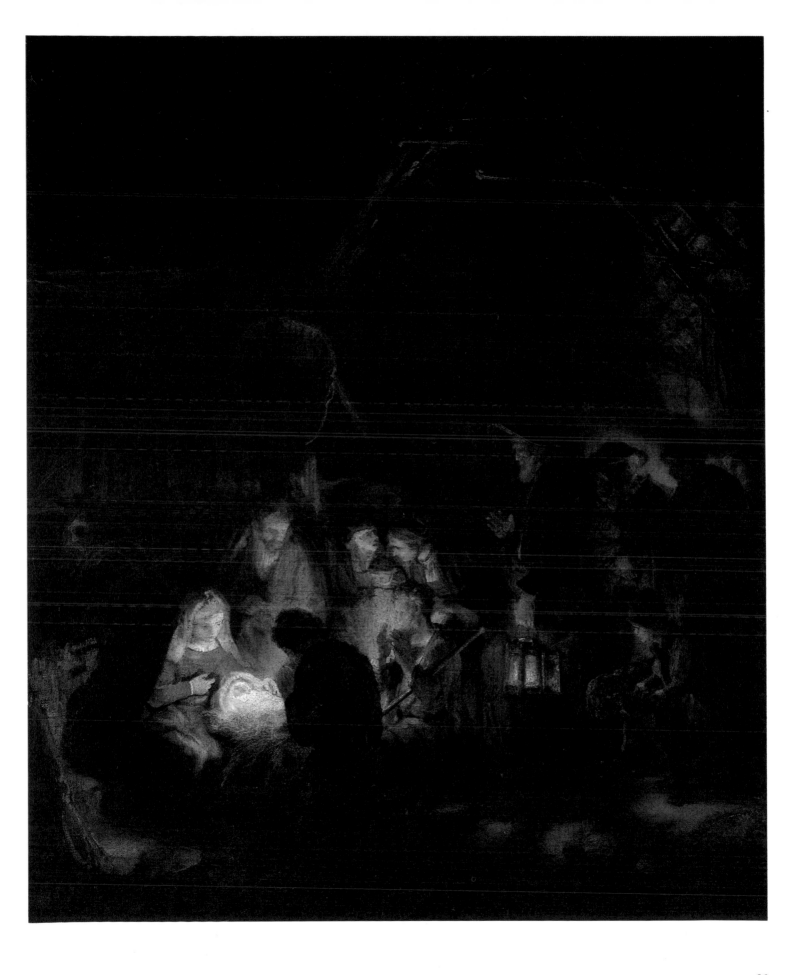

tion is the same as several others of the canvas paintings including the *Portrait of Hendrickje Stoffels* (Cat. No. 13) and the *Self Portrait at the Age of 63* (Cat. No. 20).

The paint medium in a sample has been shown to be linseed oil, and many of the dark background tones incorporate small quantities of pale-coloured azurite to assist the paint to dry.

The painting is carried out very directly, but surprisingly little direct use is made of the ground colour. It can be seen as a rich deep brown at the lower left corner and clearly imparts an overall tone to the picture, but similar colours that occur elsewhere in the composition have been painted on top.

In the depths of the roof recess the brown canvas preparation has been covered with a simple layer of rather pure bone black concealing the rough texture of the surface of

Plate 47 The paint structure for the broom-handle, left edge. The surface paint contains red ochre with a little added vermilion, and the lowermost modelling layer is virtually pure bone black. Cross-section, 195x.

the ground beneath. The details such as the rafters and the broom to the left simply pass over the dark underpaint (Plate 47). As the setting for the figure group implies, the pigments chosen are sombre: yellow ochre, bone black and chalk for the khaki rafters, and dull-coloured earth pigments for the handle of the broom. The flesh tones seem to be based on little more than red and brown earths mixed in varying proportions with white. But there are unexpected touches of colour: a little scarlet vermilion added to red ochre for the warm highlight on the broom handle (Plate 47), and primrose-coloured touches of pure lead-tin yellow for the baby's swaddling blanket. Mary's dress and bodice are similarly higher in key with a striking mixture for the lower part of blue mineral azurite with lead-tin yellow, white, yellow ochre, red ochre and black (Plate 48). The red bodice contains vermilion, again added for extra emphasis to the main pigments of

Plate 48 Greenish blue of Mary's skirt. The main colouring component is mineral azurite combined with white and other pigments. Top surface of an unmounted fragment, 200x.

red earth and white.

The style of painting is somewhat tentative. A fluid, broad handling more suited to a larger canvas has been curtailed and scaled down to fit this one. Brushstrokes are in general short and dabbed. The only freely painted strokes are in the upper right background: they show clearly in the X-ray and under the paint surface, but since they were covered by the background their function is not entirely clear.

On a dark ground such as this, a conventional lay-in of warm brown tones would be superfluous and difficult to see. There may be a few guidelines laid down in even darker paint, but Rembrandt seems to have proceeded almost directly to the painting stage. The X-ray is useful in charting the evolution of the picture and revealing a number of small but significant *pentimenti*.

The kneeling shepherd in front of the main group was clearly always intended to be the pivot around which the other figures are centred. The sharp outlines in the X-ray show that the reserve left for him was planned right from the outset and the illuminated figures behind were painted only up to his silhouette. Three small adjustments to the reserve outline were made subsequently: the hands were raised slightly, the line of his back was moved a little to the right and a knot of hair or a collar was painted out at the back of his neck

There are several other *pentimenti*, some only minor adjustments of outline. For example, the hat of the woman to the right of the man holding the lantern was initially taller and narrower (compare the reserve left for it in the X-ray); Saint Joseph's hand was at first a little lower; the face of the woman next to Saint Joseph was inclined at a different angle; and, perhaps most interestingly, the principal light source was original-

ly a much smaller lantern to the left of the present one – but it is not clear how it was supported.

Bibliography: HdG No. 77; Bauch No. 78; Bredius/Gerson No. 575.

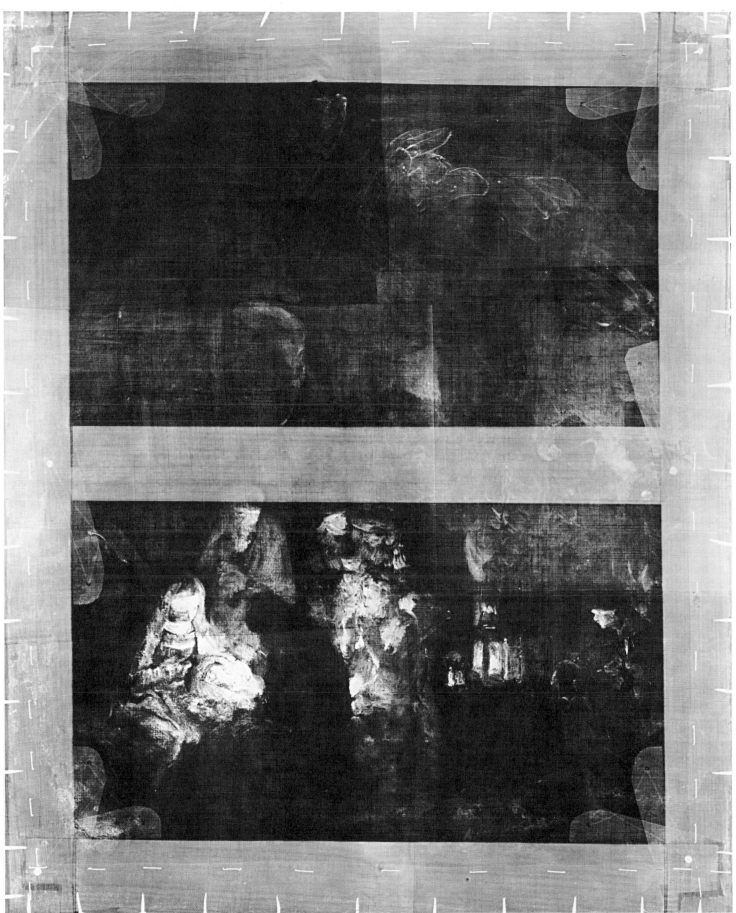

72. *The Adoration of the Shepherds.* X-ray mosaic

11.
A Woman bathing in a Stream

Oak, 61.8×47 (24⁵⁄₁₆×18½)

Signed on the bank, bottom left: Rembrandt f 1654 (The last digit of the date has been read as a '5' but is undoubtedly a '4')

The rich robe lying on the bank would support the idea that the bathing woman is intended to be a Biblical or mythological figure such as Susanna, Bathsheba or Diana. The picture displays a spontaneity and freedom in the handling of paint which have few parallels in Rembrandt's work. It appears unfinished in some parts, but was clearly finished to Rembrandt's satisfaction as he signed and dated it 1654. Its size and support might suggest that it was a sketch for a larger history painting but no such painting is known and, unlike Rubens, Rembrandt did not usually make preliminary oil sketches for larger projects. (The single exception is a group of sketches for etchings, made in the 1630s, of which Cat. No. 2 is one.)

The key to the painting may well be the identity of the model, who was probably the artist's mistress, Hendrickje Stoffels. She is first mentioned as a member of Rembrandt's household in a document of 1 October 1649, in which she is said to be 23. By that time she had replaced Geertge Dircx as the nurse of Rembrandt's son Titus and as the painter's mistress. (Saskia van Uylenburch, Rembrandt's wife and Titus's mother, had died in 1642.) In July 1654 – the year in which the picture was painted – Hendrickje was summoned before the Council of the Reformed Church in Amsterdam and admonished for living with Rembrandt 'like a whore' and banned 'from celebration of the Lord's Supper'. Rembrandt and Hendrickje's only child, a daughter, was born that year and baptised on 30 October 1654. She was named Cornelia after Rembrandt's mother. Hendrickje remained in Rembrandt's household for the rest of her life. She died in 1663 and was buried in the Westerkerk on 24 July.

There is no documented portrait of Hendrickje Stoffels but there are a number of paintings showing the same model and dating from the time when she was living with Rembrandt. The recurrence of this model and the affection and informality with which she is painted point to her being

Hendrickje. There are at least five portraits of her – one of which is No. 13 of this Catalogue – as well as the present painted study.

Hendrickje Stoffels would have been about 28 when this picture was painted. It was the year in which she suffered public humiliation because of her liaison with Rembrandt and bore his child. The picture is, as mentioned above, most unusual in his painted oeuvre and it seems quite possible that this is an intensely personal work, a

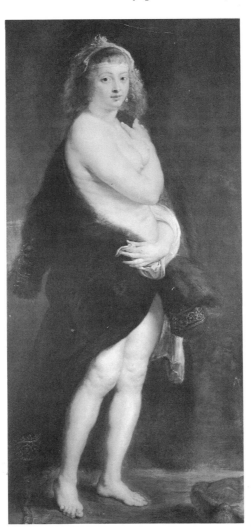

73. Peter Paul Rubens: *Hélène Fourment in a Fur Wrap ('Het Pelsken')*. Vienna, Kunsthistorisches Museum

loving and sensual study of the painter's mistress – who may well have been pregnant with his child at this very moment – in the guise of an Old Testament heroine or a goddess. This would have been an entirely acceptable mid-seventeenth-century artistic convention. In this respect the painting recalls *Het Pelsken* (Fig. 73), Rubens's famous portrait of his young, second wife, Hélène Fourment, shown in the guise of Titian's Venus, naked but for a fur wrap. Rubens's life-size canvas is powerfully erotic; Rembrandt's small panel also has an erotic mood, but it is also tender and even lyrical, painted with affection born of long companionship as well as sensual delight.

Technical description

The panel is a single piece of oak, grain vertical, the back edges chamfered as normal for a panel of this period. At some time the wood has split vertically along a line through the left eye and leg of the figure: the repair is imperfect and shows on the surface.

The ground, in common with the other panel paintings, is chalk with a thin warm brown *imprimatura* at the surface. This priming consists of yellow-brown earth pigment and a little umber combined with lead white, which shows a few quite large scattered nodules which protrude into the paint layer above (see Plate 50). The ground

Plate 50 Reflection in the water, lower left edge. Red lake glaze as a single layer over the chalk ground and thin yellow-brown *imprimatura*. A large aggregate particle of lead white occurs in the *imprimatura*. Cross-section, 335x.

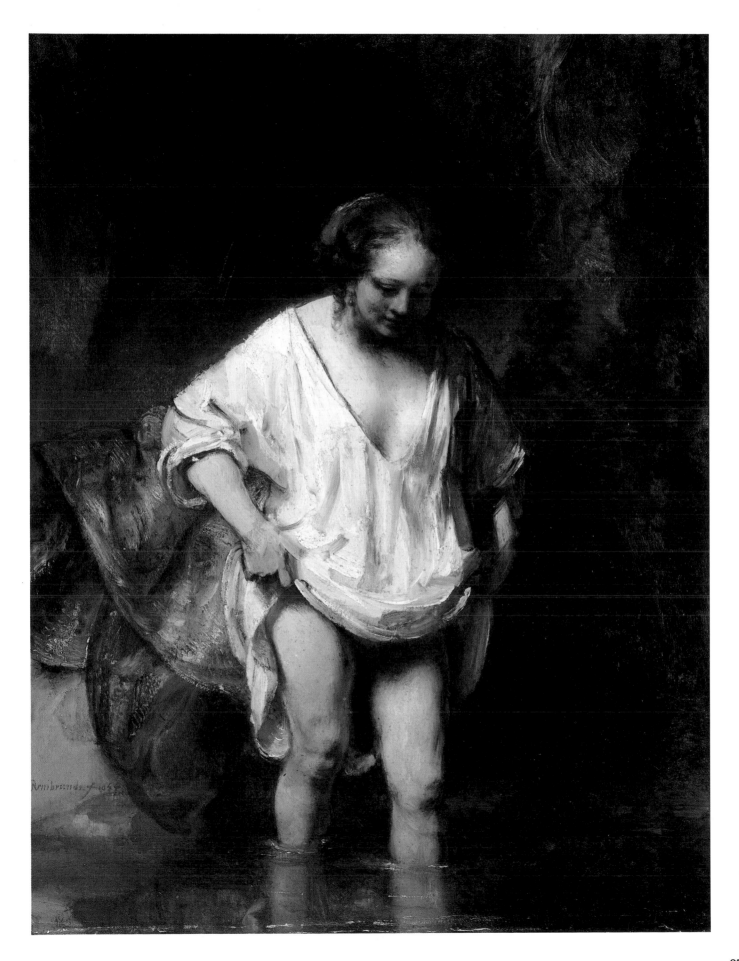

is clearly visible in many parts of the picture as a warm buff colour. Near the lower edge of the woman's shift, a whole curved strip is left unpainted and the preparation with the wood grain showing through can be studied directly (Plate 52): it can also be seen along the upper edge of the arm and around the hand. Elsewhere it is used as a warm light tone beneath translucent paint or between brushstrokes to suggest half-tones and form. The structure of the background is largely suggested by allowing the lighter colour to shine through swirling glazes of black and brown, an effect made dramatically clear by the infra-red photograph (Fig. 76). For example, to the left edge the thin dark brown shadows are a single layer of translucent black and brown pigment suspended in a matrix of red and yellow lake. Similarly, the transparent red reflection of the robe in the water is mainly achieved by a red lake glaze with red earth and yellow lake in small quantities. In the browner reflections the glazing mixture contains the same selection, but with the incorporation of a great deal more earth pigment of a variety of colours. For the opaque touches on the water's surface the ochre content of the paint predominates, and where it becomes very dark and crusty, the layer is mainly of bone black. The slightly thicker highlight strokes on background foliage are comparable in composition to the impasto of the foreground (see Plate 51).

The painting, at first glance, seems to be done entirely *alla prima*, wet-into-wet, at one go, and most of what we see was indeed painted at great speed with fluid paint and loaded brushes. However, there is evidence that many of the main shadows were sketched in first and had dried before the rest of the painting was done. A clear example is the wide reddish-brown strip along the bottom edge of the woman's shift extending into her

Plate 52 *A Woman bathing in a Stream.* Unpainted, curved strip near the lower edge of the shift

Plate 53 *A Woman bathing in a Stream.* Detail of the shift

Plate 51 Orange-yellow impasto highlight on background foliage containing yellow ochre reinforced with red lake. Cross-section, 160x.

left thigh, which was undoubtedly dry before the white material and the dark shadow of the leg were painted over it (visible in Plate 52). Similar dark sketching can be seen under the paint elsewhere, and this may well correspond to the so-called 'dead-colouring' stage which is said to precede the principal colouring. Indeed, the whole of the shadowed left sleeve appears to be unmodified dead-colour lay-in, with no superimposed paint layers at all except two diagonal highlights.

The painting of the woman's shift is a famous and outstanding example of Rembrandt's virtuosity in handling paint (Plate 53). The technique is direct and obviously broad, and appears deceptively simple: but the calculation of tone and texture is both complex and exact. The structure of the brushstrokes is clearer in the X-ray than on the picture itself: the light-coloured preparation hardly registers in the radiograph and we are seeing an image of the paint layers alone, unaffected by the lighter tone beneath (Fig. 74). We can see every movement of the brush with a freshness and immediacy that conjure up the very act of painting. Where the brush hit the panel, where it twisted, lifted, cut across a highlight to make a fold or a shadow, where a brush was loaded or dry – all can be read directly from the X-ray.

Surface examination of the shift shows

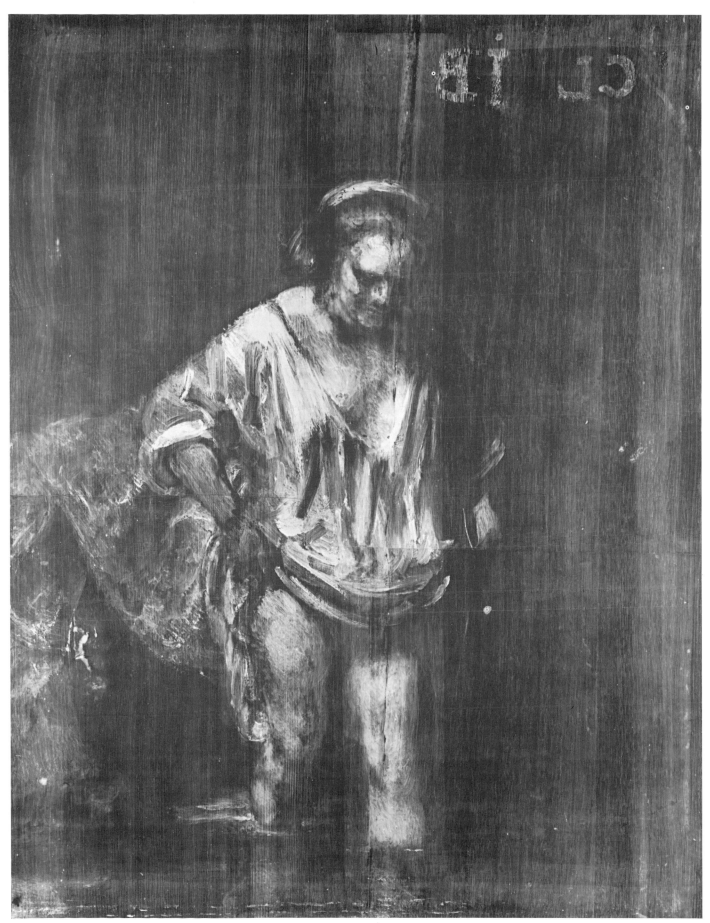

74. *A Woman bathing in a Stream*. X-ray mosaic

that some shadows were sketched in first (as described above), followed by a thick light grey and then the main colours. In many places, the brush seems to have been dipped into several shades of white, unmixed on the palette, and these differently coloured strokes show side by side. Some of the cool half-tones are mixtures of white and black; others are produced by allowing the warm brown underpaint to show through with a mauve effect. In some places the mauve is actually achieved by admixture of red. Deepest shadows are marked by strokes of pure black dashed into the still wet brush-strokes of white and grey.

The flesh paints are, in general, more smoothly worked in a conventional sequence: shadows first, followed by mid-flesh colour forming cool half-tones where it overlaps the shadows; then heightening with thick, more colourful flesh tones; and finally the darkest shadows applied very thickly with deep transparent blacks and browns. This is the overall sequence, but so rapidly done that, in places, darks and lights overlap almost randomly. Some of the pigment mixtures for flesh paint are rather complex: for example at the figure's left breast the main component of lead white is tinted with small amounts of charcoal black, red, yellow and brown earths, red lake pigment, vermilion and even traces of blue in the form of a few grains of natural azurite. The cool tone of her lower shin also contains a range of earths, brown and black mixed into the matrix of white. Beneath the surface paint at both points, cross-sections show an underlayer of similar composition but more muted tone, corresponding perhaps to the dead-coloured initial sketch (Plate 54).

The alternation of warm light tone, cool middle tone and warm shadow is observed fairly consistently. Only in two places are warm cast shadows directly adjacent to warm light colour, and it is instructive to observe

Plate 54 Flesh paint of the woman's shin in several layers. Cross-section, 415x.

75. *A Woman bathing in a Stream.* Detail of the right hand and wrist

how the recession into shadow fails to work at these points. One is where the shadow of the hand falls on the thigh and the other is where a narrow stroke of red-brown marks the shadow on the woman's right breast. Because Rembrandt was usually so careful to preserve the juxtaposition of warm against cool against warm, it is possible that there is some paint loss at these places.

There is, however, no paint loss at the woman's wrist, where the paint has been brushed and dragged with too dry a brush and the form is not completed (Fig. 75). This was thought at one time to be a damage across the wrist and was repainted last century by an overzealous restorer. The same restorer also remodelled the hand, giving it a more rounded, finished appearance. The repaint was removed when the picture was cleaned in

1946 and we now see Rembrandt's brilliant cursory modelling without 'improvements'.

The robe lying behind the woman is again painted with an apparently simple technique, but with great richness of effect. There are glazes of red and yellow lakes adjoining translucent blacks. The deep red lower layer appears again on top in places. Middle tones are of a cooler grey containing charcoal, lending a bluish tinge, and the brocade is suggested by a whole variety of irregular strokes and, finally, impasto lights of pure orange and yellow ochres.

Bibliography: HdG No. 306; Bauch No. 27B; Bredius/Gerson No. 437.

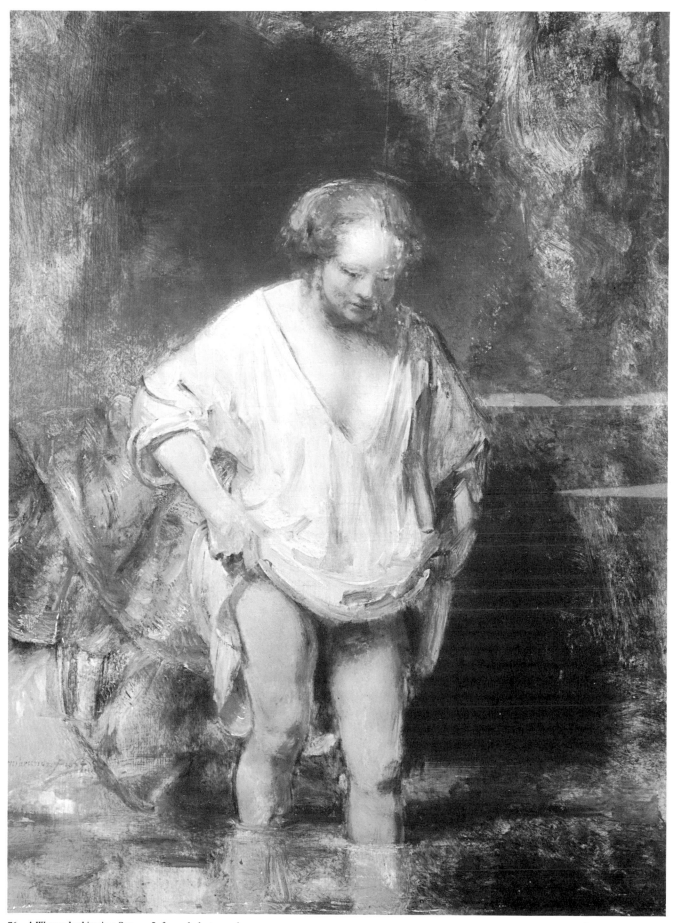

76. *A Woman bathing in a Stream.* Infra-red photograph

12.
A Franciscan Friar

Canvas, 89 × 66.5 (35^1/$_{16}$ × 26^3/$_{16}$)

Signed, right edge, centre: Rembrandt. f. 165[?]; although worn and faint, the signature and the first three figures of the date are legible by ultra-violet light

Rembrandt painted his son, Titus, in a Franciscan habit in 1660 (Amsterdam, Rijksmuseum; Fig. 77) and painted another portrait or study of a Franciscan in the following year (Helsinki, Ateneum; Fig. 78). Before the removal of thick brown varnish in 1952, the date on the present painting was not visible and the style hard to judge. It was grouped by Hofstede de Groot and Bredius with the other two Franciscans and so dated at about 1661. However, as MacLaren stated in his 1960 catalogue, it is certain that the third figure of the date is a '5' and the style would seem to be of around 1655/6.

Technical description

This is a damaged and much treated painting. Structurally it is on canvas marouflaged to a synthetic board: however, various signs suggest that it has in fact been transferred to a new canvas and that, in the process, part of the original ground seems to have been removed.

The paint surface has the typical appearance of a transferred picture: the fragile paint

Plate 55 Greyish-khaki background, left edge. Mixture of earth pigments, black and white over a thick dark underpainting. The dense upper layer of ground is original and contains lead white mixed with colourless glass particles. The lower layer in this sample is gypsum, and relates to the transfer of the picture. Cross-section, 375x.

layers have shrunk and collapsed into voids caused by the transfer process. Typically for a canvas painting, these follow prominent weave lines in the original, or weave faults in the new canvas. They can also be caused by

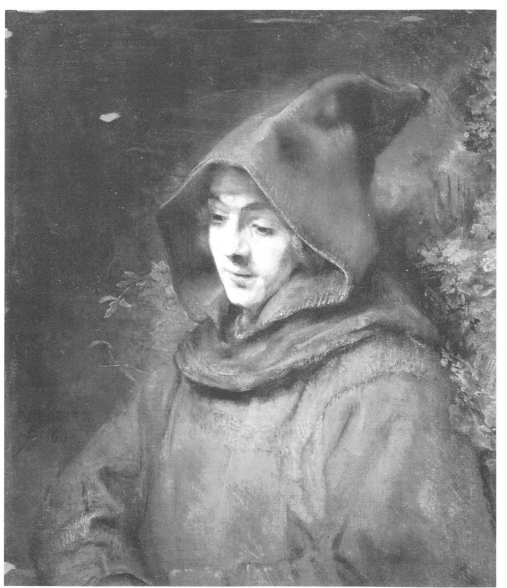

77. *Titus as a Franciscan.* 1660. Amsterdam, Rijksmuseum

imperfect application of the new ground on the reverse of the original paint or ground. Here they are principally horizontal and occur notably in the area of the head.

In each cross-section taken, beneath the first paint applications there lies a layer of granular lead white, containing a little colourless smalt (Plate 55). Under this lead white ground there is a further light-coloured

layer of gypsum (calcium sulphate dihydrate). However, at several points sampled, the interface between the two layers bears traces of orange-coloured earth pigment. Gypsum is not a material found in the original grounds of Dutch seventeenth-century pictures, and must represent a layer of additional ground or adhesive applied to the back of the surviving part of the original

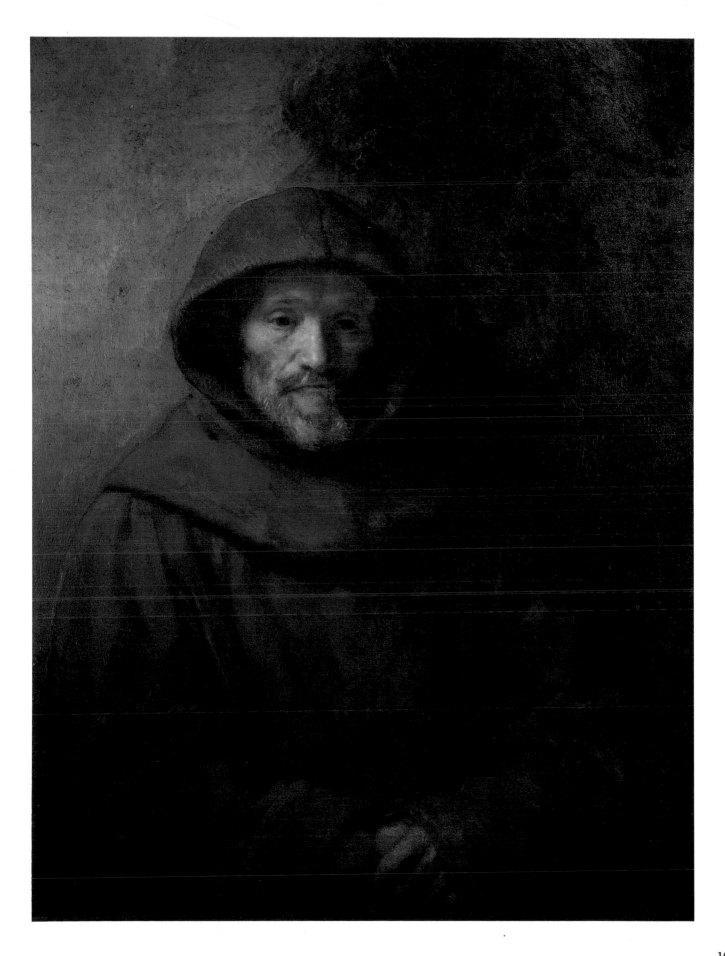

ground during the transfer to a new canvas support. It seems likely that the original canvas had a double ground, with orange-red earth for the lower layer, and the lead-white-containing layer over that. For the transfer, the lower orange ground would have been removed, but survives as vestiges here and there.

The X-ray image (Fig. 79) is confused and unhelpful, although the canvas weave visible in it is probably that of the original, its imprint preserved in what remains of the original ground layers. The ground layers are now very uneven and obscure most of the detail. Very little information regarding the paint layers can be derived from the radiograph, except for the presence of lead white in both the background and the figure.

The face is painted in opaque colours, all the modelling being on the surface. The mid-tones of the face contain lead white tinted with earth pigments, red lake and a little black. The highlights are quite flat with no impasto, but the radical nature of the transfer would probably have flattened any texture that may originally have been present. The mouth is painted in the usual dark line, applied last.

There is a *pentimento* in the hands: the left cuff has been painted over the back of the left hand. The hands are painted in a regular sequence, with a mid-brown lay-in, followed by the deepest shadows, and the relative lights finally brushed on top (Plate 56). For the fingers, the middle-tone reddish browns involve red and yellow ochres, red lake pigment, black and white in the lower and in the upper layers, while the shadow is rich in bone black, warmed with a little red lake and red earth pigment. Unusually, the brush-strokes of the hand cut across the form of the fingers, rather than follow along it.

Plate 56 Shadow of the hand, containing red lake, bone black and red earth, over a lighter tone with lead white in addition. A trace of the original orange-red lower ground layer, removed from much of the picture during transfer, is visible. Cross-section, 340x.

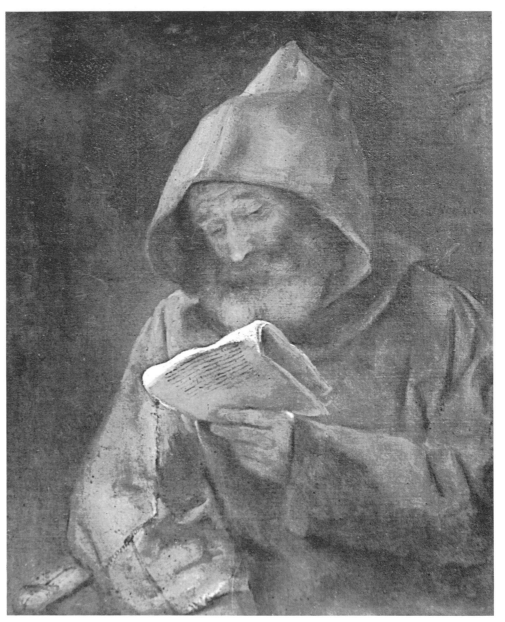

78. *A Franciscan Monk Reading.* 1661. Helsinki, Ateneum

A second *pentimento* is visible at the top of the cowl: it was at first a little higher, and the paint of the background has been continued across the outline. The habit is painted in a mixture of earth colours, bone black with red and yellow lakes. The paint above and to the left of the friar's head is the thickest remaining paint on the picture. The background at the right is badly damaged and heavily repainted, although the original glazing technique can still be assessed. In the darkest sections, a double glaze containing mainly bone black is used, with smalt in the lower layer and red earth in the upper layer. Where the background to the right becomes much warmer, the principal pigment is a red lake, darkened with a little black and containing a few particles of azurite as a drier.

The opaque light greyish khaki to the left comprises a mixture of lead white, Cologne earth, yellow ochre and black, over a thick, dark underlayer of black, mixed with a little red earth and white, and containing in addition traces of blue verditer (Plate 55).

Bibliography: HdG No. 191; Bauch No. 205; Bredius/Gerson No. 308.

79. *A Franciscan Friar.* X-ray mosaic

13.
Portrait of Hendrickje Stoffels

Canvas, 100 × 83.5 (40¼ × 33¾)

Signed (falsely?), lower left: Rembrandt f 16[5 or 6]9

Hendrickje Stoffels, who was born in 1625/6 or a little earlier, is first mentioned as a member of Rembrandt's household in 1649. She was employed as a nurse for Titus, Rembrandt's son by his marriage to Saskia van Uylenburch. She became the artist's mistress and their child, Cornelia, was born in 1654. Hendrickje remained with Rembrandt until her death in 1663. There is no documented portrait of Hendrickje Stoffels, but there are a number of paintings showing the same model which date from the time when she was living with the artist. The recurrence of this model and the affection and informality with which she is painted point to her being Hendrickje. There are at least four portraits and a painted study, in addition to the present painting, which show the same model. They are the portrait in the Louvre (Fig. 80), painted in the early 1650s and possibly a pair to the *Self Portrait* in

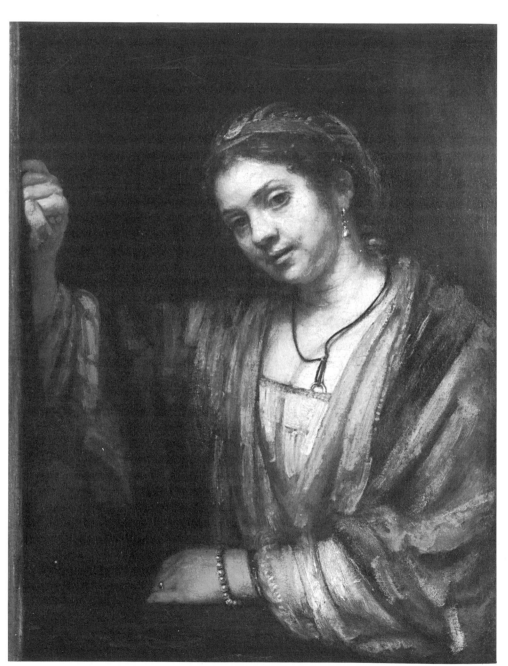

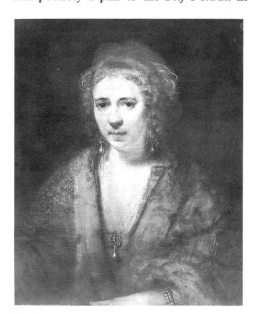

80. *Hendrickje Stoffels*. Paris, Louvre

81. *Portrait of a Woman leaning at an Open Door.* Berlin-Dahlem, Gemäldegalerie

Cassel which is dated 1654; the *Portrait of a Woman leaning at an Open Door* in the Gemäldegalerie, Berlin-Dahlem (Fig. 81), painted in the late 1650s; the portrait in the Metropolitan Museum of Art, New York

(Fig. 82), which is dated 1660 and is a companion to a *Self Portrait* in the same collection; and the study of *A Woman bathing in a Stream* of 1654 (No. 11 in this Catalogue). The painting bears a signature and a date in

the lower left-hand corner. After cleaning in 1976 three digits became legible: 16[]9. The third is either a '5' or a '6': there is damage at the point where the two are differentiated. The second date, 1669, the year of the artist's

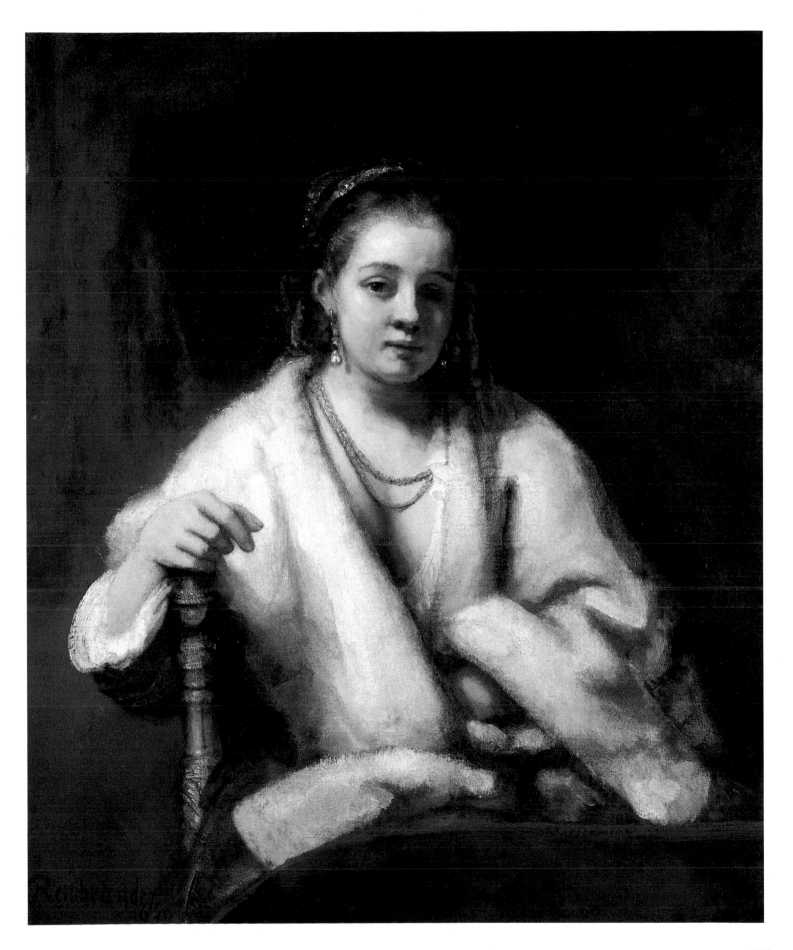

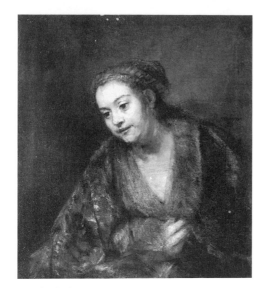

82. *Hendrickje Stoffels*. 1660. New York, Metropolitan Museum of Art

death and six years after Hendrickje's death, is impossible on stylistic grounds. The former, 1659, is possible. The signature, however, is too large and uncharacteristically formed in comparison to other signatures of the 1650s. The most likely explanation is that the signature is not authentic, but was added to the painting later, probably in the late seventeenth or early eighteenth century.

Stylistically the painting belongs to a group of three-quarter-length painted and etched portraits of the 1650s; in the 1651 etched portrait of *Clement de Jonghe* (Fig. 83) and the 1652 painting of *Nicolas Bruyningh* at Cassel (Bredius 268) Rembrandt can be seen experimenting with the three-quarter-length

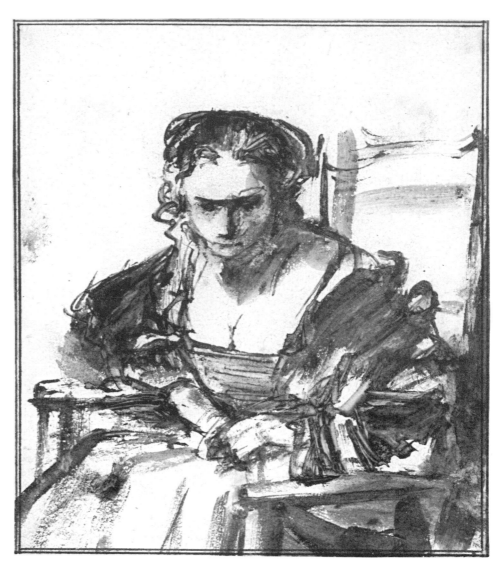

84. *A Seated Woman*. Drawing. London, British Museum

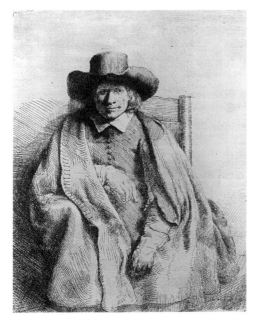

83. *Clement de Jonghe*. 1651. Etching, first state. London, British Museum

pose and the complex spatial relationship between sitter, chair and picture space. Other near-contemporary examples of this portrait format are the etched portraits of *Jan Lutma* and *Arnold Tholinx*. It seems likely that it was about this time that Rembrandt painted Hendrickje in the present informal portrait. The radiograph, which is discussed in detail below, shows significant changes in the pose and the position of the hands. A drawing in the British Museum (Fig. 84) shows a woman seated in a chair, leaning slightly forward, her hands clasped together in her lap. This drawing which, it has previously been suggested, may represent Hendrickje, has been dated 1655/6. A comparison of the drawing with the radiograph of this portrait makes it possible that the drawing shows an early stage of the composition of the painting. It would seem, therefore, that a reasonable date for the

present painting would be between 1654 and 1656, when the sitter was aged 30 to 32. It should be stressed that this is hypothetical and it is possible that the date 1659, although added by a later hand, has some basis in fact. The painting must date from before 1660: the portrait in the Metropolitan, which in style and technique has striking similarities to this portrait, shows that by 1660 Hendrickje had aged markedly.

Certain formal aspects of the painting remain difficult to clarify: the precise nature of the material of Hendrickje's wrap, the table sketched in the right foreground and the background. These are clearly unfinished, although it may be asked whether they were ever intended to be finished in view of the informal nature of the portrait.

Technical description

The canvas weave, faintly visible in the X-ray

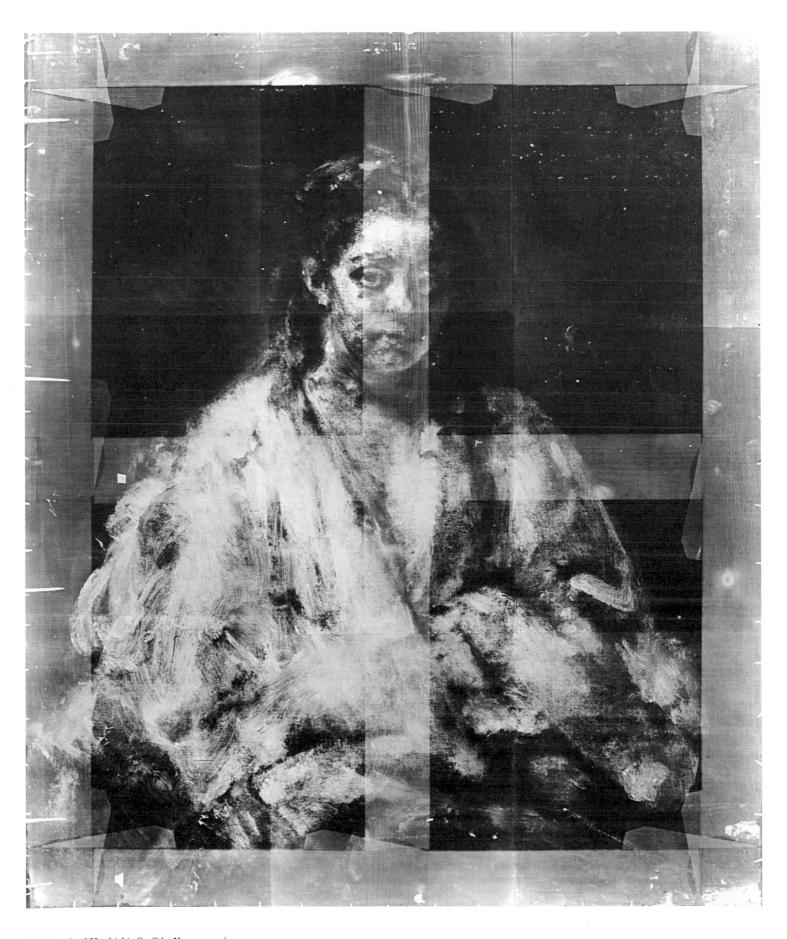

85. *Portrait of Hendrickje Stoffels.* X-ray mosaic

against the stretcher bars, is fine and regular. The possibility cannot be excluded that it is a transfer canvas, but there is no real evidence that it is.

The image of the support in the radiograph is faint because the ground is rather transparent to X-rays. The ground consists of a mixture of quartz (silica) and small amounts of brown-coloured ochre and lead white (Plates 59 and 60). It is closely similar in constitution to the ground layer in the *Self Portrait at the Age of 63* (Cat. No. 20) and *Portrait of Frederik Rihel on Horseback* (Cat. No. 19).

The dark brown colour of the ground is clearly visible in many parts of the painting, notably in the lower part of the white wrap (Plate 57). It plays a significant role in the overall tone of the picture – partly because the picture is unfinished, but perhaps now more than originally intended, since the paint layers are quite worn and thin in some areas. In fact, the condition of the picture is an important factor here in our interpretation of its technique, because the overall wearing, cracking and subsequent retouching of the paint layers all affect the image to some degree and alter our perception of the way the image is constructed.

The X-ray of the whole portrait (Fig. 85) shows distinct phases in the evolution of the composition. The X-ray can be divided essentially into two parts: Hendrickje's head, shoulders, and left side form a coherent image echoing closely the visible portrait. The structure in these areas is clear and conforms reasonably well to a typical Rembrandt foundation. The X-ray image of Hendrickje's right arm and hands is, by contrast, a confused swirling mass of broad, light strokes quite unrelated to the visible painting but overlying a more coherent structure: clearly some major reworking has occurred in this area.

It seems that Rembrandt originally painted Hendrickje with folded arms or with hands clasped in her lap as in the British Museum drawing. The left arm was across the body, as now, but not tucked into the wrap. The right arm dropped vertically from the shoulder and folded across to link with the left. This would have resulted in a rather slumped pose, and Rembrandt clearly decided to open up the figure by moving the right hand up and outwards, introducing the arm of the chair to support it, and to conceal the left hand within the folds of the wrap. In making these alterations, he seems to have

Plate 57 *Portrait of Hendrickje Stoffels.* Detail of the white wrap

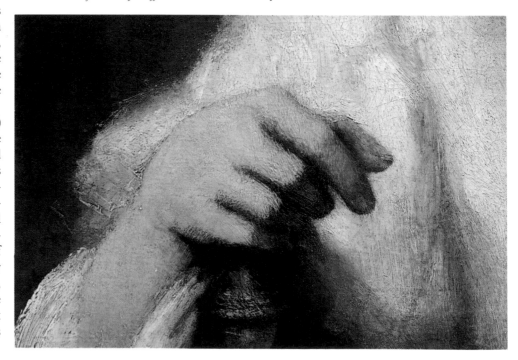

Plate 58 *Portrait of Hendrickje Stoffels.* The right hand and arm

obliterated the original image with vigorous scrubbed brushstrokes of lead white and then painted the present design on top. Even the most cursory inspection of the picture surface shows the broad brushstrokes of the obliterating paint underlying the right hand and the arm of the chair (Plate 58). A cross-section from a golden-yellow highlight on the arm of the chair shows the thick initial lay-in of lead white directly over the ground from this earlier stage of the composition (Plate 59). Some part of the chair, however,

was clearly meant to be shown in the first design since paint containing lead-tin yellow, with no intermediate layers, is present beneath the lilac patch of Hendrickje's dress (Plate 60).

Once this sequence of construction is realised, the X-ray becomes straightforward. The X-ray image of the face is perfectly unambiguous, although broken up by severe cracking. The lights of the forehead, nose, cheeks, eyelids, lips and chin are laid in with lead white lightly tinted with vermilion

Plate 59 Highlight of yellow ochre on arm of the chair, passing over a warm brown underlayer for the chair. Beneath this is a thick layer of pure lead white laid over the brown coarse-textured 'quartz' ground, representing the initial arrangement of Hendrickje's sleeve or arm. Cross-section, 190x.

directly on to the brown ground (there is no evidence of any underdrawing or lay-in underneath). Beneath the cool pink paint of the flesh, as the shoulder passes into shadow at the edge of the wrap, there is an area of translucent brown made from Cassel earth, white and black, over which the lighter tone is worked; but the dark layer is not a general feature of the flesh painting. The appearance of the eyes in the radiograph is slightly unusual. Rembrandt seldom left such a pronounced oval around the eyelids as here – usually the construction is more subtle. But comparison with the somewhat fainter image of the right eye in the *Self Portrait at the Age of 34* (see Fig. 68, p. 83) shows a similar, if narrower, continuous dark oval.

The ground colour is not much used in the face, except for parts of the shadowed side. Around the eyes, the shadow and half-tone is apparently all achieved on the surface, although it should be pointed out that there is a good deal of retouching here.

The right hand and arm are also worn and retouched, but their flat and unconvincing

Plate 60 Lilac patch of Hendrickje's dress, lower left, containing red lake, charcoal and white, over a layer of lead-tin yellow belonging to the initial painting of the chair. The 'quartz' ground is visible as the lowest layer. Cross-section, 200x.

shape cannot be ascribed solely to condition. They provide a telling demonstration of how tonality must be manipulated in order to suggest recession and form. Painted at a late stage in the composition, they appear to have almost no half-tones between light and shadow, and there is no variation in tone as the arm recedes (see Plate 58). This gives the effect of flatness, and the arm appears not to project from the sleeve but to lie in front of it. Some of this is undoubtedly due to wearing, but Rembrandt has clearly not worked at the form of this late alteration in as detailed a way as on the head – which, despite its worn state, has a more realistic structure.

The *Portrait of Hendrickje Stoffels* displays some rather striking uses of colour. The tablecloth in the foreground is represented with a warm brown underlayer similar in colour to the densest parts of the background, and contains a mixture of earth pigments, a little white, red lake and black; it is then glazed with a thick layer of mixed crimson-coloured and yellow lake pigments.

Plate 61 Detail of the opaque red highlight on the tablecloth of orange-red ochre reinforced with red lake pigment. Cross-section, 450x.

In the darkest shadow to the left, black is incorporated into the upper layer. Analysis suggests the red lake component probably to be based on cochineal, but the yellow lake remains to be identified. The opaque red highlight that marks the edge of the table-cloth is painted in a thick streak of pure orange-red ochre intensified by admixture with further transparent red lake pigment (Plate 61), anticipating the technique used for the most powerful reds in *Frederik Rihel on Horseback*.

The muted lilac of Hendrickje's dress is an unusual colour for Rembrandt, and although a violet tone might be expected to contain a mixture of red and blue pigment, the paint actually consists only of a mixture of lead white, charcoal black and red lake. The mauve colour results from the bluish reflec-

Plate 62 Opaque orange-brown background, left edge, painted in two layers. The paint mixture makes use of earth pigments with red lake and black, with a greater proportion of the translucent pigments in the upper layer. Cross-section, 390x.

tion of charcoal combined with white, together with the reflection of red light by the lake pigment. This technique for a violet or purple-coloured pigment mixture is also known for paintings by Rubens and Van Dyck; no pure violet pigments were available in the seventeenth century. The bluish cast of wood charcoal when mixed with white is exploited here in the bluish-grey tones of Hendrickje's wrap and the cuff of her sleeve.

The light-coloured reflections on the arm of the chair are in small dabs of pure yellow and orange ochres, with lead-tin yellow for the palest touches.

The opaque part of the background is painted in two layers: underneath, a hot orange-brown mixture of red and yellow ochres, red lake pigment and a little black; over this, a layer of the same kind, but richer and more translucent owing to a higher proportion of lake pigment (Plate 62). In the darker background to the right, only a single translucent layer of red lake pigment, earths and black passes over the 'quartz' ground. The construction of these layers is remarkably similar to that of the background structure in *An Elderly Man as Saint Paul* (Cat. No. 15).

Bibliography: HdG No. 715; Bauch No. 521; Bredius/Gerson No. 113; C. Brown and J. Plesters, 'Rembrandt's Portrait of Hendrickje Stoffels', *Apollo*, vol. 106, 1977, pp. 286-91.

14.
A Bearded Man in a Cap

Canvas, 78 x 66.7 (30¾ × 26¼)

Signed, left, below the level of the shoulder:
Rembrandt. f. 165 [7?]; the last digit is covered
by a *pentimento* of the outline of the right arm

As with other studies of this kind by Rembrandt, the sitter has been described as 'A Jewish Rabbi'. In the present case, this title cannot be traced farther back than 1844, and in 1798 the picture was simply described as 'An Old Man's Head'. The man may possibly be Jewish and is bearded; there is no other reason for supposing him a rabbi. The same man may have served as the model for other paintings by Rembrandt and his pupils, for example, in *Aristotle contemplating a Bust of Homer* (New York) of 1653 (Fig. 13)

and *A Bearded Man* (Leningrad) of 1661 (Fig. 86).

The date has often been read as 1657, but the last digit is not legible. Its resemblance to a '7' is an effect due only to a brush mark in the overlying paint. The minute portion of the digit now visible could only be the top of the horizontal stroke of a '3' or a '7'; judging by the placing of the digits in the dates on Rembrandt paintings of 1653 and 1657 it could be either. 1657 is more acceptable on stylistic grounds.

Technical description
The canvas on which *A Bearded Man in a Cap* is painted is heavily cusped at the left and right edges, with very little cusping at the top and bottom. This suggests that the canvas was stretched tightly from side to side when being primed, with rather little tension in the vertical direction. It is possible that this may be an example of a canvas cut from a primed length stretched between two long battens and loosely secured at top and bottom.

The picture has a double ground with an orange-red ochreous underlayer containing many coarse silica particles, and an upper priming of lead white tinted with umber (see Plate 63).

The dark sand colour of the upper ground layer is visible at several points in the face – for example around the sitter's right eye – and also showing through the dark background at the upper right, where it is thinly covered by a glaze of bone black with a little red earth and red lake pigment. These sombre glazes also contain small amounts of fine pale-coloured blue verditer (artificial azurite), mixed in probably as a drier. The more solid mid-brown of the upper left quadrant has a second layer of bone black over a warm version of the glaze to the right.

The picture is painted very directly with no significant *pentimenti* other than minor adjustments of outline, such as that which hides the last digit of the date. The technique is quiet, with few of the flourishes that characterise portraits from other periods. This is made clear by the X-ray (Fig. 87), which yields little information: the whole image is dominated by the dense ground filling the weave of the relatively coarse canvas. The only feature of the paint layers that shows clearly is the dense highlighting of the nose and cheek – and these are almost the only pastose parts of the entire picture. Here the flesh paint comprises a single application of lead white combined with yellow and red earth colours and just a little vermilion (Plate 63). Subsequent adjustments to the shadows

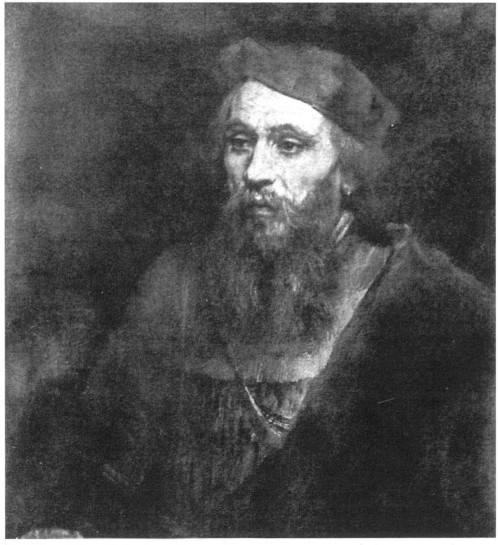

86. *A Bearded Man.* 1661. Leningrad, Hermitage

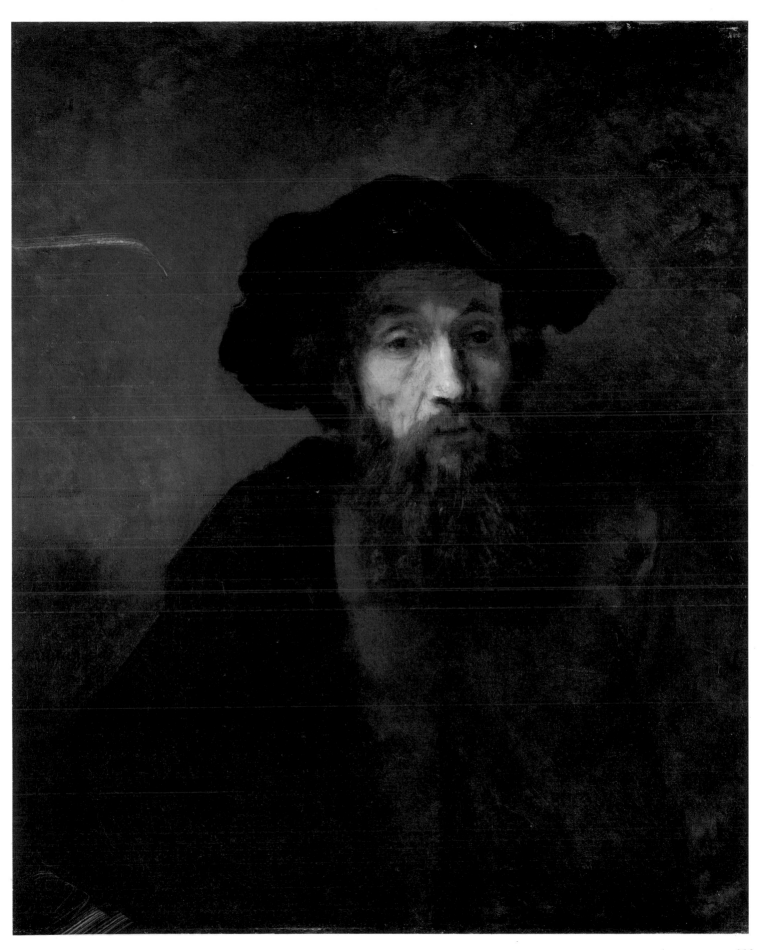

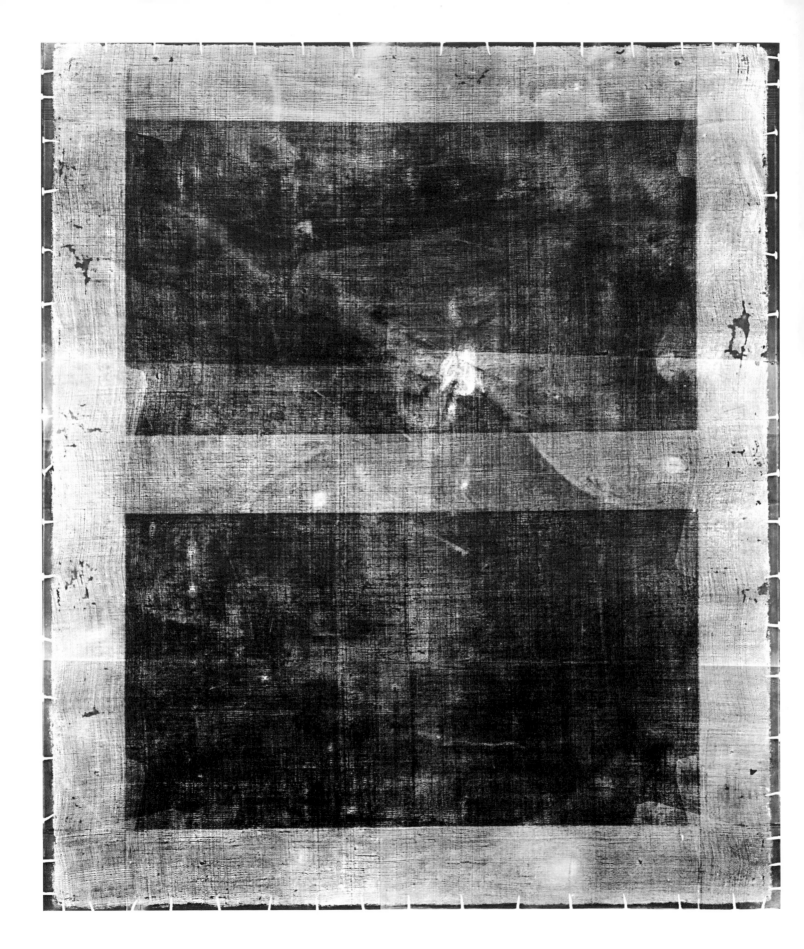

87. *A Bearded Man in a Cap.* X-ray mosaic

114

Plate 63 Single layer of flesh paint for the cheek over the double ground. Cross-section, 185x.

of the cheek to the left are made in the same paint enriched by a brownish-red lake pigment. The rest of the face is painted very smoothly, in a conventional sequence: the main shadows are sketched in a warm brown, followed by the duller mid-flesh tone which barely registers in the X-ray, with the highlights and deepest shadows applied last. The palette is controlled and limited, the only colourful touches appearing on the cheek and moustache.

The cap and coat are painted directly and simply in pigment mixtures which closely correspond to the composition of the darkest background colours. Bone black has been identified as the principal pigment, but some warmth and depth are lent to the dark-coloured paint by admixture with small amounts of red lake and red ochre. The more solid greenish grey of the sitter's tunic combines yellow, red and brown earth pigments with black and a little white. The background passes under the cap for a little way and the final outline is modelled over it.

Bibliography: HdG No. 392; Bredius/Gerson No. 283.

15.
An Elderly Man as Saint Paul

Canvas, 102 × 85.5 (40⅛ × 33⅝)

Signed, right, on the level of the head: Rembrandt / 165[9?]

In a roundel in the top corner is Abraham's Sacrifice (in monochrome)

The picture may have been cut down a little on each side. The present left edge touches on the figures in the roundel in the top right-hand corner, and on the other side the last letter of the signature is rather near the edge of the canvas and there is no room for the 'f' which Rembrandt nearly always puts after his name on paintings. There is wearing in the roundel in the top right-hand corner and in the hands. A small damage above the sitter's left eye was repainted in 1972.

The book and the sword are the usual attributes of Saint Paul, symbolising the word of God and the saint's martyrdom, and are introduced in Rembrandt's other pictures of Saint Paul, for example those in Stuttgart and Nuremberg. The roundel of Abraham's Sacrifice (Fig. 88) is additional evidence of this identification, as it often

88. Detail of the roundel in *An Elderly Man as Saint Paul* showing the Sacrifice of Isaac

appears as a prototype of the Crucifixion and is used as such in Saint Paul's discourse on the nature of faith in his Epistle to the Hebrews (11:17).

The roundel is very summarily painted but is sufficiently clear to show that the

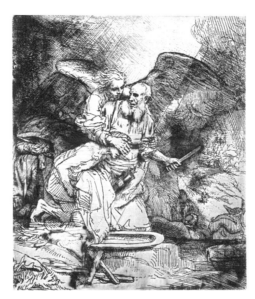

89. *Abraham's Sacrifice*. 1655. Etching, first state. London, British Museum

composition is based (in reverse) on Rembrandt's only etching of the subject, which he made in 1655 (Fig. 89). The date on the painting should probably be read as 1659. All that remains of the last digit resembles a '0' but there is a mark at the bottom of it to the right which is almost certainly the beginning of the downstroke of a '9'. The style accords well with securely dated works of the late 1650s. Gerson pointed to 'some obvious weak parts in the picture (the modelling of the hands, the unbalanced colour scheme), due either to heavy wear or to the fact that the picture is only an old copy'. There is, as has been stated above, wearing in the roundel in the top right-hand corner and in the hands. However, Haak, by contrast, considers it the best of the group of half-length apostles and saints from the years around 1659/60. As will be seen, there are no technical reasons for thinking this fine half-length apostle to be anything but an original painting by Rembrandt.

Technical description

The X-ray image of the painting is dominated by the fairly irregular medium-weight canvas weave. Study of the cusping indicates that it may have been trimmed a little at the bottom as well as at the sides (see above), but not by a significant amount.

The weave is made visible in the X-ray (Fig. 90) by the ground, which contains lead white in both layers. The picture is unusual among the National Gallery Rembrandts in having a double ground with a brown rather than reddish-orange underlayer, and a fairly thick upper layer of greyish brown. The first ground is composed of lead white, umber and black, while the second contains granular lead white mixed with coarse wood charcoal and a little umber (Plate 64).

The half-length portrait is technically similar to others of the late 1650s. The whole painting is carried out simply and directly. Only the head is emphasised by vigorous, textured brushwork: all the rest, including the hands, is flat, quiet, understated.

The head – and presumably the rest of the figure – was laid in with a brown sketch on the grey upper ground layer. This can be seen at the edges of the shadows below the sitter's left eye, in which the ground is left exposed. On top of the lay-in, the head was built up with rapid thick strokes of dense paint, first establishing the broad lights, then adding the detailed structure and finally the highest lights on cheeks, nose and eyelids (see Plate

Plate 64 Detail of the double ground. The lower brown layer contains umber, and the greyish brown upper layer incorporates splintery particles of charcoal black and large aggregate particles of pure lead white. Cross-section, 400x.

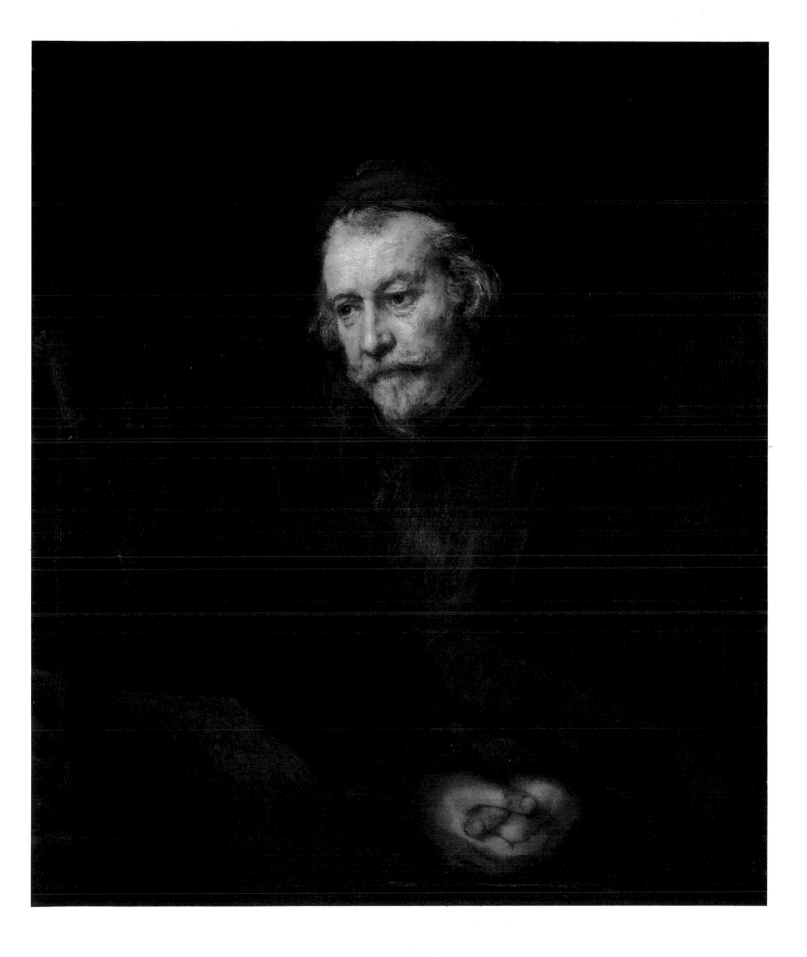

Plate 65 Warm shadow over the eyebrow. Lead white tinted with earth pigments at the surface. The double ground is visible. Cross-section, 175x.

65). In cross-section some intermediate darker paint is present beneath the highlights where they are adjacent to the shadows. Apart from lead white, the tinting pigments for the flesh seem exclusively to be finely ground earth pigments of reddish brown or brown. The profile at the left is seen to pass over the adjacent hair, and so must have been one of the final adjustments to the shape of the face. The fact that the X-ray image corresponds so closely with the painted image shows us that the head was worked up without any hesitation or alteration: even the darks of the eyes and the shadows of eyelids, nose and mouth were determined with total precision from the moment of the first lay-in.

The composition of the paint shows that similar warm glazing mixtures were used in the background darks, the cover of the book (Plate 66) and the figure's fur-edged robe. For the rich, deep semi-translucent reds and browns, combinations of bone black and red lake pigment, with added red ochre, form the basic mixture, with the proportions of the pigments varied to provide greater or lesser depth of colour and translucency. The hottest, most opaque browns, for example in the cover of the book, contain vermilion in addition (Plate 67), while some of the darker rich semi-transparent blacks contain quanti-

Plate 66 Warm deep brown translucent paint of the cover of the book, lower left. A semi-glazing mixture containing lake pigments, red and yellow earth and bone black is used. Cross-section, 300x.

ties of poor-coloured smalt and a high proportion of bone black.

The system for the warm brown glazes is very close to that used in *The Woman taken in Adultery* (Cat. No. 9); there, however, the paint is very thinly applied in the background depths. In the *Elderly Man as Saint Paul*, although not rivalling the heavy applications for the flesh of the face, the translucent paint layers are rather thickly worked – particularly in the very dark paint where coarse, neutral-coloured glassy particles of smalt are present in large amounts. The smalt was probably incorporated to bulk out and give body to the paint film, but it may also have been added for its siccative effect where pigments which do not dry well in oil, such as bone black and the red lakes, are used. Smalt with bone black and red lake are the main pigments in the very dark glazes to

Plate 67 Dark golden-brown cover of the book. The upper layer contains earth pigments and black with added vermilion. The darkest undermodelling layer combines bone black with pale-coloured smalt. Only the upper grey-brown ground layer is present. Cross-section, 165x.

the right edge, in the concealed background beneath the cover of the book to the left edge (Plate 67), and in the deepest shadow glazes on the book's cover. The use of smalt in this manner is comparable to the construction of glazes for the backgrounds and costumes in the later portrait pair of *Jacob Trip* and *Margaretha de Geer* (Cat. Nos. 16 and 17). The warmer reddish-brown glazes contain small amounts of pale blue azurite, in insufficient quantities to modify the colour of the red, black and brown transparent pigments with which it is mixed. It is presumably included as a drier, in the way that smalt is used for the translucent blacker paints. These intense semi-glazes pass over rich mid-brown underlayers, for example in the robe, which are made up of more opaque mixtures of earth pigments, red lake and some white. The lower body-colour layers for the surface glazes are in turn under-

painted in thin translucent browns which lie directly over the brownish-grey upper ground.

The only touches of a higher key other than in the flesh paint are provided by fairly pure strokes of earth pigment, for example in the cap, which makes use of red and brownish-yellow ochres at the surface.

The only alteration of any significance is at the collar, where originally more white material seems to have been visible. To concentrate attention solely on the head, Rembrandt glazed it out to leave just a thin white highlight below the chin.

The hands do not have any of the raised, broken impasto of the face: they are, by contrast, painted in an entirely smooth manner. It is possible that there is some wearing of the paint here which may make them a little weaker than they were originally, but clearly the contrast in texture was deliberate.

Bibliography: HdG No. 291; Bauch No. 224; Bredius/Gerson No. 297; B. Haak, *Rembrandt: His Life, His Work, His Times*, London 1969, p. 298.

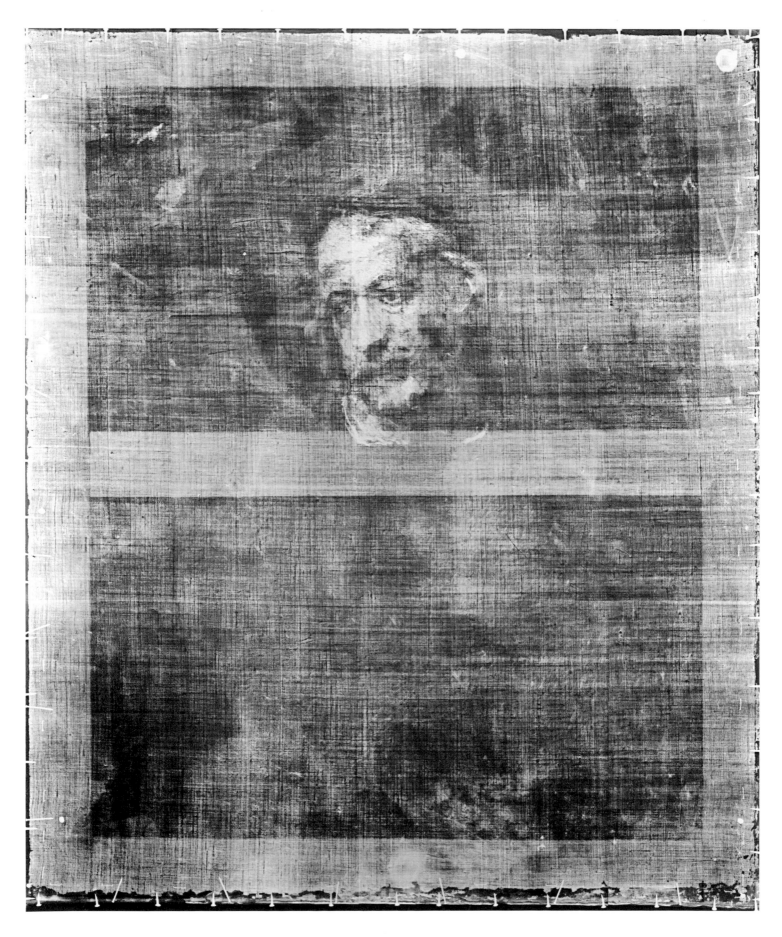

90. *An Elderly Man as Saint Paul.* X-ray mosaic

Portrait of Jacob Trip

Canvas, 130.5 × 97 (51⅜ × 38¼)

Signed, on the right, a little above the level of the sitter's left hand: Rembr (interrupted by the present edge of the canvas); the signature, which is certainly genuine, is fully visible only in ultra-violet light.

Jacob Jacobsz. Trip (1575-1661) was an immensely wealthy Dordrecht merchant. He had settled in the town when he was a child, and in 1603 he married Margaretha de Geer. His brother, Elias, and his brother-in-law, Louis de Geer, were in business together as ironmasters and armaments manufacturers, and after 1626 Jacob played a key role in the enterprise. Two of Jacob and Margaretha's sons, Louis and Hendrick, were also successful armaments dealers based in Amsterdam and the Trippenhuis (Fig. 91), a palatial house on the Kloveniersburgwal with a richly decorated facade of seven bays dominated by a giant Corinthian order, was built for them by the classical architect Justus Vingboons between 1660 and 1662. It has recently been argued by Dudok van Heel that the National Gallery's portraits of Jacob and Margaretha Trip were commissioned from Rembrandt by the two sons to hang in the Trippenhuis. A date of about 1661 is likely on stylistic grounds. Jacob Trip died in Dordrecht in May 1661 and it is unclear whether or not the portrait was begun before his death. There is a marked difference between the two portraits: his is a hieratic image, hers an animated study. It seems quite possible, therefore, that the portrait of Jacob was painted not from life but from another portrait. Jacob and Margaretha were often painted by Dordrecht artists, among them Aelbert Cuyp (Fig. 92) and Nicolaes Maes, but the most likely prototype would seem to be a portrait of 1651 by Jacob Gerritsz. Cuyp which today is in a private collection in New York.

Trip and his wife spent their lives in Dordrecht, but one or both of them presumably sat to Rembrandt in Amsterdam. Rembrandt had had an earlier contact with the Trip family, having painted Alotte Adriaensdr., the widow of Jacob's brother Elias, in 1639 and her daughter Maria Trip in 1639, portraits which today are respectively in the Boymans-van Beuningen Museum, Rotterdam, and the Rijksmuseum, Amster-

91. *The Trippenhuis, Amsterdam.* Engraving by Jan Vingboons

dam. The Trip family was one of the richest in Holland and these large-scale formal portraits, quite possibly destined for the grandest private residence in Amsterdam built in the newest classical style, were a major commission. They attest the continuing popularity of Rembrandt as a portrait painter in Amsterdam in the last decade of his life.

Technical description

The truncated signature at the right edge and the lack of cusping indicate that the canvas has certainly been cut down on the right, possibly by about 5 cm. The partial cusping at the top and bottom, visible in the X-ray (Fig. 93), suggest that these edges have been trimmed too, but not by so much. Allowing for turnovers, the original width of the canvas could well have corresponded to the standard '1½ ell' measurement. The canvas has the same slightly uneven weave as that used in the companion portrait, but does not have the same prominent weave fault as found there.

The canvas is prepared with a double ground comprising a rather coarse-textured lower layer of orange-red earth pigment, covered by an upper layer of dull khaki. Both layers are rather heterogeneous, with silica particles and small quantities of red lake pigment in addition to the main ochreous component in the lower, and a mixture of coarse lead white, chalk, yellow ochre, umber and charcoal in the upper ground (see Plate 68). There are three factors which suggest that the grounds for this portrait, and its companion, *Margaretha de Geer* (Cat. No. 17), were applied in Rembrandt's studio, rather than the canvases having been

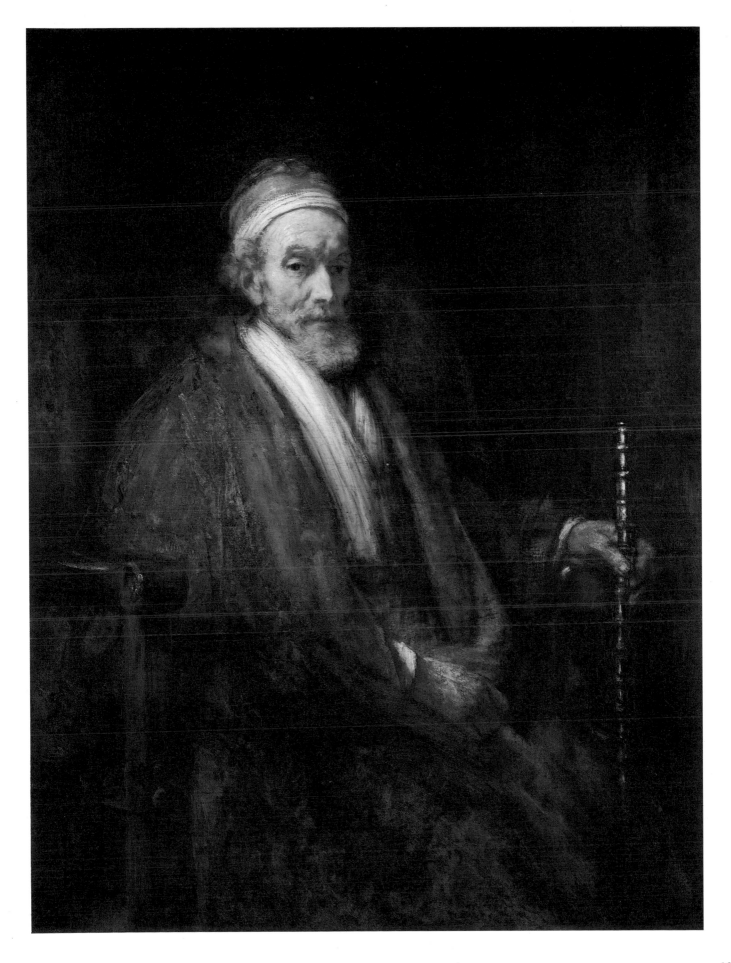

obtained ready grounded. The inclusion of red lake in a red earth lower ground is unlikely to have been a commercial practice, since lakes, particularly the reds, were costly pigments and would have had no function in a layer intended to be entirely concealed. It is more probable that the lake pigment is an accidental contaminant arising from the activities of a busy – and dusty – studio. Secondly, the interface between the two ground layers, as well as that between the upper ground and the lowermost paint layers, can be seen in cross-sections to merge together, suggesting that each layer was not entirely dry when the next layer was applied (Plate 68). Perhaps Rembrandt was pressed for time in painting these commissions. In the majority of double grounds the junctions are quite sharp and distinct. Most significantly, there are layers of paint in the portraits which are identical in colour, texture and, by analysis, chemical composition to the upper khaki ground layer, suggesting these to have the same origin – that is, in Rembrandt's studio.

Plate 68 Double ground structure, with orange-red below and dull khaki above. Note the red lake pigment particle in the lower ground layer. Cross-section, 170x.

The upper ground layer is not used directly as a visible tone in the finished painting, since it appears to be covered in all areas with a further layer or layers similar in colour. It is this tone that Rembrandt is using as the basis for his mid-tone throughout the painting. It can be seen unmodified in the brown area below Trip's beard, between the sides of his shirt and, in the usual way, around the eyes (Plate 70). It also forms much of the shadowed side of the face. Rembrandt has therefore used a much more economical style of painting here than in the companion *Portrait of Margaretha de Geer*, in which the brown underlayer is hardly exploited at all in the build-up of the face. Jacob Trip's hands, too, make use of dull greyish-brown and dark brown underpaints, which

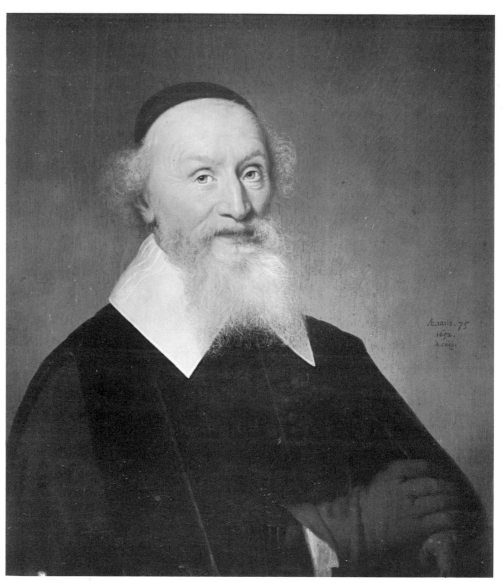

92. Aelbert Cuyp (1620-1691): *Portrait of Jacob Trip*. 1652. Amsterdam, Private Collection

form the shadow structure, and can be seen through the touches of light-coloured impasto of lead white mixed with earth pigment dabbed on top (Plate 69).

The texture of the paint in the male portrait is more direct, more fluid than in the female portrait, although both make use of an unusual mixture of yellow and red lake pigment, bulked-out with poorly coloured smalt, to create ridges of translucent dark impasto. In *Jacob Trip* the technique is applied to the bolster on the chair (Plate 71); in *Margaretha de Geer* it is the textured fur edging to her robe which is built from glazing pigments laden with smalt (see Plate 76). The fur lining and deep red-brown material of Jacob Trip's cloak are similarly worked, but the paint is less thickly elaborated than in his wife's portrait.

These subtle differences in handling and

build-up between the two portraits give an instructive and cautionary lesson in interpreting Rembrandt's technique. They do not, of course, imply that the two portraits are by different hands or are not a pair: they

Plate 69 Middle tone of right hand over shadow underlayers. The surface paint is lead white with a scumble of earth pigment. Incomplete layer structure. Cross-section, 160x.

122

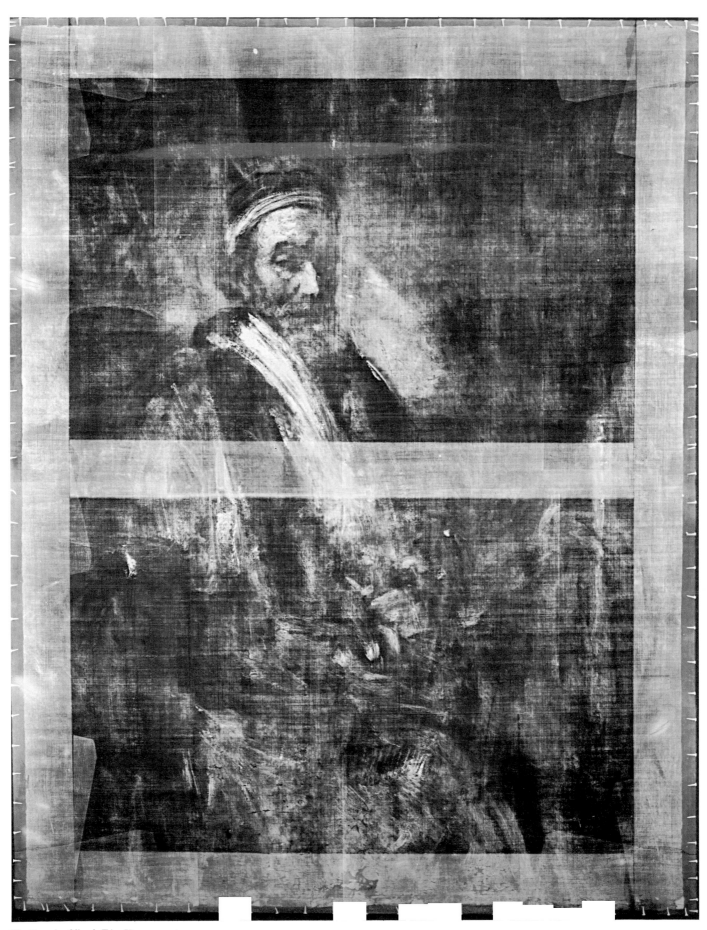

93. *Portrait of Jacob Trip*. X-ray mosaic

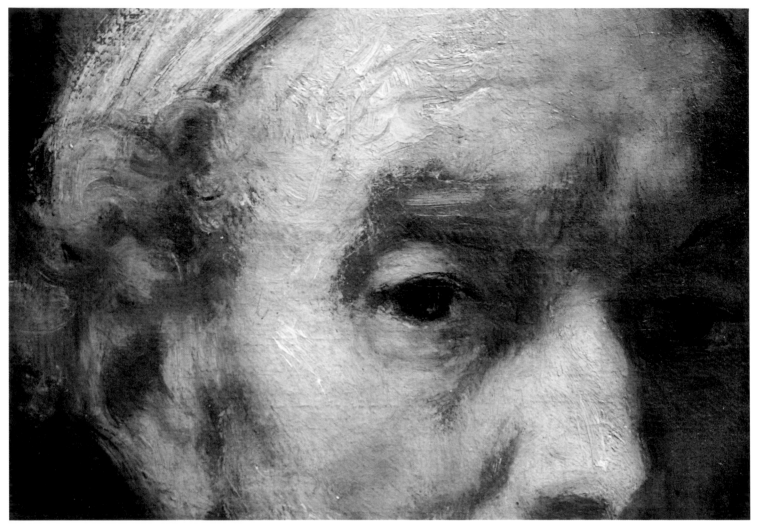

Plate 70 *Portrait of Jacob Trip*. Detail of the face

show rather that the painter's approach could vary according to circumstances and the sitter, and could lead to considerable technical differences in the process of catching a likeness. But similarities in ground structure, palette, and particularly in the construction of dark glazes containing smalt mixed with red and yellow lakes show how closely the two portraits can be identified with one another in their essential method of painting.

It has often been remarked that, in pairs of portraits by Rembrandt, the male portrait is of higher quality: here it is not a matter of quality, but of complexity. Clearly the *Portrait of Jacob Trip* was achieved rapidly and easily, in a direct and more economical style. The *Portrait of Margaretha de Geer* is much more carefully worked, partly fluid and partly dabbed with drier paint covering the underlayers with repeated reworking. One is easy and straightforward, the other more careful, painstaking and laboured.

These differences are clearly explained if we accept that Jacob Trip was painted not from life, but from another portrait – Rembrandt was simply reproducing an image, not responding to a real face as he was when he painted Margaretha de Geer.

There are two principal changes of

Plate 71 Deep orange-brown textured glaze of bolster, left. The thick glaze contains a mixture of red and yellow lake pigments, extended with pale-coloured smalt. The double ground is visible beneath a thin reddish-brown undermodelling layer. Cross-section, 175x.

composition in the *Portrait of Jacob Trip*. First, his right hand has been moved to a lower position: the earlier, slightly higher hand can be seen clearly on the picture surface and the X-ray shows faintly that it may have been holding the stick at this stage.

Secondly, the deep, high-backed wing chair in which Jacob Trip now sits was not the original design. The X-ray shows a quite different arrangement: Trip originally sat forward on a much simpler round-backed chair and was silhouetted against a light background. Cross-sections show the chair originally to have been lighter in tone, painted in mid-brown and dull orange colours, with a raised texture built up by the addition of colourless smalt to a mixture of reddish-brown earth, red lake and black (Plate 72), perhaps initially to represent a brocaded upholstery. The dense background paint around the head and left shoulder is clearly visible in the X-ray and at its lower edge, against the shoulder, it has

124

Plate 72 Dark paint of the chair-back, left. A scumble of bone black is laid over a textured paint of earth pigments bulked out with poorly coloured smalt. Cross-section, 185x.

been brushed up into a double ridge where the fluid paint has accumulated. Just above this, in the X-ray, some speculative scratch marks are just visible, as if Rembrandt was idly sketching in the line of Trip's collar in the wet paint of the background.

The composition was then altered and these light areas glazed over with a mixture of smalt and bone black for the dark paint of the present chair (Plate 72). Elsewhere, too, light features have been glazed down: the elaborately painted coat clearly had many more lights and highlights at one stage, but Rembrandt has subdued them to give emphasis to the sitter's head and hands.

Although dominantly a dark picture stressed in warm colours, *Jacob Trip* makes use of surprisingly large quantities of smalt. It is found in mixture with lake glazing pigments for the thick, translucent red-brown paints of the cloak and the bolster; in the underlayers for the chair back; with yellow ochre and black for the dull khaki of the cloak; and as a final glaze with bone black with or without lake pigments in the darkest colours of the background setting. This cobalt-glass pigment is in many of the samples quite poor in colour, but would seem to have been incorporated as much for its textural and siccative properties as for its tinting effect.

Bibliography: HdG No. 512; Bauch No. 429; Bredius No. 314; S. A. C. Dudok van Heel, 'Het maecenat Trip, opdrachten aan Ferdinand Bol en Rembrandt van Rijn', *De Kroniek van het Rembrandthuis*, vol. 31, 1979, pp. 14-26 (see also I. H. van Eeghen in R. Meischke and H. E. Reeser, eds., *Het Trippenhuis te Amsterdam*, Amsterdam 1983, pp. 72-3).

17.
Portrait of Margaretha de Geer

Canvas, 130.5 × 97.5 (51⅜ × 38⅗)

The portrait is unsigned. It is the same size as the *Portrait of Jacob Trip* (Cat. No. 16) and is a pendant to it. It has recently been suggested that the two portraits were painted for the Trippenhuis in Amsterdam (see p. 120 above) but they are first definitely recorded in the collection of the Lee family in England in the eighteenth century. They were then considered to be a pair and remained together until their purchase by the National Gallery in 1899.

Margaretha de Geer, daughter of Louis de Geer, was born in Liège in 1583. Her family settled in Holland in 1595, first in Aken and then Dordrecht. She married Jacob Trip in 1603 and died in Dordrecht in 1672. Her ruff and gown are in a style which came into fashion more than forty years earlier. For details of the circumstances of the commission of these two portraits, which were probably painted in 1661, see under the *Portrait of Jacob Trip* (Cat. No. 16). Other portraits of Margaretha de Geer, three by Jacob Gerritsz. Cuyp (Fig. 94), two by Nicolaes Maes – both Dordrecht painters – and one by Rembrandt (Cat. No. 18), are known. Two drawings have been associated

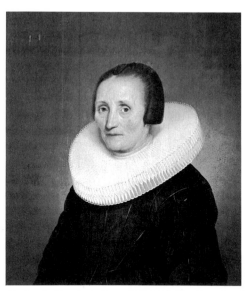

94. Jacob Gerritsz. Cuyp (1594-1651/2): *Portrait of Margaretha Trip*. 1651. Amsterdam, Rijksmuseum

with this portrait – Benesch Cat. Nos. 757 and A10 – but it is by no means clear that they show Margaretha de Geer and both, even if they are by Rembrandt himself, must date from the 1630s.

Technical description
Study of the cusping in the radiograph (Fig. 95) shows that this portrait, like its companion, has been trimmed somewhat at all four edges, the largest loss being at the right edge.

Plate 73 Detail of the double ground structure. Splintery particles of charcoal are evident in the upper layer, and the lower layer is notably heterogeneous. Cross-section, 420x.

It is most probable that both portraits have always remained together and were treated together: thus they have both been trimmed to the same size. However, there are marked differences in the two radiographs which suggest that this canvas was treated less expertly than its companion.

In the upper half of the X-ray image are broad diagonal sweeps of a fairly opaque material, some of which, on close inspection, can be seen as ridges on the picture. These have nothing to do with the original painting, but are accumulations of lining adhesive on the back of the original canvas, roughly applied without any attempt to smooth them out. They are also quite distinct from a sickle-shaped curve of paint seen at the top of the radiograph against the upper stretcher bar: this plays no part in the composition, was painted out by Rembrandt himself and is difficult to interpret. In a cross-section, the dense paint beneath the dark surface glaze is a warm light brown. It can only represent some abandoned feature of the interior setting for the portrait.

The canvas, made visible by the ground in the radiograph, is of the same type and weight as that of the companion portrait. There is a very prominent weave fault running down through the right side of the sitter's head, with one very thick thread (dark in the X-ray) and some loose weave on either side of it.

The canvas has a double ground identical to that of *Jacob Trip* (Plate 73). As there, the structure and composition suggest that both layers of ground were probably applied in Rembrandt's studio and formed an integral part of the painting process. In general the paint, including the background colours, is laid so thickly on top that the upper layer of ground plays no part in the final colour composition.

In contrast to *Jacob Trip*, which has been changed only slightly, Rembrandt clearly had considerable difficulty in arriving at the final details of the *Portrait of Margaretha de Geer*. The most notable change is in the position of her left hand. It was first painted side-on, thumb and forefinger showing, resting in her lap; then resting on the arm of the chair to the right of the present position, and finally as we see it now. Of these three attempts, the first and second show clearly in the X-ray; the third and final version lies between them and its X-ray image is lost in an accumulation of dense brushstrokes. The first placing of the hand can be seen in Plate 74, which shows in cross-section the brownish-red shadow of the thumb concealed by at least six layers of rich, translucent dark-coloured paint representing the fur trim to the robe worked on top. It appears that the hand at this early stage was painted directly on to the upper layer of ground, with no

Plate 74 Fur trim of robe over the *pentimento* of the thumb. The concealed flesh paint is brownish pink. Only the upper layer of ground is included in the sample. Cross-section, 150x.

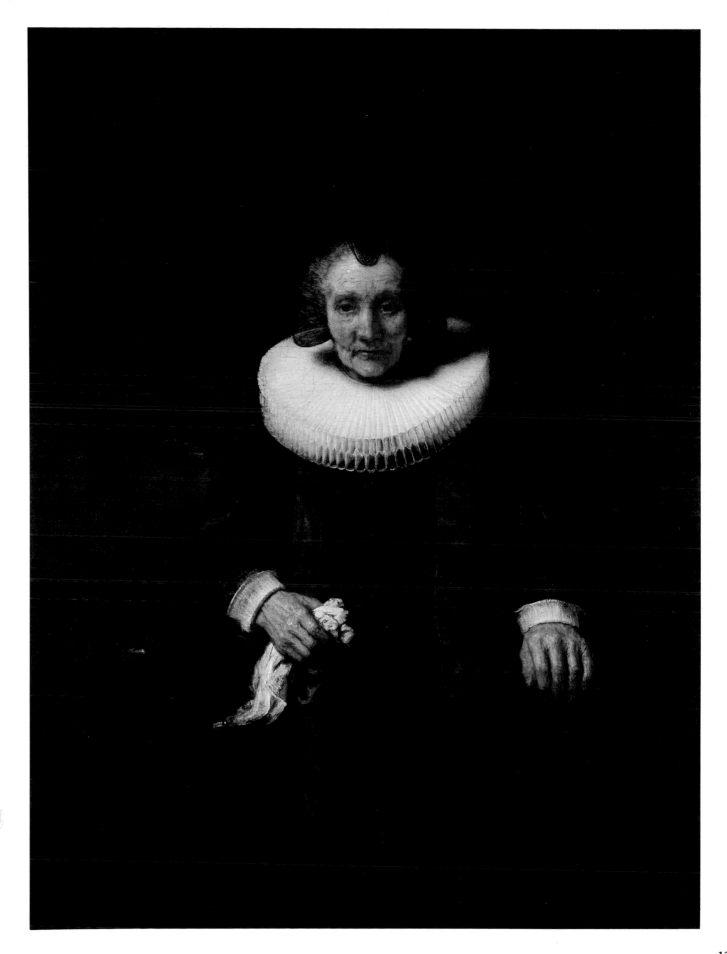

preparatory sketching stage detectable.

There are other changes too: the great ruff was altered in shape more than once as it was being painted. At first it was tilted more towards us, the back higher and the front a little lower. The adjustment of outlines not only tipped it back a little to the present angle, but slanted it too, so that it is now slightly higher at the back right than on the left.

The X-ray shows us that the sitter's white cuffs were originally trimmed with lace: this is just visible below the picture surface, too. Rembrandt glazed it out to the present severe, plain outline. The handkerchief in her right hand is slightly confused in the X-ray image, and an unexplained white fold drapes towards the left over the arm of the chair.

The overall structure of the head seen in the X-ray is very similar to that seen in *Jacob Trip* – the classic Rembrandt construction. Forehead, cheeks, nose, eyelids, top lip and chin are all modelled strongly in lead white. One would expect to see – as in the companion portrait – the ground or under-layer exposed in the usual way around the eyes and mouth: but these areas of shadow and half-tone have been mainly modelled on top in earth colours, dabbed over where the ground would normally show, but over underlayers similar in colour to the upper part of the ground (Plate 75). Apart from the forehead, which is painted in the same fluid manner as Jacob Trip's, the whole face seems much more worked and reworked than his: the cheeks are dabbed to suggest skin tone and texture and the thin mouth is a pastose black line similar to those we have observed in earlier portraits, but absent from *Jacob Trip*.

Except for where there are *pentimenti*, as in the curved feature seen in the X-ray above the sitter's head, the background darks are fairly simply constructed, although the paint layers incorporate a multiplicity of pigments. For example, the very dark greyish-green wall to the left is achieved in two layers, with a dark brown underpaint comprising red, orange and yellow earth pigment combined with bone black and a trace of lead white, and then glazed with a mixture of smalt, red ochre and probably also a quantity of yellow lake pigment. As the wall passes into deeper shadow, a glaze of bone black adjusted with a little red lake and red ochre replaces the smalt-containing upper layer. Smalt is also present in the warmest translucent deep

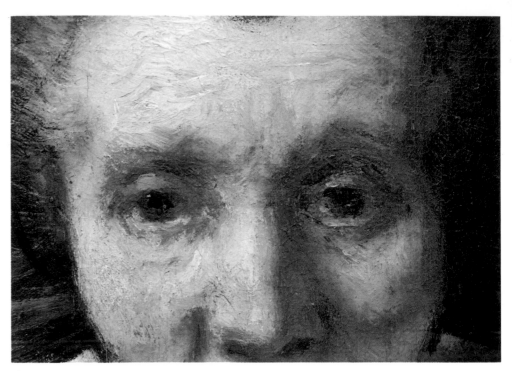

Plate 75 *Portrait of Margaretha de Geer*. Detail of the face

brown shadows to the left edge, where it is used to bulk out a thick glaze of red and yellow lake pigment laid over a thin under-paint of bone black.

These rather unusual combinations of

Plate 76 Textured deep translucent brown glaze of the fur trim to the robe, lower edge, over a khaki underlayer. The double ground is visible beneath a thin black lay-in. Cross-section, 120x.

Plate 77 Detail by transmitted light of the glaze layer shown in Plate 76. The thick translucent paint is built up of two applications of yellow lake pigment and smalt, with a proportion of red lake pigment and chalk in addition in the lower layer. Thin cross-section, 175x.

smalt with mixtures of transparent lakes for warm dark brown glazes are most compre-hensively employed in the painting of the fur edging to Margaretha de Geer's robe, and find their counterparts in the textured sections of Jacob Trip's cloak and the bolster against which he is seated. The orange-brown of the fur trim here passes over a solid khaki underpaint, the translucent upper layers applied in a mixture of yellow and red lake pigment, smalt and chalk, then further heavily glazed in yellow lake pigment ex-tended with even more smalt (see Plates 76 and 77). The smalt is not of a strong blue and many of the particles are entirely colourless. It is likely that it would have been incorpo-rated to give texture and bulk to the glaze without undue effect on the colour. There is the additional advantage that the cobalt-glass would have exerted a siccative effect on the medium of a paint film containing lake pigments, which on their own dry poorly in oil, particularly when thickly worked.

Even the rather simply painted dark robe itself incorporates smalt in a glaze of bone black, warmed with a little reddish-brown lake pigment.

Bibliography: HdG No. 857; Bauch No. 523; Bredius/Gerson No. 394.

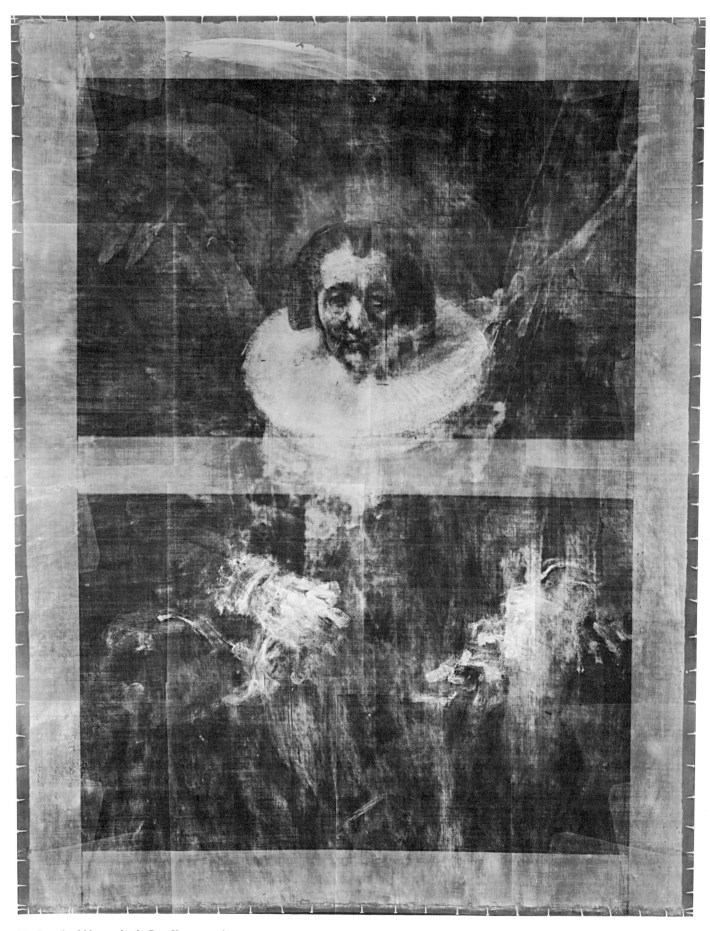

95. *Portrait of Margaretha de Geer.* X-ray mosaic

18.
Portrait of Margaretha de Geer, Bust Length

Canvas, 75.3 × 63.8 (29⅝ × 25⅛)

Signed on the left, below the level of the shoulder: Rembrandt. f 1661

This is the smaller of the two portraits of Margaretha de Geer in the National Gallery. The other, a three-quarter-length, is a pendant to a portrait of her husband, Jacob Trip, which is also in the National Gallery (see Nos. 16 and 17 of this Catalogue). The present portrait shows her in a different pose but also wearing a peaked head-dress and a millstone ruff, of a type which had first been worn some forty years earlier. The pair of three-quarter-length portraits should be dated, as has been argued above, about 1661, which is the date on this painting. That Rembrandt should have executed two portraits of Margaretha Trip with different poses and in different formats within a short period is not in any way surprising. It has been cogently argued that the three-quarter-length portraits were commissioned to hang in the Trippenhuis in Amsterdam, the residence of the couple's sons, and the smaller portrait could have been intended for the Trips' own house in Dordrecht or to be presented to another member of the large family. It is quite likely, however, that both paintings were based on a single sitting or series of sittings, as Margaretha would have had to come to Amsterdam from Dordrecht for this purpose. If, as seems likely, the smaller portrait was painted after the three-quarter-length one, it would be expected that it would be more confidently painted, with fewer *pentimenti* and a less complex paint structure. This has indeed proved to be the case. There are, however, a number of surprising results of the technical investigation of the painting, and the possibility of its being painted by a follower of Rembrandt cannot be ruled out. The painting was first recorded in the collection of Lord Charles Townshend in 1818, when he lent it to an exhibition at the British Institution.

Technical description
The canvas weave visible in the X-ray (Fig. 96) is a regular tabby, like that of the larger version; but it has a different, somewhat thickened and blurred appearance. This is partly caused by thicker, more fibrous threads, but is largely due to the way the ground in this picture is different from that of the larger picture and is, indeed, unlike the grounds of other canvas paintings by Rembrandt.

The canvas bears a double ground with a lower layer of chalk and an upper layer comprising a mixture of granular lead white, chalk and charcoal black, with red and yellow earth pigments in small quantities (Plate 79). Two features of the ground are unusual when compared with other Rembrandt canvas paintings which have a two-layered system. Generally the lower layer is not chalk but an orange or reddish-orange ochre, as in the larger *Portrait of Margaretha de Geer* (Cat. No. 17). Secondly, the particle form of the yellow earth pigment in the upper ground is unlike that of most specimens of yellow ochre in paint and ground samples examined for Rembrandt. The pigment is present as yellow rod-like crystallites, rather than rounded particles, which are the common form. However, analysis has shown that no materials that are anachronistic for a seventeenth-century picture are employed in the ground or paint layers for *Margaretha de Geer, Bust Length*.

The ground is partly radioabsorbent and therefore makes the canvas structure visible in the X-ray. It can be seen that on all sides of the picture the outermost part of the canvas has been used as a tacking edge (although at the top, only fragments remain) which has now been flattened into a plane with the picture surface.

The presence of this tacking edge is puzzling. It has ground on it, but is unpainted: two painted-out hands at the lower edge, which can be seen in the X-ray, do not extend on to it. A cross-sectional sample through the hidden proper right hand has shown a brownish-pink flesh paint concealed by a bone black glaze for the sitter's costume. Since the canvas which forms these margins is indisputably con-

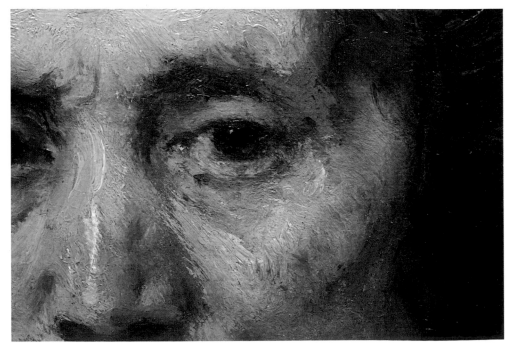

Plate 78 *Portrait of Margaretha de Geer, Bust Length*. Detail of the face

130

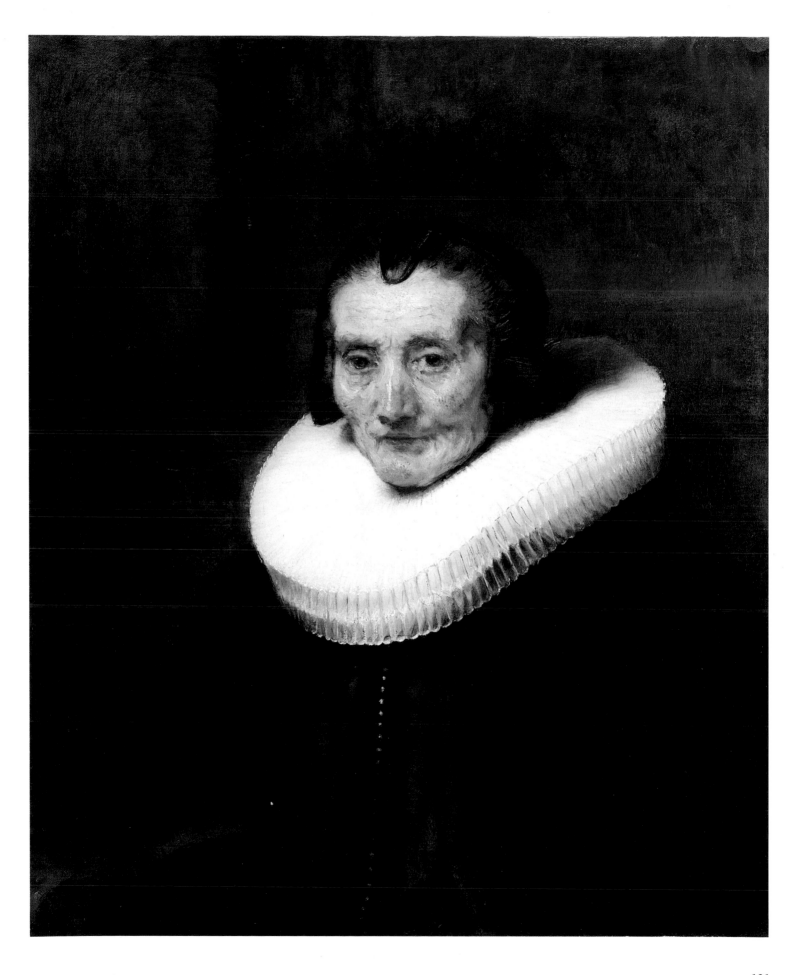

tinuous with the main part of the picture, and since it is unpainted, it must be the *original* tacking edge: it cannot be the result of reducing the picture size and using some of the picture area for a new edge (as was the case with the *Self Portrait at the Age of 34; Cat. No. 8*).

It must be said that the survival of original tacking edges in a canvas picture of this age is unusual. In addition, the canvas near the edges does not appear to be cusped: this indicates that it was cut from a larger prepared piece and attached lightly to a conventional strainer before painting. There is certainly no possibility that it was either prepared with ground in its present size or that it was painted in a stretching frame.

Neither of these factors is impossible to reconcile with an authentic Rembrandt; but, taken together with the unusual ground type, their significance must be taken into account.

The light brown ground colour is used as a mid-tone in many places in the sitter's head. Around the eyes, beside the nose and between forehead and hair, the ground shows extensively (Plate 78). The technique here is certainly very different from that of the larger portrait, in which the ground colour is hardly visible at all.

Similarly, the handling of the paint is quite different. As we have seen, the larger version is careful, painstaking and reworked, layer over layer, to achieve the final likeness. This smaller portrait is fluid, rapid and yet almost careless in its execution. One might single out for comment the odd curved brushstroke on the upper part of the nose which gives it a strange dented shape totally unlike that in the larger version. The brushstrokes elsewhere in the face seem to lack the precision in defining form that we see demonstrated, in quite different ways, in the two Trip portraits.

Elsewhere on the portrait the paint is handled fairly conventionally. The X-ray image has a less forceful structure than that of the large portrait, the brushwork less sure, less expansive. In the ruff, shadows have been scratched into the wet paint with the brush-handle. At the bottom of the picture the hands, which were never more than glimpsed at the very edge, were painted out as the composition was finalised.

The palette required for a portrait of this type is clearly rather restricted, but the pattern of pigments used reflects Rem-

brandt's conventional painting practice. The translucent deep browns of the background employ the rather complicated glazing mixtures found for a number of pictures by Rembrandt, and contain bone black, red and reddish-bown lakes, combined with yellow, red and orange earth pigments (Plate 79). Unlike those in the upper ground, in the paint layer the earth pigments have the usual rounded particle form found in naturally occurring ochres. The degree of translucen-

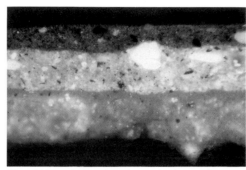

Plate 79 Translucent deep brown background, upper right. The surface paint contains earth and lake pigments with bone black, over a double ground, with chalk as the lower layer, and lead white with charcoal and ochre as the upper ground. Cross-section, 180x.

cy and the colour of the glazes reflects the varying proportions of each pigment component incorporated.

The sitter's black dress is painted principally in a layer of bone black, but as in the darkest background shadows to the large *Portrait of Margaretha de Geer*, and in the black coat of *A Bearded Man in a Cap* (Cat. No. 14), the paint is warmed by the addition of a little red lake and red earth pigment.

The presence of two portraits of Margaretha de Geer in the National Gallery collection allows an interesting appraisal of the technical criteria of authenticity. The larger version has been unquestioningly accepted as a fine and characteristic portrait of the early 1660s. As we have seen, the smaller picture differs from it in several respects and its authorship is therefore problematic. Here, then, is an intriguing example of a picture with quite definable technical characteristics which may or may not fall within the parameters acceptable for an authentic Rembrandt. If the picture is to be accepted as by Rembrandt, we certainly have to widen those parameters to include the unusual features that have been observed here.

We are therefore confronted with two possibilities: the small portrait of *Margaretha*

de Geer is either an extremely skilful imitation of the work of Rembrandt painted between 1660 and 1818, or an authentic painting whose function and execution have led to considerable physical differences from the larger portrait.

Bibliography: HdG No. 492; Bauch No. 524; Bredius/Gerson No. 395.

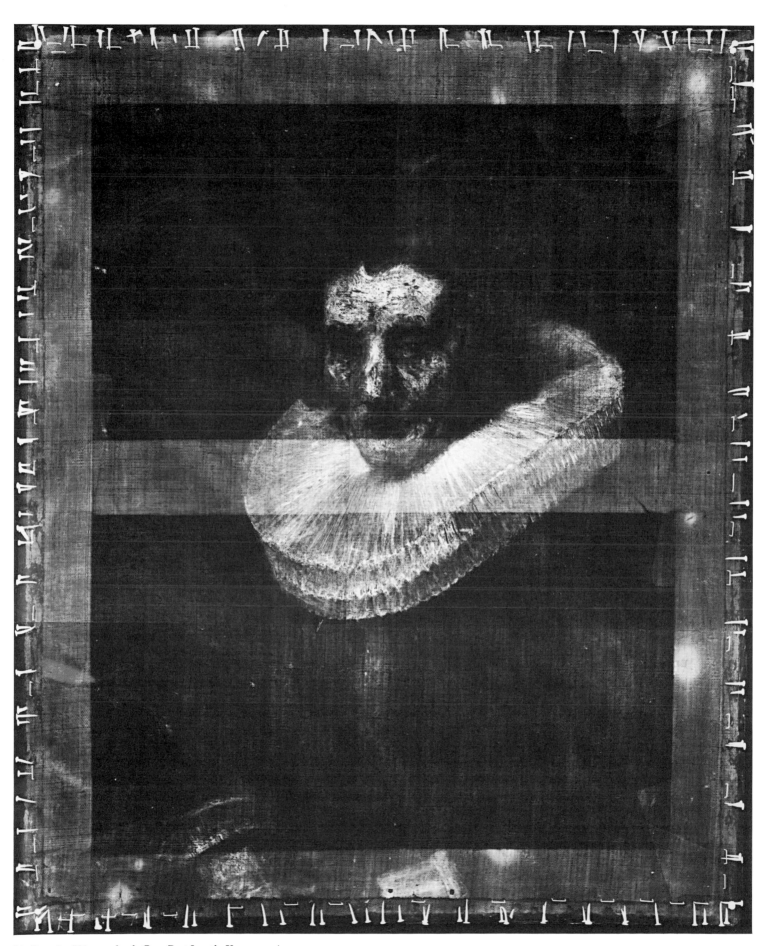

96. *Portrait of Margaretha de Geer, Bust Length.* X-ray mosaic

Portrait of Frederik Rihel on Horseback

Canvas, 294.5 × 241 (116 × 95)

There are faint remains (visible by means of infra-red photography) of a signature,and date, lower left: R[...]brandt 1663 [?]

The rider is taking part in a procession which winds around a stretch of water in the lower left, where the prow of a boat can be seen. On the left the façade of a building is roughly sketched. In front of it is a coach in which three occupants and a groom on the running-board can be made out: the heads of the driver and two coachmen at the rear can also be seen. The coach is part of the procession, as are the two (or three) riders on horseback, who all wear hats, on the right behind the principal rider.

Frederik Rihel was born in Strasbourg in 1621. His father was a paper merchant and his family were well-known printers in the city. He had moved to Amsterdam by 1642, where he lodged with the Bartolotti family. He settled in the city and enjoyed a successful career as a merchant. Rihel lived on the Herengracht and became a *vendrig* (cornet) in the civic guard in 1677. He died in 1681 and was buried in the Nieuwe Lutherse Kerk. The identification of the rider as Rihel was first made by Bredius on the basis of an item in the inventory of his property drawn up after his death: *Het conterfijtsel van de overleden te paert door Rembrandt* (The portrait of the dead man on horseback by Rembrandt). There is nothing in the known provenance of the painting to link it with Rihel – it is first documented in an Amsterdam sale in 1738 – but, on the other hand, there is only one other known equestrian portrait by Rembrandt, the so-called *Polish Rider* in the Frick Collection, New York (Bredius/Gerson No. 279), which dates from the mid-1650s. There is no documented portrait of Rihel to confirm Bredius's identification, but a study of Rihel's inventory (which was undertaken by Miss van Eeghen) revealed that there are a number of items of dress and accoutrements similar to those worn by the rider. The bachelor Rihel's great love of horses would explain the unusual – at least for Rembrandt – commission. Rihel, as a member of the Amsterdam civic guard, took part in the entry of Prince William of Orange into the city in 1660. The prince entered the city by the Heiligewegspoort. It seems likely that the portrait commemorates Rihel's participation in the procession and that the building sketched in the lower left is intended to represent the Heiligewegspoort. (The detailed arguments for the identification of the rider as Rihel and the rejection of an alternative identification of him as Jacob de Graeff will be given in the new edition of the National Gallery Dutch school catalogue, to appear early in 1989.)

The date appears to read 1663, and this would be acceptable on stylistic grounds. A drawing of a coach in the British Museum (Benesch No. 756) has been associated with this painting, but in fact does not seem to have any real connection with it.

Technical description

The large canvas consists of three pieces seamed together with a simple running stitch that shows clearly in the X-ray (Fig. 98). The upper seam runs horizontally through the horse's bit and the pommel of the sword below Rihel's elbow. The lower seam runs horizontally just below the horse's front right hoof and at the top of the front left hoof.

The top strip of canvas is approximately 106 cm wide, the centre strip 114 cm and the lower strip 74.5 cm. From X-ray details they appear to have the same or similar weave characteristics. The top strip corresponds well to the standard '1½ ell' measurement; the centre strip is rather wide for this loom width, but might just fall within a generous interpretation of the range; the lower strip was presumably cut from a wider piece of canvas.

The canvas weave does not show very strongly in the radiograph because the ground is fairly transparent to X-rays. The ground is of the dark brown 'quartz' type, composed of silica with a little brown ochre (Plates 80 and 81), closely similar to that in, for example, the *Self Portrait at the Age of 63* (Cat. No. 20).

The brown of the ground and similarly coloured underlayers form a visible tone in much of the painting, although rather little of this shows directly in the face and figure of Rihel himself, which are opaquely painted. The horse was probably completed before the rider was placed on top.

The design of the picture has been sketched in with broad strokes of blackish paint applied with a brush. This bold underdrawing is visible everywhere in the infra-red photograph (Fig. 99) and seems to have been used to define both the horse and Frederik Rihel, as well as foreground and background features. The horse's legs are

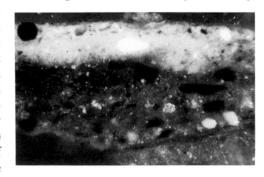

Plate 80 Yellow skirt of rider's coat, painted over horse's flank. The dark underlayers contain smalt and red lake combined with other pigments, and the brown 'quartz' ground is also visible at the base of the sample. Cross-section, 160x.

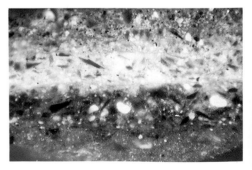

Plate 81 Greyish-brown tasselled scarf, painted over horse's flank. The splintered particles of smalt are readily seen in the multilayered paint structure for the horse. The 'quartz' ground is also visible. Cross-section, 120x.

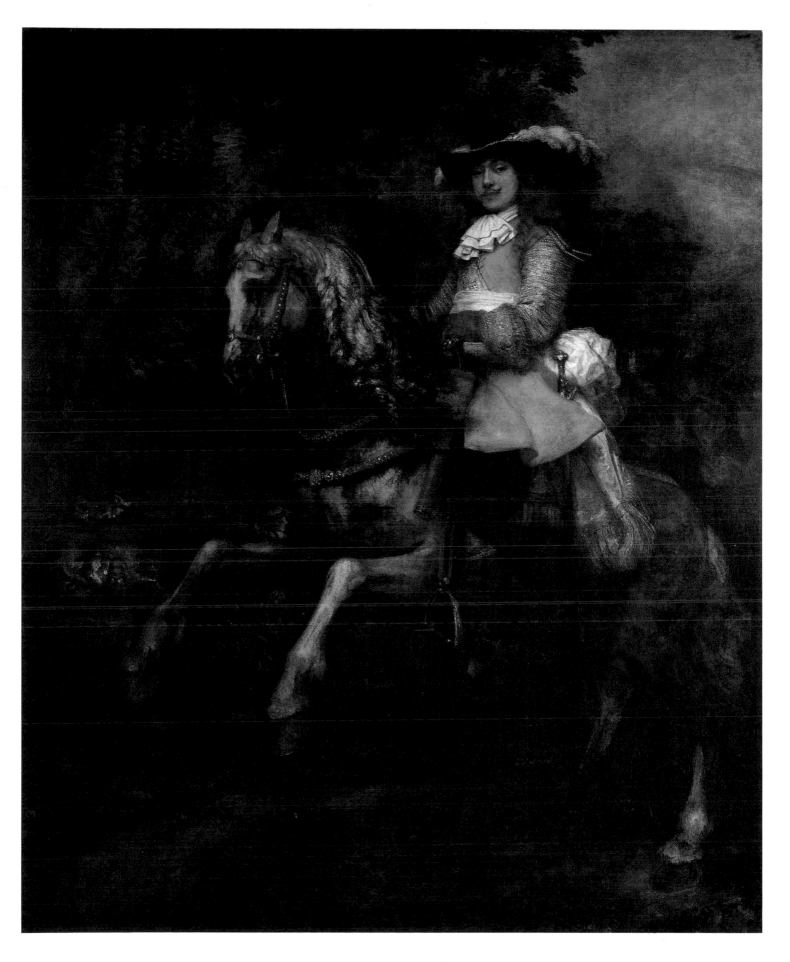

clearly outlined, including a *pentimento* of the right hind leg to the right of the present one passing over the foreground paint layer; and there are bold sweeps of drawing alongside Rihel's hair and the feather in his hat.

The infra-red photograph shows changes made during the evolution of the portrait. Most obviously, Rihel's hat was initially taller in the crown and wider at the brim; this alteration can also be seen faintly on the picture surface. The hat is painted in a dense mixture of carbon black containing a small amount of red earth; the absorption of infra-red by the carbon results in a dark image on the infra-red photograph. In addition, several changes of outline in the horse's head and legs are visible.

At least one modification to the background design fails to be detected in infra-red examination. In the area of the lower section of sky, Rembrandt initially laid in thickly painted foliage greens, and later painted them out with the present sky, again thickly. A cross-section shows two solid layers of green and yellow-green, containing smalt, azurite and yellow ochre, obscured by

Plate 82 Greyish-blue sky, upper right corner. The sky at the level of the rider's hat-brim conceals earlier thick green landscape paint, containing yellow ochre, smalt and azurite. The sky is painted in several layers of smalt and lead white, with a final glaze of smalt. The lowermost layer for the sky incorporates a little red lake pigment. Cross-section, 150x.

several applications of smalt with lead white for the sky paint (Plate 82). The lead white upper layers are too substantial to allow infra-red photography. The density of the sky paint can be judged from the X-ray image.

The infra-red photograph is also very useful in clarifying the image of the whole composition. It is undoubtedly the case that the picture is somewhat darker now than when it was painted – partly through varnish discoloration, but also partly because a dark ground always becomes more prominent as

97. *Portrait of Frederik Rihel on Horseback.* Detail of the yellow coat

paint ages and increases in transparency. The infra-red image shows features of the background barely visible in ordinary light, most notably the carriage and figures to the left of the horse, and the two (or more) riders behind Frederik Rihel at the right.

The application of paint in the *Portrait of Frederik Rihel* spans the whole range of textures and techniques found in Rembrandt's painting. The foreground and main elements of the background have been outlined with brush underdrawing and then thinly glazed and scumbled with local colour. The trees behind and the horse's mane are combinations of dabbed and fluid brushwork. The horse's left foreleg consists simply of one or two huge open brushstrokes of lead white with earth pigments and smalt on a

darker underpaint. The figure of Rihel himself shows all of Rembrandt's accumulated mastery in handling paint and using it to suggest texture and relief. Many of the underlayers are bulked-out with smalt to assist the broad areas of impasto (Plates 80, 81 and 83).

The yellow coat is thickly and relatively smoothly painted, but Rembrandt could not resist a flourish with the brush handle in the shadow at the lower left (Fig. 97). In the cravat and sash, the paint begins to pile up following the highlights, but it is only in the left sleeve and cuff, the hat brim and sword hilt that Rembrandt fully exploits the thickness and shine of full impasto to convey the brilliance of metal and glittering fabric. Knowing that a painting such as this would

98. *Portrait of Frederik Rihel on Horseback*. X-ray detail

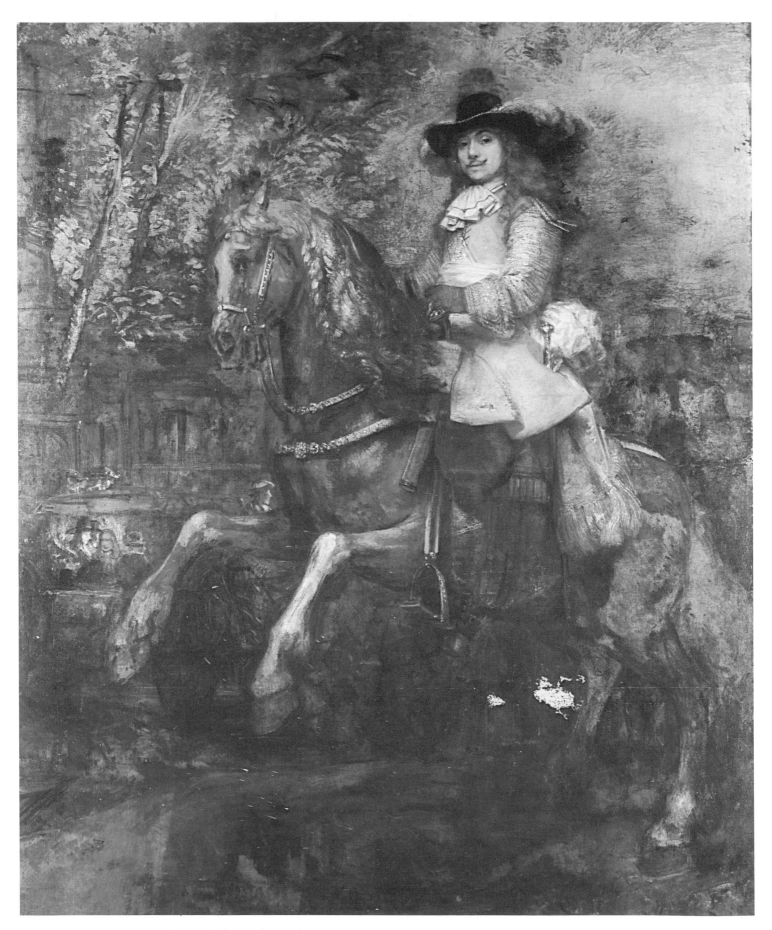

99. *Portrait of Frederik Rihel on Horseback*. Infra-red photograph

hang high and catch the light, he allows the highlights on sleeve and sword to achieve a double effect, to have both visual and actual texture, to combine the brightness of lead white paint with the sparkle of real reflected light.

Some interesting colour and textural effects are achieved with a fuller palette than Rembrandt generally adopts, but the scale and subject matter clearly require a wider range of colours than that of his indoor compositions.

Smalt is used in great profusion: as the blue pigment for the patch of greyish-blue sky (Plate 82); in mixture with white, earth pigments and red lake for the darks of the flank of the horse (Plates 80, 81 and 83); and in association with yellow pigments for the dull landscape greens. Coarsely ground smalt is also used to build texture in the brown paint of the horse's flank, and to add a cooler tone to the lighter patches of paint

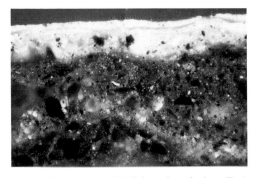

Plate 83 Greenish-grey highlight on horse's chest. Each of the layers which make up the paint of the horse contains smalt. Incomplete layer structure. Cross-section, 175x.

containing lead white drawn over the top (Plate 83). The greyish blue of the sky is achieved with a glaze of smalt over two solid underpaints of the pigment mixed with lead white (Plate 82), the lower of which is tinted with a little red lake. Smalt is vulnerable to discoloration in oil medium and this, together with yellowing of the varnish, have caused the loss of the subtlety in colour lent by the lake pigment to the sky. The landscape greens, fairly dark though they were probably always intended to be, have also been dimmed by discoloration. In common with other pictures by Rembrandt, no actual green pigment is used. The yellowest foliage greens to the upper left are based on mixtures of yellow lake pigment with smalt, here relatively thinly painted, but colour change of both pigments in the paint layer has allowed the brown ground to become more prominent. Others of the

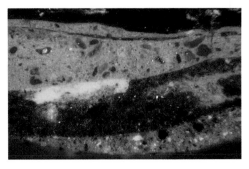

Plate 84 Brightest red impasto of stirrup strap, worked in red ochre mixed with red lake pigment, over darker underlayers. Incomplete layer structure. Cross-section, 175x.

duller brownish greens incorporate black pigment or Cologne earth in addition, so would have been dark to start with. It must be mainly contrast and definition rather than colour that has been largely lost in the background landscape.

The brightest of colour touches involve techniques familiar in Rembrandt's work. For the red of the stirrup strap, a rather pure red ochre is intensified by mixture with red lake pigment, and painted wet-into-wet over a series of warm dark underlayers (Plate 84); while the reflective lights on the horse's bit are in pure lead-tin yellow.

Bibliography: HdG No. 772; A Bredius, 'Rembrandtiana', *Oud Holland*, 1910, pp. 193-5; Bauch No. 440; I. H. van Eeghen, 'Frederick Rihel een 17de eeuwse zakenman en paardenliefhebber', *Amstelodamum*, vol. 45, 1958, pp. 73-81; Bredius/Gerson No. 255.

Self Portrait at the Age of 63

Canvas, 86 × 70.5 (33⅞ × 27¾)

Signed and dated, lower left: [.......]t f / 1669

When the painting was cleaned in 1967 the fragmentary signature and the date 1669, the last year of Rembrandt's life, were revealed. The fact that only the 't' of the signature remains makes it likely that a strip of about 3 cm was cut from the left-hand side of the canvas. Cusping of the canvas threads, visible to some degree in the X-ray, confirms this: the cusps at the right are more complete than those at the left. Cleaning also revealed that the background had been extensively overpainted. The *Self Portrait* in the Mauritshuis, The Hague (Fig. 100), in which the artist again wears a turban, is also dated 1669. Rembrandt died on 4 October and was buried four days later in the Westerkerk in Amsterdam, where Hendrickje Stoffels had been buried in 1663.

Technical description

The canvas is prepared with a single layer of coarse-textured brown ground, the main component of which has been identified as quartz (silica) tinted with a little brown-coloured ochre (Plates 85 and 88), and is closely similar to the ground type in the *Portrait of Hendrickje Stoffels* and the *Portrait of Frederik Rihel on Horseback* (Cat. Nos. 13 and 19).

The paint layers vary enormously in texture and thickness. The face, turban and collar are constructed on massive founda-

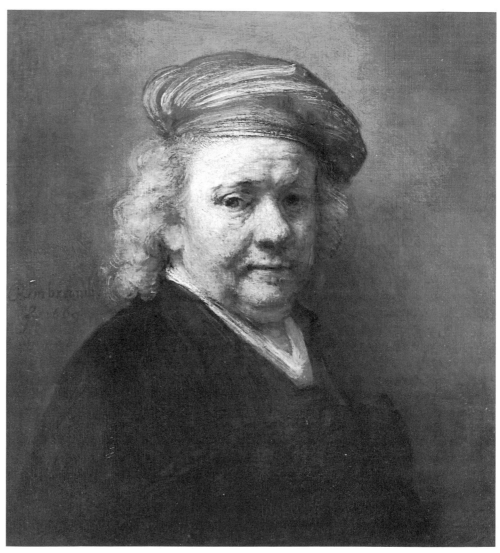

100.*Self Portrait.* 1669. The Hague, Mauritshuis

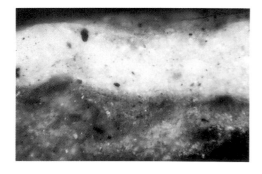

Plate 85 Thick impasto flesh layer of cheek, mainly of lead white tinted with earth pigments, over a brown undermodelling. The brown 'quartz' ground is also visible. Cross-section, 200x.

tions of lead-white brushstrokes (see Plates 85 and 88). In the X-ray image the forms appear almost sculptural in the way they are built up (Fig. 101). The lower sleeve and cuff are also fairly thickly elaborated in layers of earth colour. Both in the X-ray and on the picture surface we get the impression of depth and texture actually modelled in paint, piled up for the highlights on turban, forehead, nose and chin, brushed out for the mid-tones and absent from the receding shadows. Moreover, the very handling of the brush gives detail and texture: broad horizontal strokes for the front of the turban, short verticals and diagonals for the main structure of the face and then reworking, wet-into-wet, dabbing, twisting, dragging the paint into broken impasto to suggest the old man's pockmarked skin. The heavy application at the cheek can be seen in Plate 85, the mass of the paint of the light tone being lead white coloured only with a little

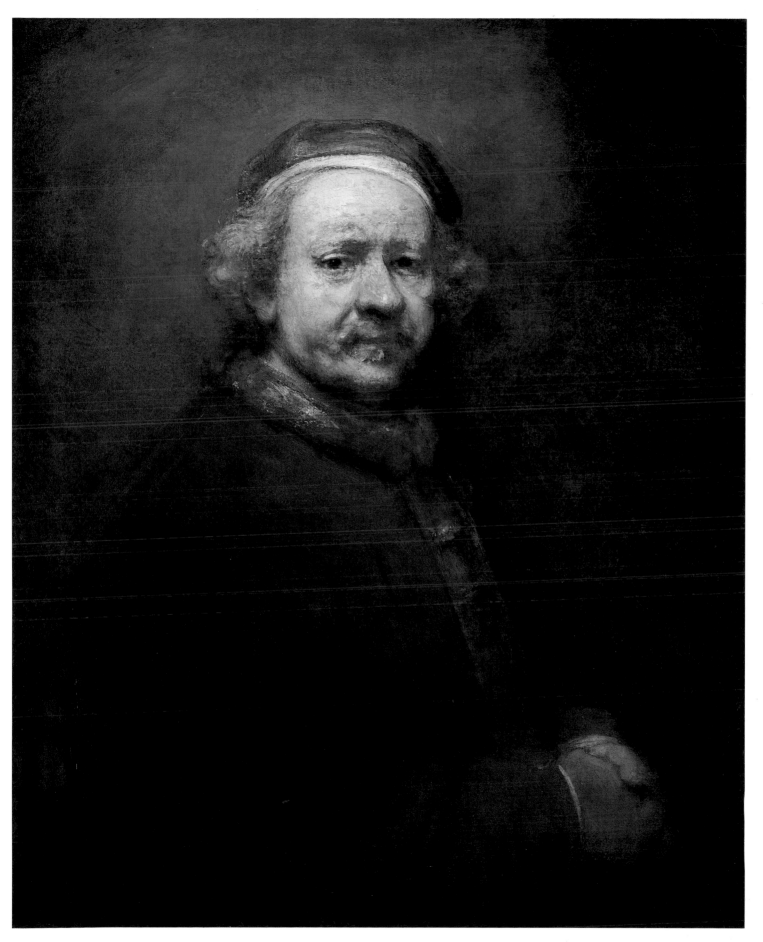

reddish ochre and a translucent brown pigment over a brown undermodelling layer.

The modelled paint leaves the ground colour and perhaps a little undermodelling exposed around the eye-sockets and mouth, and also in the background and sleeve. Half-tones are achieved mainly superficially with cool paint mixtures, but there is some use of semi-transparent scumbles over darker undermodelling.

The remainder of the portrait is painted much more directly and smoothly. Even the hands are relatively untextured. As with many of the portraits, the heavier application of paint for the faces and highlight details on costumes is juxtaposed against more glaze-like treatment of the darks of the background settings. For example, the rich, almost black shadow to the right is a fairly thin single layer of translucent dark brown pigment containing some orange-coloured earth over the dark brown ground, which here must influence the surface colour. Where the paint is more opaque, above and to the left of the head, a second layer containing some white and a little red lake pigment as well as the earth colours has been applied over the translucent underpaint.

The darkest plum-coloured shadows of the coat are equally glaze-like in treatment, with the richest depths thinly and directly applied to the textured ground in a mixture of

Plate 86 Dark plum-coloured glaze of coat, lower left, containing red and yellow lakes mixed with black. Unmounted fragment by transmitted light, 200x.

red and yellow lake pigment intensified with black (Plate 86). For the mid-tones of the central part of the sleeve, there is only the lightest scumble of red earth and black enhanced with some red lake pigment, but as in the background there is no preliminary underpainting and the ground colour and texture show through. As the sleeve and cuff become elaborated towards the hand, the layer structure of the painting can be seen to become more complicated (Plate 87), with a

Plate 87 Multilayered structure of the red paint of the cuff. The 'quartz' ground is visible as the lowest layer. Cross-section, 400x.

sequence of underpaints for the thicker surface highlights. For example, the muted red impasto at the cuff is underpainted first in brown, then in a layer of orange-coloured earth, and over that a deep red glaze combining lake and red ochre. The upper paint layer incorporates a rich mixture of orange ochre, red and yellow lake pigments, and a little black as final, thickly applied strokes. The lightest tones of red and dull yellow make use of surface touches of earth pigment of a pure single colour. The way of constructing these warm colours shows interesting comparisons with the constitution of the various shades of red in *Hendrickje Stoffels* and *Frederik Rihel*.

There are two major *pentimenti* visible in the X-ray. Firstly, the turban was initially much higher and fuller and hung down more at the right; it appears also as if it was then entirely white – presumably much like that in the Kenwood *Self Portrait* (Fig. 20). Later Rembrandt reduced it in height and width with broad strokes of background paint and coloured the upper part brown. A cross-section from above the head (Plate 88) shows a thick layer of lead white of the originally larger turban laid directly over the ground and pulled up into a jagged impasto. Two

Plate 88 Light greyish-brown background paint above the head, concealing thickly worked white *pentimento* of the turban. Note the rough texture of the dried paint beneath the surface. Cross-section, 190x.

layers of the light khaki paint of the background have been drawn over this rough surface to alter the design, but the texture of the paint beneath can still be glimpsed. The paint of the turban must have been thoroughly dry before this alteration was made, since the brushstrokes have not been disturbed by the application of the background paint on top.

Secondly, the hands were originally painted open, not clasped, and in the painter's right hand was a single brush or mahlstick. By closing them and removing the point of interest at the lower right-hand corner of the canvas, Rembrandt focused attention solely on the searching examination in paint of his own face.

Bibliography: HdG No. 551; Bauch No. 339; Bredius/Gerson No 55; G. Martin, 'A Rembrandt Self Portrait from his last year', *Burlington Magazine*, vol. 109, 1967, p. 355.

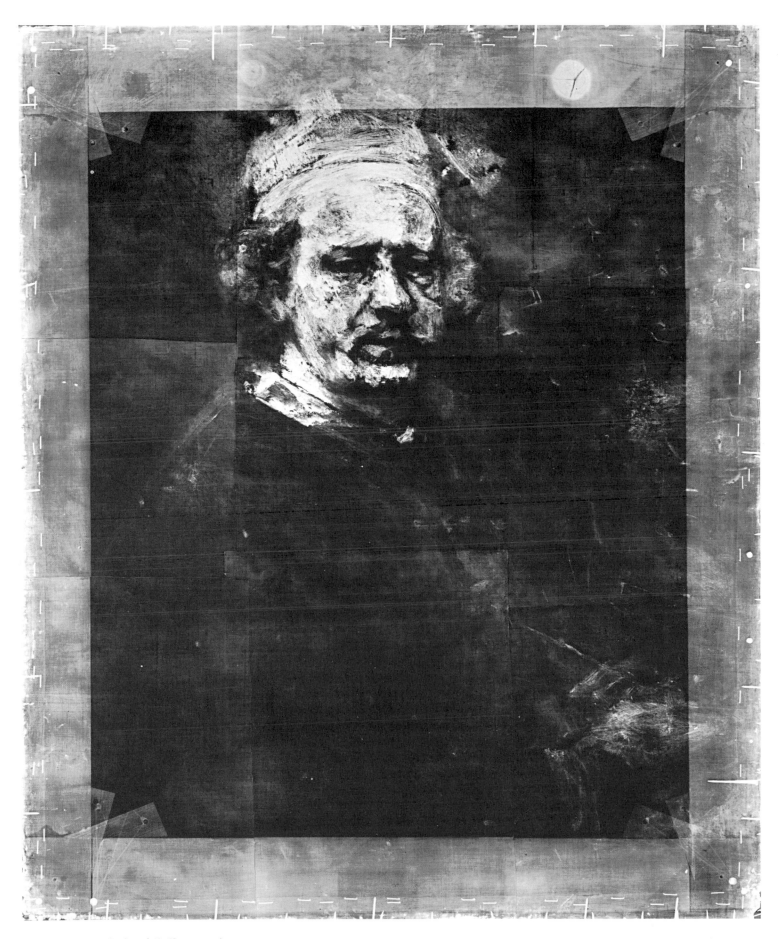

101. *Self Portrait at the Age of 63.* X-ray mosaic

Glossary

This defines technical terms used in this Catalogue, and also briefly explains some materials and techniques. A much fuller account of pigments is given in the essay on 'Rembrandt's painting materials', p. 21.

alla prima Painted in one session, without alteration; cf. *pentimento*.

azurite Natural basic copper carbonate, blue or blue-green in colour according to its purity; used as a pigment and, in small amounts, as a drying agent in oil paint.

bone black A black pigment made from carbonised bone, which gives a warmer black than does wood charcoal.

carbon black A black pigment made from wood or other vegetable matter or carbonised bone (see charcoal, bone black).

Cassel earth A dark brown earth pigment (q.v.) prepared from lignite (brown coal), and containing a good deal of organic matter as well as iron oxide; later known as Vandyke brown.

chalk A natural form of calcium carbonate. Mixed with oil, it becomes translucent, and can be used to stiffen glazes without rendering them opaque; it is also used as a cheap extender for lead white, whose opacity it reduces, and as one of the materials of grounds.

charcoal Carbon made by burning wood. Sticks of charcoal are used for sketching. Wood charcoal, powdered and used as a pigment, has a bluish-black colour.

cochineal A red dye extracted from the cochineal scale insect, used to make crimson lake (see lake).

Cologne earth Similar to Cassel earth (q.v.).

cool Of a colour: tending towards the blue end of the spectrum. Cool colours tend to seem farther away from the spectator than warm colours, a phenomenon used to create perspective effects.

cross-section By examining minute samples of paint in cross-section under the microscope, the layer structure of the painting, including the ground layers, can be determined for that sample point. Many pigments can be identified by their colour and optical properties in a cross-section, and analysis by LMA (q.v.) or EDX (q.v.) can be carried out on individual layers. Samples are mounted in a block of cold-setting resin, then ground and polished to reveal the edge of the sample for examination in reflected (incident) light under the optical microscope. The usual magnification range is 60-800x.

crystallite A small or imperfectly formed crystal.

cusping Wavy distortion of the weave at the edge of a canvas, caused by its being held taut with cords while the canvas was primed. Lack of cusping on an edge is sometimes a sign that a painting has been cut down in size.

darks Dark coloured paints; the dark areas of a picture.

dead colour Monochrome or dull colours used to build up the light and dark areas of a feature of a painting before further colour is applied on top.

dendrochronology A technique used to date wooden objects, including panel paintings, by examining annual growth rings in the wood. Trees grow faster in favourable summers, giving wider rings than those formed in bad summers. A sequence of ring widths has been worked out reaching many centuries into the past, so that dates can usually be calculated for when a tree was alive. The year in which it was cut down can be known precisely only if the final ring, just under the bark, is present, but an estimation of the felling date can usually be made.

drier See siccative.

earth pigment One of a range of natural pigments mined in various parts of the world. They consist of a mixture of clay and various oxides of iron in different proportions, and other substances, and are yellow, red, brown or even black in colour. (Green earth also exists, coloured by another iron compound, ferrous silicate.) See Cassel earth, Cologne earth, ochre, sienna, umber.

ell A unit of measurement traditionally used for the width of fabric. A Flemish ell, as used in the Netherlands, in the seventeenth century, is 69 cm (but an English ell is 114 cm).

energy-dispersive X-ray microanalysis: EDX A method of elemental analysis carried out in the scanning electron microscope (q.v.). Small areas of a sample which has been imaged in the SEM can be selected and analysed for their component elements. For example, a single paint layer in a cross-section, or a single pigment particle, may be selectively analysed. The electron beam which falls on the specimen in the SEM generates X-rays which are characteristic in their energies of the elements in the sample which produce them. The instrument measures the energies of these X-rays and assigns them on a visual display to the elements present. For the purposes of pigment identification, the results show whether the sample contains lead, copper, iron, cobalt and so on, but not what the actual component

pigments are. These analytical data must then be interpreted in conjunction with the examination of paint samples by optical microscopy in order to specify the pigments involved. (See also LMA.)

etching A method of making prints. A copper plate is coated with an acid-proof wax or varnish, known as a *resist*, and then drawn on with a stylus to scratch through the resist. Acid is applied to eat away the exposed metal, forming small indentations. After this, the resist is removed. To make a print, the plate is inked and then wiped, leaving ink only in the indentations. When the plate is pressed on to paper, this ink prints a picture which is a reversed, mirror-image version of the original drawing.

glaze A layer of translucent paint applied over other paint to modify its colour, or to give depth and richness of colour.

grisaille The process of painting in different shades of grey or near-monochrome; a painting so executed.

ground A preparatory underlayer, its colour sometimes giving a prevailing tone to the paint applied over it. Two different layers may be used (a *double ground*).

gypsum Natural hydrated calcium sulphate, which when heated becomes plaster of Paris; commonly used in grounds for Italian Renaissance panel paintings.

half-tones The transitional regions between light and dark areas of a painting.

impasto Thickly applied paint which stands out from the surface in relief.

imprimatura A thin layer applied to a basic ground to modify its colour preparatory to painting.

imprimeur A craftsman who applies grounds (q.v.) to canvases and panels.

infra-red A form of radiation similar to visible light, but slightly too long in wavelength for the eye to see. However, it can be photographed. Two apparently similar colours may look quite different when photographed under infra-red. Some materials opaque to ordinary light are transparent to infra-red, so that otherwise invisible underlayers of paint or drawing may be seen. *Pentimenti* and underdrawing containing black show particularly clearly in an infra-red photograph; on light ground pictures the structure of the brushstrokes often appears accentuated because of the greater penetration of infra-red radiation to the reflecting layers underneath.

lake A pigment made by precipitation on to a base from a dye solution – that is, causing solid particles to form, which are coloured by the dye. Lakes may be red, yellow, reddish brown or yellowish brown and are generally translucent pigments when mixed with the paint medium. Often used as glazes.

laser microspectral analysis: LMA A method for elemental analysis of minute samples, yielding similar information to EDX analysis (q.v.). An area of a sample is selected for analysis under a specialised microscope, and a laser pulse fired at this spot causing part of the specimen to be vaporised. The specimen vapour passes between a pair of electrodes across which an electrical spark is induced. This heats the vapour to a high temperature very rapidly, causing it to emit light of wavelengths which are characteristic of the composition of the sample. The emitted light is analysed by a spectrograph and recorded on a photographic plate as a spectrum of lines related to the elements present in the sample. In the same way as

in EDX analysis, the pigment composition of a paint layer can be determined by referring its elemental composition to examination of the sample by optical microscopy. LMA may be used on paint cross-sections (q.v.) for a layer-by-layer analysis, or on minute unmounted flakes.

lay in To underpaint as a rough basis for some feature of a painting; such an area is known as a *lay-in*.

lead A constituent of several pigments. See lead white, lead-tin yellow, massicot, minium.

lead white Basic lead carbonate, synthetically prepared for use as an opaque white pigment.

lead-tin yellow A yellow opaque pigment made by heating lead or a lead compound with stannic (tin) oxide, pale to dark yellow according to the temperature of preparation.

mahlstick A painter's stick used to rest or steady the hand.

marouflage To stick a canvas to a rigid support such as a wall or board.

massicot A yellow pigment. Today, the term describes pure synthetically prepared yellow lead monoxide. In Rembrandt's time it was used for lead-tin yellow (q.v.)

medium The binding agent for pigments in a painting; see also oil.

minium Red lead, a synthetically prepared lead oxide; occasionally used as a pigment.

miniver Black or white fur, properly ermine (the fur of a stoat in its winter coat).

neutron activation autoradiography A method of forming images of the different types of pigment used in a painting. The painting is bombarded with neutrons, so that all the materials in it become temporarily faintly radioactive, emitting electrons and other radiation which will produce an image on special photographic film. Different substances lose their radioactivity at different rates. Film is laid on the painting and changed at regular intervals, so that a series of images is obtained. For example, a few hours after bombardment the most strongly radiating element is manganese, revealing an image of all the umber in the painting. Four days afterwards, the main emitter is phosphorus, giving an image of passages carried out in bone black.

ochre An earth pigment (q.v.) of a dull red, orange, yellow or brown colour.

oil The oils used in oil paint are *drying oils* – that is, oils which dry naturally in air – such as linseed, walnut and poppyseed oil. Pigments are ground in this *oil medium* to make paint.

pastose Of paint: mixed to a stiff texture, so that it can be used to create impasto (q.v.).

pentimento (plural *pentimenti*) Alteration made by the artist to an area already painted.

pigment identification/analysis Many pigment identifications in minute samples of paint may be accomplished by optical microscopy of mounted cross-sections (q.v.), thin cross-sections (q.v.) and pigment dispersions, by classical methods of optical mineralogy. Supplementary chemical identification is often required to confirm the results of optical examination, and in the present study included laser microspectral analysis (q.v.), energy-dispersive X-ray microanalysis (q.v.), X-ray diffraction analysis (q.v.) and chemical microscopy (wet chemical tests carried out under the microscope). Certain pigment samples and cross-sections were investigated further by imaging in the scanning electron microscope (q.v.). All the pigment and media examples for Rembrandt's painting materials quoted in the Catalogue are the result of some positive method of identification or analysis, whether by optical microscopy in some form, or by instrumental means. In many cases confirmation of the identity of a material was obtained by several different techniques.

pink In the seventeenth and eighteenth centuries, a term used for yellow lakes (see lake).

quartz See silica.

radioabsorbent Of a material: obstructing the passage of X-rays (q.v.). Lead and lead-containing pigments are strongly radioabsorbent.

radiograph An image created on photographic film by X-rays (or occasionally by other forms of radiation). The process is known as *radiography*. See X-rays.

raking light A technique for revealing surface details of a painting by casting light across it at a low angle.

recession The illusion that a certain part of a painting is farther away from the viewer than another part. See also cool and warm.

reline To reinforce the original canvas support with a secondary canvas support stuck to the back.

reserve To omit paint from an area of a composition so that some planned feature may be painted on it later; an area treated in this way.

scanning electron microscopy: SEM A technique capable of revealing the fine details of objects at far higher magnifications than is possible with the optical (light) microscope. The scanning electron microscope uses a beam of electrons to scan the sample under examination, and the electrons scattered by the surface are collected and used to generate a video image. The SEM will show surface topography and three-dimensional structure at magnifications up to 100,000x, but the image can only be in monochrome. Equipment for microanalysis of very small areas of a specimen can be attached to the SEM (see EDX analysis).

scumble To apply a thin layer of semi-opaque paint over a colour to modify it; a layer of paint used in this way.

siccative Having a drying effect; a material which has such an effect (also known as a *drier*).

sienna An earth pigment (q.v.) of a reddish-brown colour. Sienna may be used as it is – *raw* – or *burnt*, that is, heated in a furnace to make the colour warmer.

silica Silicon dioxide, naturally found as quartz or sand. Powdered, it is used in certain grounds.

smalt Potash glass coloured blue with cobalt oxide, but often rather pale in colour. It is powdered and used as a blue pigment, or as a drying agent in oil paints.

strainer A fixed wooden frame on which a canvas is mounted to hold it taut.

stretcher Strictly, a wooden frame which may be expanded with wedges or keys, and on which a canvas is mounted to hold it taut; an eighteenth-century invention, not used by Rembrandt himself. The term is often, but wrongly, used for a fixed strainer (q.v.).

stretching frame A temporary frame to which a canvas is attached with cords to hold it taut while a ground is being applied or it is being painted.

support The canvas, wood panel or other material on which a painting is executed.

tabby The simplest plain weave of a fabric.

tacking edge The margins of a canvas where it has been turned around and tacked to the edges of a strainer.

thin cross-section A method of preparing thin slivers of paint to reveal their layer structure in transmitted light under the optical microscope, up to a magnification of 1200x. The technique is particularly suitable for the examination of translucent paint and varnish layers which allow light to pass through the specimen under the microscope. (See also cross-section.)

transfer To remove the original support (whether canvas or panel) from the back of the paint and ground, and replace it with a new support. The ground may also be partially or completely removed during the process, and a new ground applied to the back of the paint layers.

ultramarine A precious fine blue pigment extracted from lapis lazuli.

ultra-violet A form of radiation similar to visible light, but slightly too short in wavelength for the eye to see. Some substances, when illuminated with ultra-

violet, fluoresce – give off visible light – allowing details not otherwise visible to become apparent.

umber An earth pigment (q.v.) containing black manganese dioxide, giving it a dark brown colour. Umber may be used as it is – **raw** – or **burnt**, that is, heated in a furnace to make the colour warmer.

undermodelling Preliminary painting of features to suggest their shape and shading, before colour and details are added.

verditer Synthetic azurite (q.v.).

vermilion Mercuric sulphide, usually synthetic but sometimes the ground natural mineral cinnabar; used as a pigment.

warm Of a colour: tending towards the red end of the spectrum. Warm colours tend to seem nearer to the spectator than cool colours, a phenomenon used to create perspective effects.

wet-into-wet Laying down one colour next to or on to another before the first is dry, so that some intermixing occurs.

X-ray diffraction analysis: XRD
A technique for the identification of substances in crystalline form (many pigments are crystalline materials). A narrow beam of X-rays (q.v.) is projected through a very small specimen inside a specially designed form of camera. The regular arrangement of atoms in the crystal scatters the X-rays, producing a 'fingerprint' pattern, unique to that crystalline material, on a strip of film. Identification of this pattern allows unambiguous recognition of the material under study. XRD is particularly suitable for the identification of fairly pure samples of crystalline pigments, containing, for example, lead white, lead-tin yellow,

vermilion, azurite, chalk, the earth pigments and others.

X-rays A form of radiation which passes through solid objects, but is obstructed to differing degrees by differing materials. The larger the atoms of which a substance is made, the more opaque it is to X-rays. Lead compounds are particularly opaque, those containing lighter metals less so. Thus in an X-ray image (known as a radiograph) of a painting, areas of paint containing lead pigments will appear almost white, areas containing iron pigments will appear in an intermediate grey, and areas containing lighter materials will appear dark. In interpreting X-rays it should be remembered that all layers are superimposed: thus the image of a stretcher and features on the back of a painting may seem to overlie the image of the paint itself. Details of the weave of a linen canvas and the grain of a wood panel would normally not register significantly in a radiograph: they are, however, made visible in the X-ray image by a radioabsorbent ground which lies directly on them and which takes on the imprint of their surface structure. Thus a prominent thread in a canvas weave will appear dark in the radiograph because there is an absence of ground in this region. Even when a canvas is removed by transfer, the X-ray image of the weave often remains, imprinted in the ground layers.

Bibliographical Appendix

The training of artists and the practice of painting in seventeenth-century Holland

The training of artists in seventeenth-century Holland was largely practical, based on a long studio apprenticeship under conditions quite clearly laid down under guild regulations, with a contract drawn up between the artist and the apprentice, or his parents or guardians. Learned treatises of the type written by Leonardo, Lomazzo and Dürer, so influential elsewhere in Europe, were irrelevant and, indeed, inappropriate to a training of this sort, although it must be said that these authors were important to later Dutch writers on painting. This strong practical tradition may contribute to the fact that there are so few books on the practice or the theory of painting in the Netherlands, at least in the first part of the century. Van Mander's *Het Schilder-Boeck* stands alone in the early part of the century and had a profound influence on later authors, although only his long introductory essay on painting is relevant in the present context.

Albrecht Dürer's works on geometry, perspective and human proportions were of greater relevance to the painter, particularly for the study of perspective: references to his work appear in Bredius's *Künstler-Inventäre*, a collection of inventories of artists' property. Other well-known treatises on perspective were available, although not necessarily in Dutch: Abraham Bosse's *Maniere universelle de Mr Desargues pour pratiquer la Perspective*...(Paris 1648; Dutch edition Amsterdam 1686), Henrik Hondius the Elder's *Brève instruction des règles de la Geometrie...nécessaire à la Perspective* ...(The Hague 1625) and *Onderwijssinge in de Perspective Conste* (The Hague 1623), and Jan Vredeman de Vries's *Perspectiva, id est celeberrima ars*...(The Hague 1604; Leiden 1605) are only a few examples of the treatises available on perspective and geometry. The study of drawing was seen as an essential preliminary to the study of painting. A number of drawing books from which young artists might be helped to learn to draw were published during the seventeenth century: in these the pictorial, rather than the theoretical, content is dominant. One of the most important was Crispijn van de Passe the

Younger's...*Van t'light der Teken en Schilder Konst*...(Amsterdam 1643), which illustrates the correct proportions of the human body, includes figure studies and representations of animals and birds, and also covers other aspects of the painter's training. (This and other drawing books are discussed by J. Bolten in *Dutch and Flemish Drawing Books: method and practice 1600-1750*, Landau 1985.) Apart from these specialised areas of teaching, theoretical treatises had no place in practical training. In the inventories of Rembrandt's property at the time of his bankruptcy (1656; Strauss Doc. 1656/12) and death (1669; Strauss Doc. 1669/5) a large collection of engravings and drawings, by Rembrandt himself and by many other artists, some of it in book form, is described, but no didactic books on painting or drawing, theory or practice, are mentioned by name.

The best known of the painting treatises, Goeree's *Inleyding tot de Praktyk der algemeene Schilderkonst*, Hoogstraten's *Inleyding tot de hooge Schoole der Schilderkonst* and Lairesse's *Het groot Schilderboek*, date from late in the century and reflect the current academic approach to painting in their treatment, with a heavy emphasis on theory and many references to the painters of classical Greece and Rome. Even then, Hoogstraten, much of whose work is a rewriting of van Mander's introductory chapters, retains strong traces of his practical training, and Lairesse only turned to lecturing and writing on painting late in his career after he became blind. In order to consider how far a study of any of the works listed helps to elucidate Rembrandt's painting methods it is necessary to reflect on how far the works describe studio practice in Rembrandt's day at all, given that most of them date from considerably later, and whether or not Rembrandt's working methods – particularly perhaps in his late works – may be taken as typical. It is also helpful to consider whether or not the authors had any intimate knowledge of Rembrandt's working methods. (In fact it cannot be assumed that painting treatises of this period were neces-

sarily up to date in their practical content: they were frequently written towards the end of the authors' own painting careers – as is the case with Hoogstraten, Lairesse and, indeed, van Mander himself – and the authors would, perhaps, tend to refer back to their own practice of earlier years.)

The works primarily on watercolour painting, ter Brugge's *Verlichtery Kunst-Boeck*, Goeree's *Verligterie-Kunde* (a revision of ter Brugge) and Beurs's *De groote Waerelt in t'kleen geschildert*, stand a little apart from the others listed, being relatively straightforward manuals of instruction, listing suitable materials and describing their use. Beurs contains some colour theory in the tradition of Lomazzo (Giovanni Paolo Lomazzo, *Trattato dell'arte de la pittura*, Milan 1584) and others, but this is not unusual; his work is, in any case, later in date. Ter Brugge's work was referred to by Biens in his manual *De Teecken-Const*. This work is unusual, in that it does seem to have been written as a manual for amateurs or students and has a largely non-theoretical content, much derived from van Mander. It lists pigments appropriate for use in oil colour, particularly valuable in the present context, and also describes the method of assembling a lay figure.

Goeree published a number of works on painting and related topics: his intention was to produce an encyclopedia on the subject, an ambition never completely realised as books on colour and other matters never appeared. His treatment of painting, in the works published, is too theoretical to be of much assistance. Hoogstraten was Rembrandt's pupil (from 1640/1 to early 1648); one might assume that he would have some knowledge of Rembrandt's working methods and that a trace of this might be reflected in his writings. Sadly, Hoogstraten gives no precise comments on the practical side of Rembrandt's painting methods, although he does comment generally on the artist's colour, particularly his flesh tints, and on his handling of light and shade. He does not give a systematic description of the process of painting a picture either, such as one finds in

Lairesse or Sandrart: his book is divided broadly into subject areas, each named after one of the nine Muses. The sixth book, including much of Hoogstraten's discussion of colour, is named after Terpsichore. His discussion of the theory and symbolism of colour is similar to that of earlier authors (Lomazzo and van Mander to name but two), but, far more useful in the present context, he also lists the pigments currently available to the artist, with some of their disadvantages (he bemoans the lack of a good green). There is also a short discussion of varnishes and, interestingly, he makes the point that a painting with a smooth surface is better protected against dust and dirt. His historical discussion of painting methods in the ninth book, named after Urania, owes much to van Mander (and, before him, to Vasari). He pays particular attention to drawing as the foundation of the artist's training in his first book ('Euterpe') and discusses drawing materials at some length.

Lairesse's work is undoubtedly more straightforward. However, it was written in 1707, after Lairesse, whose portrait had been painted by Rembrandt late in his career in 1665, had modified his admiration for the artist's style of painting in tune with the current bias towards classicism and preference for a rather lighter and more balanced overall tonality than that used by Rembrandt. It is likely that the precepts laid down in the book are reflections of the author's own painting practice before he went blind in 1690. To apply Lairesse's principles to a work painted perhaps thirty years earlier, it is necessary to assume that the procedure of painting in seventeenth-century Holland was relatively standard and unchanging in its essentials. More research into later seventeenth-century Dutch practice is necessary before it can be seen how far this is in fact the case. Although there are few published Dutch manuals on painting practice of the period with which Lairesse's work can be compared, a study of works by other European authors (English, Italian and Spanish) suggests that the basic procedure of constructing a painting varied remarkably little in its essentials, not only in the Netherlands but also in other parts of Europe. The process of painting a picture, using an oil medium, is discussed in some detail elsewhere in this catalogue and only the briefest summary is given here. After the composition has been sketched on the prepared support (either directly or using drawings for guidance), the artist lays in a preliminary layer of underpaint of appropriate colour. When this is dry, the final layers of colour, highlights and reworkings are applied as required. Lairesse describes the procedure, as he knew it, in the first six chapters of book 1 of *Het groot Schilderboek*; the process he mentions is more elaborate than the brief summary given above. He discusses such matters as the choice of colour for various subjects, and the handling of light and shade, at length in later chapters in the book. It is to be expected that his description may vary in detail from that given by another author or, indeed, from that revealed during the technical examination of an individual painting.

In this context, by way of comparison with Lairesse's description, it is valuable to consider the practical comments in the introductory essay of Sandrart's *L'academia todesca*... Sandrart trained in Holland with Gerrit Honthorst in Utrecht and practised in Amsterdam from about 1637 to 1645; it is not clear whether he knew Rembrandt personally. His work too was published after Rembrandt's death, by which time he was living once more in Germany, his home country; but in many ways his statements may be as valuable for an understanding of Dutch seventeenth-century painting practice in general, and Rembrandt's in particular, as are Lairesse's. His description is given mainly in chapters IV and VII of his introductory essay on painting in part I, book III of the 1675 volume of *L'academia todesca*, with a list of suitable pigments in chapter XIV. (The summary in part II of the 1679 volume is less useful.)

On rare occasions, artists contemporary with Rembrandt and certain others with a good knowledge of current painting practice have committed their thoughts to paper: frequently such material was not published at the time, and may never have been intended for publication. Some observations on painting technique, attributed to Sir Anthony van Dyck and dating from the 1640s, were preserved in the commonplace book of Dr Thomas Marshall and provide material for comparison with the observed technique of Rembrandt during this period. A more important source is the so-called de Mayerne manuscript, *Pictoria, sculptoria, tinctoria et quae subalternarum artium spectantia*...(British Museum, MS Sloan 2052), which was compiled by the physician Theodore Turquet de Mayerne between the years 1620 and 1646, during his period of residence at the English court. Here he was able to meet, and obtain practical information from, many distinguished painters visiting from the Low Countries. The work, while not, strictly speaking, a Dutch source, is therefore relevant for an understanding of seventeenth-century Dutch practice during the earlier part of the period. It could equally well be considered as one of the technical sources (which are discussed later in the catalogue), as it gives valuable information on materials.

Select bibliography

Primary sources for Rembrandt's methods, techniques and studio practice

Baldinucci, Filippo, *Cominciamento e progresso dell'arte d'intagliare in rame...*, Florence 1686, pp. 78-80.

Félibien, André, *Entretiens sur les Vies et sur les Ouvrages des plus excellens Peintres anciens et modernes*, 5 vols., Paris 1666-88; vol. 4, 1684, pp. 150-7.

Hoogstraten, Samuel van, *Inleyding tot de hooge Schoole der Schilderkonst...*, Rotterdam 1678. The author makes references to Rembrandt throughout the book; some of the comments, on Rembrandt's ability to handle the portrayal of emotions (p. 75), for example, are of no assistance in attempting to understand the painter's working methods. His comments on Rembrandt's colour (pp. 291, 306) and in particular his flesh tints (pp. 227-8), his chiaroscuro and other aspects of his treatment of light (pp. 176, 273, 305-6), and on aspects of his manner of composition (pp. 176, 191) are perhaps of more interest. He also quotes advice given him by Rembrandt when he himself was one of Rembrandt's students (p. 13).

Houbraken, Arnold, *De groote Schouburgh der nederlantsche Konstschilders en schilderessen*, 3 vols., Amsterdam 1718-21; vol. 1, 1718, pp. 254-73. Note also the comments on the painting methods of Aert de Gelder, a pupil of Rembrandt, vol. 3, 1721, pp. 206-9, particularly pp. 206-7.

Huygens, Constantyn, [*Autobiographie*]: the original manuscript, in Latin, is in the Koninklijke Bibliotheek in The Hague. A modern Dutch translation is *De Jeugd van Constantijn Huygens, door hemzelf beschreven*, translated by A.H. Kan, A. Donker, Rotterdam 1946, reprinted 1971; see pp. 78-81, particularly pp. 78-9.

Lairesse, Gerard de, *Het groot Schilderboek...*, 2 vols., Amsterdam 1707; vol 1, book 1, ch. 12, pp. 41-2 (on Rembrandt's colouring in shadows), book 5, ch. 21, p. 320 (a reference to Rembrandt in a chapter on the necessary variation in handling of paint and colouring when painting faces in perspective in large and small pictures), ch. 22. pp. 323-5 (on forcefulness, impasto and Rembrandt's style in general), vol. 2, book 7, ch. 3, p. 18 (on Rembrandt's colour).

Lecomte, Florent, *Cabinet des Singularitez d'Architecture, Peinture, Sculpture et Graveure...*, 3 vols., Paris 1699-1700; vol. 3, second part 'Le Cabinet des tableaux, des statues et des estampes', pp. 125-7. There is also a mention of Rembrandt's manner of painting in vol. 1, pp. 51-2, in the author's general discussion of painting methods.

Piles, Roger de, *Abregé de la Vie des Peintres...*, Paris 1699, pp. 433-5 (biography), pp. 435-8 ('Reflexions sur les ouvrages').

Piles, Roger de, *Cours de Peinture par principes...*, Paris 1708; this contains his 'Balance de Peintres', wherein he awards marks for composition, drawing, colour and expression to noteworthy painters of the day, pp. 489 ff.

Sandrart, Joachim von, *L'academia todesca della architectura, scultura e pittura, oder, Teutsche Academie der edlen Bau-, Bild- und Mahlerey-Künste...*, 2 vols., Nuremberg, vol. 1, 1675; vol. 2, 1679; vol. 1, part II, book III, pp. 326-7. Useful material on studio practice is contained in the biographies of other Dutch artists, for example, Gerrit Dou (vol. 1, part II, book III, pp. 320-1,) and Gerrit van Honthorst (vol. 1, part II, book III, pp. 303-4), with whom Sandrart studied.

A selection of Dutch seventeenth-century literature on painting, theory and practice

The more technical books, which include recipes for pigments and varnishes as well as practical instructions for the painter, are listed in the next section. Many of the books listed below include lists of suitable pigments.

Beurs, Willem, *De groote Waerelt in t'kleen geschildert...*, Amsterdam 1692; German edition published Amsterdam 1693. This is mainly on watercolour painting.

Bie, Cornelis de, *Het gulden Cabinet van de edele vry Schilder-Const...*, Antwerp 1661. The author was a notary. The bulk of the work consists of biographies of the famous artists of the time, in verse. De Bie was full of uncritical admiration for Rembrandt's work (p. 290), but his account contains nothing of relevance to Rembrandt's working methods. He also wrote a general discussion on the art of painting, including a chapter entitled 'Op den natuer oft cracht der verwen' (pp. 208-11), in which many of the pigments used in oil painting are listed.

Biens, Cornelis Pietersz., *De Teecken-Const: ofte een korte ende klaere aen-leydinghe tot die lofelijcke const van teeckenen tot dienst ende behulp van de eerstbeghinnende jeucht ende liefhebbers, in elf capittelen vervat*, Amsterdam 1636; reprinted in Klerk, E. A. de, 'De Teecken-Const, een 17de-eeuws nederlands traktaatje', *Oud Holland*, 96, 1982, pp. 16-60. The text of the treatise was taken from a manuscript transcript appended to a study by C. Muller-Hofstede, in the Kunstmuseum, Basel; no printed copy of the work appears to be extant.

Brugge, Geerard ter, *Verlichtery Kunst-Boeck in de welcke de rechte fondamenten eñ het volcomen gebruyck der illuminatie...*, Amsterdam 1616; later edn. Leiden 1634. (The author's surname also appears in the form 'Terbrugghen'.) This is on watercolour painting; later in the century a revised edition was brought out by Willem Goeree under the title *Verligterie-Kunde* (cited below).

Goeree, Willem, *Inleyding tot de Praktyk der algemeene Schilderkonst...*, Amsterdam 1697, but in existence by 1670; reprinted

1704. A German collected edition was published in Hamburg in 1678 which also included translations of *Inleydinge tot de algemeene Teyken – Konst*, about 1668, on drawing, and *Verligterie-Kunde*, 1670. Other books forming part of Goeree's planned encyclopedia of art are his *Natuurlyk en schilderkonstig Ontwerp der Menschkunde*, Amsterdam 1682, on anatomy, proportion and related topics; and *d'Algemeene Bouwkunde...*, Amsterdam 1681, on architecture.

Goeree, Willem. *Verligterie-Kunde of regt gebruik der water-verwen...*, Amsterdam 1670; several later edns., 4th printing 1704, together with the works mentioned above. An English translation was published in 1674. This is on watercolour painting and is a considerably expanded revision of ter Brugge's work (cited above).

Hoogstraten, Samuel van, *Inleyding tot de hooge Schoole der Schilderkonst*, Rotterdam, 1678. Book 1 ('Euterpe') includes references to drawing materials and techniques (pp. 26, 29-32); in book 6 ('Terpsichore') the author mentions the benefit of copying paintings (p. 218) and refers to pigments and varnishes in his discussion of colour (pp. 220-3; see also p. 241, on paintings with smooth surfaces). There are brief comments on the effect of the colour of the ground on the overall harmony of light and shade in the painting in book 8 ('Calliope'), pp. 306, 321. Book 9 ('Urania') contains a historical discussion of painting methods (pp. 333-40).

Lairesse, Gerard de, *Het groot Schilderboek*, 2 vols., Amsterdam 1707; English translation London 1738. (See also: Dolders, Arno, 'Some remarks on Lairesse's *Groot Schilderboek*', *Simiolus*, 15, 1985, pp. 197-220.) A general description of painting procedure is given in book 1, chs. 1-6.

Mander, Karel I. van, *Het Schilder-Boeck: waer in voor eerst de leerlustighe iueght den grondt der edel vry schilder-const... * Haarlem 1604; 2nd edn. Amsterdam 1618. The discussion of painting appears in the introductory essay, 'Den grondt der edel vry schilder-const', which has been published in facsimile, with modern Dutch translation and commentary by Hessel Miedema, 2 vols., Haentjens, Dekker & Gunbert, Utrecht 1973. Most of van Mander's discussion of pigments appears in ch. XII (fol. 46v-50 in 1604 edition).

Sandrart, Joachim von, *L'academia todesca...* (details in previous section). Although this work is not Dutch in origin, the author received part of his training as a painter in Holland. The long, largely theoretical, essay on painting forms book III of part I of the first volume. Sandrart's comments on the more practical aspects of painting are of considerable interest, including suggestions for the size and lighting of an artist's studio (ch. XI, pp. 80-1) and brief comments on pigments (ch. XIV, p. 86). He also gives some insight into the methods of oil painting in his day (ch. IV, p. 66; ch. VII, pp. 72-3).

Unpublished sources

Dyck, Anthony van: Some observations on painting technique attributed to Anthony van Dyck are reproduced in the original Dutch, with a German translation, in: Vey, H., 'Anton van Dijck: über Maltechnique', *Bulletin van der Koninklijke Musea voor Schone Kunsten*, 9, 1960, pp. 193-200, and also, in English translation only, in Talley, Mansfield Kirby, *Portrait Painting in England: studies in the technical literature before 1700* (cited below under 'General References for painting materials and techniques'), ch. 7, pp. 150-5.

Mayerne, Theodore Turquet de, *Pictoria, sculptoria, tinctoria et quae subalternarum artium spectantia...*, 1620-46, British Museum, MS Sloane 2052. A number of transcriptions of the manuscript have been published, the earliest complete transcription by Ernst Berger in 1901 and the best annotated by J.A. van de Graaf in 1958: there is also a French translation of the manuscript by M. Faidutti and C. Versini. These are as follows: Berger, Ernst, *Quellen für Maltechnik während der Renaissance deren Folgezeit (XVI-XVIII. Jahrhundert)*, Georg D.W. Callwey, Munich 1901; reprinted by M. Sandig, Walluf bei Wiesbaden 1973 (Beiträge zur Entwicklungsgeschichte der Maltechnik, IV); Graaf, J. A. van de, *Het de Mayerne Manuscript als bron voor de schildertechniek van de Barok*, (dissertation), Utrecht 1958; Faidutti, M. and Versini, C., *Le manuscrit de Turquet de Mayerne*, Audin Imprimeurs, Lyon n.d.; the text was originally published in the journal *Peintures, Pigments et Vernis* during the years 1965-7. The manuscript is also discussed at length by M. Kirby Talley in chapter 6 of his book, cited above.

Contemporary technical literature on painting materials

The de Mayerne manuscript cited above is equally valuable as a source of technical information on artists' materials.

Alessio Piemontese (Girolamo Ruscelli?), *De' secreti del Reverendo Donno Alessio Piemontese...*, Venice 1555 or 6; 2nd edn. 1557. The first Dutch edition, *De Secreten van den Eerweerdighen Heere Alexis Piemontois*, Antwerp 1561, was translated from the French edition of Christophle Landré (Paris 1559). Seventeenth-century editions include those printed in Delft, 1602, and Amsterdam, 1631. Dutch editions of the second part of 'Alessio's' work, derived from the same French source – actually a reprint of the 1549 edition of Andriessen's work (q.v.) – appeared in the same years, with a later printing also in 1670 (see Vandamme, cited below).

Andriessen, Symon, *Een schoon Tractaet van sommighe Werckingen der Alchemistische dinghen, om gout, silver te maken...noch een schoon tractaet boecxken, inholdende van alderley verwen te maecken...*, Amsterdam 1581. (The author's surname also appears in the form 'Andree'.) There are a number of

151

editions of this work, differing in content. The work was first published in 1549: this edition is largely a translation into Dutch of a work published in Augsburg in 1537: *Künstbüchlin, gerecht-ten grundtlichen Gebrauchs/ aller kunstbaren Werckleut*...The 1552 edition, entitled *Vier rondigh Tractaet Boeck*..., contains four tracts, the second of which contains detailed recipes for colours and their use. (This is not found in the *Künstbüchlin*.) The 1581 edition is different again in content, containing only the last tract of the 1549 edition and the second tract of the 1552 edition. The 1600 edition is a reprint, uniting the earlier editions (1549 and 1581), itself reprinted in 1687. Andriessen's work appears in other forms also, as described above.

Batin, Carel, *Secreetboek, waerin vele diversche secrete ende heerlicke consten, in veelderleye materien uut seker latijnsche, fransoysche, hoochduytsche ende nederlantsche authoren te samen by een gebracht zyn*...Dordrecht 1601, 1609; Amsterdam 1650, 1656. (The author's surname also appears in the form 'Battus' in the later editions.) The wording of the title is slightly different in the later editions, which also have an appendix (dated 1651 and 1656 respectively) including an unattributed section on painting and pigments; this is a reprint of the second tract of the 1552 and 1581 editions of Andriessen.

Dat playsant Hofken van Recepten, in het welcke gheplant syn diverse boomkens van naturael philosophie, inhoudende seer schoene remedien tot alle gebreken des lichaems..., Antwerp 1548. This is translated from a French version, itself derived from an Italian source (see Vandamme, cited below). Other editions appeared in 1551, 1553 and 1657, all printed in Antwerp.

Morley, Christopher Love, *Collectanea chymica leydensia, id est maetsiana, margraviana, le mortiana scilicet trium in Academia Lugduno-Batava facultatis chimicae*...*professorum*..., Leyden 1684; later editions 1693, 1702. A German edition was published in 1696.

Schendel, A.F.E. van, 'Manufacture of vermilion in 17th-century Amsterdam: the Pekstok papers', *Studies in Conservation*, 17, 1972, pp. 70-82. (Municipal Archives, Amsterdam, No. N-09-23.) The original manuscript contains recipes for a few other pigments, including Spanish green (verdigris) and *schuytgeel* (a yellow lake pigment).

Vandamme, E., 'Een 16e-eeuws zuidnederlands receptenboek', *Jaarboek van het Koninklijk Museum voor Schone Kunsten Antwerpen*, 1974, pp. 101-37 (Plantin-Moretus Museum No.253). The author also gives an annotated list of published sixteenth-century Netherlandish treatises, including a number of the small collections of 'secrets' mentioned in the essay on technical literature on painting materials.

General references for painting materials and techniques

Bredius, Abraham, *Künstler-Inventäre: Urkunden zur Geschichte der holländischen Kunst des XVIten, XVIIten and XVIIIten Jahrhunderts*, 8 vols., M. Nijhoff, The Hague 1915-22. There are very few references to artists' materials in the inventories: as tools of the painter's trade they seemed to have been excluded usually, or to have passed under the most general of comments. There are scattered references to ultramarine (for tax purposes, for example). There appear to be two inventories wherein pigments are listed, as well as grinding stones, brushes, and canvases and panels in various stages of completion, which thus give some documentary evidence of the pigments actually available and purchased by painters. These are: (i) the inventory of the property of the flower painter Jacob Marrell following the death of his wife in 1649 (*K-I*, vol. 1, pp. 112-19); (ii) The inventory of the possessions of the painter Cornelis Cornelisz. van Harlem, 1639 (*K-I*, vol. 7, pp. 77-86).

Graaf, Johan A. van de, 'Betekens en toepassing van "lootwit" en "schelpwit" in de XVIIe-eeuwse nederlandse schilder-kunst', *Bulletin de l'Institut Royal du Patrimoine Artistique*. IV, 1961, pp. 198-201 (French summary).

Harley, Rosamund D., *Artists' Pigments 1600-1830: a study in English documentary sources*, 2nd edn., London 1982.

Martin, W., '"Een kunsthandel" in een klappermanswachthuis', *Oud Holland*, 19, 1901, pp. 86-8. (This article refers to the opening of a shop dealing in artists' materials in Leiden in 1643; before this date no shop dealt specifically with these materials.)

Miedema, Hessel, and Meijer, Bert, 'The introduction of coloured ground in painting and its influence on stylistic development, with particular respect to sixteenth-century Netherlandish art', *Storia dell'Arte*, 35, 1979, pp. 79-98.

Talley, Mansfield Kirby, *Portrait Painting in England: studies in the technical literature before 1700*, published privately by the Paul Mellon Centre, London 1981.

Other references may be found in the Rembrandt *Corpus*, cited earlier in this Catalogue.

Select bibliography of scientific and technical examination of Rembrandt's paintings

Ainsworth, Maryan Wynn, and others, *Art and Autoradiography: insights into the genesis of paintings by Rembrandt, van Dyck and Vermeer*, Metropolitan Museum of Art, New York 1982. (Detailed bibliography.)

Bauch, J., Eckstein, D. and Meier-Siem, M., 'Dating the wood of panels by a dendrochronological analysis of the tree-rings', *Nederlands Kunsthistorisch Jaarboek*, 23, 1972, pp. 485-96.

Coremans, Paul, 'L'*Autoportrait* de Rembrandt à la Staatsgalerie de Stuttgart: examen scientifique', *Jahrbuch der Staatlichen Kunst-*

sammlungen in Baden-Württemberg, 2, 1965, pp. 175-88. (See also supplement to article on the painting by C. Muller-Hofstede, *Pantheon*, 2, 1963, pp. 94-100.)

Coremans, Paul, and Thissen, Jean, 'Het wetenschappelijk onderzoek van het *Zelfportret van Stuttgart*: Bijdrage tot de Rembrandtvorsing', *Bulletin de l'Institut Royal du Patrimoine Artistique*, VII, 1964, pp. 187-95 (French summary).

Froentjes, W., 'Schilderde Rembrandt op goud', *Oud Holland*, 84, 1969, pp. 233-7 (English summary).

Groen, Karin, 'The examination of the *Portrait of Rembrandt in a Flat Cap*', *Bulletin of the Hamilton Kerr Institute*, 1, 1988, pp. 66-8. The report describes features which indicate that the painting is by an imitator of the artist.

Groen, Karin, 'Schildertechnische aspecten van Rembrandts vroegste schilderijen', *Oud Holland*, 91, 1971, pp. 66-74 (English summary).

Hermesdorf, P. F. J. M., Wetering, E. van de and Giltaij, J., 'Enkele nieuwe gegevens over Rembrandts *De Eendracht van het Land (The Concord of the State)*', *Oud Holland*, 100, 1986, pp. 35-49 (English summary).

Hours, Madeleine, 'Rembrandt: observations et présentation de radiographies exécutées d'après les portraits et compositions du Musée du Louvre', *Bulletin du Laboratoire du Musée du Louvre*, 6, 1961, pp. 3-43.

Houtzager, M. E., and others, *Röntgenonderzoek van de oude schilderijen in het Centraal Museum te Utrecht*, Centraal Museum, Utrecht 1967. The investigation by X-radiography of sixteenth- and seventeenth-century Netherlandish paintings in the Museum collection: this is a general study providing comparative material and enabling Rembrandt's work to be viewed in context.

Johnson, Ben B., 'Examination and treatment of Rembrandt's *Raising of Lazarus*', *Los Angeles County Museum of Art Bulletin*, 20, 1974, pp. 18-35.

Kelch, Jan, and others, *Bilder im Blickpunkt: Der Mann mit dem Goldhelm: eine Dokumentation der Gemäldegalerie in Zusammenarbeit mit dem Rathgen-Forschungslabor SMPK und dem Hahn-Meitner-Institut Berlin*, Staatliche Museen Preussischer Kulturbesitz Berlin, Gemäldegalerie, Berlin 1986. (See also paper by G. Pieh, cited below.)

Kühn, Hermann, 'Untersuchungen zu den Malgründen Rembrandts', *Jaarbuch der Staatlichen Kunstsammlung in Baden-Württemberg*, 2, 1965, pp. 189-210.

Kühn, Hermann, 'Untersuchungen zu den Pigmenten und den Malgründen Rembrandts, durchgeführt an den Gemälden der Staatlichen Kunstsammlungen Kassel', *Maltechnik/Restauro*, 82, 1976, pp. 25-32.

Kühn, Hermann, 'Untersuchungen zu den Pigmenten und den Malgründen Rembrandts, durchgeführt an den Gemälden der Staatlichen Kunstsammlungen Dresden', *Maltechnik/Restauro*, 83, 1977, pp. 223-33.

Pieh, Gerhard, 'Die Restaurierung des *Mann mit dem Goldhelm*', *Maltechnik/Restauro*, 93, 1987, pp. 9-34. (See also the booklet published by the Gemäldegalerie, Berlin, cited above.)

Sonnenburg, Hubert F. von, '*Maltechnische Gesichtspunkte zur Rembrandtforschung*', *Maltechnik/Restauro*, 82, 1976, pp. 9-24. Extensive bibliography of earlier work.

Sonnenburg, Hubert F. von, 'Rembrandts *Segen Jacobs (Jacob blessing the Children of Joseph)*', *Maltechnik/Restauro*, 74, 1978, pp. 217-43.

Sonnenburg, Hubert F. von, 'Technical aspects: scientific examination' (round-table discussion), in *Rembrandt after Three Hundred Years: a symposium – Rembrandt and his followers*, 22-4 October 1969, Art Institute of Chicago, Chicago 1973, pp. 83-101. Extensive bibliography of earlier work.

Symposium on Technical Aspects of Rembrandt Paintings, organised by the Rembrandt Research Project and the Central Research Laboratory for Objects of Art and Science 22-4 September 1969 (abstracts), Amsterdam 1970.

Vries, A. B. de, and others, *Rembrandt in the Mauritshuis: an interdisciplinary study*, Sijthoff & Noordhoff International Publishers, Alphen aan de Rijn 1978.

Wetering, Ernst van de, 'De jonge Rembrandt aan het werk', *Oud Holland*, 91, 1977, pp. 27-65.

Wetering, Ernst van de, 'Painting materials and working methods', Rembrandt *Corpus*, vol. I, ch. 2, 1982, pp. 11-33.

Wetering, Ernst van de, 'The canvas support', Rembrandt *Corpus*, vol. II, ch. 2. 1986, pp. 15-43.

The last two papers have also appeared, together with the same author's chapter entitled 'Problems of apprenticeship and studio collaboration' (Rembrandt *Corpus*, vol. II, ch. 3,), bound together in book form, for the award of a higher degree at the University of Amsterdam in 1986. This work is entitled *Studies in the Workshop Practice of the Early Rembrandt*; it contains an interesting introductory article summarising opinions of Rembrandt and his work held by some earlier authors.

Wetering, Ernst van de, Groen, Karin and Mosk, Jaap A., 'Summary report on the results of the technical examination of Rembrandt's *Nightwatch*', *Bulletin van het Rijksmuseum*, 24, 1976, pp. 68-98.

J. K.

Technical literature on painting materials in seventeenth-century Holland

The treatises on painting discussed previously are primarily theoretical. Apart from, perhaps, a description of painting procedure and a discussion of suitable pigments for particular purposes, the technical content of these works is negligible. The de Mayerne manuscript, described earlier, is an exception: the preparation of grounds, drying oils, suitable pigments and the choice of brushes for various purposes are among the topics discussed. For the investigation of the materials and methods used by Rembrandt, or by any other painter, a study of technical literature, written for the craftsman, is of great value.

The development of any technology depends in part on the spread of information: science and industry were able to evolve in parallel with the growth of the printing and publishing industry in the sixteenth and seventeenth centuries. During this period there were considerable developments in science and technology generally in the Netherlands (notably in the field of dyeing, for example): the Dutch printing industry, also, was flourishing. It was during the seventeenth century that an increased understanding of the scientific principles underlying natural phenomena and technical processes – for example, the use of the microscope in the discovery of certain protozoa and bacteria (by Anton van Leeuwenhoek), or the effect of tin salts on the colour of cochineal dyestuff (by Cornelius Drebbel) – began to be reflected in the publication of increasingly more specialised technical literature, although it must be said that seventeenth-century technical literature in the Dutch language appears to be rather scarce. As far as pigments are concerned, it seems that, in general, technical literature of this kind appeared towards the later years of the seventeenth century (for example, in Germany: *Der curiose Mahler* . . . [Dresden 1695] is a very thorough treatise). However, before this, it was not unusual for a work on a relatively restricted but related field, such as glass-making, to contain instructions for preparing certain pigments; for example Antonio Neri's *L'arte vetraria* (Florence 1612; Latin translation Amsterdam 1686) contains detailed recipes for making lake pigments from such dyestuffs as cochineal. (The revised English and German translations [Merret, London 1662; Kunckel, Frankfurt and Leipzig 1679] were probably also known in Holland.) It is also important to remember that technical material of this kind, intended for practical workshop use, did not necessarily find its way into print at all: the tradition of protecting trade secrets, or, perhaps, guild regulations, may have been partly responsible for this, but also there are rare survivals of manuscript material, recipes noted down by the craftsman for his own use or compiled for the benefit of apprentices. Seventeenth-century Holland was known for the excellent quality and colour of the manufactured form of vermilion produced there: one of the most detailed descriptions of the manufacturing process is to be found in a collection of private papers, known today as the Pekstok papers (Municipal Archives, Amsterdam, No. N-09-23), which also contain shorter recipes for other pigments, including a yellow lake. The vermilion process is given in the paper by van Schendel, 'Manufacture of vermilion . . .', listed in the bibliography.

A study of the chemical literature of the period throws a little light on the study of materials used in painting. Christopher Morley, a student at the University of Leiden in the latter part of the century, published his *Collectanea chymica leydensia*, notes taken from lectures given by the chemists Karl Maets, Charles Margrave and Jacob Le Mort, which include brief instructions for the preparation of lead white (the well-tried and tested method, known today as the Dutch or stack process [see p. 21], here ascribed to Le Mort), vermilion, various varnishes (not necessarily for pictures) and the purification of linseed oil: a very similar method for the last-named process is also given by de Mayerne.

Traditional technical literature, such as the books of 'secrets', also remained relevant, to the general reader at least, in parallel with the specialised literature reflecting the increased knowledge and understanding of more learned authorities. This more popular literature received its first printed form in the sixteenth century, but descended from considerably older manuscript collections and folk remedies. The 'secrets' book consisted of a wide-ranging collection of recipes, particularly suitable for use by the craftsman or in the home. Not surprisingly, many recipes were medicinal. (The more formal equivalent to these recipes are found in the Pharmacopoeiae published in various cities, also based on earlier sources, which prescribed standard remedies and materia medica. The chief editor of the first Amsterdam Pharmacopoeia (1636) was that same Nicolaas Tulp painted by Rembrandt in *The Anatomy Lesson of Dr Tulp* in 1632.) Instructions were also included for a wide range of other preparations: alchemical, metallurgical, cosmetic, culinary, cleaning, dyeing and pigment-making. Many such varied collections were in circulation well into the seventeenth century, some more thorough and detailed, others rather trite.

Alessio's work of 1555/6, *De' secreti del Reverendo Donno Alessio Piemontese*, was one of the most famous: a best-seller, it ran into many editions and was translated into many European languages. There were at least six Dutch editions and the book was reprinted well into the seventeenth century. Alessio's work, in the earliest Italian editions, consisted of six books: these form the first part of the later, two- or three-part, editions. The second part varies: in the Dutch (and English) editions, derived from Landré's French edition (1559), it consists of the 1549 version of Symon Andriessen's tract, discussed below. Most of the pigment recipes appear in book 5 of Alessio's original work: they include recipes for ultramarine, red lake pigments, various artificial blue pigments and vermilion. Instructions are given also for grinding pigments to their best advantage, particularly blues, which are inclined to lose their colour if too finely ground.

Batin's *Secreetboek* contains perhaps the cream of the many individual collections, as

is described in the foreword to the book. He gives the original source for many of the recipes. Apart from one or two recipes from Alessio – for vermilion and for a red lake pigment prepared from dyed clippings of cloth – he does not attribute the main section on pigments, which is a translation of the first part of Valentin Boltz's *Illuminirbuch* (Basel 1549), itself a much reprinted, thorough and influential work. (It forms the basis of a later Dutch work, *Den geheimen Illuminir-Kunst*... by J.B. Pictorius [Leiden 1747], which is partly concerned with watercolour painting.) Boltz's book is an artist's manual: the colours to use for painting various items are suggested and instructions are given for preparing, washing and grinding a wide range of pigments. The recipes are for those pigments easily prepared, such as lakes. Batin updates the work only in minor details. The later editions of Batin's work have an appendix which includes Andriessen's tract on painting described below.

There was a market in northern Europe, notably sixteenth-century Germany, for small practical handbooks, for home use or for the craftsman, which drew on a similar type of source material to that of the 'secrets' books and had similarly been in circulation in manuscript form. The contents, too, were similar, although the range was rather more restricted. New collections of old recipes were compiled at intervals, or old collections were reprinted. The 'Kunstbüchlein' group of books is an example of these. Andriessen's tract is partly related to this group: part of the 1549 edition of *Een schoon Tractaet* is a translation of the *Künstbüchlin* (Augsburg 1537), itself descended from an earlier work. Other editions of Andriessen's work – the 1552 and 1581 editions – contain a more detailed tract. This, like Boltz's work, is an artist's handbook: it resembles Boltz's work also in that it is aimed more at the illuminator of manuscripts than at the easel painter, although many of the pigments used are common to both. It is much shorter and less sophisticated, containing a far narrower range of pigments. These are, however, of a similarly good quality; many are lakes and

others, for which no recipes are given, such as vermilion, massicot and even expensive blues such as azurite, are at least mentioned by name. This work was reprinted in the seventeenth century.

Other small works, usually anonymous, with a history as long as that of the 'Kunstbüchlein' group, were in circulation in the Netherlands in the sixteenth century. *Dat playsant Hofken van Recepten*... (Antwerp 1548) was translated from a French edition and was reprinted as late as 1657. The recipes are traditional, including instructions for preparing a blue pigment from verdigris and for making vermilion. An interesting collection in manuscript form is that published by Vandamme (Plantin-Moretus Museum, No. 253), which is useful firstly for the diagrams of some of the ovens and apparatus used, and secondly for its rare description of a method for making the yellow pigment massicot.

It is important to note that traditional sources such as these persist unchanged over a long period of time. Whether or not they are reliable indicators of current practice is debatable. The method of preparing pigments such as lead white or the manufactured variety of vermilion remained relatively constant: in such cases, the recipes are likely to have remained valid and useful. Information on technological progress appeared in print relatively slowly, and the possibility of restrictions on publishing trade secrets has already been mentioned. As a result, the absence of a recipe for a given pigment does not necessarily indicate that it was not prepared or used. The curious lack of contemporary recipes for massicot – or lead-tin yellow, as it is now believed to be – the presence of which has been confirmed in many paintings of the period, including Rembrandt's, is an example of this. Equally, the listing of a particular pigment, or the presence of a recipe for it, must also be treated with a certain amount of caution. This is particularly true of Alessio's recipes which, as well as having a long history, are also north Italian in origin. They are unlikely to reflect accurately seventeenth-century Dutch practice where, for example,

the blue pigments ultramarine and azurite became increasingly difficult to obtain and extremely expensive (and Batin, in his selection of recipes from Alessio, did not include any for ultramarine). The same caution is necessary when reading certain artists' manuals, such as Goeree's 1670 revision of ter Brugge's work on watercolour, *Verlichtery Kunst-Boeck*..., first published in 1616, which gives a surprisingly long list of suitable pigments, much longer than in the original. However, although one may wonder if some were still widely used or, indeed, available by 1670, watercolour is very much more economical in its use of pigments than is oil painting on panel or canvas, and the use of an expensive, rare pigment would have been possible.

Bibliography: *Amsterdam Pharmacopoeia, 1636*, facsimile of the first Amsterdam Pharmacopoeia, with an introduction by D.A. Wittop Koning, B. de Graaf, Nieuwkoop 1961; Ernst Darmstaedter, *Berg-, Probir- und Kunstbüchlein*, Verlag der Münchner Drücke, Munich 1926; J. Ferguson, 'Bibliographical notes on histories of inventions and books of secrets', *Transactions of the Archaeological Society of Glasgow*, Glasgow 1883; supplement 1894; J Ferguson, *Bibliotheca chemica: a catalogue of the alchemical, chemical and pharmaceutical books in the collection of the late James Young of Kelly and Durris, Esq....*, 2 vols, J. Maclehose & Sons, Glasgow 1906; J. Ferguson, *Some early treatises on technological chemistry*, Glasgow Philosophical Society, Glasgow, 1888; supplements 1894, 1910, 1912, 1913, 1916; Vandamme, 'Een 16e-eeuws zuidnederlands receptenboek'..., pp. 101-13.

List of Illustrations

42. Rembrandt: *Saskia in a Straw Hat, 8 June 1633.* Silverpoint on vellum, 18.5 x 10.7cm (7¼ x 4³⁄₁₆in.). Berlin-Dahlem, Kupferstichkabinett

43. Rembrandt: *Saskia as Flora.* 1634. Canvas, 125 x 101cm (49³⁄₁₆ x 39¾in.). Leningrad, Hermitage

44. Govert Flinck (1615-1660): *Saskia as Shepherdess.* Canvas, 74.5 x 63.5cm (29⁵⁄₁₆ x 25in.). Brunswick, Herzog Anton Ulrich-Museum

45. Govert Flinck (1615-1660): *Rembrandt as Shepherd.* Canvas, 74.5 x 64cm (29⁵⁄₁₆ x 25³⁄₁₆in.). Amsterdam, Rembrandthuis (on loan from the Rijksmuseum)

46. Rembrandt: *Saskia van Uylenburch in Arcadian Costume.* X-ray detail, showing triangular canvas repair

47. Rembrandt: *Saskia van Uylenburch in Arcadian Costume.* X-ray mosaic

48. Peter Paul Rubens (1577-1640): *Judith with the Head of Holofernes.* Panel, 120 x 111cm (47¼ x 43⅝in.). Brunswick, Herzog Anton Ulrich-Museum

49. Rembrandt: *Judith and Holofernes.* Pen and wash, 17.8 x 21.2cm (7 x 8⅜in.). Paris, Louvre, Cabinet des Dessins

50. Rembrandt: *The Lamentation over the Dead Christ.* Diagram showing the original paper and the canvas pieces mounted on the oak panel

51. Rembrandt: *The Lamentation.* Brown, grey and white oil colours and pale brown ink over red chalk, 21.3 x 25.4cm (8⅜ x 10in.). London, British Museum, courtesy of the Trustees

52. Bernard Picart: Engraving after *The Lamentation.* 1730. Published in Picart's *Impostures innocentes ou Recueil d'estampes d'après divers peintres illustres,* Amsterdam 1734. London, British Museum, courtesy of the Trustees

53. Ferdinand Bol (1616-1680) (?): *The Lamentation* (copy after Rembrandt). Brush and brown ink over a sketch in black chalk, 16.3 x 24.5cm (6⁷⁄₁₆ x 9⅝in.). West Germany, Private Collection

54. Rembrandt: *Saint John the Baptist Preaching.* Canvas on panel, 62 x 80cm (24⅜ x 31½in.). Berlin-Dahlem, Gemäldegalerie

55. Rembrandt: *The Lamentation over the Dead Christ.* X-ray mosaic

56. Rembrandt: *Cupid blowing Bubbles.* 1634. Panel, 74.5 x 92cm (29⁵⁄₁₆ x 36¼in.). Paris, Collection of Baron Bentinck

57. Rembrandt: *Samuel Menasseh ben Israel.* 1636. Etching, first state, 14.9 x 10.3cm (5⅞ x 4¹⁄₁₆in.). London, British Museum, courtesy of the Trustees

58. Menasseh ben Israel, *De termino vitae,* Amsterdam 1639, p. 160 (showing the Hebrew inscription written on the wall during Belshazzar's Feast). London, The British Library

59. Rembrandt: *The Angel taking leave of Tobias.* 1637. Panel, 68 x 52cm (26¾ x 20½.). Paris, Louvre

60. Rembrandt: *The Wedding Feast of Samson.* 1638. Canvas, 126.5 x 175.5cm (49¹³⁄₁₆ x 69¹⁄₁₆in.). Dresden, Gemäldegalerie

61. Studio of Rembrandt: *Abraham's Sacrifice.* Canvas, 195 x 132cm (76¾ x 52in.). Munich, Alte Pinakothek

62. Rembrandt: *Belshazzar's Feast.* X-ray mosaic

63. Raphael (1483-1520): *Baldassare Castiglione.* Canvas, 82 x 67cm (32¼ x 26⅜in.). Paris, Louvre

64. Titian (active before 1511; died 1576): *Portrait of a Man.* Canvas, 81.2 x 66.3cm (32 x 26⅛in.). London, National Gallery

65. Govert Flinck (1615-1660): *Portrait of a Man.* 1643. Panel, 72 x 53cm (28⅜ x 20⅞in.). Sold at Sotheby's London, 11 December 1985 (lot 62)

66. Rembrandt: *Portrait of Castiglione* (after Raphael). 1639. Pen and bistre, 16.3 x 20.7cm (6⁷⁄₁₆ x 8⅛in.). Vienna, Albertina

67. Ferdinand Bol (1616-1680): *Self Portrait.* 1646. Canvas, 90 x 72cm (35⁷⁄₁₆ x 28⅜in.). Dordrecht, Dordrechts Museum

68. Rembrandt: *Self Portrait at the Age of 34.* X-ray mosaic

69. Rembrandt: *The Woman taken in Adultery.* X-ray mosaic

70. Rembrandt: *The Woman taken in Adultery.* Infra-red photograph

71. Rembrandt: *The Adoration of the Shepherds.* 1646. Canvas, 97 x 71cm (38³⁄₁₆ x 27¹⁵⁄₁₆in.). Munich, Alte Pinakothek

72. Rembrandt: *The Adoration of the Shepherds.* X-ray mosaic

73. Peter Paul Rubens (1577-1640): *Hélène Fourment in a Fur Wrap ('Het Pelsken').* Panel, 176 x 83cm (69⁵⁄₁₆ x 32¹¹⁄₁₆in.). Vienna, Kunsthistorisches Museum

74. Rembrandt: *A Woman bathing in a Stream.* X-ray mosaic

75. Rembrandt: *A Woman bathing in a Stream.* Detail of the right hand and wrist

76. Rembrandt: *A Woman bathing in a Stream.* Infra-red photograph

77. Rembrandt: Titus as a Franciscan. 1660. Canvas, 79.5 x 67.5cm (31⁵⁄₁₆ x 26⁹⁄₁₆in.). Amsterdam, Rijksmuseum

78. Rembrandt: *A Franciscan Monk Reading.* 1661. Canvas, 82 x 66cm (32⁵⁄₁₆ x 26in.). Helsinki, Ateneum

79. Rembrandt: *A Franciscan Friar.* X-ray mosaic

80. Rembrandt: *Hendrickje Stoffels.* Canvas, 72 x 60cm (28⅜ x 23⅝in.). Paris, Louvre

81. Rembrandt: *Portrait of a Woman leaning at an Open Door.* Canvas, 86 x 65cm (33⅞ x 25⁹⁄₁₆in.). Berlin-Dahlem, Gemäldegalerie

82. Rembrandt: *Hendrickje Stoffels.* 1660. Canvas, 78.4 x 68.8cm (30⅞ x 27¹⁄₁₆in.). New York, Metropolitan Museum of Art. Gift of Archer M. Huntington in memory of his father, Collis Potter Huntington, 1926 (26.101.9)

83. Rembrandt: *Clement de Jonghe.* 1651. Etching, first state, 20.7 x 16.1cm (8⅛ x 6⁵⁄₁₆in.). London, British Museum, courtesy of the Trustees

84. Rembrandt: *A Seated Woman.* Pen and wash, 16.5 x 14.4cm (6½ x 5¹¹⁄₁₆in.). London, British Museum, courtesy of the Trustees

85. Rembrandt: *Portrait of Hendrickje Stoffels.* X-ray mosaic

86. Rembrandt: *A Bearded Man.* 1661. Canvas, 71 x 61cm (27¹⁵⁄₁₆ x 24in.). Leningrad, Hermitage

87. Rembrandt: *A Bearded Man in a Cap.* X-ray mosaic

88. Detail of the roundel in *An Elderly Man as Saint Paul* showing the sacrifice of Isaac

89. Rembrandt: *Abraham's Sacrifice.* 1655. Etching, first state, 15.6 x 13.1cm (6⅛ x 5³⁄₁₆in.). London, British Museum, courtesy of the Trustees

List of Exhibits

In addition to the twenty paintings featured in the Catalogue the exhibition also includes the following:

Rembrandt: *Study for Judas*. Pen and wash, corrected with white, 22.6 x 17.6cm (8⅞ x 6¹⁵⁄₁₆in.). Amsterdam, Rijksmuseum, Rijksprentenkabinet

Rembrandt: *The Lamentation*. Brown, grey and white oil colours and pale brown ink over red chalk, 21.3 x 25.4cm (8⅜ x 10in.). London, British Museum (0.o. 9-103)

After Rembrandt: *Saskia as Flora*. Pen and wash, 17.3 x 21.9cm (8⅜ x 10in.). London, British Museum (0.o 10-133)

Rembrandt: *A Seated Woman*. Pen and wash, 16.5 x 14.4cm (6½ x 5¹¹⁄₁₆in.). London, British Museum

Rembrandt: *Christ Crucified between Two Thieves*. Etching and drypoint, first state. 13.6 x 10cm (5⅜ x 3¹⁵⁄₁₆in.). London, British Museum (1973.U.917)

Rembrandt: *Self Portrait*. 1639. Etching, 20.5 x 16.4cm (8¹⁄₁₆ x 6½in.). London, British Museum (1973.U.912)

Rembrandt: *Ecce Homo*. 1635. Etching, first state. 54.9 x 44.7cm (21⅝ x 17⅝in.). London, British Museum (1973.U.936)

Rembrandt: *Ecce Homo*. 1635. Etching, second state (with corrections in pen by the artist). 54.9 x 44.7cm (21⅝ x 17⅝in.). London, British Museum (1933.U.937)

Rembrandt: *Samuel Menasseh ben Israel*. 1636. Etching, first state. 14.9 x 10.3cm (5⅞ x 4¹⁄₁₆.). (London, British Museum (1843-6-7-155)

Rembrandt: *Clement de Jonghe*. 1651. Etching, first state. Drypoint and burin, 20.7 x 16.1cm (8⅛ x 6⅜in.). London, British Museum (1973.U.1041)

William Pether: *Saskia as Flora*. 1763. Mezzotint, third state. Oxon, Burford, Collection of the Hon. C. Lennox-Boyd

Reynier van Persijn: *Titian's Ariosto* (after a drawing by Sandrart). Engraving, 25.3 x 18.8cm (9¹⁵⁄₁₆ x 7⅜in.). London, British Museum (X. 1-10)